Tapestry of Cultural Issues in Art Therapy

p. 72

A Multi-Modal Approach to Creative Art Therapy
Arthur Robbins
ISBN 1 85302 262 4

Art Therapy with Offenders
Edited by Marian Liebmann
ISBN 1 85302 171 7

Art Therapy – The Person-Centred Way
Art and the Development of the Person, Second Edition
Liesl Silverstone
ISBN 1 85302 481 3

Tapestry of Cultural Issues in Art Therapy

Edited by Anna R. Hiscox and Abby C. Calisch

Jessica Kingsley Publishers
London and Philadelphia

First published in the United Kingdom in 1998 by
Jessica Kingsley Publishers Ltd
116 Pentonville Road
London N1 9JB, England
and
1900 Frost Road, Suite 101
Bristol, PA 19007, U S A

Copyright © 1998 Jessica Kingsley Publishers

Library of Congress Cataloging in Publication Data
A CIP catalogue record for this book is available from the Library of Congress

British Library Cataloguing in Publication Data
Tapestry of cultrual issues in art therapy
1.Art therapy 2.Art therapy – Cross-cultural studies
I.Hiscox, Anna R. II.Calisch, Abby C.
615.8'5156

ISBN 1 85302 576 3

Printed and Bound in Great Britain by
Athenaeum Press, Gateshead, Tyne and Wear

Contents

Acknowledgments

Anna R. Hiscox

This book would not have come to fruition without the love of my daughter Erin, who patiently and lovingly endured my absence. My admiration and gratitude go to Mel Miles, who believed in this project and supported my goals, and to Brenda Huges, who taught me the value of education and endurance. A special note of appreciation is extended to Cathy Malchiodi for her support and guidance.

I thank my extended family for their spiritual guidance, grounding and ceaseless advocacy of diversity. I also thank my colleagues, students and teachers who have shared their wealth of knowledge and experience so freely. The contributors to this book gallantly heighten our awareness of multicultural and cross-cultural issues. Due to their dedication and vision, a wonderful dream is now a reality.

Abby C. Calisch

First, I wish to thank my parents for their life-long support of my inquisitiveness and determination. I also wish to thank my colleagues, students, teachers and clients for their thoughts, ideas and inspiration that have fostered and supported my own interest in diversity and multi-culturalism. Over the past 24 years in the profession of art therapy I have had such varied opportunities in diverse academic and clinical settings with varied disciplines that I have acquired a level of appreciation for context, dissimilarity and distinctiveness.

Since it is my firm belief that my interests in diversity and multiculturalism emanate from my own experiences, it is pivotal to acknowledge both the tender and painful aspects. My earliest experience with another race was throughout childhood with an African American nanny who was a respected surrogate parent alongside of my own and considered part of our family. In direct juxtaposition to this experience was the active racism and segregation prevalent in the 1950s in Texas. I constantly questioned, and was frequently disturbed by, what I saw around me. Another prejudice personally

experienced was that of religious prejudice: I was Jewish in a predominantly Protestant school and community. Since I have had the opportunity as an adult to move to more cosmopolitan and ethnically diverse areas, I have encountered wider experiences and more ethno-relativistic viewpoints regarding diversity and race. These experiences have sensitized my awareness and led me to an interest in teaching and applying art therapy services to diverse populations in a culturally relativistic fashion.

This text is a means to acknowledge my own awareness of being encapsulated in Eurocentric thinking and my discomfort with the lack of literature on cultural diversity. We need to know more about our own culturally imposed construction of reality and the impact of a particular world on research, assessment, training, interventions and ethical considerations. What is essential is to develop an openness to cultural variability and the relativity of our own values. I urge readers to take what is offered here not as the truth but rather as a map, which, while it covers only limited aspects of the terrain, may nevertheless be a useful guide to explorers seeking a path.

The editors would like to thank Illinois State University administrative staff, students and faculty for their support and gratis hours of active listening. Kathy Johnson's administrative assistance has helped us to culminate a finished text because of her resourcefulness and technical astuteness. We thank David Kuntz and Michael Lazenka for their enduring patience and computer technical assistance. Vickie Outerbridge is an art therapy graduate student. She has exhibited nationally and enthusiastically agreed to design the book cover. Frances E. Anderson, EdD, ATR-BC, HLM, provided a wealth of knowledge and leadership which helped to turn bleak days into sunshine. Earline Rae Ferguson, Ph.D., is a tower of support. Her genuineness, humor and research skills helped to make this book a tapestry of art therapy beginnings in multicultural and cross-cultural research.

Last, but not least, the editors would like to thank Jessica Kingsley, publisher, and Louise Massara and Helen Parry for their patience, understanding and assistance. Your belief in this book and continued support of art therapy enables all art therapists to strive for excellence. We appreciate the opportunity you have given us to increase the body of knowledge in art therapy and your encouragement of us in pursuing uncharted territory.

Introduction

The psycho-social phenomenon of culture and ethnicity is the story of our connections to our heritage and ancestors. It is also always a story of our evolution of group identities as we migrate, organize and reorganize ourselves to meet the challenges of changing historical and geographic circumstances.

Our very definitions of human development are ethnoculturally based. Eastern cultures, for example, tend to define the person as a social being and categorize development by the growth in the capacity for empathy and connection. By contrast, many Western cultures begin by positing the individual as a psychological being and defining development as growth in the capacity for differentiation. Although the study of cultural influences on human emotional functioning has been left primarily to cultural anthropologists, art therapists and other health professionals are compelled to acknowledge and confront practical problems and issues in working with increasing numbers of culturally different people. These demographic and professional realities have provoked moral sensibility, political consciousness and social action within the health professions and within mental health.

All human behavior is influenced by, and is a reflection of, the cultural context within which it is nurtured. Culture includes such features as attitudes, forms of emotional expression, patterns of relating to others and ways of thought. It is a patterned, organized and integrated collection of characteristics and traits like a weaving or tapestry. Members of a particular culture share common threads with the group as a whole while also retaining some individuality. It is important to allow for both the separateness and the intimate relationship toward one's culture to grow. From the perspective of clinical understanding of ethnic persons, this is important because it ensures that differing degrees of assimilation of the subculture or the individual to the larger culture are considered. Each thread within the tapestry is unique and provides a function within the textile as a whole. Each influences, and is also influenced by, the larger integrated field of which it is a part.

In the broadest sense, the goal of this book is to contribute to the early stage of education, knowledge and training of art therapists and other mental

health workers. It is intended to fill a curricular need and a service gap which has widened due to the need of multicultural curriculum in training and the need for skills in addressing the multicultural participants in the health care system. The book is designed to be informative to both beginning and experienced practitioners alike.

All of the chapters are new contributions. They represent a synthesis of the scholarship and clinical experiences of their authors and are designed to stand independently as well as contribute or complement the tapestry as a whole. Readers will notice that there are differences in the use of terminology by the various contributors and that the editors have decided to respect the individual choices. The contributions come from practitioners in the United States, Australia, Canada and Britain and include issues from an even wider array of cultural experiences. We hope that the readers will find the contributions to be stimulating and informative regarding this important and expanding area.

PART 1

Clinical Issues in Art Therapy

Art Therapy and the Concept of Blackness

Pascale C. Annoual

Abstract

This chapter explores issues of theory and practice relating to racism, race and blackness revealed in the developing field of art therapy. Such issues are seldom the subject matter for research in the broader field of mental health, yet they have considerable impact on the lives of stigmatized individuals dealing with racism and concepts of blackness. Realizing that racism is not only prejudice but is a practice that is systematically institutionalized, art therapy can only be enhanced by exploration of the undercurrents of discrimination and racism.

Introduction

Within the matters of ethnicity and social appurtenance, blackness has become the subject of popular disputes, hence an urgent matter for sciences that try to make sense of social identification. Racism, as a form of social exclusion, is such an intriguing and elusive experience in the lives of black people that it is, perhaps, in the manageability of image-making that the tensions can best be captured. This chapter is an exploration of issues of racism, race and concepts of blackness as categories of identity revealed in the developing field of art therapy. Realizing that racism is not only prejudice but is a practice that is systematically institutionalized, art therapy can only be enhanced by exploration of the undercurrents of discrimination and racism.

As an art therapist, I find myself in places and situations 'untypical' for blacks, which allows me to address my nagging feeling of being different, not being able to simply blend in with my peers. Making full use of this sentiment, I have isolated what is individual and what are common difficulties in my experience of situating myself within both a black

community and a professional group. Within the Canadian context, I am considered a 'visible minority'. Within the broader North American context, current events arise regularly that remind me of a history in which blacks and whites have struggled in their co-existence. Sartre is quoted: 'The person is summed up and for this reason universalized by his epoch, he in turn resumes it by reproducing himself in it as a singularity' (Denzin 1989, p.19). My experience is one of many, yet unique in its way.

In a similar vein, I have been told that my success in this field might serve to pave the way for others, burdening myself with further responsibilities. I was also told that my presence alone (undermining my abilities) in the mental health disciplines would have a positive effect not only on the staff with whom I would interact but also on the black patients that I would come to treat. In discussing this with other black art therapists, students and professionals in various disciplines of mental health, I realized that such feelings of self-doubt are not isolated. My personal experience in becoming an art therapist has been reflected in the stories documented by other black providers of health care services (for example, Jones, psychiatry intern, in Thomas and Sillen, 1993; Venture 1977).

In fact, acknowledging that there are undeniable similarities in the collective identity of blacks, I believe that the most tangible one is of a shared socio-historical nature pertaining to the legacy of slavery in this hemisphere. However, following its abolition (in which blacks shared an assigned status), the experiences, beliefs and values of black people have diverged immensely. Today, perhaps the most tangible similarity among black community members is a legacy: the way in which we are perceived, imagined and represented by the society in which we live.

While evidence of discrimination against certain groups of people is readily found in society, it is difficult to inspect one's own practice critically to see how racism may have infiltrated. The attitudes that engender discrimination cause considerable damage to the self-esteem and self-perception of the stigmatized individuals. Cultural assumptions made about the worth of minorities that are grouped by racial classifications impact negatively on these individuals and their self-perceptions. The role of art therapy must, therefore, include an awareness of how discrimination of this type impacts the therapeutic setting. It is possible that the psychic wounds inflicted by racism on an individual in day-to-day living can be reiterated and deepened in the context of art therapy.

Racism is not only prejudice but is a practice that is systematically institutionalized. Thus, even the practitioner who is aware of his or her racial prejudice is not exempt from racism that is prevalent in the institution. Furthermore, while this chapter deals mainly with stigmatized individuals, current anti-racist work demonstrates how racism impacts on diminishing the humanity of all persons, regardless of color, as long as it is not eradicated (see hooks 1990, 1992, 1993; Knowles 1991, 1994, 1996; West 1989).

Racism

Even though we can easily get bogged down with terminology related to racism, the lack of agreement on definitions and terminology should not prevent the recognition of the existence of racism, nor should it temper our efforts in its rectification. I have seen how a prolonged discussion about terms pertaining to racism can be a defensive way of undermining the acknowledgment of racism and a distraction from whatever efforts could be deployed instead to working against racism itself.

In order to use a working definition for this chapter, 'racism' is defined as an ethnic prejudice based on a difference in skin color, a visually distinguishable characteristic. Sometimes, the word 'racism' is incorrectly used to describe various types of ethnic prejudice that are not based solely on phenotypes. Allport's (1979) definition of racism as an ethnic prejudice encompasses general aspects of the issue: '(Racism as an) ethnic prejudice is an antipathy based upon a faulty and inflexible generalization, and may be felt or even expressed. It may be directed toward a group as a whole, or toward an individual because he (or she) is a member of that group' (p.9).

The net effect is 'to place the object of prejudice at some disadvantage not merited by his own misconduct', which is the basis of oppression (ibid.). This type of adjustment of the belief to justify the attitude is called 'rationalization' and has been evident throughout the history of prejudice. Duckitt (1992) asserts: 'an analysis of the history of prejudice suggests that different theoretical frameworks were advanced by their authors in response to specific social and historical circumstances' (p.1182).

Thomas and Sillen (1993) explain how 'the mental health field (who had assumed that they were immune) has been undergoing a painful reassessment of its own role in perpetuating and reinforcing white racist attitudes and practices' (p.v). How many times did I hear that an acknowledgment of racism was not required because recognition of individual cultures is implicit

in the practice of therapy? It seems that in raising those particular issues, I was unsettling the comfortable notion of a racism-free art therapy discipline.

Do not take my words as those of a cynic for, throughout this ordeal, I remained convinced that those discrepancies between my peers, professors and myself were not intentional or malicious. After all, we are all influenced by broader circles of culture, we are all products of academic institutions that have not thoroughly addressed the issue of diversity.

In their examination of some of the ways in which racism has touched theory and practice in psychiatry and allied fields, Thomas and Sillen (1993) explain how 'myths from the past', on which institutions are shaped, are, therefore, inseparable from them. They state that white racism has 'improvised a thousand variations on two basic themes. The first is that black people are born with inferior brains and a limited capacity for mental growth. The second is that their personality tends to be abnormal, whether by nature or by nurture'(p.1).

Thomas and Sillen expounds their theory by asserting that, stemming from the above assumptions, 'ranking the races' has resulted in placing black people of Afrocentric ideology in inferior, disadvantageous positions. These authors also demonstrate that research goals are manipulated to produce racist findings and that such findings indicate a systematic way by which blacks are dealt with in the psychiatric system.

Knowles' (1991;1996) accounts of the over-representation of Afro-Caribbeans diagnosed as schizophrenics in Britain expose the disadvantages that blacks face in their encounter with psychiatry because of the latter's power of containment and surveillance over the affairs of black families. Thus she stresses that racism in psychiatry is not without potentially grave consequence to black people.

For example, the articles, theories and case studies that I studied in my training program were heavily anchored in a Eurocentric, white perspective. In the case of the few articles addressing the cross-cultural setting in art therapy the therapist was always from the dominant mainstream group, while the 'patient' represented the 'other culture'. As a student exposed to such material, I was not permitted to identify solely with the art therapist but very often could see myself reflected in the minority patient culture. Being projected (represented) into the position of a minority patient has had a direct impact on my self-confidence as an art therapy student.

Race

I have organized my chapter in such a way that the notion of race is discussed after that of racism. Race should be understood as a product of racism, and, therefore, as a problematic category, yet it continues to go unchallenged as a category for human classification.

Anthony Smith (1985) denounces the way in which some people, under the guise of 'science', have twisted the concepts of natural process in order to establish prejudice as a biological process. The concept of classification by race has been used by racist individuals within institutions, out of a scientific context, to an appearance with difference in intelligence, hoping to establish that a natural hierarchy exists (Thomas and Sillen 1993; Smith 1985). Although some studies have been commissioned to compare and correlate average brain size within groups to intellectual capacity (Smith 1985; Duckitt 1992; Thomas and Sillen 1993), most scientists assume that brain size and intelligence do not correlate within the human species. Philip Vernon is quoted in Smith (1985) as saying: 'it is unprofitable to investigate racial difference in intelligence…because intelligence…is always the interaction between genetic potentialities and environmental pressures' (p.25). Unfortunately, 'despite the conclusive refutation of the racial "inferior brain" thesis by anthropologists and other scientists, notably Franz Boas, this myth is by no means dead' (Thomas and Sillen 1993, p.5).

Smith (1985) on the concept of race and how it relates to the body, explores how hair and skin color are used as a characteristic basis for classifications of the human race, namely black and white. He also mentions that a full spectrum exists in the shades between those two colors. I have witnessed how shades of skin and hair texture has become the token of interaction within groups of blacks. In my own practice of art therapy I have taken notice of the shades and textures that clients have used in their self-portraits and in their relation to me. This attention to phenotypes has engaged blacks in what is sometimes referred to as 'shadism', 'slave mentality', 'in-group racism', etc. If these comparisons have mostly negative connotations, it is because they are seen as dividing a constructed group that has been struggling with issues of unity. In the art therapy setting, the use of colors for the expression of the nuances and shades could be contained. However, this requires precaution since all characteristics pertaining to blackness have long been dehumanized. It is a very touchy subject to explore by members of a constructed group and, to a larger extent, by anyone perceived as an outsider.

On the other hand, groups of black people have also used the concept of race in efforts towards self-determination. Liberation movements have been mobilized to contest the negative categorization sanctioned by some whites. Recognition of phenotypic demarcations such as skin color, widened nose and hair texture have been valued as unique and positive attributes by people of color and have found their way in the work of many artists. However, Lippard (1990) captures the struggles of confronting negative images of oneself through the eyes of the dominant culture and the creative solutions to these conflicts. In the 1970s the Black Nationalist movement declared that 'black is beautiful' (hooks 1992; Thomas and Sillen 1993; Venture 1977). In the late 1980s, Afrocentrism had become a powerful way of contesting mainstream Eurocentrism (hooks 1990; Lippard 1990). Hyphenated naming such as African-American and African-Canadian have become ways of affirming the positive contributions of the African legacy. hooks (1992) writes: 'black nationalism, with its emphasis on black separatism, is resurging as a response to the assumption that white cultural imperialism and white yearning to possess the other are invading black life, appropriating and violating black culture' (p.30).

Thus she explains that this type of cultural essentialism is a survival strategy that serves to protect the voice and story that black people have to relate about their experience within the patriarchal, white supremacist society. She then states that it is the specific historical and social content of black experience which informs cultural productions and the emergence of distinct black styles. To love blackness is then framed as a constructive, naive form of folk purism.

Racism and Race in the Culture of Art Therapy

In this way, 'race' has become a culture. As an institution, art therapy has only begun to deal with the issue of racism. If we look at the literature produced by the art therapy community, racism is not dealt with directly. At present, it is discussed mostly as cultural differences encompassed in the cross-cultural, multicultural and inter-cultural art therapy (see Campanelli 1991; Lofgren 1981; McGee 1982).

Campanelli (1991) writes: 'ethno-cultural factors play an important role in the way clients think, feel, and behave' (p. 34). He is also a proponent of a form of treatment that focuses on the ethnic tendencies of the client and the therapist, called 'ethnotherapy' (ibid.).

Emphasizing the art-making process over the context in which it is made, Ciornai (1983) states that 'art traditionally reflects the myriad of complexities involved in both the artist's unique personality and his (or her) cultural roots' (p.64). Ciornai posits that art, as a mode of communication, bypasses certain linguistic limitations yet allows certain cultural factors not to be overlooked as these will remain implicit in the artwork. From Ciornai's article it can be inferred that if one accepts racism as a societal problem, it would also make sense to approach art therapy work dealing with racism in a way that does not 'focus exclusively on intrapsychic factors in the understanding of clients' problems' (ibid.). If a therapist neglects the social and economic factors, he or she will, in fact, 'blame the victim' (ibid.). The article also advances that the art process can be used as a concrete method in therapy to 'help transform nebulous and difficult-to-define life situations' (p.67), such as the cultural component of ethnicity.

Art therapy programs, students and recent graduates are beginning to contribute to the body of literature on issues of culture related to art therapy. Goldman (1994), a recent graduate of the art therapy program at Concordia University, has done extensive research for her thesis. Although her research does not deal extensively with racism, it offers a broader overview of the type of intervention that occurs when therapist and patient come from different cultural and ethnic backgrounds. More recently, students were asked to participate in a masters level research in art therapy dealing with the experience of black students enrolled in art therapy programs. The evolving interest of students to begin tackling the very complex issue of racism and blackness is a very exciting prospect. I hope that this type of work continues to develop.

A few therapists have dealt with the theme of racism as a relevant issue in art therapy (see Lewin 1990; Venture 1977). Lucille Venture addresses her dissertation to 'anyone' who is interested in learning about the history of art therapy and about 'the Black experience'. She shares with the readers her personal experience as a black art therapist and presents some cases of therapy with black children. Although it is a manuscript unique in its content as it acknowledges racism, there is actually very little that directly pertains to it.

When racism is an intractable phenomenon it can be imputed to the person seeking treatment. When I first began to explore the issue as related to art therapy I understood it only as an issue of prejudice sustained by individuals that would, in turn, influence other individuals. As my research

developed I was able to extend the notion to the understanding of systemic and institutional phenomena. Therapists, uncomfortable when realizing the existence of racism, can be relieved to know that the responsibility to address this issue should also be that of institutions with whom they work and train.

Blackness as an Identity Factor of Art Therapy Clients

Every culture has its labels for different types of people. For example, consider the labels of 'visible minority', 'schizophrenic' and 'Black'. These labels may affect people at the surface level, where it is barely felt, or at a deep level and leave indelible marks (Denzin 1989). Identification labels, once given, usually enable people to dispose of the stigmatized person in a way that is prescribed by that label (Knowles 1991; 1996). For instance, once a schizophrenic is diagnosed, he or she will be dealt with according to preset ways of dealing with sufferers of schizophrenia, which may include pharmacotherapy. People do have objective characteristics, even though the categorization of those qualities into labels is subjectively ascribed by others. One is not born 'black' but rather one becomes 'black' either by self-identification or through social maneuver. Whether identification is self-defined or socially ascribed will have different meanings for the individual.

Black, as an identity, is highly contested and is by no means a static concept. In fact, it is to be understood as a highly individualistic process in the construction of identity. As with other elements of self-identification, one's blackness is something that may change depending on situation and context.

In the art therapy situation, a client's divulging of his or her awareness of this identity may depend on several factors. It may depend on the milieu of therapy, the client/therapist match, one's personal awareness of this identity or the relevance to the problem for which one presents oneself to therapy.

It is my hope that presenting blackness as an identity construct effectively differentiates between objective and subjective identities. I am mostly concerned with the latter, for it allows me to conceptualize what is to be looked at in art therapy as problematic. In therapy it is never blacks as people who are to be healed but rather the ways in which they have been affected by the mechanisms of racism that are to be addressed.

As a mechanism of exclusion from mainstream society, racism plays an important role in the therapeutic process where the client is already dealing with feelings of isolation and alienation. This is done through its impact on

the operation of institutions and on the administration of mental health care to its recipients.

If the client's preferred version is not given its due consideration, and, instead, the illness narrative is analyzed into a diagnosis of illness, the therapy situation may only reiterate the very form of exclusion that might have been problematic for the patient prior to therapy. It is easy for therapists to internalize institutional behavior and neglect and/or avoid the client's presentation of self.

The cultural dimension is especially relevant to the milder forms of distress, whereas the more dramatic forms of psychiatric illness are more easily discernible across cultures (Kirmayer 1989a and b). To look at the illness behavior of black people would demand at least an understanding of the influence of the particular history of slavery and colonization. One needs to examine the particular impact these have on the development of the present social dynamics between blacks and whites to this day.

Conclusions

Completing this chapter has been a laborious but worthwhile exploration of racism, race and blackness, and art therapy. Each of these issues are very complex, and potentially alienating, variables in the therapeutic context, that are difficult to discuss but, in any case, necessary.

Whether or not it is relevant to discuss the issues of racism in relation to the practice of art therapy continues to be debated. I have attempted to examine the many ways in which various aspects of art therapy are influenced by racism and, conversely, the many ways in which the artwork produced in therapy may reflect concepts of blackness. As an art therapist, it is important that I become familiar with the symbols used to situate oneself within a black identity that is complicated by elements of gender, age, nationality, religion and more factors of identification.

This chapter has been an investigation of the issues of racism, race and blackness and their interaction within the lives of individuals engaged in art therapy. I contend that the lives of the many art therapists that will be working with clients of color will also be affected. It is my wish that this work benefit those persons who are concerned with understanding more about the experiences of black clients and therapists as they are engaged in art therapy.

References

Allport, G.W. (1979) *The Nature of Prejudice* (3rd ed.). Ontario: Addison-Wesley Publishing Company.

Annoual, P. (1995) *Art Therapy and the Concept of Blackness.* A Research Paper in the Program of Art Therapy. Montreal: Concordia University.

Campanelli, M. (1991) 'Art therapy and ethno-cultural issues.' *The American Journal of Art Therapy 30,* 34–35.

Ciornai, S. (1983) 'Art therapy with working-class Latino women.' *The Arts in Psychotherapy 10,* 63–76.

Denzin, N.K. (1989) *Interpretive Interactionism.* London: Sage Publications.

Duckitt, J. (1992) 'Psychology and prejudice: A historical analysis and integrative framework.' *American Psychologist 47,* 10, 1182–1193.

Goldman, S. (1994) *Intercultural Intervention in Art Therapy.* A Thesis in the Program of Art Therapy. Montreal: Concordia University.

hooks, b. (1993) *Sisters of the Yam: Black Women and Self Recovery.* Toronto: Between the Lines.

hooks, b. (1992) *Black Looks: Race and Representations.* Toronto: Between the Lines.

hooks, b. (1990) *Yearning: Race, Gender, and Cultural Politics.* Toronto: Between the Lines.

Kirmayer, L. (1989a) 'Cultural variations in the response to psychiatric disorders and emotional distress.' *Social Science and Medicine, 29,* 3, 327–339.

Kirmayer, L. (1989b) 'Psychotherapy and the cultural concept of the person.' *Sante Culture Health, VI,* 3.

Knowles, C. (1996) 'Racism, biography, and psychiatry.' In V. Amit-Talai and C. Knowles (eds) *Re-Situating Identities.* Peterborough, Ontario: Broadview Press.

Knowles, C. (1994) *Exploring Racism and Schizophrenia Through Life Stories.* Chaire Concordia-UQAM en etudes ethniques. Working Papers, No 5.

Knowles, C. (1991) 'Afro Caribbeans and schizophrenia: How does psychiatry deal with issues of race, culture and ethnicity?' *Journal of Social Policy 20,* 2, 173–190.

Lewin, M. (1990) 'Transcultural issues in art therapy: Transcultural issues: Considerations on language, power, and racism.' *Inscape,* 10–16.

Lippard, L.R. (1990) *Mixed Blessings: New Art in a Multicultural America.* New York: Pantheon Books.

Lofgren, D.E. (1981) 'Art therapy and cultural difference.' *American Journal of Art Therapy 21,* 2, 54–60.

McGee, S.E. (1982) 'Cultural awareness and the creative process.' In A.E. DiMaria (ed) *Art Therapy: A Bridge Between Worlds.* (The proceedings of the Twelfth Annual American Art Therapy Association, Liberty, New York, 1981). Falls Church, VA: The AATA, Inc.

Smith, A. (1985) *The Body.* New York: Penguin.

Thomas, A. and Sillen, S. (1993) *Racism and Psychiatry.* New York: Citadel Press Books.

Venture, L.D. (1977) *The Black Beat in Art Therapy Experiences.* Doctoral Dissertation. Ann Arbor, MI: Xerox University Microfilms International.

West, C. (1989) 'Black culture and postmodernism.' In B. Kruger and P. Mariani (eds) *Remaking History*. Seattle: Bay Press.

An Experiential Model for Exploring White Racial Identity and its Impact on Clinical Work

Nancy M. Sidun and Kelly Ducheny

Abstract

Despite the fact that 91 per cent of art therapists are white and are working with an increasingly diverse clientele, training and continuing education programs fail to address the impact of being white on art therapists and their clients of color. It is essential that art therapists take an opportunity to increase their awareness and appreciation of themselves as racial beings. This awareness will deepen an appreciation of culture and world view and will improve art therapists' effectiveness when working with all clients, most notably those of different racial or ethnic backgrounds. The authors briefly address the stages of white racial identity and outline an experiential workshop model designed to facilitate an exploration of white racial identity. This workshop is composed of six elements; an introduction and invitation, a short didactic presentation, a group discussion, creation of artwork, examination of the artwork, and summary. Participant and facilitator experiences are discussed with illustrative examples.

In our training to become competent art therapists we spend numerous hours analyzing and observing the quality and effectiveness of our clinical work. Within supervision and formal education it is stressed that we must not only understand art but must know 'in some depth and at a personal level, what it means to create with art media – the pain as well as the pleasure, the tension as well as the release' (Rubin 1984, p.70). However, understanding art alone is insufficient.One must also have a deep appreciation and knowledge of one's 'self': one's values, intellect, human connectedness, flexibility, instincts and receptivity. While a high value is placed on self-awareness, certain areas of self-exploration are more actively encouraged than others. Some elements of self-exploration are noticeably absent or even actively discouraged in

training and in the field as a whole (Ducheny and Sidun, in press). One of those unspoken aspects of 'self' is the impact of being white (Alderfer 1994). An authentic awareness of our own racial identity is critical in understanding the impact of being white, as well as the effect world view has on our personal and professional effectiveness.

According to the most recent American Art Therapy Association (AATA) membership survey, 91 per cent of art therapists are white (Pearson *et al.* 1995). By the year 2000, Hispanics, African Americans, Asian Americans and Native Americans will make up 30 per cent of the United States population and 52 per cent of the population by the middle of the twenty-first century (Alvarez 1994; Ambush 1993). Studies of mental health services for clients of color indicate that even now this population is not being adequately served (Sue *et al.* 1991). With these changing demographics and the paucity of art therapists of color, a salient issue emerges: white art therapists will be increasingly challenged to deal with issues of culture and race. While similar racial background has been shown to have some positive effect on length of treatment, 'cultural responsiveness' is seen as the essential component in developing rapport and therapeutic effectiveness with clients of color (Sue *et al.* 1991). The development of cultural responsiveness through self-introspection and exploration has become a prerequisite for the provision of effective, culturally appropriate services.

While the importance of multiculturalism is acknowledged within art therapy, few authors offer an in-depth exploration of these issues. Specifically, the issue of white racial identity and its impact on therapeutic work has not been addressed. Some authors in the field of cross-cultural psychology have begun to explore white racial identity and its impact on the therapeutic exchange.

As psychotherapy is not a culturally free activity, art therapists need to remain aware that cultural variables enter into treatment in ways that parallel their operation in society (Jenkins-Hall and Sacco 1991). Since the majority of art therapists are white, it is essential that they take an opportunity to increase their awareness and appreciation of themselves as racial beings. This, in turn, will significantly impact their ability to be culturally responsive and effective in dealing with a rapidly changing world.

In cross-cultural psychology, Helms (1992, 1995), Hardiman (1982) and Ponterotto (1988) have suggested developmental models of white racial identity. Across these models, white racial identity progresses through a

series of stages or statuses that are fluid and dynamic (Hardiman and Cross 1994; Helms 1995; Ponterotto 1988). Hardiman and Cross (1994) discuss a first stage of Pre-Socialization that characterizes a child's beginning exploration of the social world; a curiosity about race and difference not yet clouded by stereotype or judgment. By the age of three or four years, a white child has already begun to learn the 'neutrality' or normalness of being white and has been exposed to the *status quo* of racial blindness in the white community (Hardiman and Cross 1994). The second stage of white racial identity is characterized by a lack of awareness of cultural and racial issues. This Pre-Exposure stage is characterized by simplistic unquestioned acceptance of white privilege and racial stereotypes (Ponterotto and Pedersen 1993). Hardiman makes the distinction between passive and active acceptance within this stage (Hardiman and Cross 1994). Individuals in passive acceptance take their race for granted and are largely unaware of the impact that oppression and racism have on their interactions with people of color. Individuals in active acceptance are very aware of their whiteness and strongly support the superiority of the white race.

Disintegration or Resistance is the third stage and is characterized by 'ambivalence and conflict fueled by the inherent contradiction of a person's increasing awareness of oppression and their perception of Whites as fair and humane' (Ducheny and Sidun, in press). At this point white people begin to question their assumptions and struggle as a basic frame of reference for their world is dismantled or shaken (Hardiman and Cross 1994; Helms 1992). During this stage whites begin to experience guilt, shame, anger and fear. Should an individual become overwhelmed with the struggle and discomfort of the Resistance stage, she or he may retreat, even more rigidly, into a stance of racial blindness or white superiority (Helms 1992, 1995; Ponterotto and Pedersen 1993). As an individual continues the struggle to question the, sometimes, subtle education white people receive regarding race and privilege, he or she enters the stage of Redefinition (Hardiman and Cross 1994).

During Redefinition, white people begin to reconstruct their perception of the world·by increasing their awareness of oppression, decreasing racism, and begin to incorporate race as a salient element of their identity. Hardiman and Cross (1994) note that growth in this stage cannot be accomplished in isolation. Instead, a group dialogue with other white people is necessary to redefine what it means to be white and to reach some sense of peace with this as a positive element of identity. All three racial identity models describe

advanced stages in which an individual gains a more sophisticated and personally incorporated awareness of themselves as a racial being and a deeper appreciation of the impact of white privilege and oppression. Helms (1995) labels these advanced statuses Pseudo-Independence, Immersion/ Emersion and Autonomy. Hardiman describes this stage as Internalization (Hardiman and Cross 1994). While white racial identity is often discussed using a stage model, a person's progression through different phases or statuses of white racial identity is fluid. Helms (1992) offers an apt metaphor in which the different phases of white racial identity can be seen as liquids of various weights within a single container (e.g. oil and water). The composite of different amounts of all the white racial identity phases will depend on a person's life experiences, environment and maturational level (Helms 1992). This composite will shift as a person becomes increasingly aware of their own race and the power of white cultural socialization.

White racial identity and race consciousness impact our perceptions of others, the perceptions we have of ourselves and our perceptions about how others view us (Ducheny and Sidun, in press). The exploration, and even simple acknowledgment, of white culture by white people is atypical (Helms 1992). The beginning exploration of white racial identity can be extremely uncomfortable and can lead to feelings of guilt, confusion, anger, shame and self-doubt (Alderfer 1994; Helms, 1992). Any contradiction of the white cultural norm of racial blindness can have consequences within a white person's personal and professional life. White people moving beyond the cultural norm of blindness can be ostracized or disregarded by professional colleagues, peers and even family members (Alderfer 1994; Helms 1992). As a white person's awareness of racial oppression and white privilege increases, she or he will be forced to re-examine relationships with others that are actively engaged in the *status quo* of racial blindness. In the search for white identity, a person will experience discomfort and confusion when questioning their foundation of training, the system of mental health, their cultural heritage, their personal relationships and even their families of origin (Alderfer 1994; Helms 1992; Pedersen 1995).

As an individual becomes increasingly aware of the, sometimes, subtle education white people receive regarding their culture and privilege, sensitivity to racism and oppression is heightened (Helms 1995; McIntosh 1988). Exploring white racial identity can also produce positive feelings of release and clarity, authenticity and honesty and can normalize feelings of isolation. While often intimidating, the search for a white racial identity adds

a richness and depth to one's understanding of culture and to the complexities of healing in therapy (David and Erickson 1990). Without a forum for discussion, white art therapists struggle in isolation and imposed silence. The need to establish a community dialogue is pressing, for it is within a community that reactions can be normalized and feelings worked through (Hardiman and Cross 1994).

In working with white therapists, the authors have developed an experiential workshop model to facilitate exploration of white racial identity. This model provides an opportunity for art therapists to begin a candid, honest examination of the impact of being white in working with clients of color. This experiential model is rooted in the belief that a full exploration of white racial identity cannot occur in isolation but, instead, requires an interchange with other white people (Hardiman and Cross 1994).

There are six basic, yet essential, elements within this model:

1. An introduction and invitation

2. A short didactic presentation

3. Group discussion

4. The creation of art work

5. An examination of the artwork, and

6. Summary.

To begin, workshop facilitators should introduce themselves, describing their own interest or experiences that draw them to this topic. Participants should be invited to share their reasons for attending the workshop and to describe what they hope to gain from it. This open introduction and invitation sets the stage for sharing and candid dialogue. This beginning group dialogue allows the facilitators to make a quick assessment of participants' awareness of their racial identity and to make note of issues to be dealt with in later stages of the workshop. The second element of the workshop is a presentation about the importance of owning, recognizing and embracing white racial identity. This didactic element need not be lengthy but should provide a context which fosters and invites art therapists to begin their own personal exploration. Information regarding the changing demographics of the United States and the current research regarding therapeutic effectiveness needs to be offered. Third, group discussion is encouraged to allow participants a safe, contained environment

to explore all feelings that surround their race – such as pride, guilt and confusion. It is strongly encouraged that facilitators of such a workshop follow a feminist foundation which invites and encourages all members to equally share in the ownership of the dialogue. The fourth, and, perhaps, the most essential, element is the creation of artwork. Participants should be invited to create an art piece in response to what has been discussed both within the didactic component and in the group discussion. Art making is an extremely powerful mode of self-discovery; drawing feelings or one's world view offers an opportunity to communicate and understand experiences in new ways. The very process of creating can facilitate a diffusion of inner pain or conflict and can reduce a sense of isolation (Oster and Montgomery 1996). The healing power of the art making itself is well documented within Native American cultures (Burt 1993; Dufrene and Coleman 1994; LaFromboise 1995). Drawings provide opportunities for self-reflection, self-confrontation and new perspective. The very creation of artwork serves to encourage candid and spontaneous interactions (Oster and Montgomery 1996). 'Unexpected things may burst forth in a picture or sculpture, sometimes totally contrary to the intentions of its creator' (Wadeson 1980, p.9). Talking about the images or characters created can be far less threatening than directly discussing emotionally loaded topics. The richness of discussion within the workshop is greatly enhanced by the creation and exploration of the artwork. In addition to stimulating and enhancing the depth of community dialogue, the creation of artwork facilitates a creator's 'inner' dialogue while drawing and creating, as well as an 'outer' dialogue among the workshop participants (Dalley, Rifkind and Terry 1993).

Use of the art making facilitates an internal dialogue for participants and leads to rich small-group discussions. Interacting with art materials offers participants an opportunity to examine unstated beliefs regarding race, identity and the impact of being white. For example, one participant, in a previous workshop with art therapists and other mental health professionals, discussed an internal dialogue about choosing materials for her collage (Ducheny and Sidun, in press). She discussed the process of gluing a large white pom-pom and a small black pom-pom on her paper to represent people of those races. Her choice of materials caused her to consider the subtle implications of her representations. This woman then made a conscious effort to alter that representation to include materials of both colors and sizes. Another example, as seen in Figure 2.1, was a participant's choice to overlay her drawing with a layer of white (Ducheny and Sidun, in press). She

discussed the impact of realizing that the overlay of white pastel was not immediately obvious to observers and that others had to go out of their way to recognize it.

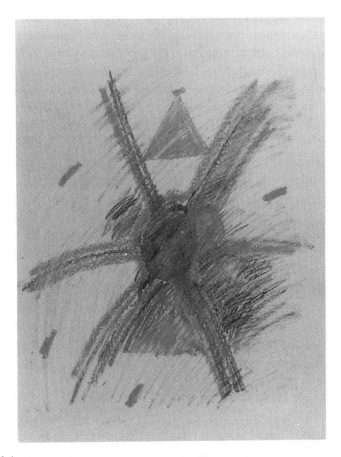

Figure 2.1

After participants complete their art piece, small groups are formed as the fifth element of the model. Creators are asked to show their work while other small group members react to the piece. After the group has offered their reactions, the creator may discuss her or his experience of creating the artwork and the intention behind any elements of the design.

A sixth, and final, component of the model is a large group discussion in which participants are invited to share reactions or their artwork with the facilitators and participants outside of their small group. This dialogue offers

participants an opportunity to witness patterns and similarities in the struggles of others addressing the complexity of issues surrounding white racial identity.

Common themes of participants include a sense of division within themselves and their work (as clearly seen in Figures 2.2, 2.3, 2.4, 2.5), a struggle with continually having to question the foundation of their education, training and conception of the world, a sense of relief that others asked the same questions and felt the same discomfort, a sense of loss and feelings of hope and pride. Participants have also articulated a struggle to coalesce a growing awareness of the historical treatment of people of other

Figure 2.2

Figure 2.3

Figure 2.4

Figure 2.5

cultures by the white dominant majority with an individual attempt to minimize racism and oppression. This struggle sometimes led to feelings of frustration, powerlessness, self-distrust and discouragement. Participants wondered how much of a difference they could make and were very aware that a heritage of racism and oppression follows each white American. On the other hand, this struggle also led participants to feelings of renewed commitment to affirmative work with clients of other cultures, a sense of personal pride and a renewed strength to challenge the *status quo* of an unexamined culture.

At the completion of past workshops, the majority of participants have voiced an appreciation for the opportunity to directly address the issues of being white in their work with clients of color and described the workshop as the first step in a long process of exploration. The authors have also found benefit in facilitating these dialogues. A deepening commitment to issues of white racial identity and an increasing awareness of white socialization has resulted. For example, upon examining the model and past workshops, the

authors noticed the choice of paper made available to participants. Upon discussion, the authors realized that available art materials required participants to place colors or materials on white paper only. The use of whiteness as a foundation upon which other colors could be placed was seen as a subtle reinforcer of white privilege and of the conception that white culture forms the basis upon which all other races are examined (Ducheny and Sidun, in press).

Future areas for exploration include investigating the amount of impact this type of a workshop has and whether it empowers participants to address these issues on a professional and personal level. It is hoped that these workshops increase the sensitivity of participants and that issues that were raised in this small forum would 'trickle down' through discussion and dialogue with others that had not attended the workshop.

Through the experiential model presented, white art therapists can begin to explore their racial identity and deepen their awareness of white culture, subtle forms of oppression and racism. With these steps, art therapists widen their self-knowledge and foster professional, culturally responsive service provision. This is an exciting time for the profession to welcome the challenge of addressing white racial identity.

References

Alderfer, C.P. (1994) 'A white man's perspective on the unconscious processes within black-white relations in the United States.' In E.J. Trickett, R.J. Watts and D. Birman (eds) *Human Diversity: Perspectives on People in Context.* San Francisco: Jossey-Bass.

Alvarez, J. (1994) 'Psychology responds to America's changing demographics.' *Cultural Impact, Newsletter of the Center for Intercultural Psychology, Chicago School of Professional Psychology 2,* 2, 2.

Ambush, D. (1993) 'Points of intersection: The convergence of aesthetics and race as a phenomenon of experience in the lives of African American children.' *Visual Arts Research 19,* 2, 13–23.

Dalley, T., Rifkind, G. and Terry, K. (1993) *Three Voices of Art Therapy: Image, Client, Therapist.* London: Routledge.

David, A.B. and Erickson, C.A. (1990) 'Ethnicity and the therapist's use of self.' *Family Therapy 17,* 3, 211–216.

Ducheny, K. and Sidun, N.M. (in press) 'Exploring the unique rewards and stresses of white therapists in their work with clients of color: An experiential workshop.' In J. Alvarez, M. Christensen and R. Saafir. *Cultural Impact Conference: Promoting Healthy Families and Community Support Systems.* Chicago: Chicago School of Professional Psychology.

Dufrene, P.M. and Coleman, V.D. (1994) 'Art and healing for Native American Indians.' *Journal of Multicultural Counseling and Development 22,* 145–152.

Hardiman, R. (1982) *White Identity Development: A Process Oriented Model for Describing the Racial Consciousness of White Americans.* Doctoral dissertation, University of Massachusetts, 1982. Dissertation Abstracts International, 43, 01A.

Hardiman, R. and Cross, W.E. (1994) *White Identity Theory: Origins and Prospect* (Videotape). (Available from Microtraining Associates, Inc., Box 9641, North Amherst, MA, 01059–9641).

Helms, J.E. (1992) *A Race is a Nice Thing to Have: A Guide to being a White Person or Understanding the White Persons in your Life.* Topeka, KS: Content Communications.

Helms, J.E. (1995) 'An update of Helm's white and people of color racial identity models.' In J.G. Ponterotto, J. Manuel Casas, L.A. Suzuki and C.M. Alexander (eds) *Handbook of Multicultural Counseling.* Thousand Oaks, CA: Sage.

Jenkins-Hall, K. and Sacco, W.P. (1991) 'Effect of client race and depression on evaluation by white therapists.' *Journal of Social and Clinical Psychology 10*, 3, 322–333.

LaFromboise, T. (1995, Winter) 'Conference excerpt.' *Cultural Impact, Newsletter of the Center for Intercultural Psychology, Chicago School of Professional Psychology 3*, 1, 2.

McIntosh, P. (1988) *White Privilege and Male Privilege: A Personal Account of Coming to see Correspondences Through Work in Women's Studies.* Wellesley, MA: Center For Research on Women, Wellesley College.

Oster, G.D. and Montgomery, S.S. (1996) *Clinical Uses of Drawings.* Northvale, N.J.: Jason Aronson, Inc.

Pearson, S.L., Walker, K.K., Martinek-Smith, M., Knapp, N.M. and Weaver, K.A. (1995) *American Art Therapy Association, Inc.: The Results of the 1994–1995 Membership Survey.* Muldelein, IL: American Art Therapy Association, Inc.

Pedersen, P.B. (1995) 'The culture-bound counselor as an unintentional racist.' *Canadian Journal of Counseling 29*, 3, 197–205.

Ponterotto, J.G. (1988) 'Racial consciousness development among White counselor trainees: A stage model.' *Journal of Multicultural Counseling and Development 16*, 4, 146–156.

Ponterotto, J.G. and Pedersen, P.B. (1993) 'White racial identity development and prejudice prevention.' In *Preventing Prejudice: A Guide for Counselors and Educators,* 63–83. Newbury Park, CA: Sage.

Rubin, J.A. (1984) *Knowing Art Therapy: The Art of Art Therapy.* NY: Bruner.

Sue, S., Fujino, D.C., Hu, L., Takeuchi, D.T. and Zane, N.W.S. (1991) 'Community mental health for ethnic minority groups: A test of the cultural responsiveness hypothesis.' *Journal of Consulting and Clinical Psychology 59*, 4, 533–539.

Wadeson, H. (1980) 'Advantages of art therapy.' In *Art Psychotherapy,* 8–12. NY: John Wiley.

Art Therapy
An Afrocentric Approach

Charlotte G. Boston & Gwendolyn M. Short

Abstract

There are many established approaches in art therapy, including Jungian, Analytic and Gestalt. There is, however, another approach to treatment that has been used by other disciplines but has been ignored and under-valued by art therapists. This chapter documents an Afrocentric approach to art therapy. The origin of this theory derives from African heritage and traditions…it is a holistic approach to treatment. It fosters love and community interdependence and focuses on the client's strengths. This chapter contrasts an Afrocentric model with Eurocentric models of art therapy. The rationale and goals are cited in addition to case vignettes.

Introduction

This chapter proposes to define and explore an Afrocentric model of art therapy and contrasts this perspective with Eurocentric approaches. The rationale for using this model will be discussed with examples of programs that emphasize the Afrocentric approach.

With the Eurocentric model, distance may occur based on the establishment of roles in the therapeutic process. The Afrocentric approach, in contrast, models principles of interconnectedness, harmony, cultural awareness and authenticity that facilitates the healing process and therapeutic work from the onset. The origins of this approach may be seen from a holistic perspective, with its source from African tribal heritage which fosters treatment with love and a sense of community and focuses on strengths. When one works from a model that is familiar to clients, the rapport and progress is enhanced and productive.

Nobles (1977) documented the contrasts between the European World-View and the African World-View (p.201). The European World-View

differs greatly from the African World-View of 'we'. Individuality, uniqueness and differences represent the psycho-behavioral modalities of the European World-View. Competition, individual rights, separateness and independence also make up the values and customs of the European World-View. In addition, survival of the fittest, control over nature and experimental communality comprise the ethos of this world-view. In contrast, the African World-View is represented by groupness, sameness and communality. The values and customs are co-operation, collective responsibility and interdependence. Survival of the tribe, one with nature and experimental communality form the ethos of the African World-View (Perkins 1985).

Rationale

Many urban art therapy student placements and art therapy paid employee positions service mainly non-white clients. Many African American clients referred for art therapy services come as a result of courts, welfare departments, child welfare agencies, health care and mental health providers, by way of other social service agencies and/or schools (Boyd-Franklin 1989). The trends in population demographics indicated that the non-white population is growing faster than the white population, the pool of prospective students was changing and colleges and universities were facing a declining pool of college-bound, white 18-year-old students and a high drop-out rate of minority students at the secondary school level (Wells 1995).

> The 1990 Census reported nearly 30 million black Americans; at 12.3 percent of the population blacks represent the largest minority group. With respect to the number of health status indicators, however, the statistics for blacks have lagged behind the total population. Infant mortality is twice as high for black babies and life expectancy is lower for blacks especially than the general population. Other issues which face the black community are; violence, adolescent pregnancy, HIV/ substance abuse, cancer and heart disease… There is a need for increased family and community involvement in intervention strategies as well as evaluation of ongoing research and programs. (U.S. Department of Health and Human Services 1994)

An Afrocentric approach to art therapy honors and values the person. Because of issues of building trust with families, clinicians often find that

they have to postpone extensive information gathering until after trust has been established. This often means that extensive joining, initial attention to assessment and problem-solving occur before extensive historical data collection can take place (Boyd-Franklin 1989). Thus, even though, traditionally, the clinician must get all of the administrative formalities out of the way – such as time conditions of the therapeutic contract and gathering the information for the intake – this can be perceived as intrusive and focus more on the clinician than the client. Although unintentional, this manner of doing business can offend the client and, in some cases, the extensive collection of data may be the reason clients do not return. Joining does not occur and the client may not feel valued.

Understanding time from an Afrocentric perspective is very important. Orientation to time is often focused on the 'here and now'. Therefore, the initial sessions address the problem or crisis. Efforts to yield to the pressures of a predetermined number of sessions with a given time limit may often be met with resistance. The duration and timing of sessions may be less regimented and more flexible. Regardless of ethnic origins, middle-class therapists have been socialized in terms of mainstream values. The concepts of Doing, Future, Mastery-over-Nature and Neutral relate to these mainstream values. Doing relates to the core of the United States life-style. Competition and the strive upward toward jobs and social contacts are associated with Doing. Doing often involves controlling our feelings to get the job done properly. The Future is a concept of time and the temporal focus of human life. It places importance on novelty and transience. The Neutral orientation relates to the basic nature of man. This assumes that we are born neither good nor evil but more like a blank slate upon which the environment leaves its imprint during the course of growth and development. Mastery-over-Nature is based on the assumption that there are few (if any) problems that cannot be solved with the help of technology and the expenditure of vast sums of money (McGoldrick, Pearce and Giordano 1982). Given this framework, the therapist will be Future-oriented, expecting clients to be motivated and keep appointments punctually. He or she will also expect families to be willing to work on therapeutic tasks (Doing), over reasonable periods of time (Future), with the prospect of change before them (Mastery-over-Nature). All this is to be done while taking a pragmatic view of moral issues (Neutral) and, at the very least, the therapist will expect to help the client distance themselves from any overwhelming moral burden or intense feeling of shame. Clients will be

expected to separate themselves from enmeshment in the family structure and to develop increased autonomy (Individual) (McGoldrick, Pearce and Giordano 1982).

Afrocentric Approach

A Maryland suburb of Washington, D.C., was 70 per cent African American. A comprehensive community mental health center (CMHC) was located in this community. It had a staff which was primarily master's level clinicians and above (professionals), 85 per cent of whom were white. Those below the master's level, and many were high school graduates (para-professionals), were all African American. They were trained by the health department and were selected from the community since they would be in a better position to give feedback on the immediate needs of the community in which they lived. Master's level African Americans were routinely caught in the crossfire of the conflict between the professionals and the para-professionals. This was very irritating since new staff members were not aware of the origin of this conflict. The para-professionals eventually shared that this particular center was developed to provide service to the African American community. African Americans did not feel that they were treated with dignity and respect when they came to the CMHC, which was opened soon after desegregation. Even though the health department spent time, energy and money on sensitivity seminars and workshops, many of the bias attitudes remained intact. Following the passage of the 1963 Community Mental Health Centers Act, which authorized construction of the facilities, were a number of amendments to the Act which dealt with personnel for staffing, types of care, extension of funding, special grants for specific types of service and consideration to poverty areas. The basic policy format of CMHC was to provide a comprehensive, coordinated program of mental health services for 75,000 to 200,000 persons that would be located in one or more facilities in the community. The stated purpose was to provide a varied range of accessible and coordinated services to help prevent mental illness and to treat the mentally ill (Gary 1978).

There was an effort toward using staff persons who were residents in the neighborhood to provide mental health services to primarily African American and low-income white clients who used the community center. In addition, advisory boards were set up – supposedly to enable the community residents to participate to a greater extent in the service of their communities. This was to be maximum feasible participation (Gary 1978).

Initially, the leadership was an African American male and the atmosphere was quite community oriented with walk-in services. The administrator position was given to a white female and with her came an imposed structure which began to alienate the community. The changes reflected the clinic's interest rather than the clientele. Needless to say, the 'no show' rate for clients increased.

Transportation was a big issue in this community. Many of the clients travelled by buses that were scheduled every hour at best. Therefore, many clients arrived exceedingly early or late for an appointment. Many white clinicians would not see a client early, which would reduce the client's waiting time. These same clinicians would not see someone more than fifteen minutes late, despite the knowledge of the client's situation.

Flexibility in the treatment of African Americans may take on many different forms. Visiting the homes of the clients allows the clinician to see another side of the client. The neighborhood, the home and the conditions in which the client lives all help the clinician to understand the client's plight more clearly. Meeting the client at his or her home also facilitates the valuing of the client and in building trust.

Art therapists have been travelling with supplies since the beginning of our existence. Therefore, it is not a hardship to take art therapy into a client's home. Sometimes the familiarity of the home environment facilitates the client's participation. For the therapist, remaining flexible helps to reduce ill feelings that could develop as a result of having to work more to keep the client involved in his or her treatment. Boyd-Franklin (1989) addresses how overwhelmingly demanding and draining this work can be.

The Afrocentric model fosters efforts which encourages healing in a unit (incorporating families). This is patterned after the ways of tribes, which is a collective focus. This approach leads the person to solve problems themselves and build upon them. Here one capitalizes on the esteem that already exists. What can distinguish Afrocentric group therapy from groups that are conducted and attended by whites is the incorporation of African principles of wellness. A nurturing atmosphere is established from the beginning. The cultural patterns of communication are different, which may include soothing language or a supportive touch. This approach emphasizes strong non-verbal gestures which were used by African slaves to save lives or to alert someone quickly. Lewis (1994) states: 'part of the African perspective is a sense of wellness, a sense of community – a feeling that we are all in this together' (cited in Shelton-Pinkney 1994, p.32). There is also the

expectation that one gives back to others who helped the person to get where they are. Dr Maulana Karenga emphasized this sense of community in one of the seven principles of the Ngaza Saba in his creation of the African American holiday Kwanzaa. Ujima is the name given to the principle of collective work and responsibility. The values and customs involved are those of co-operation, collective responsibility and interdependence. Community members work together to build and care for their community and solve problems for everyone's benefit.

> Another vibe which some African Americans are particularly sensitive is that of 'missionary racism'. In this situation, the clinician (often without conscious awareness) conveys to the family that his or her goal is to 'save them from their plight' or take care of these poor people. This is often a very subtle vibe, particularly notable as an attitude characteristic of the well-meaning clinician (African American or White), who can unwillingly convey a patronizing stance to an African American family without intending to. (Boyd-Franklin 1989, p.97)

Boyd-Franklin describes a vibe as the term applied to a multilevel perception in the African American culture. This is because African Americans have been socialized to pay attention to all of the facets of behavior and not focus on the verbal message. The following sections will elaborate upon the six key points outlined from an African American Culture Conference presentation by Felicia Coffield and Leila Waters (1996).

Afrocentric Key Points

1. Look for the strengths. Many families do not present with strengths showing. The first session is the connection. 'Join' with the family and chat with them so they get a sense of who you the therapist is.

2. Empower families to help themselves. Empowerment and therapeutic change are important treatment goals with a family, regardless of ethnicity or cultural background.

3. Most family units within the African American community tell members not to tell the family business and keep family business in the family. Don't tell, don't trust. Therapy is considered a very public thing.

4. Therapy was initially perceived as for the affluent and those who had time. In an Afrocentric approach, the power of a crisis pulls together all family members around a specific issue. Historically, this is the only time to seek treatment because prevention of the crisis was not an option. It empowers them to make a decision and may facilitate their trust in the therapist. The therapist forms an alliance with the powerful people in that family unit. In a crisis, the therapist asks the family: 'Do you want it to be different?' Discuss and prepare families in advance regarding what happens in therapy (i.e. rules and expectations). Ask the family 'how can we get the most out of this hour?' This focuses the family and allows them to feel that they are in control of how the time is spent. This subtly brackets the time, without the therapist appearing to drive it. Therapists should keep in mind:

 · many families/clients are dealing with issues of abandonment

 · peer supervision is important among therapists

 · address issues of transference

 · don't be turned off by the feedback.

5. A major role of African Americans is to prepare children to face a society that is not always accepting of them. It's important to rear children to understand racism. This is not to make children hard or bitter but to prepare them. Racism in our society is much more subtle than in previous decades. It's critical to educate African American children about these issues. African Americans have a lot of anger regarding how they are treated in society. How we manage our anger is a very important part of our lives.

6. Afrocentric therapy utilizes the belief in a higher being – belief in God. The notion of the importance of religion is often removed in our training as clinicians but we should understand its importance within the African American community. Many look at therapy as a secular experience 'worldly'. Our elders often express objections to therapy and/or have mistrust or misunderstanding of how therapy can be an agent of change. African Americans believe the psyche and the spirit are one.

An example of the aforementioned points where a therapist was successful using an Afrocentric approach is the case of John. John was uprooted, he had to live with his aunt. Due to the nature of his sudden relocation and the situation he left, therapy was arranged. His first therapeutic venture lasted a year and a half, but without much progress. Thus his aunt sought out an African American male for John. After many failed attempts, she located an Afrocentric-based African American man.

The First Therapy Session

The therapist said to John: 'Someone who loves you very much called me and said you were having some problems and asked if I would work with you.' John smiled from ear to ear and started shaking his head 'yes'. He crawled out from under his aunt. John knew he was nurtured and knew he would be all right with this therapist. In contrast, a Eurocentric approach to this particular case would focus on problems and there would be none or minimal sharing of self with the client(s).

The Second Therapy Session

The second session emphasized empowering the family toward change. Given the legacy of slavery and the history of racism experienced by African Americans in the United States, empowerment and therapeutic change become essential components of any treatment plan for this cultural group. One of the most devastating outcomes of the legacy of slavery and oppression is the feeling of powerlessness and rage that many African Americans experience (Grier and Cobbs 1968). Empowerment often involves helping parents to take back the control of their own families and feel that they can effect important changes for themselves (Boyd-Franklin 1989).

Art therapy can provide the visual arena for making decisions and exploring possible outcomes. This affords the families an opportunity to develop a plan of action, a road map. It offers the client time to examine different options without having to experience them all.

African Americans in Therapy

The following issues address the mistrust and perception of African Americans in therapy. One may not know how many government agencies a family has had involvement with for their survival. Each time the family or

head of household is interviewed by an agency, the questions strip away at any sense of dignity and pride. Years ago, if a family was on welfare, there could not be a man in the home. To receive government assistance, the agency set guidelines for the family. This rule was now a legitimate way to divide families and it put them in the precarious position of having to lie (keep secrets). Another problem with the aforementioned is that an outside person, usually the social worker, determines what a family can or cannot afford to have in their home. With this, another stereotypic image is placed on the family.

> Grier and Cobbs (1968) suggest that the issue of trust for some African Americans reflects 'healthy cultural paranoia' or refusal to identify with and trust persons differing from themselves in color, lifestyle, values and so on. This suspiciousness is frequently a direct, learned, survival response that African American children are socialized at an early age to adopt. (McGoldrick, Pearce and Giordano 1982, p.101)

A crisis, as identified in point 4, pulls the family together around a specific issue. This relates to our World-View of groupness, it is what makes us feel connected. When one considers the division which took place in families during slavery, these separations were involuntary, so, when given a choice, groupness is a comfortable fit.

During a crisis, individual therapy for an African American can defeat the networking process. In contrast, the group experience gives members the support they need. In groups, the members can assist each other in dealing with their rage and anger. Members can help each other live with anger and not be consumed by it. Group members can begin to figure out how they are going to deal with their issues.

Anna Shaw poignantly describes the effects of group interaction in her youth when family and friends gathered socially: 'There was a sense of openness that brought me back to a time when our own mothers got together in the kitchen and cooked and quilted and talked. You were nurtured and knew you weren't alone in what you were going through' (cited in Shelton-Pinkney 1994, p.32). The essence of any group is problem-solving, identifying troubling issues and determining how and whether they can be resolved. When there is no solution, the focus shifts to learning how to cope (Shelton-Pinkney 1994). A culturally sensitive art therapist may be able to provide a similar environment.

Issues for the Therapist

The term 'countertransference' has not been a popular one in family therapy literature. It is, however, particularly relevant here when it is applied to the conscious and unconscious racial stereotypes that we all hold and which may influence the treatment process. It is extremely important that all therapists explore their own stereotypical beliefs (positive and negative) about African Americans. Part of the development of any clinician who wishes to work effectively with African American clients and families must include the process of soul-searching. No matter how much the therapist may feel they can identify with the families, there are still elements of one's own growth and development that lead to a different set of values and attitudes. Being committed to the human service profession makes it mandatory that one explores one's own thoughts and feelings.

Another issue relevant to the culturally sensitive art therapist is the attention given to administrative issues. A Eurocentric approach first establishes the parameters of the therapeutic session and/or number of sessions. The initial session sets the stage for what will occur and identifies what is expected of everyone. With this approach – the manner in which the therapy session is established – clinicians distance themselves from their African American client before a rapport is established. This is in contrast with the Afrocentric approach since the African American client would not feel valued due to the greater focus on administrative issues.

Addressing issues involving preparation or prominent issues which affect how one is treated in society is the focus of point 5. The following example illustrates this point. When an African American male goes into a store to shop, he may be followed or closely watched. Or, when the same man talks loudly, this may be interpreted by whites as being aggressive when this is, in fact, his way of getting his point across, getting the attention that he would not get if his tone was lower.

The final point addresses religion and its importance in the African American community. Since the time of slavery, religion has been, and continues to be, a pivotal element in the lives of African Americans. Religion in the form of spirituals has conveyed life-saving messages. Prayers have helped slaves endure the atrocities of that time. Spirituality was the foundation of African cultures long before slaves were brought to this country. During slavery it was forbidden for slaves to have church. This only helped the slaves to become more creative in their determination to worship God. Church, once established, has been a source of hope, help and relief for

whatever its members needed. Church has also been a vehicle for ordinary people to be respected by their positions in the church. One's job outside of the church – maid, janitor, etc. – did not matter. In church they were ministers, deacons and deaconesses who were dignified and respected for their roles.

Boyd-Franklin (1989) addresses the clinicians' flaw about not asking about African American's role in their church. Many agencies are very clear to keep religion out of the sessions, out of the schools and out of government as much as possible. In the African American community, religion is prevalent and it is just as prevalent in the art work as religious symbols and topics often surface spontaneously in art therapy sessions. A mental breakdown can sometimes cause a person to return to a level of comfort. Once a client initiates the topic of religion or faith, which is often identified as a source of strength, the clinician can use this in the treatment process. However, if bound by the limits of the rules, many treatment opportunities will continue to be lost. One may, in some cases, attend weddings, funerals or special performances of family members of clients since this may be an important part of working together. A Eurocentric approach, in contrast, views church involvement as a psychosocial issue and not necessarily information that is related to the problem which brings the client(s) to therapy.

Finally, knowing and understanding one's own World-View in relation to the World-View of those who seek you for healing is one thing. Applying this concept is another. Using it will prove invaluable in your clinical work. An Afrocentric use of art therapy connotes that the therapist joins the client where they are and does so by extracting their strengths and building upon them. Is the success of therapy based solely on the ethnic background of the clinician and the client being the same? No! Using the ethnic background as the strength of the client to facilitate treatment is the aim and foundation of this approach.

Summary

Incorporating an Afrocentric art therapy approach may facilitate treatment of African American families who remain at risk with traditional therapeutic interventions. Traditional approaches to psychotherapy and models of psychotherapy often are not as effective with African Americans who are already overwhelmed by life's demands and socioeconomic deprivations. The socio-economically poor have often had a heavier burden struggling with the oppression of poverty, having to live in urban areas wrought with

crime, violence, gang life, drugs, households which may not be able to meet basic needs, cycles of unemployment, poor housing and inadequate community services and few, if any, male role models (Boyd-Franklin 1989). Due to this type of environment, many youths perceive a life expectancy of 25 years. Illiteracy and opportunities for social activities may be limited to church functions, school trips (especially those which are free) or those offered in neighbourhood community centers.

An Afrocentric approach to art therapy meets the African American client where they are and empowers them toward problem-solving strategies that are practical and validates their way of life. This type of approach is especially helpful to clinicians whose living environment and cultural background is totally opposite that of their African American client.

The genesis of an Afrocentric approach to art therapy came about because it felt good. It was in keeping with our ethnic heritage and cultural background. Our traditional training provided us with the theoretical knowledge but its application did not feel natural. In addition, the African American heritage of the tribe, slavery, the need for practical application of therapy that acknowledges and validates the unique ethnic background of clients and wider acceptance of alternative therapies to empower disadvantaged urban populations are also factors which contributed to this approach. The Afrocentric approach has been used, but unnamed, as a way of doing therapy by pioneers of color who were involved in the formative years of the American Art Therapy Association (AATA). Their way of interacting or forming an alliance with their African American clients can be viewed as an Afrocentric approach. Lucille Venture, Georgette Powell, Sarah McGee and Cliff Joseph are a few of the African American pioneers in art therapy who utilize this approach.

References

Boyd-Franklin, N. (1989) *Black Families in Therapy*. New York: Guilford Press.

Coffield, F. and Waters, L. (1996) *African American Culture*. Paper presented at the Pediatric Developmental Clinic Conference, Kennedy Kreiger Institute, Baltimore, MD.

Gary, L.E. (1978) *Mental Health: A Challenge to the Black Community*. Philadelphia, PA: Dorrance and Company.

Grier, W. and Cobbs, P. (1968) *Black Rage*. New York: Basic Books.

McGoldrick, M., Pearce, J.K. and Giordano, J. (1982) *Ethnicity and Family Therapy*. New York: Guilford Press.

Nobles, W.W. (1977) *Extended Self: Rethinking the So-Called Negro Self Concept. Black Children Just Keep On Growing.* Washington, DC: Black Child Development Institute, Inc.

Perkins, U. (1985) *Harvesting New Generations: The Positive Development of Black Youth.* Chicago: Third World Press.

Shelton-Pinkney, D. (1994) 'Afrocentric therapy.' *Essence*, December, 32–34.

U.S. Department of Health and Human Services (1994) *Healthy People 2000: Progress Report for Black Americans.* Public Health Service brochure. Washington, DC: Office of Disease Prevention and Health Promotion.

Wells, S.A. (1995) *Addressing Multicultural Issues at a National Level.* Paper presented at American Occupational Therapy Association, Bethesda, MD.

Art Therapy
with a Cree Indian Boy
Communications across Cultures

Nadia Ferrara

Abstract

The following chapter is a case study of a hearing-impaired Cree Indian boy in art therapy. The main purpose of this study was to record and evaluate the therapeutic process as it unfolded between the child and myself, an art therapist. My underlying intentions included following through with my interest in offering art therapy to a child of a different culture and, in turn, to add to the scarce amount of literature regarding Native American clients in art therapy. This chapter attempts to recapitulate and discuss the sessions that highlight Luke's (a pseudonym) therapeutic art experience.

In order to help evaluate Luke's progress, the Ulman Personality Assessment Procedure (Ulman and Dachinger 1975) was presented to him during pre-, mid- and post-treatment stages and they were thoroughly reviewed. The termination process will also be illustrated.

Introduction

The purpose of this case study is to record and evaluate the therapeutic process as it unfolded in art therapy between a child and myself, an art therapist. For the past nine years I have been working with the Native American population (Ferrara 1991, 1994, 1996). The following case study is special because he was my first Native American client in art therapy. I have always been intrigued by the Native American culture and I considered this case study an opportunity to add to the literature, specifically with regard to Native American clients in art therapy (Lofgren 1981; Dufrene 1990). Luke helped sow the seeds for my pioneering efforts in this field.

Nine-year-old Luke (a pseudonym) was of the Cree Indian culture. He was admitted for two years of residential treatment. Luke had a hearing

deficit partially compensated by a hearing aid. His hearing deficit was the result of having meningitis when he was four months old. Luke comprehended spoken language and he was attending an oral school for the deaf, where he was being taught in English.

Luke's medical report stated that he was later found to be developmentally delayed as a result of his three-month hospitalization due to meningitis. His developmental delay was considered to be a primarily organic problem – contributing factors included his hospitalization and the lack of social learning in his environment. His hearing aid was not socially acceptable, thus he experienced rejection, especially by his peers.

Luke's behavior problems were mainly in opposition to wearing his hearing aid and his angry and aggressive reactions to peers teasing him for wearing it and being violent towards him. It seemed to the staff that he was not able to deal effectively with his handicap. The treatment team noticed that his hearing seemed, at times, to be selective. He was often defiant and oppositional and he had a very low frustration tolerance.

Luke was one of eleven children. His family members spent eight months of the year in the bush for hunting purposes. Both parents were involved in this seasonal employment that entailed hunting, fishing and trapping. They lived in a village of 600 people approximately 750 miles away from Luke's residence while in treatment.

Luke had never had a stable home and school environment; he lived in many different homes, mostly with foster families, while his parents lived in the bush. Due to his disruptive behavior, he was not allowed in the bush – not even during special occasions. Luke's prior school experience involved moving from one school to another. Apparently, along with his teachers, his parents and foster families also considered Luke as being hyperactive and very difficult to handle.

For the most part, Cree child-rearing is non-directive, with the adults showing youngsters appropriate paths to take and the children internalizing the values and following suit (Red Horse 1980). In Luke's case this growth process was more challenging because the communication difficulties due to his hearing deficit and his early illness presented special problems for his family.

Normally, the arrangement of the child attending a boarding school while the parents live in the bush camp works well for a Cree Indian child. It is considered an accepted pattern of the Cree family lifestyle. Nevertheless, Luke and his family were faced with compounding problems, mainly related

to his hearing deficit. Luke was referred for treatment because of his psychosocial problems, as well as his educational problems, for which he needed special educational assistance. During a team conference the treatment team recommended Luke for art therapy because of his lack of impulse control and his difficulty in expressing his feelings.

Along with his Cree native tongue, Luke understood English and some French. However, when he spoke he used simple functional structures in English (e.g. What you want?). During the first two sessions, Luke was cooperative and expressed his interest in art therapy by requesting to have it every day. He experimented with the materials and explored the art therapy room. Luke seemed to listen attentively and he helped to define the short-term goal of evaluating art therapy as being useful for him or not. He complied with the idea of completing specific art tasks, which constitute a modified version of the Kramer Diagnostic Assessment Procedure (Kramer and Schehr 1983) as presented to me in my art therapy training. In addition, I decided to present the Ulman Personality Assessment Procedure (Ulman and Dachinger 1975) to Luke periodically while in therapy in order to help assess the therapeutic process. The results of the assessments will be discussed thoroughly, then selected sessions will be illustrated, as well as the termination process.

The Kramer Evaluation procedure entails the making of two drawings, one painting and one clay piece. In the first drawing the child is presented with paper, a variety of lead pencils and colored markers. The child is asked to draw a picture of his or her choice. In the second task the child is asked to draw about people doing something, using the same materials. For both the painting and the clay sculpture the child is encouraged to create anything he or she would like with the materials offered.

For the first picture, Luke drew a star in the center of the page and, after signing his name below it, he began drawing in a clockwise fashion around the star (Figure 4.1). He added a small heart with a line over the bottom tip, wrote my name twice and then meticulously drew a portrait of me (Figure 4.2).

He observed my facial features quite carefully and seemed calm while drawing me. Still rotating the paper, Luke glanced up at me and then drew a form with two tips, erased it and tried again. He said it was a boat with two chairs. Then he said, in a scared tone, that it was going underwater really fast. Luke completed this piece with a carefully drawn Batman symbol that happened to be the print on his shirt.

Figure 4.1

Figure 4.2

Figure 4.3

For the next drawing, I asked him to draw about people doing something. He immediately wrote his name and mine very close to each other and then enclosed each of them in a box-like form. He rotated the paper full circle and drew a heart in the center. Luke created two short lines with a small shape on the ends and on each side of the heart (Figure 4.3). He selected the markers to color in his picture.

Luke hastily scribbled in the heart with a red marker. He asked me to color with him. When I explained that it was his drawing time and not mine, Luke still insisted I 'help' him color. Giving me the black marker, he showed how to color in the heart. Luke divided the heart with a vertical line across the mid-section of the form. Luke seemed pleased with the result and he placed his work in his portfolio. On his way out he wrote his name and mine on the chalkboard that sits near the door.

In the first drawing, Figure 4.1, the small heart with a line over the bottom tip, resembling an arrow, may illustrate a sense of powerlessness or depotentiation. Rather than going through the heart, the tenuous line seems to be cutting off a part of the heart. I wondered if the heart was depicted as a symbol of love, possibly indicating unfulfilled or unrequited affection that Luke may have felt anxious about.

The most detailed of all the drawings in Figure 4.1 was the portrait of me (Figure 4.2). My initial reaction to Luke's writing my name and drawing a portrait of me was that I felt flattered. I later contemplated the possibility of it being this child's attempt to establish an exploratory base. This attempt may also reflect the transference that surfaced in this session. I think it was Luke's identification of me as a mother figure. The facial expression he gave me looks like one of pain. I wondered if he was unconsciously unloading his internal emotional pain and placing it into this visual container, representing me. In addition, Luke may have seen me as a member of his cultural group because of my dark features and almond-shaped eyes, thus he related to me with ease.

The impression I received from Luke's drawing of the boat 'going underwater really fast' was that the child felt he was plunging into the experience too fast. Luke might have found it to be too overwhelming. I thought that the boat may have alluded to his cultural experiences, especially in the bush camp. This boat may represent a sense of power that is manifested in the hunting and fishing ventures of the Cree people. From this tentative interpretation, I conceptualized a therapeutic goal for Luke that involved encouraging him to develop an awareness of his culture. The rotation of the paper signifies the Cree way of thinking, that is in a circular fashion (Storm 1972).

My feeling about the arrow in Figure 4.3 was that it looked like something was occurring behind the heart, where the arrow lies, since it does not seem to penetrate the heart. In a discussion with a psychiatrist working with the Cree, he suggested that the arrow resembled a crutch rather than a pointed form; instead of being pierced by a pointed arrow, the heart seemed to be leaning on a crutch. He noted that this may indicate an inhibition towards hurting something or someone. This psychiatrist remarked that Luke's choice of colors may indicate a link to his cultural heritage, inasmuch as red and black are predominant in the Cree culture and other Native Indian cultures. The Cree community workers whom I have worked with noted that in Luke's community, red can represent a visionary or feeling state and black signifies reason. Thus in his giving me the black marker, he may have been asking me to help him try to make some sense of his mixed emotions.

Luke's invitation for me to join him on the same paper and in the same form may underline his wish to merge with me. Nevertheless, it is quite possible that he misunderstood the directive of drawing about people doing something and thought that I meant for us to do something together. Yet it

appears that Luke was portraying an inner conflict of ambivalent emotions. He seemed to possess a wish to merge with me. However, he appeared to have some anxiety about it. This created a boundary in his dividing the heart in half. The idea of merging with me and not feeling as if he were a separate person may also reflect his fragile ego boundaries (Linesch 1988).

I realized that I had to place more emphasis on the idea that it was his time for art therapy, not mine. In other words, I needed to monitor and look for ways to not do art work with this child. His apparent lack of strong ego boundaries may be overwhelming for him to face up to without yet having a secure base to work from. In addition, I was not yet ready to engage in the art process with him. Overall, it seemed to me that Luke cathected very positively and very quickly to both me and the art process.

The second session involved the continuation of the Kramer Diagnostic Assessment Procedure. The materials that were offered to Luke included gray bogus paper, tempera paints and a variety of paintbrushes. Before beginning his painting, Luke sketched in the air what he wanted to make. Then he created a large heart in the center of the page in red (Figure 4.4).

Luke wrote my name inside the heart, then carefully created four horizontal stripes below it in blue, yellow, white and brown. He talked about

Figure 4.4

going home for about a week and emphasized coming back. He appeared quite anxious about it as he impulsively painted the inside of the heart in black, using a large brush. He painted short yellow lines around the heart with a very fine brush and said that it was the sun behind the heart. He later added an arrow-like form to the heart.

When asked to create anything he would like with the clay, Luke carefully made a square clay tile and carved both my name and his and then, with a brayer, he flattened it out hastily. Luke extracted pieces from the clay and began throwing them on the wall. He threw several pieces and then I wondered if he saw a picture in the bits of clay on the wall. He said he saw a dog. Luke seemed surprised and laughed at his discovery. Just before leaving, he wrote my name and his on the chalkboard.

I initially considered my reaction to Luke's throwing the bits of clay as an imposing gesture that may reflect my resistance to the loss of control. However, I later reappraised it as an intervention that helped redirect Luke's focus. He seemed to accept it as a gentle entering into his activity.

I noticed that when Luke explored the materials he smelled them and examined the texture. I wondered about this behavior during the session. I later realized that he may have been using his other senses in order to compensate for his hearing impairment (Greene 1981; Henley 1987).

In this session I sensed Luke's anger and frustration. I considered him to be a bundle of feeling. Contrary to what the team thought, he seemed to be at a feeling level. In other words, he appeared to be communicating his feeling world quite clearly to me.

Luke spoke of leaving to go back home for a week, then painted my name over in black. He carved both our names in clay, flattened them and then threw them at the wall in bits. I wondered if he was afraid that going away would destroy our relationship. There seemed to be ambivalence and strong, mixed feelings about leaving and, specifically, leaving me for a week. Luke was going home for 'Moose Break', which is regarded as a special occasion by the Cree Indians. This venture involves hunting for moose and feasting with one's extended family members (Ward 1975).

Looking at the artwork in Figure 4.4, I also got the impression that the juxtapositioning of the heart and the sun resembled an eclipse, shedding darkness instead of light. I thought the blackness over the heart might be covering up possibly good things that were not yet known to Luke, like the art therapy experience. Although the arrow again seemed to resemble a crutch, not penetrating the heart (cf., Figures 4.1 and 4.3), the sun's rays

around the heart appeared to me to be prickly, creating an uninviting appearance.

After his precursory activity that involved exploring the clay and pounding it, a form of chaotic discharge appeared (Kramer 1971) as Luke began throwing the clay against the wall. He seemed to have become involved in playful regression at this point in the session. This may be interpreted as testing his limits in the art therapy room.

Summary of the Kramer Diagnostic Assessment

The primary aim of this evaluation procedure, that spanned two sessions, was to gain as much information as possible. In the drawing medium the developmental stage at which Luke seemed to be functioning was the schematic stage, since the drawing in Figure 4.1 appeared to reflect his active observational skills (Lowenfeld and Brittain 1987). In both the painting and clay modeling media it appeared to me that Luke regressed to the scribbling stage. Perhaps this was due to the introduction of new media for him. However, the scribbling was firmly contained in the painting, as well as the marker drawing.

I observed that the character of the artwork moved from depicting a personal stereotype as a product in the service of defence (i.e. the star, heart) to a product in the service of primitive discharge to no product at all (i.e. the clay play) (Kramer and Schehr 1983). His attitude towards his artwork appeared to change from being highly invested in the first session to being destructive in the second. I also wondered about the formal quality of his artwork possibly symbolizing ambivalence, specifically depicted in the painting in Figure 4.4. Here there seems to be a contrast between the subject matter and the formal nature of it – that is, chaos contained within a heart.

Luke seemed to possess the capacity to reintegrate after an initial regression with the clay material. I think Luke also demonstrated his capacity to muster inner resources through artwork (Kramer and Schehr 1983). His art activity revealed his ability to express himself through art, a personality trait that was not otherwise in evidence.

The Ulman Personality Assessment Procedure

In the following session I presented the Ulman Personality Assessment Procedure (Ulman and Dachinger 1975) to Luke. Luke was asked to draw anything he wanted for the first picture. He outlined the Batman emblem in

Figure 4.5

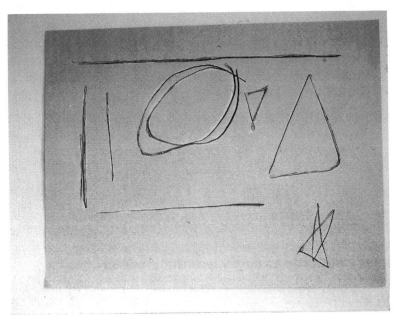

Figure 4.6

green and used blue to color it in with controlled, longitudinal scribbles (Figure 4.5). His use of space was shallow, expansive and organized.

For the kinesthetic exercises before the second drawing, Luke's movements were initially very controlled in that he did not use his whole body. He moved more freely after I encouraged him to. When it came to recording his movements on paper, they became constricted again (Figure 4.6). He did, however, continue to use the space expansively as he drew lines and varied geometric shapes.

For the scribble picture (Figure 4.7), Luke chose to close his eyes for most of the picture. He refused to look for a picture or image in his scribble when I asked him to. His arm movements were less restricted and the forms created were more fragmented.

For the fourth drawing Luke was given a choice to either draw anything he wanted or go with the scribble again. He chose the former and drew a pumpkin. He added details like 'a knife to carve', as he described it (Figure 4.8). He completed the whole assessment in fifteen minutes, then engaged himself by working with clay. He made clay coins, which he later gathered and made one large '100 dollar' coin (Figure 4.9).

For the drawing in Figure 4.5, I think that the cool colors he chose (green and blue) may have been an attempt to help subdue the apparent arousal of

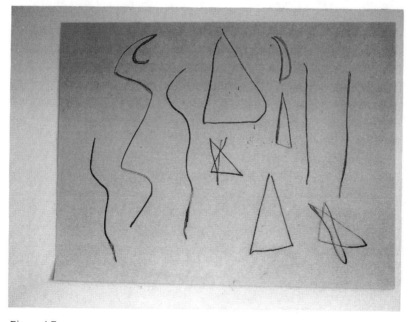

Figure 4.7

Figure 4.8

Figure 4.9

his inner anxiety. However, there was an apparent attempt to control his feelings of anxiety as his coloring stayed within the contour of this organic, closed form. According to Sobel (1980), a super-hero symbol like Batman is often used effectively by latency age boys to contain and express inner conflicts.

What impressed me in both the kinesthetic and scribble drawings (Figures 4.6 and 4.7) was that the lines and forms appeared in pairs. The kinesthetic drawing shows that he did not follow the instructions given, perhaps because he did not understand how to record the movements. This can be due to his apparent language problem. As a scribble drawing in Figure 4.7, it seemed quite vacant and impoverished. His refusal to look for an image may indicate a fear to give form to his drawing that does not appear to be an entity.

The drawing in Figure 4.8 seemed to portray Luke's effort to place the bits or fragments together. It looked like this was extended into his clay experience. Once again, in this drawing (Figure 4.8) the forms appeared in pairs, although, in contrast with the drawings in Figures 4.6 and 4.7, the shapes seemed connected.

I think Luke's artwork in this session mirrors a creative growth process that he experienced throughout the assessment. His series of drawings evolved from a personal stereotype to fragmented pieces to a whole that integrated the fragments in a well-balanced fashion. I concluded that this child was a good candidate for art therapy. The expected duration of art therapy with Luke was one year. He was to be seen in individual art therapy for one hour on a once-a-week basis.

The art therapy treatment plan for Luke was developed in an effort to complement the agency goals and to attend to the problems that I identified in art therapy with Luke. In addressing this child's problems, long-term goals were defined and divided into manageable segments or objectives. Furthermore, Luke's assets were recognized in the development of the treatment plan. His assets included his motivation to learn and his ability to persevere with tasks. This treatment plan was to be reviewed every six weeks and presented to the treatment team for discussion.

Luke's behavioral problems included low self-esteem, impulsiveness and low frustration tolerance. Luke displayed disruptive behaviors such as acting out and defiance. As previously mentioned, his oppositional behavior was mainly related to his difficulty in dealing with his handicap. According to Schlesinger and Meadow (1972), oppositional behavior, or 'motor

exuberance', is potentially increased for the hearing-impaired child. They suggest that verbal exuberance is diminished in a deaf child, yet the feelings remain exhilarated – as was apparently exemplified in Luke's artwork. Therefore, one possible underlying reason for the oppositional behavior of a hearing-impaired child is that since he or she is deprived of the ability to express powerful feelings in words, these feelings usually erupt in actions (Katan 1961).

As set forth by Farris *et al.* (1980), with Native Americans, self-concept is closely associated with the esteem one feels for one's sociocultural group. This cultural perception of self-concept formation was recognized by the agency in developing the goal for Luke to maintain contact with his native traditions.

In art therapy I planned to encourage Luke to develop or maintain an awareness of his culture of origin and incorporate it into his self-identity. Another art therapy long-term goal established in alliance with the agency goals entailed helping Luke to increase his feelings of self-worth. The art therapy approach, or method, in treating Luke's low self-esteem involved acknowledging both his good and bad feelings. In addition, his artwork would be respected and considered as meaningful. As contended by Kramer (1971), I too believe that the narcissistic investment of creating artwork may contribute to the building of one's self-esteem. During the previous sessions with Luke I discerned that this child seemed to possess fragile ego boundaries and he appeared overly dependent. Therefore, establishing appropriate ego boundaries would be promoted by helping him to attain a self-identity and, in turn, develop a self-understanding. Ego strength may be fostered in Luke by my offering him technical assistance, not merging into his creative art-making and assisting him in building self-competencies.

The short-term goals entailed developing a therapeutic alliance between Luke and myself. Furthermore, Luke would be encouraged to develop a sense of comfort within the 'framework for freedom' ambience (Rubin 1984) in the art therapy room.

In Session 7 Luke engaged both of us in a craft common among the Cree: braiding leather laces to create a bracelet (Figure 4.10). He continued to invest himself in the creative process as he made a drawing of his apparent preoccupation to go swimming (Figure 4.11).

Luke meticulously drew diving boards with myself on the top one and himself and two other children who were also in art therapy with me.

The braided bracelet (Figure 4.10) seemed to involve binding something,

Figure 4.10

Figure 4.11

perhaps feelings towards me and the art therapy experience. With the idea of the bracelet and his gesture of placing it around my wrist, it seemed that Luke was staking a claim to have or own me. In the swimming picture (Figure 4.11), I thought he was simply expressing his desire to bring me to his other experiences and was showing his readiness to plunge into the unconscious.

Luke's portrayal of the two of us in Figure 4.12 was a graceful-looking picture. It seemed to express a romance, in the widest sense, that was occurring in the room. As he hastily wrote his name and then carefully added volume to mine, he was in the process of deriving inner strength from my own. This was the first time Luke had drawn himself.

In one session he expressed pain in his ear and did not have his hearing aid on. On his own, Luke decided to create a tailor-made ear patch (Figure 4.13). He wore it for the session and then removed it as he left the room. I considered the ear patch to be a significant element made within a transformative state. He was showing me that he felt accepted and understood, in the art therapy milieu, as a deaf person (Silver 1970). However, he was not ready to translate this in his outside world.

At this point in therapy it appeared to me that a holding environment had been created, a psychological, transitional space (Winnicott 1971). It seemed that Luke had adopted my offering of the art materials and used them within a transitional arena. His inner self had found expression through image and symbol. Luke appeared to be using art for transformation in this psychological space. According to Winnicott (1971), this is an intermediate area between 'mother and child' that is neither inside nor outside but lies somewhere in between.

I felt Luke had responded quite positively to the therapeutic process. He expressed himself evocatively through his artwork. It seemed that a more secure sense of identity was forming within Luke since he was apparently using the creative art process as a transitional link between his inner and outer worlds.

Figure 4.12

Figure 4.13

Luke also showed his ability to call upon his cultural experience by creating the 'Indian house' (Figure 4.14) and bringing it into our relationship. This teepee may have been a representation of his therapeutic containment. There may have been a time when he felt secure in a teepee. Perhaps this feeling had become the core of his art therapy experience.

I realized that it became crucial for me to show my profound interest in his cultural background. I was suddenly quite aware of the significant role I could play in helping Luke incorporate his ethnicity into his self-identity.

The progress noted in the review of his treatment plan after Session 16 was that Luke appeared to have developed a willingness to share his cultural heritage. This may provide the opportunity for fostering his cultural awareness.

I realized that the transference phenomena in therapy with Luke had emerged in the artwork as a narrative screen (Agell *et al.* 1981). Luke's relationship to his artwork became the basis of the transference that was evolving in his therapeutic process. In taking Allen's (1988) viewpoint into consideration, he appeared to have invested himself in the art process and product. Naumburg (1966) referred to this as a narcissistic cathexis to the artwork. The transference to his artwork may have essentially become a dialogue with himself and a reflection of his inner world. I believed that Luke possessed tremendous resources for the art process.

The Ulman Personality Assessment Procedure

In Session 19 Luke was presented with the Ulman Personality Assessment Procedure to assess the middle stages of therapy.

The content of the first drawing was four names of kids he knew (Figure 4.15). There was a shallow, organized and expansive use of space. For the kinesthetic picture, Luke seemed to follow the instructions. He recorded his movements by separating the lines and circle movements (Figure 4.16).

The spiral form that he began drawing from the outside in towards the center, was somewhat organic.

The concentric spiral reappeared in the scribble drawing in Figure 4.17. He used the whole page to create this organic, open form. When asked to look for a picture in his scribble, he initially hesitated. He projected the image being a 'slide going underwater'.

In the last drawing (Figure 4.18), he immediately chose to draw 'Batman'. The form was organic and closed and the lines were of medium density.

Figure 4.14

Figure 4.15

Figure 4.16

Figure 4.17

Figure 4.18

Figure 4.19

After the assessment he created an 'Indian' mask, with meticulous care, out of a paper plate (Figure 4.19). He cut a whole section for the nose and mouth. He later wore it for the whole session. He removed it on his way out, like his ear patch.

Luke's first picture of the assessment (Figure 4.15) alluded to his growth as a social being. He was using the new language that he was learning to record it. The names were in relation to his outside world. Perhaps the different names represented the bits of himself located on the outside.

The kinesthetic drawing in Figure 4.16 appeared to represent a polarity of some kind. The splitting seemed encapsulated in this picture. There was not the same sense of fragmentation that existed in the kinesthetic drawing of Luke's first UPAP (Figure 4.6). This latter picture seemed to portray pre-splitting. His sense of self was somewhat fragmented. There may have been more cohesion in his second kinesthetic drawing in Figure 4.16. This was reflective of the progress he demonstrated in his therapeutic journey and the sophisticated developmental level he had attained.

Luke's move to a more organic form was apparent in the scribble drawing (Figure 4.17). He used the roundness of form to create a unified inner image. His projection of it being 'a slide going underwater' reminded me of the statement about his first drawing (Figure 4.1) of a boat going underwater. However, the metaphor of going underwater with his slide did not seem as overwhelming for Luke as with his boat in his first session. Perhaps he had reached a state of comfort with going into his unconscious or his inner world with someone he trusted.

In his creation of the Batman symbol in Figure 4.18 he seemed to have added more body to the form. This is in comparison to the same superhero symbol he depicted in his first UPAP picture (Figure 4.5). It seemed that the form in his rendering of Batman in Figure 4.18 was more cohesive. It shed more light than darkness, in contrast to the heart painting in Figure 4.4. What he seemingly recorded in this assessment was his attempt to locate himself in the outside world, and then he went inward to capture and express a self-statement. Within this self-statement (i.e. Figure 4.18), there was a sense of containment and an apparent sense of identity. Luke's development as a social being and his growth as an individual were, apparently, happening concurrently.

His sharing of the 'Indian' in him with me, in the making of his mask (Figure 4.19), catered to his treatment goal of developing his cultural awareness. I wondered about his creation of a mask depicting his need to

make it 'removable', thus allowing him to share it only with chosen individuals. By removing the mask, Luke possibly thought that he would blend more easily into the majority culture. In cultivating his cultural awareness, it seemed that Luke was at the stage of trying to come to terms with both his ethnicity and the foreign culture surrounding him.

I discerned that in supporting his efforts I could convey to Luke that his Native Indian heritage was a very positive factor contributing to his self-concept formation. I felt the need to help foster his Native Indian pride and to encourage that it is an asset and a strength (Farris *et al.* 1980).

What became much more obvious to me was that Luke appeared to be refuelling his emotional reserves from the imagery instead of from me. It seemed to me that there was a dialogue going on between him and the image as he was becoming self-sustaining. I felt that Luke had initially recognized me as a 'self-object', which is a person or thing valued for its function in enhancing one's self (Lachman-Chapin 1979). The loosening of transference occurred when he moved into his artwork, as it became his self-object.

I thought that somehow my self-confidence lent support to his attempts to develop an autonomous sense of self. In Lachman-Chapin's (1979)

Figure 4.20

viewpoint, 'we (therapists) allow patients to merge with this part of ourselves, giving them temporary strength through their identification with us, until the accomplishment of the art product frees them from needing us' (p.6).

In the review of his treatment plan I noted that Luke appeared to be building self-competencies while gaining inner ego strength. Moreover, he was showing his attempts to develop a cultural awareness. The team also noticed this as he approached them by asking questions about his culture.

In Session 22 Luke drew the Batman form quickly, yet with precision. He cut it out and glued it on the white sheet of paper and diagonally opposite drew an oval form (Figure 4.20). He said that it was a light shining on Batman. I felt that he had added a new dimension to Batman since he used a new medium: collage. There seemed to be a depiction of a dichotomy involving consciousness and unconsciousness, represented by the light and the shadow of the Batman. There was an indication that two sides were present and that something unknown was being acknowledged. The formless Batman appeared as a darkened shadow below the figure that he had easily formed, at which the light was directed. In Jungian psychology one's rejection of the shadow archetype is considered to flatten the personality. If the shadow is not suppressed, it can contribute to an individual's vitality and creativity (Hall and Nordby 1973).

I later realized that my role had possibly entailed helping him create links between the two different cultures he was experiencing, and developing an understanding of their differences and similarities. I also believed that he needed to build a sense that he had an alternative, since he appeared to know his hearing was a problem, realizing that he may not be able to live up to the male role of the Cree culture. Nevertheless, because he was living in this other culture, he had a choice and could survive.

In our last session before the summer break, Luke decided to draw about his 'Goose Break' ritual. For the first time, he was accepted back in the bush camp. In the drawing of Figure 4.21 there was partial regression. The possibility to grow into wholeness seemed to be present. There was a feeling of flowing boundaries and a place that invited the possibility to merge. Moreover, this drawing alluded to a metaphor for our reunion in the fall. With a reinforced line, he linked art therapy and his home that looked like a thought bubble. During the break he might retain this link or transitional space between home and art therapy. Luke depicted me holding him quite firmly in this drawing. This may have hinted at a sense of containment he experienced in art therapy.

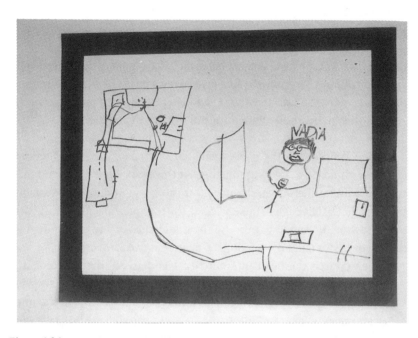

Figure 4.21

Figure 4.22

The boat he created in Figure 4.22 appeared to represent his getting in touch with his masculine identity, as he identified with his father. His boating experience with his father may have made him feel accepted, since in the past he was not allowed to participate in any hunting events because of his impulsiveness. In my eyes this clay boat symbolized the vehicle he used in his therapeutic journey, that initially began as being somewhat overwhelming. It went 'underwater too fast' (Session 1) and later became something concrete and safe. This helped him attain a fruitful growth experience.

Soon after our return from the summer break we had begun the termination process for the subsequent ten sessions. Luke unhesitatingly asked if we could do a drawing together. At this point I felt ready and Luke was more self-confident than in our first session. I suggested the Winnicott squiggle (1971). Once again, Luke selected the red and black markers. Unlike the first session, he suggested we use them interchangeably. In Figure 4.23 Luke discovered images of two dogs, a man bent over and a pear.

He then created the heart in Figure 4.24 and asked that we color it in together. He emphasized making the connection inside the heart, showing me how to do it. This connection alluded to our relationship and the inner sense of security and trust he had attained. As compared to the heart drawing in Figure 4.3, this heart has a lot more volume and it is more of a formed expression (Kramer 1971).

When termination began, Luke had difficulty expressing his feelings of sadness directly to me and chose to express them through his 'Indian Bart Simpson' (Figures 4.25 and 4.26). 'Bart Simpson' became the third person he spoke through to express himself, which, to him, was less threatening.

In the spring Luke had gone back home for Goose Break and he symbolically entered manhood with the killing of his first goose. This is a significant event in Cree culture. He drew Figure 4.27 with pride and excitement, describing his venture in detail (Figure 4.28). Once his treatment terminated, Luke was to return to his village and live with his uncle, which he was quite pleased about it.

The Ulman Personality Assessment Procedure

To assess the post-treatment stages of therapy, a final Ulman Personality Assessment Procedure was given. In his final UPAP, Luke had combined the forms of his previous UPAPs and there was a specific focus on the center (Figures 4.29–4.31). There was also a suggestion of the inner sense of containment he had obtained and a realization that our relationship, or, as he

Figure 4.23

Figure 4.24

Figure 4.26

Figure 4.25

Figure 4.27

Figure 4.28

called it, 'the dream', was going to end and was going to be just fine. In Figure 4.32, Luke is holding himself, as compared to the drawing in Figure 4.21, where I was holding him.

Luke experienced noted progress in the area of wearing his hearing aid without any problems. During his two-year treatment, Luke had gained forty-five months in test age according to his psychological assessment. His self-esteem had increased significantly. Luke had accepted himself and his peers accepted him as both a deaf and Cree person. In the final stages of therapy Luke had encountered what Winnicott (1971) termed the 'cultural experience,' which means that Luke was living within himself and through his surrounding culture, making cultural links and incorporating them into his self-identity as a Cree, hearing-impaired individual.

Summary: Luke's Map of the Journey

In a developmental framework, Luke's therapeutic journey involved tackling milestones and attaining goals that were conducive to his personal growth. In terms of his ego identity development, it seemed to me that in the early stages of therapy he was feeling out how much fusion with me was possible. My initial response to this, that consequently became a therapeutic strategy, was to refuse to participate in his art-making. I felt he had fragile ego boundaries. During the final stages of therapy I realized that he was probably looking for a relationship rather than total fusion.

What I found interesting was his use of the chalkboard in the initial stages of therapy. He seemed to use this when he wanted to share a new experience with me and in his dialogue with himself. The ephemeral quality of the chalkboard allowed him to explore new feelings and assimilate them when he was ready to.

In addition, there was a cultivation of early basic trust as he showed his ability to separate and explore the world with a sense of security and self-assuredness in later stages of therapy (Edward, Ruskin and Turrini 1981; Mahler, Pine and Bergman 1975). Along with an increasing development of trust, he acquired an evocative memory (Segal 1975). He possessed an internal image of me which was demonstrated by his less extreme anxiety about leaving to go home for some time. Furthermore, Luke's feeling of being understood may have been the significant element that stirred the emergence of imaginative activity in this latency age child.

Interestingly, in Luke's first session he created a picture (Figure 4.1) that expressed unique symbols and personal and cultural stereotypes. These later

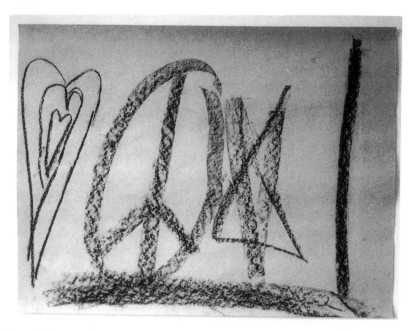

Figure 4.29

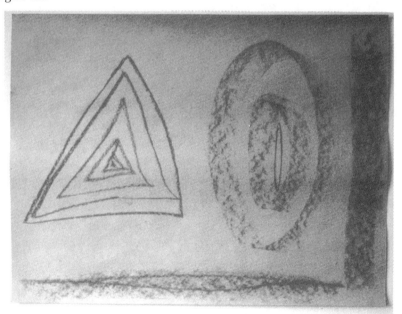

Figure 4.30

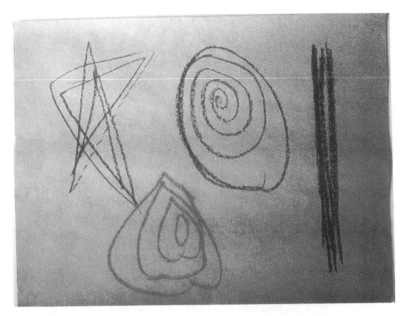

Figure 4.31

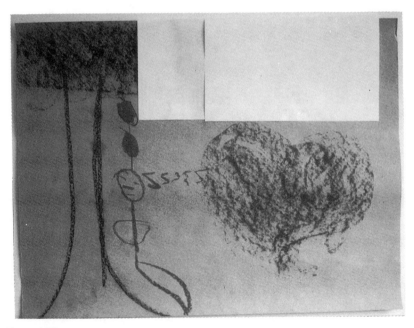

Figure 4.32

evolved, mirroring his self-transformation. The itinerary of his journey in art therapy seemed to be available in symbolic form in his first drawing. In this connection, Shoemaker (1978) discussed the introduction of personal symbols in the client's first picture that 'often are carried throughout art therapy experience, especially if they are unresolved problems' (p.158).

Although in subsequent sessions the large star he drew in his first art product did not reappear in the same form, it seemed to me that it was a symbol of his self (Jung 1964), a major point he was moving towards as his inner complexes transformed themselves. These were represented in the symbols surrounding the star. In addition, the star Luke created was a joining of two halves. On one side he drew my portrait, on the other side he drew the Batman figure and, between, a 'failed' symbol of love (i.e. a heart with an arrow) and a boat that he said was 'going underwater really fast'. The integration of the two halves becoming a whole may have signified his striving to attain self-cohesion. In his move towards it, he needed to encounter and try to resolve several issues in his inner world. His therapeutic movement seemed to have been symbolized by the circular fashion he worked in as he rotated the paper in his first drawing. This view of things in a circular formation is characteristic of the Cree's way of thought (Storm 1972).

In retrospect, I believe that he may have seen me as a member of his cultural group because of my dark skin color and my almond-shaped eyes. This may have contributed to his positive response towards me as he related warmly. Edwards and Edwards (1980) stipulated the importance of assessing the uniqueness of each Native American client in terms of whether the client views the therapist as an individual or as a member of a group. As therapy progressed and Luke moved on into more sophisticated levels of development, his vision of me appeared to change.

The transference relationship that initially developed towards me may have been a 'mirror transference'. That is, his wish for merging was linked with a wish to share in my 'magic powers' through identification (Lachman-Chapin 1979). In evaluating our therapeutic relationship, with Kohut's (1971) theory in mind, I realized that my role for Luke entailed performing the function of self-object by responding with nurturing attention (Lachman-Chapin 1979) that seemed reparative for Luke. In gaining enough inner strength, he transferred my role as self-object to his artwork. This became valued for its function in enhancing his inner self. I thought this movement, or change, was associated with his artwork

becoming his transitional object, a substitutive symbol re-creating his mother image (Winnicott 1971).

It felt obvious to me that Luke's visual imagery reflected his personal growth, especially with the Batman superhero symbol he selected and developed throughout his therapeutic process. It appeared to become an analogy of his internal processes and difficulties. Luke possibly used this framework to safely and enjoyably contact his feelings. The use of Batman in his work seemed to facilitate interrelating his inner and outer realities. It revealed how he organized his world and himself (Sobel 1980).

In the early stages of therapy with Luke I became cognizant of my responsibility to become culturally aware, learning about his lifestyle outside of the therapy session. I strongly believed in the potential of art therapy to adapt itself strikingly well to divergent cultural values (Lofgren 1981). Luke may have responded positively to my approach via art materials, because this non-verbal means was consistent with his cultural and personal background as a hearing-impaired Cree child. My sensitivity towards his culture developed throughout therapy and I realized the importance of guarding against emphasizing values antagonistic to those held by Luke.

As a growing art therapist, the knowledge I acquired about my role was that, at times, I was engaged in what Kramer (1986) termed 'inward participation'. This 'third-hand' service involved hopes, surprises, disappointments and pleasures I experienced and subliminally communicated to Luke.

I considered myself as having adapted well to the twin obstacles of Luke's hearing impairment and the language limitations stemming from his different cultural background. With Luke I had grown to feel comfortable with the absence of verbal language that would prevail at times. This may have essentially led to positive results as we focused more energy on the significance of the art object.

Overall, I did believe and feel that Luke's artwork became a bridge between his culture and language and mine, and a common focal point (McNiff 1984). In art therapy Luke was given the opportunity to express and share his uniqueness as a hearing-impaired Native American child. His creativity and my efforts to understand his personal mosaic contributed to the sowing and cultivation of the specific ingredients for a fruitful therapeutic experience for both Luke and myself. Not only did Luke experience a self-transformation, but I did as well. I became a more culturally sensitive art therapist.

References

Agell, G., Levick, M.F., Rhyne, J., Robbins, A., Rubin, J.A., Ulman, E., Wang, C.W. and Wilson, L. (1981) 'Transference and countertransference.' *American Journal of Art Therapy 21*, 3–23.

Allen, P.B. (1988) 'A consideration of transference in art therapy.' *American Journal of Art Therapy 26*, 113–118.

Dufrene, P. (1990) 'Exploring Native American symbolism.' *Journal of Multicultural and Cross-Cultural Research in Art Education 8*, 38–50.

Edward, J., Ruskin, N. and Turrini, P. (1981) *Separation-Individuation: Theory and Application.* New York: Gardner Press.

Edwards, E.D. and Edwards, M.E. (1980) 'American Indians: Working with individuals and groups.' *Social Casework: The Journal of Contemporary Social Work 61*, 498–506.

Farris, C.E., Neuhring, E.M., Terry, J.E., Bilecky, C. and Vicker, A. (1980) 'Self-concept formation in Indian children.' *Social Casework: The Journal of Contemporary Social Work 61*, 484–489.

Ferrara, N. (1991) 'Luke's map of the journey: Art therapy with a Cree Indian boy.' *Journal of Child and Care 6*, 73–78.

Ferrara, N. (1994) 'Native American experience of healing through art.' *Art Therapy Journal of the American Art Therapy Association 11*, 216–217.

Ferrara, N. (1996) 'Art therapy with a Cree bushman.' *The Canadian Journal of Art Therapy 10*, 1–6.

Greene, J.C. (1981) *An Experimental Study of Developmental Gains by Hearing Impaired Children Through Art.* Ann Arbor: University Microfilms International.

Hall, C.S. and Nordby, V.J. (1973) *A Primer of Jungian Psychology.* New York: Mentor.

Henley, D. (1987) 'An art therapy program for hearing-impaired children.' *American Journal of Art Therapy 25*, 81–89.

Jung, C.G. (1964) (ed) *Man and his Symbols.* New York: Dell Publishing.

Katan, A. (1961) 'Some thoughts about the role of verbalization in early childhood.' *Psychoanalytic Study of the Child 16*, 184–188.

Kohut, H. (1971) *The Analysis of the Self.* New York: International Universities Press.

Kramer, E. (1971) *Art as Therapy with Children.* New York: Schocken Books.

Kramer, E. (1986) 'The art therapist's third hand: Reflections on art, art therapy, and society at large.' *American Journal of Art Therapy 24*, 71–86.

Kramer, E. and Schehr, J. (1983) 'An art therapy evaluation session for children.' *American Journal of Art Therapy 23*, 3–12.

Lachman-Chapin, M. (1979) 'Kohut's theories on narcissism: Implications for art therapy.' *American Journal of Art Therapy 19*, 3–9.

Linesch, G.D. (1988) *Adolescent Art Therapy.* New York: Brunner/Mazel.

Lofgren, D.E. (1981) 'Art therapy and cultural difference.' *American Journal of Art Therapy 21*, 25–30.

Lowenfeld, V. and Brittain, W.L. (1987) *Creative and Mental Growth (8th ed.).* New York: Macmillan Publishing.

Mahler, M., Pine, F. and Bergman, A. (1975) *The Psychological Birth of the Human Infant.*

New York: Basic Books.

McNiff, S. (1984) 'Cross-cultural psychotherapy and art.' *Art Therapy: Journal of the American Art Therapy Association 1*, 125–131.

Naumburg, M. (1966) *Dynamically Oriented Art Therapy: Its Principles and Practice.* New York: Grune and Stratton.

Red Horse, J.G. (1980) 'Family structure and value orientation in American Indians.' *Social Casework: The Journal of Contemporary Social Work 61*, 462–467.

Rubin, J. (1984) *Child Art Therapy: Understanding and Helping Children Grow Through Art* (2nd ed.). New York: Van Nostrand Reinhold.

Schlesinger, H.S. and Meadow, K.P. (1972) *Sound and Sign: Childhood Deafness and Mental Health.* Berkeley: University of California Press.

Segal, H. (1975) *Introduction to the Work of Melanie Klein.* London: Hogarth Press.

Shoemaker, R.H. (1978) 'The significance of the first picture in art therapy.' In B. Mandel, R.H. Shoemaker and R.E. Hays (eds) *The Dynamics of Creativity.* Baltimore: American Art Therapy Association.

Silver, R. (1970) 'Art and the deaf.' *American Journal of Art Therapy 9*, 63–77.

Sobel, C.B. (1980) 'The use of the superhero with a group of latency age boys in a school setting.' *Pratt Institute Creative Arts Therapy Journal 1*, 44–49.

Storm, H. (1972) *Seven Arrows.* New York: Ballantine Books.

Ulman, E. and Dachinger, P. (1975) *Art Therapy: In Theory and Practice.* New York: Schocken Books.

Ward, F. (1975) 'The changing world of Canada's Crees.' *National Geographic 147*, 541–569.

Winnicott, D.W. (1971) *Playing and Reality.* New York: Tavistock Publications.

Surviving the Loss of a Child
A Case Study of Cross-Cultural Parents

Romy Montoya-Gregory

Abstract

This chapter presents the case study of a 28-year-old Caucasian mother and a 32-year-old Philippino father whose four-week-old son died of Sudden Infant Death Syndrome (SIDS). The purpose of the study involved utilizing art therapy as treatment modality to successfully identify coping strategies for each parent. Special consideration was given to similarities and differences in coping styles and intensity of feelings for each of the parents due to gender differences. The Perinatal Grief Scale (PGS) and Daily Coping Inventories (DCI) were utilized as part of the study's research instruments. The results of the study supported the hypothesis that art therapy would be successful in helping both parents identify coping strategies as they grieved the loss of their child. However, results from the PGS indicated that no change occurred, rejecting the hypothesis that art therapy would help relieve parental grief. Lastly, gender differences were noted in the grieving style of each parent, rejecting the hypothesis that no differences would be found in how the parents coped with their loss as measured by the DCI.

Review of the Literature

In a review of the literature from 1987 to 1995, the loss of a child has been generally recognized as one of the most traumatic events in the life of a parent. Most recently, researchers on the subject have been concerned with the impact that a child's death has on mothers and fathers and their ability to cope. Maternal and paternal similarities and differences in grief responses, intensity of feelings and coping strategies have been noted by most recent studies. Growing emphasis has been placed on gender differences when making comparisons of mothers' and fathers' grief following the death of a child.

Results of studies with treatment implications clearly indicate a difference in the amount of grief experienced between mothers and fathers, with

mothers showing higher intensity and duration of grief feelings (Dyregrov and Matthiesen 1987). In addition, gender differences – such as fathers showing a lower level of bonding than mothers (Thomas and Striegel 1995), scoring higher than mothers on the denial scale (Smith and Borgers 1988) and acknowledging the loss, keeping feelings to themselves and remembering the child (Carrol and Shaefer 1994) – provide valuable information for facilitating grief interventions when working with fathers in contrast to mothers.

In terms of coping styles, research results indicate a difference in the gender related coping styles of both mothers and fathers. Mothers appear to use a greater variety of coping strategies and to a greater extent than fathers (Schwab 1990). Similarly, fathers have been reported to use a more active style of coping than mothers as they use more emotional expressions and comforting cognition. Both of these gender related styles appear to change in the time immediately following the loss and before 18 months. When compared to mothers, fathers experience less disruption of their capacities to cope with everyday events and problems (Littlewood et al. 1991). Religiosity has also been addressed as an often-used coping strategy of bereaved parents. Lower levels of grief, due to church attendance, have been reported as more significant for mothers than fathers (Bohannon 1991).

Studies of bereaved parents have shown that the sex of the parent is important in relation to experiencing anger as an emotional expression to the loss of a child. Being the mother, rather than the father, increases the odds of feeling anger towards the deceased child (Drenovsky 1994). As a grief response to perinatal death, it has been reported that mothers' scores on the anger/hostility scale have been significantly higher than fathers' (Smith and Borgers 1988). However, mothers' levels of anger have also been noted to decrease by the end of the year, while fathers' levels show an increase (Bohannon 1990). As fathers' grief scores have been found to slightly increase over time, it indicates their tendency to deny their feelings in the time immediately following the loss (Stinson et al. 1992).

Marital disruptions due to gender differences between spouses over time have not been clearly substantiated. Couples have reported feeling better about their marriages or about the same as they did before the child's death (Bohannon 1990). Furthermore, gender differences in coping styles of parents who grieve the loss of a child have been reported to exist primarily in the period immediately following the death (Stinson et al. 1992). Consequently, marital discord, when noted, has been most prevalent during

the time immediately following the child's death, with difficulties in communication and understanding between spouses about the intensity of their feelings.

To summarize, research has demonstrated several differences in intensity and expression of grief feelings between mothers and fathers. Most of the differences in grief responses between bereaved mothers and bereaved fathers have been indirectly and/or directly attributed to gender and/or sex of the parent. However, despite almost a decade of research, little has been firmly established about the role of gender and parental grief differences. Do mothers and fathers clearly demonstrate gender differences in their emotional reactions and coping strategies as they grieve the loss of a child? In an attempt to answer this question and provide additional empirical data on the subject, this case study focused on utilizing art therapy to identify coping strategies for a mother and father whose four-week-old son died of Sudden Infant Death Syndrome (SIDS). Additionally, through a null hypothesis, this study explored the question: did the mother and father demonstrate gender differences in their treatment responses to the art therapy interventions as they coped with the loss of their child?

The Study

The data collected for this report was obtained from a single case study of a 28-year-old Caucasian mother and a 32-year-old Philippino father who lost their one-month-old son to SIDS. These parents presented themselves in a support group for bereaved parents at a local hospice program. Due to the group's cancellation, and their need for intervention, they were offered an opportunity to participate in this case study. Their presenting problem was to seek effective ways of coping and grieve the loss of their child.

Hypotheses

Three hypotheses were tested:

(1) Art therapy will successfully identify the coping strategies of parents in grief due to the loss of their child to SIDS

(2) Art therapy interventions will prove successful as a treatment modality for relieving parental grief as measured by the Perinatal Grief Scale (PGS)

(3) There will be no differences in how the parents cope with the loss
 of their child as measured by the Daily Coping Inventories (DCI).

These hypotheses were selected on the expressed need of the clients in identifying coping resources for dealing with the death of their child. It was also a goal of this study to discover the effectiveness of art therapy as a treatment modality in relieving parental grief. Certainly, the evidence derived from the review of the current literature on gender differences led to the exploration of notable differences in the coping styles of both parents.

Method

A single case methodology was chosen for this chapter. The single case methodology has been proven to be one of the most effective and flexible ways for clinicians to aid their clients in proper problem identification and problem solving processes. Furthermore, due to its empirical basis, the single case methodology yields information that can be best evaluated on the premises of effects and causes and/or determining influences on behavior and emotions (Behling and Merves 1984). It is, therefore, for reasons of flexibility, empirical basis and basic purpose that the single case methodology was chosen for this chapter.

Research Design

A multiple baseline design was utilized for this case study. The multiple baseline design permits the examination of the impact of an intervention on more than one client, more than one situation and more than one problem (Behling and Merves 1984). Consequently, for the purpose of this study involving two clients, it was concluded to be the most appropriate design. Specifically, it granted the exploration of the impact of art therapy as treatment modality for two parents grieving the loss of their child. The same baseline and treatment period, AB, was individually analyzed for both parents with implications on their grieving process and coping style.

Measures

Two different measures were utilized for this study. The short version of the Perinatal Grief Scale (PGS) was utilized as pre-test and post-test measure. While the PGS was originally designed to measure perinatal loss, the statements utilized as items to solicit assenting and disagreement from

individuals were considered appropriate and directly related to the experience of the parents involved in this case study who lost a child due to SIDS.

The PGS is divided into three empirical subscales, each consisting of 11 items, designed to measure active grief, difficulty coping and despair. The PGS is scored by summing items on the five-point Likert-type scales for each subscale and for the total score (Fischer and Cocoran 1994). Analyses undertaken to establish reliability and validity of the PGS have showed excellent internal consistency, good stability and good factorial validity (Fischer and Cocoran 1994).

The DCI was created for this study as a self-monitoring scale for the participants to record individual information. The DCI is divided into three sessions: 1) activity level; 2) feeling level; 3) perception/helpfulness level. A five-point Likert-type scale was used to score the inventory. The participants were asked to circle the number, ranging from 1 to 5, above the response that best indicated how helpful the activity and awareness of feelings had been to them. Both participants were asked to complete the DCI during a seven-day baseline period and throughout the course of treatment extending over a period of four weeks.

Treatment Plan

A treatment plan was specifically entertained to suit both mother's and father's need to deal with the death of their child. The original established treatment plan included participation in six weekly individual art therapy sessions to help each parent identify coping strategies to more effectively deal with the loss of their child. These interventions were chosen with the intention to provide both parents with activities that would facilitate their expression of grief feelings, identification of present behavior and recognition of grief process and coping strategies.

Results

The PGS was administered twice, with subjects completing the scale during the initial and last meeting. During the initial meeting and at pre-treatment, the mother's (Carol) individual results on the PGS yielded a total scale score of 106.0, with her subscale score on active grief being 39.0, on difficulty coping 37.0 and on despair 30.0. The father's (Bob) pre-treatment total score on the PGS was 93.0, with subscale scores of 37.0 for active grief, 34.0 on

difficulty coping and 22.0 on despair. These results placed Bob within the norm on the total and each of the subscale scores. However, Carol's scores placed her slightly above the norm on the total scale and despair subscale, with significantly higher scores on the difficulty coping subscale. She fell within the norm on the active grief subscale. When comparing both of their score results, the largest difference between Carol and Bob was on the despair subscale, with Carol scoring significantly higher than Bob.

The PGS scores at post-treatment period, applied during the last meeting, resulted in an increase of the total scale scores of both parents. Specifically, Carol's subscale scores were computed at 39.0 on active grief, 44.0 on difficulty coping and 32.0 on despair. Her total PGS score was 115.0, indicating a significant increase from her pre-test results. This increase in the total PGS score placed Carol significantly outside the norm.

Bob's PGS results on the post-test were 38.0 on active grief, 34.0 on difficulty coping and 26.0 on despair. His total PGS score was 98.0, also indicating a slight increase from the pre-test. However, this increase was not significant enough to place Bob outside the norm and/or indicate any relative change from pre-test to post-test. Bob's scores at post-treatment remained lower than Carol's.

The overall results from the PGS presented Carol's scores as higher than Bob's during both pre- and post-tests. Differences were noted between the sexes as Carol consistently scored higher than Bob on each subscale and total scale of the PGS. However, it is important to note Bob's slight increase in scores from pre-test to post-test as this indicated a more congruent relationship between both parents in feelings and experience as they grieved the loss of their child. The overall increase of the PGS scores for Carol resulted in rejection of hypothesis 2 (art therapy interventions will prove successful as a treatment modality for relieving parental grief as measured by the PGS). There was a slight increase in Bob's score, which indicated no improvement from pre-test to post-test. This also warranted rejection of hypothesis 2.

The DCI was a self-report kept by the subjects for a period of 35 days, including 7 baseline days and 28 treatment days. These daily ratings were graphically represented on three individual graphs (activity, feeling and perception) for each of the subjects. To analyze the graphical data, the Relative Frequency Technique was used. This procedure allows for the baseline to be used as a base for the calculation of an area of 'typical behavior' that is then projected onto the intervention phase. The data can then be

observed to fall within a desirable and/or undesirable range of typical behavior. Once the typical zone of behaviour is determined and marked on the graph, significance is determined by noting the data points which fall in the desirable range (Behling and Merves 1984).

Using the relative frequency technique to analyze Carol's DCI data, it was found that her behavior rarely fell within the desired zone of behavior. In other words, no significant changes can be noted from Carol's DCI as her ratings placed her consistently outside the desired zone of behavior. It is important to note that she did not find any strategies useful. This indicated that throughout treatment, no matter what her activity level was, nothing assisted her in coping with the death of their child.

Results from the relative frequency technique of Bob's DCI data indicated no change on the activity and feeling level items. His behavior during the baseline and treatment phase fell within the typical zone for both items. Data for the perception/usefulness level item indicated change from the typical range to the desired range. He scored 16 points in the desired range during the treatment phase. However, this change was not significant at the $p<.05$ level. He needed to score 19 points in the desired range (instead of 16) to make the change significant. The overall results from Bob's DCI showed little change during treatment.

It is noteworthy that Bob's data registered no extreme patterns. This is in contrast to Carol's, which went from one extreme of the graph to the other. On the activity and feeling level items Bob never fell below the typical range of behavior. This is significant in that it demonstrated that Bob never avoided his feelings but ranged between briefly experiencing some feelings and being more than just aware of his feelings.

To summarize, the results from the PGS and DCI indicated no significant improvements in helping either parent cope with the loss of their child. Furthermore, the results obtained from the PGS rejected hypothesis 2, indicating that art therapy did not prove successful in relieving the subject's parental grief. Hypothesis 3 was also rejected, as indicated by the results of the DCIs. Marked differences were noted in how each parent coped with the loss of their child as Carol showed a pattern of 'undesired typical behavior' and Bob a pattern of 'desired typical behavior'.

Art Therapy Sessions

This section presents an overview of the art therapy sessions facilitated individually with a mother and father who experienced the loss of their

four-week-old child due to SIDS. The sessions described include four sessions with the mother (Carol), four sessions with the father (Bob) and two sessions with both parents together.

Background Data

Carol is a 28-year-old Caucasian female. She was born the eldest of two children and her parents were recently divorced. Carol is a high school graduate who was employed as a pre-school teacher. She had been married previously and had a 7-year-old daughter who resided full time with her and her husband. Bob is a 32-year-old Philippino male born in the Philippines. He is one of six children. He was adopted as a child, by Philippino parents. Bob had some college education and was pursuing a degree in physical therapy. He had also been married previously and had a 9-year-old son from that marriage. Bob's son spent only weekends and some holidays at home with him and Carol.

Carol and Bob had been married for 5 years. In August of 1995 Carol and Bob had their first child together, a baby boy. Thirty-three days later the baby died while the three of them slept in the same bed. Later, it was confirmed that the baby had died of SIDS.

Since the baby's death, Carol had complained of depression, suicidal ideation, insomnia, lack of concentration, irritability, hyperactivity, excessive crying and an obsession with thoughts about the baby. In addition, since the baby's death, Carol had focused on the possibility of having surgery to undo her tubal-ligation. She expressed a strong desire to have another baby. Similarly, Bob had complained of insomnia, poor concentration, irritability, feelings of helplessness and crying spells. One of his major concerns was to provide adequate emotional support for his wife during the grieving process. Also, he was preoccupied with securing a job that would provide enough financial support for his wife to have the surgery she so much wished for.

Session One: Both Parents

During this first meeting both clients were fully introduced to the case study process. They were informed about the purpose and duration of the study, measures and interventions to be utilized, structure of the art therapy sessions and introduced to art therapy as a psychotherapy and treatment modality.

After the formalities of the case study were completed, they were casually asked to summarize how they were doing since last seen when they first

attended a local support hospice group. They took turns expressing their struggles, indicating that they both seemed to be 'on the edge' much more and with less tolerance for things and people around them than before. They also indicated that they seemed to have more conflict between them with regard to agreeing on things. Finally, they acknowledged having poor understanding of each other's feelings and actions.

Carol expressed feeling like things were not getting any better and she felt she was still struggling with dealing with the loss of the baby the same as before. On the other hand, Bob expressed thinking that things were getting a bit easier for him, although he stated he realized that it was still difficult to deal with the loss. Overall, both parents agreed that outside intervention would prove helpful to them as they felt a need to find new ways of dealing with the loss of their child.

Session Two with Carol

This session began by Carol talking at length about her anger and her inability to express her feelings for fear of causing added family turmoil. She also discussed her need to find an answer as to why her son had to be the one that died. After some processing of these issues, and providing her with some choices on how to appropriately express her anger, Carol was instructed to create a collage of her world before and after the baby died (Figures 5.1, 5.2).

Once involved in the activity, Carol began quickly to tear out images from the magazines. After she finished, she began explaining that many things reminded her of the baby and that she thought about him constantly. She pointed at the collages saying that before he was born she had made many plans about what he would look like and be doing at different ages and now felt cheated because these things were not going to happen. She stated that even after his death she continued to think of him in terms of being here. She liked talking about him and, sometimes, even though it was hard, liked to look at his video. Carol indicated she drank alcohol to 'numb' herself and as a way to get a break from constantly thinking about him.

Carol continued to discuss many things, changing from one subject to another quickly and randomly. She discussed her suicidal ideation and her guilt feelings as she at times felt responsible for the baby's death. She also expressed a strong desire to have another baby. Overall, during this session Carol's feelings and thoughts poured out of her at a very fast rate, indicating her overwhelmed feelings and lack of control. She cried at times but did not allow her tears to flow, quickly composing herself.

Figure 5.1

Figure 5.2

Session Two with Bob

Bob began the session by immediately focusing on the art activity. He was also instructed to construct his world before and after the baby died (Figures 5.3 and 5.4). As he finished, Bob indicated that he could easily summarize both collages into happy, before the baby died, and sad, after the baby's death. He was asked to comment on an image that had most significance to him. For the 'before' collage, Bob chose an image of an infant standing up and being held by someone from behind. He said he thought about his son getting to this stage and that the hardest part for him was to think about the future and realize it would never come true. As he cried Bob stated: 'I feel cheated'.

For the 'after' collage, Bob chose an image of a woman holding onto her stomach, with a very painful expression on her face. He explained that he thought about his wife when looking at this image because it was as if part of her had been ripped away. Bob discussed feeling like a failure because he could not make her feel any better and because he wasn't able to provide the financial means for her to have the surgery she wanted so much. He also expressed not being able to show his feelings in front of her because he felt she needed him to be strong. He mostly cried alone and kept his thoughts about the baby to himself. Overall, Bob was very outspoken about his feelings, allowing himself to cry at different times throughout the session.

Figure 5.3

Figure 5.4

Session Three with Carol

Carol began this session by indicating that she had had a bad week as she and her husband had fought and did not speak for three days. She continued to speak at length about past marital conflicts that now, since the baby's death, seemed worse. In addition, Carol spoke about her husband's lack of understanding and poor emotional support regarding her need to have her tubal-ligation reversed. After spending a good deal of time on this topic, Carol was instructed to create a collage of the things that helped her cope with the baby's death and one of the things that didn't help (Figures 5.5, 5.6).

Carol complied with the instructions and became involved in the activity. She indicated that keeping busy, being at work and seeing other babies were all helpful. However, at times, these things could also be overwhelming to her and she would find them unhelpful, making her feel physically exhausted and/or emotionally drained. Drinking was addressed by Carol as something that she admitted using to stop thinking about the baby, but she realized it was not completely helpful and only left her feeling physically

Figure 5.6

Figure 5.5

tired the next day. By this session it was apparent that Carol was facing a great degree of difficulty in coping and in experiencing anything that was truly helpful. This was perceived mostly through her continuous expressions that no matter what she did, she did not feel good and could not get her mind off the baby.

Session Three with Bob

This session began with Bob immediately focusing on the art activity. He was instructed to construct a collage of the things he found helpful and the things that did not help him cope with the death of the baby (Figures 5.7, 5.8).

Once he completed the activities, he summarized the images selected for the 'don't help' collage by stating that he thought anger did not work because it ruined things. He indicated that he and his wife not communicating was not helpful and made things worse. Bob also spoke at length about the expectations placed on him from his family of origin and stated that he didn't feel he had met his adoptive parents' expectations. Additionally, he discussed his role expectations as a male and father and indicated feeling that, at this point, he was not fulfilling his role of husband and provider very successfully. Lastly, Bob spoke about the things that he found helpful, such as different sports, outdoor activities and, sometimes, just being alone.

In general, during this session Bob seemed to seriously reflect on the things that helped him and the things that were not helpful as he tried to cope with family problems and the loss of his child. As a male from a culture where talking about family issues and problems can be perceived as a 'betrayal', Bob took a big step admitting that they had problems. His discomfort was verified as he spoke cautiously, appearing to deliberate the appropriateness of his words.

Session Four with Carol

There was a two-week interruption between the last session and this one as Carol and Bob had canceled scheduled appointments. They also mentioned that they would be going on vacation, therefore appointments needed to be rescheduled. At this point it became apparent that there would not be enough time to meet the case study deadline and complete the originally planned six art therapy sessions. Consequently, it was decided that they and the therapist would meet two more times after this session and terminate.

Figure 5.7

Figure 5.8

Carol began this session by talking about problems with her husband, father-in-law and her need to have her tubal-ligation reversed. The rest of the time was focused on the art activity planned for this session. Carol was instructed to create her family, using any symbols. Carol chose to create small human-like figures to represent her husband, her stepson, her daughter, their deceased child and their dog (see Figure 5.9).

She was then asked to arrange the figures according to the position/order she saw them occupying within the family. She arranged them from left to right as follows: deceased baby, herself, daughter, stepson and husband. After this, she was asked to gestalt each figure. The following represents her words for each figure in the same order she first arranged them: 'I don't feel anything', 'I'm lost', 'I'm scared', 'I'm confused' and 'I'm lost and confused'.

Following this, Carol was asked to once more arrange the figures, but this time in the way she would like for everyone to be situated within the family. After several rearrangements on her part, which occurred with much prompting, and much discussion about everyone's role within the family, her figures ended as follows: daughter, stepson, Carol, her husband and dog, with the deceased baby above them (Figure 5.9).

In general, this session proved to be very emotional for Carol as she struggled with finding a desired position for everyone within the family. Much of her difficulty was around finding a position/space for the deceased child within the family and in wanting to eliminate herself from the picture. This was the first session in which Carol allowed herself to fully cry as she spoke about the baby.

Session Four with Bob

Bob began the session by immediately focusing on the art activity. He was also instructed to create his family, using any symbols he wanted. Bob chose to work at a very symbolic level as he created candles, a star, a seesaw and heavy weight, and some balloons (Figure 5.10). Once finished, he indicated that the four candles represented him, his wife, son and stepdaughter. He added that he had chosen the four candles because they represented hope and faith for him. The star represented his deceased son as he thought of him being up in heaven watching over them. The balloons were his parents and her parents, who, he stated, could sometimes be sources of support but, at other times, could really weigh things down for them. He stated that that was why he had placed the balloons on one end of the seesaw and a heavy weight on the other (see Figure 5.10).

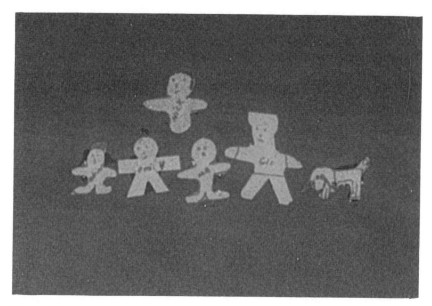

Figure 5.9

As he was asked to arrange the symbols representing his family according to desired position, Bob never changed his original arrangement on the paper. When asked about what he could do regarding the heavy weight on the seesaw, he replied that he would leave it like that because that was the way things were with his parents and her parents. At this point Bob became involved in explaining how it was customary in his culture to have parents be involved in their children's business and parents were not something that he could ignore or just disregard. He continued to talk about not being able to put any distance between him and his parents.

Overall, during this session Bob became actively involved in talking about his own family and his family of origin. He declared some rigid cultural beliefs about the role their parents occupied in their lives. This was exemplified as he did not seem to be able to physically remove their symbols from the overall picture, despite his verbal desire to do so.

Session Five with Carol

At the beginning of this session Carol appeared more upset than usual. She began the session by conversing about her secret plans to borrow money to

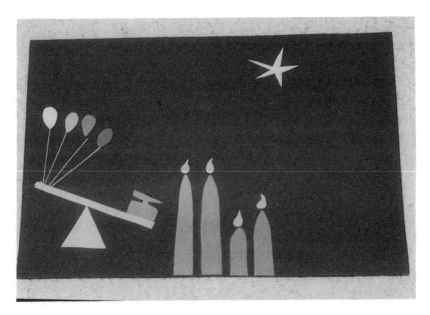

Figure 5.10

have her surgery. As Carol talked, tears flowed continuously from her, indicating the pain she felt when thinking about her only hope. Time was allowed for her to process her feelings.

Carol was then instructed to create, out of plasticine, a bridge between where she is now and wherever she wanted to get. She selected brown plasticine and, in a very sluggish way, created a thin long line that she described as her bridge. She was prompted to create a symbol of what she wanted represented on each end of the bridge. She then created a stick figure (without head) and the symbol for female. The stick figure was her and where she is now and the female symbol represented her surgery and where she wanted to go (see Figure 5.11).

After creating her bridge, Carol proceeded to discuss once again the issues surrounding her need for surgery. At one point during this discussion Carol broke off the thin line representing her bridge and indicated that she knew getting there would not be easy as things always happen that get in her way. Her previous determination to get the surgery done appeared to vanish as she sat blankly staring at the bridge. Following that, a more direct approach was then taken with Carol and she was prompted to fix her bridge. She was reminded that she had been very determined to get the surgery and had

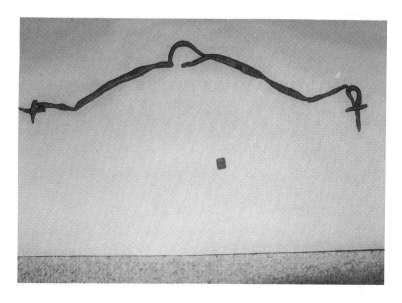

Figure 5.11

stated that no matter what, she would do it. She fixed her bridge by adding another small thin line connecting the places where she had broken the original bridge (Figure 5.11).

Session Five with Bob

Bob began his session, as always, focusing on the art activity. He was instructed to create a bridge, create a symbol of himself and place it where he thought he was on the bridge. After he had finished, Bob indicated that he was a Volkswagen and where he was now was the desert. He added that where he wanted to go was like a mirage with water and palm trees and that he would change from a Volkswagen to a red Corvette (Figure 5.12). Bob continued to explain that he could see the other side and knew how to get there but right now that was not possible because things were not the way he needed them to be just yet.

The rest of the time was spent with Bob discussing some of the obstacles he may have to overcome to get to the other side of his bridge and his struggles with getting his whole family to the other side too.

Figure 5.12

Session Six: Both Parents

This meeting took place two weeks after the last session. Both Carol and Bob were present as this was the last scheduled session of the case study. The entire session focused on exploring their feelings about the art therapy sessions, briefly reviewing the results of their work and discussing recommendations for further treatment. Both were accepting of the recommendations, acknowledging the need for further intervention as they bowed to continue to deal with the loss of their child.

Discussion

The results from the Perinatal Grief Scale (PGS) measure indicated that after treatment no change occurred in helping either parent relieve their grief over the loss of their four-week-old son. Specifically, the results of the PGS yielded the rejection of hypothesis 2, suggesting that art therapy interventions did not prove successful as a treatment modality for relieving parental grief.

In evaluation of this data, one can speculate that this may have occurred as a result of the short period of intervention allowed for the case study. The four art therapy sessions may have been too few to provide significant or

meaningful change, especially when dealing with the loss of a child. Additionally, it could also be speculated that as other issues of therapeutic need were identified through the art therapy sessions for both parents (i.e. increased marital discord), their grief was escalated. Indeed, the parents' post-test scores on the PGS indicated no change on the active grief subscale, indicating that active grief was not the main source of difficulty. Instead, the scores indicated that other issues were impacting their ability to cope.

In recapitulating the Daily Coping Inventory (DCI) results, no significant change was observed in the parents' self-reports throughout the treatment. Furthermore, Carol's relative level of functioning stayed in the undesirable behavior zone on every item of the measure. This suggested that nothing was helpful to Carol as she tried coping with the loss of her child. In contrast, Bob's responses to the DCI indicated no extreme behavior on any level of the measure. His response always placed him within the desirable zone of behavior. This suggested an increased level of coping and a wider range of feelings and activity level for Bob.

Through a comparison analysis of both parents' data, a rejection of hypothesis 3 was noted. Marked differences in how both parents coped with the loss of their child were demonstrated on the DCI. Several possibilities could account for the differences in how the parents coped with their loss. It could be speculated that Bob's preference for an active style of coping derived from gender-related preferences as males have been reported to prefer a more active coping style than females (Littlewood *et al.* 1991). Similarly, Carol's difficulty as reported on the DCI may also be gender related. In the past, mothers have reported more difficulty in coping with everyday events and the inability to cope increased intensity of grief feelings (Littlewood *et al.* 1991). Lastly, gender-related differences in terms of denial could be at the root of parental differences on the DCI. Bob often reported experiencing feelings of happiness, contentment, excitement, ambition and determination. This acknowledgment of less painful and less overwhelming feelings may have sprung from his need to deny more intense grief feelings. Research has found that fathers deny feelings of weakness and deny levels of emotional intensity due to their perception that it is socially undesirable (Smith and Borgers 1988).

In reviewing the art interventions utilized with each of the parents, the general outcome of the sessions appeared effective in providing an opportunity for each parent to explore their worlds before and after the baby died. They also examined strategies that were helpful and strategies that did

not help to cope with the loss. In addition, they reviewed their marital and family relationships as well as their outlooks about the future. The art therapy sessions served the purpose of helping both parents identify coping strategies to assist them in dealing with the loss of their child. Consequently, hypothesis 1 was supported.

Awareness developed as a consequence of the art interventions and both parents also gained insight into their ability to apply and utilize these coping resources. It was through the art interventions that Carol discovered her inability to cope with the loss of her child and she recognized a need for more intensive and prolonged treatment. The art therapy sessions provided an opportunity for Bob to express his feelings primarily through the art intervention, allowing him to communicate in a way that previously had not been available. Therefore, it is important to recognize the potential of art therapy as an appropriate mode of therapeutic treatment with bereaved males.

Limitations and Recommendations

One of the most obvious limitations of this study was the time restriction placed upon the completion of treatment due to research deadlines. It was clear that the subjects needed extended treatment intervention due to their complicated bereavement issues. Another limitation involved the PGS measure. A mistake was made by the author as she re-copied the PGS by leaving out an item from the rating scale. This meant that the subjects rated the PGS on a four-point scale instead of the original five-point Likert-type scale. The exclusion of one item may have altered the subjects' scores and weakened the validity of the PGS results. Lastly, the setting where the art therapy sessions were conducted represented a limitation of the study. The sessions were conducted in the home of the clients. This arrangement was, perhaps, not the most suitable for conducting art therapy as interruptions often occurred and may have contributed to the distraction, resistance and avoidance of the parents. The home setting also offered dynamics of the therapeutic relationship that are often not present during office visits (i.e. clients treating the therapist as a guest in their home). The boundaries of the therapeutic relationship were not as clear and interfered with treatment.

Ultimately, future research recommendations would include a follow-up study of these clients at intervals of six months and a year. This would be of interest in exploring the long-range response to the art therapy interventions.

Future research would also include exploring the lasting effects the art therapy interventions had on the clients and their grieving process.

Conclusions

Much of the information obtained through this case study supported findings from past research. The higher intensity of feelings experienced by the mother in this case study validated information previously obtained. Similarities in coping strategies utilized by both genders were also verified through the results of this case study. However, also noted were differences in coping strategies utilized by Bob and Carol. These differences appeared mostly due to their use of coping strategies at different times and stages of each parent's grieving process. These differences in coping strategies of both parents supported previous research results. Marital strain due to the different coping styles of parents were also noted in this study. Previous research results also validate this information. In general, issues that have been addressed in previous literature were reflected in the research performed in this case study.

In conclusion, the primary goal of this case study was to utilize art therapy to develop coping strategies for a couple who experienced the loss of their child to SIDS. The goal of treatment was to help the parents identify tools that would help them in coping with their grief. Although results did not indicate any significant change from pre-treatment to post-treatment, evaluation of the art therapy sessions suggested that the subjects did experience some change. Furthermore, this case study verified the effectiveness of art therapy as a treatment modality for working with bereaved parents. Finally, this research presented the study of a couple from different cultural backgrounds who worked to survive the loss of their child.

References

Behling, J.H. and Merves, E.S. (1984) *The Practice of Clinical Research: The Single Case Method.* Lanham, MD: University Press of America.

Bohannon, J.R. (1990) 'Grief responses of spouses following the death of a child: a longitudinal study.' *Omega Journal of Death and Dying 22,* 2, 109–121.

Bohannon, J.R. (1991) 'Religiosity related to grief levels of bereaved mothers and fathers.' *Omega Journal of Death and Dying 23,* 2, 153–159.

Carrol, R. and Shaefer, S. (1994) 'Similarities and differences in spouses coping with SIDS.' *Omega Journal of Death and Dying 28,* 4, 273–284.

Drenovsky, C.K. (1994) 'Anger and the desire for retribution among bereaved parents.' *Omega Journal of Death and Dying 29*, 4, 303–312.

Dyregrov, A. and Matthiesen, S. (1987) 'Similarities and differences in mothers' and fathers' grief following the death of an infant.' *Scandinavian Journal of Psychology 28*, 1–15.

Fischer, J. and Cocoran, K. (1994) *Measures for Clinical Practice*. New York: Maxwell & McMillan International.

Littlewood, J., Cramer, D., Hoekstra, J. and Humphrey, G. (1991) 'Gender differences in parental coping following their child's death.' *British Journal of Guidance and Counselling 19*, 2, 139–149.

Schwab, R. (1990) 'Paternal and maternal coping with the death of a child.' *Death Studies 14*, 5, 407–422.

Smith, A. and Borgers, S. (1988) 'Parental grief response to perinatal death.' *Omega Journal of Death and Dying 19*, 3, 203–213.

Stinson, K., Lasker, J., Lohmann, J. and Toedter, L. (1992) 'Parents' grief following pregnancy loss: A comparison of mothers and fathers.' *Family Relations Journal 41*, 218–223.

Thomas, V. and Striegel, P. (1995) 'Stress and grief of a perinatal loss: integrating qualitative and quantitative methods.' *Omega Journal of Death and Dying 30*, 4, 299–311.

Art Therapy with Obese Teens
Racial, Cultural, and Therapeutic Implications

Marcia L. Rosal, Lisa Turner-Schikler and Donna Yurt

Abstract

At an outpatient preventive cardiology clinic of a large urban children's hospital, several adolescent cardiac patients were found to be grossly overweight. For these teens, losing weight was a vital health issue. An art and nutrition therapy group was developed to assist and support the teens in their weight-loss efforts. Many of the adolescents eligible for the group were African Americans and most were female. Due to the type of clients served, it was important to understand the physical, dietary and personal issues of the overweight adolescent. However, the racial composition of the group membership also made it imperative to discern the cultural context of their obesity. In this chapter, three issues regarding the group will be examined. First, there will be a discussion regarding the importance of looking at weight issues in a cultural context. Next, an overview of what was learned from both the literature and the teens regarding the implications of race, culture and socio-economic status on perceptions of beauty and ideal weight will be explored. Finally, the initial data from the pilot art and nutrition therapy group will be reported.

Childhood and adolescent obesity is an important and serious national issue. In three recent reports it was estimated that 22 per cent of adolescents in the United States are obese and this percentage has doubled since 1965 (Gortmaker *et al.* 1987; Mellin 1993; Troiano *et al.* 1995). Obesity or overweight is defined as the presence of an abnormally excessive amount weight and body fat and is measured in terms of weight for height. Obese teens are susceptible to both physical health problems and psychosocial difficulties.

Medically, overweight teens are at risk. Many suffer from high blood pressure, high cholesterol, obstructive sleep apnea and cardiac disease (Burke *et al.* 1992; Dawson 1988; Mellin 1993; Morrison *et al.* 1994; Rhodes *et al.*

1995). Neurocognitive abilities of obese teens have been measured and reveal deficits in performance IQ scores, learning, memory and vocabulary (Li 1995).

Obese teens are also susceptible to emotional and interpersonal problems. In one study, 462 adolescents were given a set of scales to determine their concerns about eating (Mueller *et al.* 1995). Ten per cent said they were 'underweight' and 21 per cent said they were 'overweight'. Both the underweight and overweight groups had lower self-esteem and participated in lower levels of exercise than 'average weight' teens. However, only the overweight group scored higher on the depression scale than teens of average weight.

In another study by Manus and Killeen (1995), 45 fifth grade children participated in a study to examine whether obese children differ in self-esteem from their average weight peers. The study also explored whether obese children used the processes of discounting and cognitive distortion to maintain self-esteem. The obese children had lower scores than average weight children in global self-worth and in perceived competence in physical appearance and social acceptance, but not in scholastic competence, athletic competence or behavioral conduct. The pattern of results indicated that obese children did not discount the importance of physical appearance and weight but, rather, used cognitive distortion. The use of distortion by obese children resulted reports of positive self-perceptions. Manus and Killeen acknowledged that obese children often draw themselves as being of average weight or as slim.

Although the use of defensive cognition was effective in mediating the obese children's global self-worth, it was not powerful enough to completely prevent the negative effects of obesity on self-esteem. Poor self-esteem in obese children and teens was supported through a review of the literature conducted by French, Story and Perry (1995). Furthermore, poor self-concept may impede the successful accomplishment of dieting among adolescents (Newell *et al.* 1990). Therefore, if a teen is obese and has a low sense of self, the chances of successfully losing weight are lessened.

From the research, it is clear that obese adolescents have many problems associated with being overweight. Helping adolescents to cope with both the physical and the emotional consequences of obesity was at the heart of the pilot program and study.

Art and Nutrition Therapy Group

The two-fold impact of the obesity dilemma prompted the development of an art therapy and nutrition group for overweight adolescents. Over a two-year period, 16 adolescents participated in a combined art and nutrition therapy group program. Two art therapists and one dietitian developed and conducted the group project. The groups were conducted in several short-term components comprised of six to eight sessions. The demographics of the teens involved in the group project is presented in Table 6.1. The majority of the teens were between the ages of 12 and 14 years. All of the teens except two were within the 85th percentile of weight for their height, which means that only 15 per cent of the teens in their age group weigh as much as or more than they do for their height. Of the 16 patients, 11 were female (6 African American and 5 white). Only 5 males were involved in the group and 4 of the males were African American. A total of 10 African Americans took part in the group, compared to 6 whites.

Table 6.1. Demographics of the Adolescent Wellness Group Members

Patient	Age	Gender	Race*	Weight (lbs)	Height
T1.	12	M	AA	245.0	5'7"
T2.	14	M	AA	276.0	6'.¼"
L1.	14	F	AA	200.0	5'2¼"
N1.	16	F	AA	205.0	5'1½"
S.	14	M	AA	334.0	5'5"
M1.	13	M	W	265.0	5'9"
D1.	13	F	W	250.0	5'3½"
M2.	14	M	AA	198.8	5'6"
L2.	14	F	W	251.4	5'4"
C.	16	F	W		
T3.	15	F	AA		
O.	13	F	AA	206.8	5'6½"
J.	13	F	W	207.6	5'6"
B.	13	F	W	225.6	5'6¼"
N2.	12	F	AA	137.6	4'10"
D2.	12	F	AA	132.2	5'

Totals: 16 Patients 11 Female 10 AA

*AA=African American; W=White

There was an over-representation of African American teens attending the teen obesity group based on local demographics. From the beginning of the group it was evident that the African American teens were much more comfortable with their weight than were the Caucasian teens, thus the adolescents in the group verified what the literature reported regarding the relative comfort level African Americans had with their weight when compared to white teens (Fitzgibbon, Stolley and Kirschenbaum 1995; Kumanyika, Wilson and Guilford-Davenport 1993; Pratt 1994). The members confirmed that overweight black teens were not stigmatized because of their weight to the extent endured by white teens. The minority teens admitted that in their culture big is often seen as 'healthy' and/or 'tough' (Kumanyika 1993) and substantiated the notion that extra weight can be a positive attribute. Many of the minority teens added that everyone in their family or social circle was large.

Likewise, males were less self-conscious regarding their weight than females. The females in the group talked about their concerns with dress (that they could not buy the clothes which other girls their age could wear) and admitted to feelings of shame for their bodies (not wanting to go swimming or to wear swim suits). Again, the teens in the obesity project supported what was found in the literature about the politics of weight and gender: females tend to feel more shame and are shunned more often than males due to being overweight (Desmond *et al.* 1989; Fowler 1989; Harris, Walters and Waschull 1991).

Due to the startling demographics of the group membership, the variation of responses to being overweight and the gender disparity regarding how extra weight is perceived, we realized that the issue of weight had to be addressed within a larger, societal context. From a thorough review of the literature, the impact of race, gender and culture on weight issues was revealed and the impact of how our culture influences prejudices about weight was illuminated.

Review of the Literature

Four factors are associated with being an obese adolescent in the United States: (1) coming from a household with a low income level, (2) being from a minority group, (3) coming from a family where one or both parents have weight problems and (4) being female (Dawson 1988; Fitzgibbon, Stolley and Kirschenbaum 1995; Fowler 1989; Garn 1994; Kahn, Williamson and Stevens 1991; Kumanyika 1993; Sackor 1994). To develop an initial

understanding about the impact of society on weight issues, an investigation of two factors (coming from a household with a low income and being from a minority group) was deemed important in light of the demographics of the teens with whom we worked. In fact, in the United States the powerful correlation between these two factors has made it difficult for researchers to separate the effects of one from the other on obesity. Many social scientists have been conducting research on this issue and there is agreement that isolating the effects of poverty and minority status on obesity is very difficult.

There are estimates that up to twice as many obese teens come from African American, Hispanic and Native American cultures than from Caucasian households. In a survey conducted between September 1990 and February 1991, 39.3 per cent of Native American youth were found to be obese, compared to 28.6 per cent among all teens (Jackson 1993). More alarming is that the rate of obesity during the period 1992 to 1994 increased by 4.6 per cent for African American females, compared to an increase with white girls of 1 per cent (Pratt 1994). In one study, 41.5 per cent of Mexican American women were found to be overweight, as compared to 25.7 per cent of the general population (Najjar and Kuczmarski 1989). African American women were found to be heavier than both the Hispanic group and the Caucasian group in another study (Dawson 1988).

Poor people are heavier than people in higher socioeconomic classes (Carpenter and Bartley 1994; Dawson 1988; Gortmaker et al. 1993; Kahn, Williamson and Stevens 1991; Sackor 1994). Because individuals in minority groups are more often in lower socioeconomic classes, there is a cultural influence on the percentages of overweight people across economic groups. And there is evidence that poverty alone cannot predict obesity. Dawson (1988) found higher percentages of obesity in both African Americans (33%) and Hispanics (25%) than among whites (20%), even when adjustments were made for poverty levels.

The reasons for dramatic differences in obesity rates among lower socioeconomic levels and minority cultures are many and complex. The intricate and delicate nature regarding the politics of obesity is important to grasp for there to be any true understanding of the influences of culture on issues of weight. The effects of prejudice in the United States has not been fully researched and how prejudice might affect the eating habits of minority groups has received only cursory attention (Greeno and Wing 1994).

There are gender issues which must be discussed regarding obesity. More women are obese than men and this applies to adolescents as well (Carpenter

and Bartley 1994; Croft *et al.* 1992; Harris, Walters and Waschull 1991; Troiano *et al.* 1995). There are also gender differences in terms of how obese people are viewed. For example, being overweight is viewed as being a more serious problem for girls and obese teens are seen as more unattractive if they are female (Fowler 1989; Jasper and Klassen 1990). Obese males are viewed as more desirable dating partners for teens than obese females (Harris, Walters and Waschull 1991). Socially, obese teens are in a bind, especially if they are female.

Because the issues of weight, gender, economic level and race are so difficult to separate, Pratt (1994) suggested that researchers look at three main factors when studying obesity in African American adolescents: (1) psychological factors, (2) familial factors and (3) lifestyle factors (see Figure 6.1). Under each main factor are examples of what Pratt recommends be studied. An example of a study on psychological factors is an investigation by Desmond *et al.* (1989). They theorized that being overweight in the black culture is more acceptable and not as stigmatizing as in the white culture. The results of the study supported the hypothesis and obese African American teens did not have self-esteem levels lower than the norm.

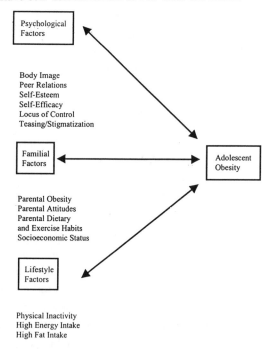

Figure 6.1. Pratt's (1994) model for examining African-American adolescent obesity
 Source: Pratt (1994)

Psychological Factors

The psychological impact of being overweight in African American cultures is not as stigmatizing as in the mainstream culture (Desmond *et al.* 1989; Kumanyika *et al.* 1993). The research substantiates the fact that overweight African Americans are less self-conscious and less depressed than overweight Caucasians. This was certainly true for the members of our groups as well. Many of the African American teens in the group did not have the self-esteem problems which plagued the white teens. They were more self-assured and reported that they felt accepted in peer groups and in school and work environments.

Familial Factors

Pratt's second area of research, familial factors, is also an important key to understanding the racial imbalance of obesity. More African American women are obese than their white peers (Dawson 1988). Therefore, African American teens are at greater risk for obesity because they come from families where at least one parent has weight problems (Fitzgibbon, Stolley and Kirschenbaum 1995; Garn 1994; Morrison *et al.* 1994). This is particularly true for daughters of obese African American mothers. However, the hereditary factors associated with obesity are not completely understood. It is not known whether African American teens are more likely to become obese because of a genetic predisposition or because they model their parents' (particularly, their mothers') habits of overeating, sedentary lifestyle and poor food choices.

In addition, obese mothers have been found to serve larger food portions and foods with higher caloric and fat content to their children than mothers who are not overweight (Fitzgibbon, Stolley and Kirschenbaum 1995). Again this was supported by our patients. The group members talked about the abundance of food brought to the dinner table and which was available in their homes. In particular, the teens acknowledged how many sweet and fatty foods (i.e. pies, biscuits and fried chicken) were available to them upon demand.

Finally, the discussion regarding the influence of familial factors is not complete without discussing the issue of poverty. Good nutrition is based on having the funds to obtain healthier foods. In African American families poor nutrition may be the result of poor food choices or poor nutrition may be the result of an inability to make healthier food choices because less fattening foods cost more (Kumanyika 1993; Sackor 1994).

Lifestyle Factors

Lifestyle factors, the third category of research recommended by Pratt, must be examined when discussing obesity in adolescence. Issues such as obese mothers serving larger portions of food and foods with higher caloric and fat content come into play as well as a lifestyle which does not necessarily value physical exercise. 'Working out' was not valued in the families with whom we worked. The teens found it very difficult to exercise. Parents were encouraged to take walks with their teens and to get adolescents involved in sports. However, the parents found it difficult because they did not regularly participate in physical activities.

The issue of fat perception is a component under lifestyle factors. African Americans are not as concerned about being overweight as white teens. In the mainstream culture, overweight people are generally perceived as more unattractive than non-overweight folks. Somehow, this is not true in African American communities where black overweight females rate themselves as being more attractive than white overweight females (Dawson 1988; Kumanyika *et al.* 1993). Black males less frequently identify an overweight female as unattractive than white males (Harris, Walters and Waschull 1991). If there is a culture of acceptance for obesity among African American teens, they will be less likely to degrade themselves for being overweight and they will not feel as badly about gaining a few pounds.

There is a negative impact on motivation to lose weight in a culture of acceptance. However, motivation is a necessary component in losing weight (Kumanyika, Wilson and Guilford-Davenport 1993). Often, there is a health risk created because of the extra pounds carried by adolescents. If the teens are not motivated to lose weight, the negative effects of being overweight can mount. This dilemma was common in the art and nutrition therapy group. One African American teen talked about her beauty and her high level of confidence. She admitted that it was very difficult for her to lose weight, especially when neither she nor her boyfriend found her weight to be a problem. Positive self-statements were seldom heard from any of the white teens.

To summarize, the issue of obesity in teens is important, timely and complex. This already complicated issue is made more multifarious when the issues of race, gender and economics become part of the equation. What seems to be true is that more must be learned about how to work with an obese teen when there may be health risks or when the teen comes from a racial or ethnic background where weight and food may have different meanings than in mainstream society.

Group Issues and Themes

The art and nutrition therapy group was developed to give self-conscious, overweight teens an alternative avenue of support, expression and improved health. The adolescents were given the chance to interact with other teens regarding weight, health and social concerns and to develop supportive peer relationships. Opportunities to be creative in a stress-free environment as a means of non-verbal, non-threatening expression were provided, as well as the opportunity to interact.

As the group evolved, the adolescents were able to discuss how excess weight impacted their lives. One 13-year-old female shared with the group that she was the only fat student in her class. Another group member said: 'I know how that is; I know how you feel' and shared similar stories. They discussed what it was like to be judged by their appearance and feared that others would not take the time to get to know them inside. Many of the members reported that they were the target of hurtful remarks made by classmates. The teens strategized and problem-solved how to better cope with unkind remarks and attitudes. One teenage girl said: 'I know how you feel girl, but you hold your head up, because if they don't get to know you, it's their loss; but I know how you feel'. The support the teens gave so freely was an incredibly powerful process, especially since there was diversity of membership in the group. The teens were from different races, socio-economic levels, private versus public school settings and lived in various areas of the city.

The group had a psychoeducational component where food concerns were addressed by the dietitian. The adolescents were taught how to count fat grams and calories and how to conceive realistic, obtainable weight-loss goals. Weight loss of one to two pounds a week and no more was encouraged. The teens learned how to make better food choices at home, school and fast food restaurants. There were opportunities for the caregivers and the people who prepared most of the meals (typically mothers and grandmothers) to join the group and learn about food choices. There were educational opportunities for learning about better methods of food preparation.

Exercise was a topic that was often dealt with as many of the kids struggled to make themselves exercise more. Because of their sedentary life styles, exercise was not second nature to the teens and was an activity they found very challenging. The dietitian offered avenues for beginning an exercise routine. Teens were encouraged to start small and gradually build an exercise program which was suitable for their health.

All three group leaders were Caucasian and most of the group members were African American. Another major difference between the leaders and the group members was in terms of weight. All three leaders were of average to below average weight. The differences were noted and the leaders discussed these issues, which had the potential to be obstacles in the group. The leaders were sensitive to the racial dynamics and often asked questions about how situations and feelings might be different between members. The members were asked to compare and contrast issues between the two races and genders. By addressing the dissimilarities outright, participants were encouraged to acknowledge that differences existed and that the emphasis of the group was to explore concerns and not to make judgements.

Group Structure

The group met once a week for an hour directly after school hours. The goals of the group were to increase their knowledge and education about health issues regarding obesity and to offer the teens a means of countering the negative effects of being overweight. An art therapy intervention was offered in each session and a short exercise component was incorporated into the group as well. The group members met in the reception area of an outpatient clinic and then walked to the group meeting room in another part of the hospital. After the session, group members walked back to the reception area to meet parents and caregivers. The walks before and after the session framed the group experience and modeled how walking can be a healthy, social activity. The teens were able to check in with each other during these times and a comradeship was created during the walking to and from group. Teens shared experiences from the school day and joked with each other.

Art Experiences

Art making was an integral part of each group session. In this section an overview of useful art therapy interventions will be reviewed. Many art experiences were formulated directly from the expressed needs of the adolescents or from topics generated during the initial discussion period. Other art therapy interventions were developed by the therapists to address specific goals and to address the three issues outlined by Pratt (1994): (1) psychological factors, (2) family factors and (3) lifestyle factors.

Collages

One of the initial art therapy projects which helped the participants become comfortable with the group was collage. During several of the group modules the teens made collages about what was important to them. In other group modules collages about future goals were helpful. The collages helped the members to get acquainted with one another and to discuss similarities of interests and goals.

The collages often had images and themes which reflected racial identity. The girls would often have images of African American fashion models and would verbalize concerns about beauty and physical appearance (see Figure 6.2). One of the males created the collage shown in Figure 6.3. Nelson Mandela figures predominantly in this collage and the young man who created the collage talked about his racial identity and his interest in black history. This collage also included a map of the demographics of people who eat *Twinkies*. The group members used this image as a vehicle for talking about their poor eating habits and the difficulty of saying 'no' to eating junk foods.

Tissue-paper collages were useful in helping the group members discuss environments and situations where they felt comfortable and where they did not. The collage in Figure 6.4 was representative of an environment where the teens felt uncomfortable. The young African American woman who created this collage talked about the tears she often experienced when she was in a place where she felt self-conscious. The tears are on the the right of her piece. She admitted that she was uncomfortable around her family because she was the only one who was obese. She was able to tell the group that she was normal in size while a baby but then she quickly became very overweight. She had fears that a medication she needed as a child contributed to her obesity. Other teens shared that they felt comfortable at home but not at school or in other social settings.

Drawings

Using simple drawing materials to express some concrete issues was useful with the teens. For example, one African American male drew how he saw himself before the group and how he would like to be after the group (see Figure 6.5). On the left hand side of the page he drew himself as sad and overweight; he wanted to see himself as losing weight and feeling happier after the group experience.

Figure 6.2. Collage created by an African American female which features African American fashion models

Figure 6.3. Nelson Mandela is featured in this collage by an African American male group member

Figure 6.4. Tissue-paper collage illustrating an African American female's feelings of discomfort with her family environment

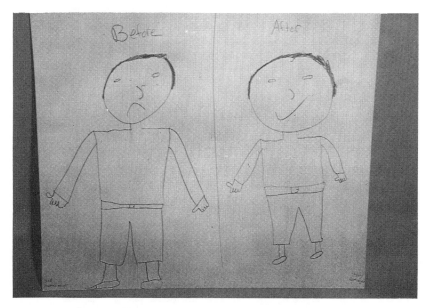

Figure 6.5. A drawing of how one African American male group member feels now and how he would like to feel after the group

At times, free drawings were revealing of true, yet veiled, feelings. In Figure 6.6, a drawing by a 15-year-old, quiet, shy African American boy reveals his anger and aggression. This group member was very soft spoken. This piece of artwork was startling yet indicative of the kind of anger that many of the teens felt. Quiet, helpless anger is one of the personality attributes that seemed common among the group members. Other members identified with the anger in this drawing.

Genograms were a valuable addition to the group art experiences. The group members learned from the genograms that obesity was a family matter. They were able to uncover the extent to which obesity existed in their family backgrounds.

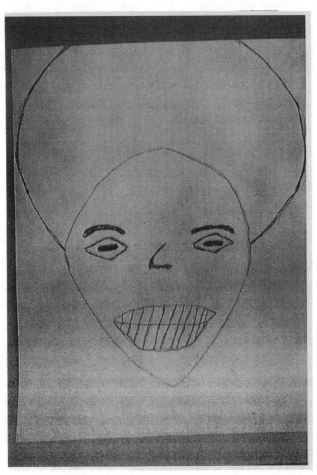

Figure 6.6. A free drawing by an African American male expresses hidden anger

Clay

Plasticine and clay were useful in helping teens create self-symbols. One exercise that was particularly conducive in uncovering issues of low self-esteem was to mold a symbol of where they were at the moment and then where they hoped to be at the end of the group. One African American girl identified herself as the blue ball, which she identified as a very unattractive form (see Figure 6.7). She wanted to be more of a bright, smiling figure, which was the yellow clay. Most of the participants involved in the making of plasticine symbols saw themselves as blue and wanted to see themselves as yellow. They all agreed that a great deal of sadness was associated with their weight problems. All wanted to be optimistic about losing weight and to believe that weight loss would make them happier people.

Group Art Experiences

Using a cardboard box as the basis of a group symbol was a successful part of several of the group modules. The box shape provided structure which helped the group define itself and to discuss the purpose of the group. One group spent several sessions decorating both the inside and outside of their box (see Figure 6.8). One African American male became attached to the box and was protective of what was placed on and inside it. The teens spent hours decorating the outside of the box and on the inside of the box they sort of put a token of their contribution to the group.

Art about the Group

At the end of each group module the members were asked to draw or make something about their experience in the group. During the first module the group began calling themselves the Adolescent Wellness Group or AWG. Two members of the AWG drew symbols of growth to represent their feelings about the group experience. One saw the group as a flower and wrote all the group members' names on the leaves and the names of the leaders in the flower petals (see Figure 6.9). He stated that the group grew together and learned to support one another. Another participant saw the group as an apple tree and wished that all would have success in losing weight and becoming happy (see Figure 6.10).

*Figure 6.7. The blue ball represents an African American female's feelings of
unattractiveness and the yellow face is how she would like to feel*

*Figure 6.8. Group art projects elicited members' feelings regarding what they brought
to the group experience*

Figure 6.9. An African American male saw the group as a flower and wrote each member's name on the leaves on petals

Figure 6.10. An African American female saw the group as an apple tree and stated that this was a symbol of growth for the group

Work with Family Members

When possible, sessions were held with a parent. In a session with a mother and daughter, each was asked to describe what they wanted or hoped for from the other. The mother wanted her daughter to accept herself for who she was but, at the same time, wanted to teach her daughter the benefits of exercising more and taking more control over her life and over her weight. She wanted her daughter to be able to enjoy being with friends and mainly to just feel good about herself (see Figure 6.11). The daughter wanted her mother to support her, to give her encouragement and to support her need to exercise (see Figure 6.12). Opportunities to work with the parents were limited. When sessions with parents occurred, it was evident that they felt much guilt regarding the weight problems of their teens.

Figure 6.11. A mother's wish list for her daughter

Figure 6.12. The daughter wished for support and encouragement from her mother and needed help to stay on an exercise regimen

Summary

The artwork completed in the group underscored the concerns and issues which were outlined by the literature. Sadness and shame about weight and body image were evident in the art. A collective, damaged sense of self was made evident through non-verbal expressions. The art illuminated the anger that many felt but were unable to verbalize. The art also communicated their need for community and for support. Through the art, the members were able to give voice to their identity and their strengths. The art allowed some group members the opportunity to express their racial identity and, for group members of different races, provided the opportunity to find a common place for understanding and friendship.

Preliminary Data from the Pilot Program

We evaluated the teens in five areas: weight, height, level of depression, measure of self-esteem and body image. Although we worked with 16 teens, data was not gathered on all the group members. Even though there is

missing information, the data was reflective of the research findings in the literature.

When discussing obesity, both weight and height are necessary for an accurate obesity assessment. Height is especially important when you are working with teens who are probably still growing. Weight compared to height is the standard measure of obesity in the United States. Much of the literature noted that weight compared to height is a Caucasian measure and some authors are suggesting that there may be more suitable measures for minority cultures in the United States (Dawson 1988). From Table 6.2 it is easy to see the weight to height ratio. Most of the teens in the group were in the 85th percentile of weight for their age and for their height, except for the last two in the table, patient N2 and patient D2. N2 and D2 were two African American girls who were short in stature. Their concern was not only their weight but that they felt unattractive because they were small in stature.

Table 6.2. Preliminary Data

Patient	Weight (lbs)	Height	CDI*	RSE**
M2.	198.8	5'6"	8	29
L2.	251.4	5'4"	7	28
C.			7	29.5
T3.			4	34
D1.	250.0	5'3½'	32	18
O.	206.8	5'6½"	16	26
J.	207.6	5'6"	21	18
B.	225.6	5'6¼"	6	29
N2.	137.6	4'10"	10	38
D2.	132.2	5'	6	38

*Children's Depression Inventory
**Rosenberg Self-Esteem Scale

The Children's Depression Inventory (CDI) (Kovacs 1982) was used to measure levels of depression. There was only one patient who was clinically depressed, D1, a white female. Clinical depression was not a major concern for the teens in this sample. The depression scores from this sample of obese teens may parallel the findings of the literature regarding African Americans. Since most of the teens were African American, their weight did not make them feel out of place with others and therefore they were not as negatively impacted by their obesity as others may have been.

However, the group members talked about depression, sadness and the dejection experienced from being shunned by peers at school. Therefore, when working with eating disordered teens, especially African Americans who may not score in the clinical range of depression, sadness and despondency should still be addressed.

The Rosenberg Self-Esteem Scale (RSE) (Rosenberg 1979) is based on a scale from 10 to 40 (higher scores indicating higher self-esteem). Again, the African American teens in our sample did not suffer from self-concept deficits. Only two teens, D1 and J, had scores which indicated problems in this area and both were Caucasian females. Again, the scores reflect the research findings. The self-esteem of females is more negatively impacted by weight problems and Caucasians are more self-conscious and self-derogatory about being overweight than African Americans.

We also wanted to measure the teens' sense of their bodies. The Body Image Self-Report (BISR) was used to evaluate body satisfaction. Teens were asked to color parts of their body that they disliked and parts of their body which pleased them. Figure 6.13 is an example of the BISR completed by M2, an African American male. M2 was dissatisfied with his abdomen but liked his hair, hands and feet. In comparison, L2, a Caucasian female, found most of her body distasteful except her face, hands and feet (See Figure 6.14). The relative body-image problems found when comparing these two teens again mirrors the differences found in the literature between the body-image problems of males and females who are obese (females are usually much less satisfied with their bodies than males).

Recommendations

The treatment model which we developed had two components: (1) a psychoeducational component on weight, nutrition, food choice, counting fat grams and calories and ideal weight calculations, and (2) the art therapy component which focused on developing a supportive peer group for the teens and on assisting the teens with the psychological and emotional issues associated with obesity. In general, we found this model to be useful and helpful for the teens. However, the psychoeducational component is based primarily on a medical model and can be seen as punitive by some teens. It was our observation that the group members received more from sharing personal experiences and learning from each other than from providing a nutrition curriculum. The teens were more than aware of the consequences of

Figure 6.14. A white female perceived almost her entire body as dissatisfactory

Figure 6.13. The body image of an African American male. He designated the abdomen area as the part of his body with which he was dissatisfied

overeating and when eating issues were discussed by the teens themselves, they were more attentive and involved in discussion.

The art was very helpful to the teens and we suggest that art therapy be a part of any nutrition group for minority teens. The art helped the teens to uncover difficult emotions and situations. Through the art the teens were able to understand their own perceptions of their bodies and themselves. At times, the newly acquired personal perceptions were shared and discussed with the entire group. It was helpful to have groups with both African American and Caucasian teens. Having a diversity of membership enriched the group and helped teens who would not normally socialize together find commonalities and gain respect for each other. The short-term nature of the group was useful for teens with busy schedules. However, more time was needed for the teens to see the gains that could be made in terms of weight loss and improvements with self-esteem.

The group was held in a medical clinic. Some of the teens were medically fragile and we felt secure to be near a medical team. We recommend that art therapy groups with obese teens be held in a medical setting if some members have acute or delicate health problems.

All three group leaders were Caucasian females, yet many of the members were African American. We were aware of the racial imbalance in the leadership triad and realized that the members were cognizant of this fact also. Although the group was successful with therapists who were homogeneous, diversity of leadership is advocated.

Conclusion

The impact of the groups presented here was limited in terms of helping teens lose weight. However, the group increased the teens' awareness in five areas: (1) learning about their bodies, (2) understanding body perception, (3) realizing how their bodies influenced how they felt about themselves, (4) comprehending the needs of others who have similar weight concerns and (5) appreciating the similarities and differences of members from other minority groups. For future groups, more data must be kept regarding changes in weight and body image. More information regarding race, ethnicity and gender among group members would better help therapists serve the needs of the group. Differences in the self-esteem needs of obese females, especially white teens, is needed because they have the most difficulties with positive self-perception. Finally, the art therapy and

nutrition group was a unique avenue for helping both minority and white obese teens find a way to cope with their weight concerns.

References

Burke, G.L., Savage, P.J., Manolio, T.A., Sprafka, J.M., Wagenknecht, L.E., Sidney, S., Perkins, L.L., Liu, K. and Jacobs, D.R. (1992) 'Correlates of obesity in young black and white women: The CARDIA study.' *American Journal of Public Health 82*, 12, 1621–1625.

Carpenter, L. and Bartley, M. (1994) 'Fat, female, and poor.' *The Lancet 344*, (8939/40), 1715–1716.

Croft, J.B., Strogatz, D.S., James, S.A., Keenan, N.L., Ammerman, A.S., Malarcher, A.M. and Haines, D.S. (1992) 'Socioeconomic behavioral correlates of body mass index in black adults: The Pitt County study.' *American Journal of Public Health, 82(6)*, 821–826.

Dawson, D.A. (1988) 'Ethnic differences in female overweight: Data from the 1985 National Health Interview Survey.' *American Journal of Public Health 78*, 10, 1326–1329.

Desmond, S.M., Price, J.H., Hallinan, C. and Smith, D. (1989) 'Black and white adolescents' perceptions of their weight.' *Journal of School Health 59*, 8, 353–358.

Fitzgibbon, M.L., Stolley, M.R. and Kirschenbaum, D.S. (1995) 'An obesity prevention pilot program for African-American mothers and daughters.' *Journal of Nutrition Education 27*, 2, 93–99.

Fowler, B.A. (1989) 'The relationship of body image perception and weight status to recent change in weight status of the adolescent female.' *Adolescence 24*, 95, 557–568.

French, S.A., Story, M. and Perry, C.L. (1995) 'Self-esteem and obesity in children and adolescents: A literature review.' *Obesity Research 3*, 5, 479–490.

Garn, S.M. (1994) 'Obesity in black and white mothers and daughters.' *American Journal of Public Health 84*, 11, 1727–1728.

Gortmaker, A., Must, A., Perrin, J.M., Sobol, A.M. and Dietz, W.H. (1993) 'Social and economic consequences of overweight in adolescence and young adulthood.' *New England Journal of Medicine 329*, 1008–1012.

Gortmaker, S.L., Dietz, W.H., Sobol, A.M. and Wehler, C.A. (1987) 'Increasing pediatric obesity in the U.S.' *American Journal of Diseases of Children 103*, 1068–1072.

Greeno, C.G. and Wing, R.R. (1994) 'Stress-induced eating.' *Psychological Bulletin 115*, 3, 444–464.

Harris, M.B., Walters, L.C. and Waschull, S. (1991) 'Gender and ethnic differences in obesity-related behaviors and attitudes in a college sample.' *Journal of Applied Social Psychology 21*, 1545–1566.

Jackson, M.Y. (1993) 'Height, weight, and body mass index of American Indian schoolchildren, 1990–1991.' *Journal of the American Dietetic Association 93*, 10, 1136–1141.

Jasper, C.R. and Klassen, M.L. (1990) 'Perceptions of salespersons: Appearance and evaluation of job performance.' *Perceptual and Motor Skills 71*, 563–566.

Kahn, H.S., Williamson, M.S. and Stevens, J.A. (1991) 'Race and weight change in US women: The roles of socioeconomic and marital status.' *American Journal of Public Health 81*, 3, 319–323.

Kovacs, M. (1982) *A Self-rated Depression Scale for School-aged Children.* Unpublished manuscript, University of Pittsburgh.

Kumanyika, S.K. (1993) 'Special issues regarding obesity in minority populations.' *Annals of Internal Medicine 119*, (7, Pt.2), 650.

Kumanyika, S., Wilson, J.F. and Guilford-Davenport, M. (1993) 'Weight-related attitudes and behaviors of black women.' *Journal of American Dietetic Association 93*, 4, 416–423.

Li, X. (1995) 'A study of intelligence and personality in children with simple obesity.' *International Journal of Obesity and Related Metabolic Disorders 19*, 5, 355–357.

Manus, H.E. and Killeen, M.R. (1995) 'Maintenance of self-esteem by obese children.' *Journal of Child and Adolescent Psychiatric Nursing 8*, 1, 17–27.

Mellin, L. (1993) 'Combating childhood obesity.' *Journal of the American Dietetic Association 3*, (March), 265–267.

Morrison, J.A., Payne, G., Barton, B.A., Khoury, P.A. and Crawford, P. (1994) 'Mother-daughter correlations of obesity and cardiovascular disease risk factors in black and white households: The NHBLBI growth and health study.' *American Journal of Public Health 84*, 11, 1761–1767.

Mueller, C., Field, T., Yando, R., Harding, J., Gonzalez, K.P., Lasko, D. and Bendell, K. (1995) 'Under-eating and over-eating concerns among adolescents.' *Journal of Child Psychology and Psychiatry and Allied Disciplines 36*, 6, 1019–1025.

Najjar, M.F. and Kuczmarski, R.J. (1989) 'Anthropometric data and prevalence of overweight for Hispanics: 1982084.' *Vital Health Statistics 11*, 239.

Newell, G.K., Hammig, C.L., Jurich, A.P. and Johnson, D.E. (1990) *Adolescence 25*, 97, 117–130.

Pratt, C.A. (1994) 'Adolescent obesity: A call for multivariate longitudinal research on African-American youth.' *Journal of Nutrition Education 26*, 2, 107–109.

Rhodes, S.K., Shimoda, K.C., Waid, L.R., O'Neil, P.M., Oexmann, M.J., Collop, N.A. and Willi, S.M. (1995) 'Neurocognitive deficits in morbidly obese children with obstructive sleep apnea.' *Journal of Pediatrics 127*, 5, 741–744.

Rosenberg, M. (1979) *Conceiving the Self.* New York: Basic Books.

Sackor, A.M. (1994) '"Healthy" or "fat"?' *RN*, December, 40–42.

Troiano, R.P., Flegal, K.M., Kuczmarski, P.H., Campbell, S.M. and Johnson, C.L. (1995) 'Overweight prevalence and trends for children and adolescents.' *Archives of Pediatric and Adolescent Medicine 140*, 10, 1085–1091.

The Use of Art Therapy in Identity Formation
A Latino Case Study

Marie K. Mauro

Abstract

Adolescence is a time for integrating and solidifying identity. Culture plays a key role in developing a cohesive sense of self. It is this researcher's opinion that this conflict can be intensified in minority populations due to living in a Eurocentric society. This chapter explores the role of art therapy in regards to identity formation. In addition, this chapter examines the role of art therapy in assisting adolescent psychiatric inpatients to integrate and formulate their cultural identity. The subjects consist of several categories, including foreign, first generation, bi-racial and adolescents who are bi-racial who were adopted into a family differing from their ethnic background. Six, one-hour art tasks were completed by the subjects. These include: Landgarten Photo Collage Assessment, a family portrait, a self-portrait, a coat of arms, a mandala and a termination folder. This chapter demonstrates the use of art therapy and focuses on the increased need for understanding and incorporating culture into psychiatric adolescent treatment.

'Culture is the collective expression of the group's personality – its wishes, values, and ideology. It is the sum total knowledge and attitudes, a vast accumulation of ways of thought, of action, and of emotional expression' (Tseng and McDermott in Cattaneo 1994, p.184). Cross-cultural research has determined that culture creates a framework of reality from which members function (Kagawa-Singer and Chung 1994). Religion, race and nationality influence how people interact in relationships (Chiu 1994). Thus a patient's environmental, social and political cultural background affects the nature of interaction within mental health professions.

Assessments, intervention and programming of services have been developed to serve the white American middle class, hence procuring a 'cultural blindness' (Pinderhughes 1989). This is a form of institutionalized racism and can result in lowered self-esteem among minorities (Martinez and Dukes 1991). Pedersen (1991) identified multiculturalism as the 'fourth force' of psychology, complementing psychodynamic, behavioral and humanistic views of human behavior. This position conceptualizes a means to recognize diversity and, at the same time, binds culturally diverse persons together. In order to validate the client's cultural identity, the service provider must understand variations within cultures and how cultures fluctuate and develop. The services must be structured in a way that allows clients to participate at their level of acculturation or assimilation in order to enhance the clients' chosen cultural identity (Pinderhughes 1989).

Culture affects the manner in which a person perceives biological changes and psychological factors, thus influencing the way a person acts out their mental illness and responds to treatment (Chiu 1994; Furnham and Malik 1994). For example, Hispanic families tend to attribute psychiatric illness to physical deficiencies such as general body weakness or weakness of the mind (Chiu 1994).

The need for training culturally sensitive counselors is now acknowledged by the American Psychological Association and American Association for Counseling and Development. However, many psychology programs are reluctant to alter their curriculums. Cultural influences affecting personality, identity and behavioral manifestations are frequently not addressed in the training of counselors (Atkinson, Morten and Sue 1993). In 1988 a task force was established by the American Psychological Association which was intended to increase awareness of the needs and services associated with ethnic and cultural diversity. In addition, the American Psychiatric Association acknowledges that the DSM-III-R is based on Western populations. It advises clinicians to utilize it in a way that is sensitive to differences in language, values and behavioral norms in non-Western cultures (Haghighat 1994).

Culture contributes to a person's sense of self and assists in developing cohesive psychological integrity. According to Erikson (1968), one of the keys to a healthy self-esteem is a cultural sense of self. 'A focus on cultural identity offers an opportunity for clients to strengthen a positive sense of self and thus to enhance integration' (Pinderhughes 1989, p.18). 'An optimal sense of identity, on the other hand, is experiences merely as a sense of

psychosocial well-being. Its most obvious indications are a feeling of being at home in one's body, a sense of "knowing where one is going," and "an inner assuredness of anticipated recognition from those who count"' (Erikson 1968, p.165).

Erikson identified that the adolescent phase of life is when the individual searches for, and attempts to resolve, conflicts regarding identity formation. He proposed that identity formation included the presence or absence of a crisis and then the presence or absence of a commitment to values, beliefs and standards. A limitation in this theory is that he based the paradigm on white, mainstream society. Some non-white ethnic groups differ from the mainstream by the manner in which identity formation is socialized. Anthropologists and sociologists who primarily work with Asian, African American and Hispanic populations have a greater propensity to define maturity in terms of familialism, norms of interdependence and obligation. Psychologists who study predominantly white middle class will define maturity as individuality, autonomy and independence (Markstrom-Adams and Adams 1995). Furthermore, the family greatly influences and affects the individualism of Hispanic patients (Moreno and Wadeson 1986). The concept of who one is, or identifies as, is partially defined by societal and cultural norms. A person's identity is affected by these external attitudes whether or not the individual fits into the norms (Weiser 1994).

Atkinson, Morten and Sue (1993) developed a five-stage Minority Identity Development (MID) Model. The model (Table 7.1) represents a schema to help counselors understand minority clients' attitudes and behaviors. Atkinson et al. suggest that not all minority individuals experience all five stages within a lifetime, nor must individuals progress sequentially within the stages. The MID model is 'intended to sensitize counselors to (1) the role oppression plays in minority individual's identity development, (2) the differences that can exist between members of the same minority group, and (3) the potential that each individual minority person has for changing his/her sense of identity' (p.33).

Table 7.1. Summary of Minority Identity Development Model

Stages of MID	Attitudes towards:			
	Self	Others of the Same Minority	Others of Different Minority	Dominant Group
Stage 1 Conformity	Self depreciating	Group depreciating	Discriminatory	Group appreciating
Stage 2 Dissonance	Conflict between self depreciating and group appreciating	Conflict between group depreciating and group appreciating	Conflict between dominant held views of minority hierarchy and feelings of shared experience	Conflict between group appreciating and group depreciating
Stage 3 Resistance and Immersion	Self appreciating	Group appreciating	Conflict between feelings of empathy for other minority experiences and feelings of cultrocentrism	Group depreciating
Stage 4 Introspection	Concern with basis of self appreciating	Concern with nature of unequivocal appreciation	Concern with ethnocentric basis for judging others	Concern with the basis of group depreciation
Stage 5 Synergetic Articulation and Awareness	Self appreciating	Group appreciating	Group appreciating	Selective appreciation

Source: Atkinson, Morten and Sue (1993)

Cattaneo (1994) states that in order to understand the relevance of a patient's style of thinking, beliefs and issues, the researcher must know how his or her own values, cultural background, and attitudes can effect constructive therapeutic intervention. Negative, confused and ambivalent attitudes and feelings can occur as a result of experiences relating to cultural differences (Pinderhughes 1989). Level of ethnic identity and acculturation, family dynamics, sex-role socialization, religious and spiritual influences, and immigration experiences are variables that might be examined in culturally sensitive counselling (Lee 1991). The client who perceives him or herself as different from the therapist is likely to be concerned about whether the therapist is of goodwill and is trustworthy, has expertise and is competent, and is credible as having sufficient understanding of the client's social reality (Davis and Proctor 1989).

Culture determines what the client considers as the problem, who they request for assistance and how the problem is presented (Pinderhughes 1989). Cultural barriers hinder the therapeutic process and can lead to early termination and misdiagnosis. Barriers in cross-cultural therapy include language, gender issues, neglect of the patient's support system, incorrect assessment of the client and dependency on linear thinking (Westrich, 1994). Language often creates a barrier, preventing the patient and therapist from understanding each other; the client may lack the verbal skills needed to benefit from verbal therapy, especially when the therapist relies on complex cognitive concepts to generate insight (Atkinson *et al.* 1993).

As indicated by Kerwin *et al.* (1993), bi-racial individuals do not seem to perceive themselves as marginal in either culture. However, according to Winn and Priest (1993), bi-racial children are often torn between selecting one parent's racial identity over the other's. Many bi-racial individuals who enter therapy present with problems related to diminished self-esteem, social isolation, depression and poor social skills. Racial identity is one of the major components which should be addressed in increasing self-knowledge (Winn and Priest 1993).

The Latino population is the second largest minority group in the United States. Individuals vary greatly in acculturation level and, hence, encounter different types of conflicts. Conflicts may include guilt regarding being unable to be a full-time mother, disloyalty to family by moving away and unresolved feelings of inferiority (Lee 1991). Religion and spirituality are deeply rooted into the culture and influence the beliefs and practices of mental health. For example, illness may be caused by one's behavior and/or

can be attributed to an environmental condition such as bad air or extremes in weather (Sue, Ivey and Pedersen 1996). Culturally, linguistically and socially appropriate interventions are of primary importance (Lee 1991).

Art de-emphasizes the verbal role of communication and provides an alternate mode of treatment (Burt 1993). McNiff (as cited in Westrich 1994) stated that art therapy has a 'unique potential to construct a cross-cultural theory of psychotherapy based on universal properties of the creative process ... because common qualities consistently present themselves in imagery and in the process of making art' (p.188). Regardless of race, age or nationality, all people can create.

Artistic expression can be influenced by cultural differences. Cultural attitudes are interwoven through the expressions of art and its inherent meaning (Cattaneo 1994). Through visual expression, people communicate who they are, how they feel and how they identify with their specific culture. It is important to acknowledge that the diagnostic portion of the art can only be measured in the context from which it originated (Campanelli 1991). For example, a Mexican American might draw a heavy outline around figures and a Japanese person might use negative space, leaving the surface unpainted. Both of these examples are part of the art tradition in their respective cultures.

Viewing self-created images can elicit metaphors and lead to seeing various aspects of the situation or person (Riley 1994). Research by Tibbetts and Stone (1990) found that short-term art therapy was significantly effective in increasing positive changes with socially emotionally disturbed adolescents. The research indicated that art therapy appeared to strengthen a sense of identity within the subjects and hence provided the subjects with a more realistic and less defensive view of self and environment.

According to Kwiatkowska (1978), family portraits assist in clarification and understanding of roles, relationships and interaction within the family. Families create 'truths' from which the members operate. These 'truths' are altered slightly as each generation is challenged with conflicting messages of society (Riley 1994). As culture influences the role of the family, it is important to acknowledge and examine the reality in which the client resides. Family dynamics may influence the manner in which the clients view and respond to treatment. For example, it is common for a Hispanic individual to first seek out the assistance of a family member when faced with a problem, while turning to mental health professionals only in extreme circumstances (Moreno and Wadeson 1986).

Case of Megan

Megan was a sixteen-year-old Panamanian female who appeared her stated age. She was referred to the inpatient psychiatric unit for violent behavior. She had a history of alcohol abuse from age twelve to fourteen while in Panama. Prior to admission, Megan drank fourteen ounces of rum and cut off the head of a stuffed animal in lieu of cutting her wrists. Her sister reported that the patient was upset because a male she liked was not interested in her. Her legal guardian reported that Megan also had severe mood swings. She denied suicidal ideation during admission to the hospital.

Megan was the of youngest of four children. She was born in Panama and resided there with her biological mother and stepfather until age thirteen. The patient reported having experienced a history of emotional and physical abuse. She noted her mother worked nights and her stepfather was an alcoholic. The subject's stepfather made sexual advances on her when her mother was not home. Her mother sent Megan to the US to reside with her eldest sister and brother-in-law at the age of thirteen. At the time of admission, the patient resided with her eldest sister, aged 31, brother-in-law, aged 32 and sister, aged 20. Her eldest sister and brother-in-law had legal custody of her.

Megan attended eleventh grade in a public high school. She was primarily receiving grades of C's and D's at the time of admission. The year prior, she received A's, B's and C's. The patient had several good friends at school, both male and female. Her reported strengths were talking, dancing and drama. The subject was active in the drama club at school and did not attend other after school activities.

Megan reported accidentally setting a mattress on fire at age six. She said that at age fourteen she thought she was fat and purged after eating for a period of one month. She also stated having tried to cut her wrists and took 'a lot of Ibuprofen, but then I got too sick and couldn't take the whole bottle'. Megan attended group meetings at school once a week with a counselor.

This was Megan's first psychiatric hospitalization. She had no history of past hospitalizations or surgeries. Megan reported having asthma and contracted bronchitis in seventh grade.

Upon the initial meeting with Megan to present and review the research consent form, she appeared clean and dressed appropriately for the weather. Megan made appropriate eye contact and asked questions in a clear and concise manner. Her questions were goal-directed and she seemed to have no difficulty finding words in English to communicate effectively.

The patient appeared oriented to time, place, person and situation. Her affect was bright. However, she seemed apprehensive regarding her participation in the research. The subject requested time to think and review the consent form independently. Prior to agreeing to participate, Megan asked the researcher questions such as: 'What is your ethnic background?', 'How old are you?' and 'How long have you been working here?' She seemed to be gaining a sense for whether or not she could trust and/or identify with the researcher.

Session One

A magazine photo collage, developed by Helen Landgarten (1994), is an 'effective technique for attaining multicultural goals with ethnically diverse clients' (p.219). The art task can be used in the form of either treatment or assessment. The pictures chosen may elicit topics which would not normally be discussed and bridge the cultural gap within the session. Landgarten stated that the collage activity facilitated divulging of secrets with Asian populations and lessened communication barriers with Hispanic populations.

Megan approached the session willingly. She was able to follow directions and work independently without assistance. She was talkative and interacted with the researcher spontaneously while choosing pictures (Figure 1). The artist titled each of the photos in writing and related the picture to her life. She labeled the pictures: *Baptism, Isolation, Innocence, Success, Strength* and *Tradition*.

Megan identified most strongly with the picture entitled 'Isolation', stating: 'This is a lonely little girl who is scared, her eyes look sad'. She referred to life being difficult for her because she was an immigrant, she was not allowed to work, she had an accent, and people made fun of her. She referred to the photo labeled 'Tradition' identifying Spanish people as 'smacking kids around' because, she confided, her mum hit her to make her a better person. When reviewing the 'Baptism' picture, she stated she felt as if she was sinning because she did not go to church and she also said: 'because so many bad things have happened to me'.

When referring to the picture labeled 'Innocence', Megan stated: 'That's the one thing I lost'. She said that the picture representing 'Strength' was her ability to be in the hospital. She referred to 'Success' being: 'That's the one thing I would like to have in my life and I think sometimes I might get it, if I work hard enough'.

Figure 7.1. 'Photo Collage'

The session was filled with references to her life in Panama and issues regarding being a minority at school. She spoke in a fast-paced manner and was theatrical in presenting examples and feelings. At times she was tangential, returning to discussing her feelings regarding her ex-boyfriend. Megan spoke most strongly about not being seen for who she was 'on the inside'. She stated her peers at school see a Puerto Rican girl and stereotype her.

Session Two

According to Goldscheider (1937), in 2650 BC the earliest known self-portrait was created by Ptah-hotep near Sakkara. Since then, hundreds of self-portraits have been created by various artists. Rembrandt was especially known for his self-portraiture work throughout his life. Chapman (1990) wrote that Rembrandt's earliest self-portraits displayed his discovery or reflection of self-consciousness. Self-portraits have been used to assist persons in claiming existence and finding identity (Wadeson, Durkin and Perach 1989). Often times, early adolescents create self-like cartoon images

as a means to explore identity and self (Malchiodi 1990). Self-portraits can assist clients discover problem areas and explore adaptations to altered self concepts (Wadeson, Durkin and Perach 1989). In addition, according to Oaklander (1988), 'Body-image is an important aspect of self-acceptance' (p.284).

Megan engaged actively and was verbal. She spoke of family, friends and herself. She spoke about her stepfather touching her breasts and then referred to boys at school wanting her for physical reasons. Megan stated having wanted to cut off her breasts the night she was admitted but, instead, cut her stuffed animal's head off. She also focused on peers seeing only her 'outside', stating they don't see her for who she is. Megan said they see her as a 'Puerto Rican slut.'

When asked who she was, Megan focused on being a sad lonely girl, then went on to preserve her virtue. She focused on defending against a perceived stereotype and expressed her anger and frustration. Megan vented, speaking about how her boyfriend left her for another girl because she refused to become physically active with him. She spoke of her male relationships, explaining that she was unable to have emotionally intimate relationships and that her male peers only wanted to have a 'piece of my body'.

She invested much energy into creating her self-portrait. She initially drew her facial outline by measuring and eyeballing the dimensions. Megan then chose her desired skin tone and hair color. The paint she selected

Figure 7.2. 'Mirror Painting Self-Portrait'

matched her natural skin tone and hair color. She mixed a blue-black hair colour and spoke of wishing she had blonde hair. She acknowledged liking her hair but wanted the blonde hair because it was beautiful. When painting her body, she layered the paint by first drawing herself nude without female definition then painted clothes over the layer of skin (Figure 7.2). The final product depicted an olive-complexioned woman who wore a colourful, decorative costume.

Megan appeared ambivalent regarding sexual issues and defended against being stereotyped as a Puerto Rican slut. The layering of clothing over her body and wrists may have represented protection from others and, at the same time, disguised her scars of self-mutilation. In addition, the figure was incomplete from the waist down, which may indicate an avoidance of sexuality.

Session Three

According to Burns and Kaufman (1972), Kinetic-Family-Drawings (KFD) 'often reflects primary disturbances much more quickly and adequately than interviews or other probing techniques' (p.2). Feelings such as anger, depression, powerlessness, fearfulness and lack of trust are often present on the drawings (Wohl and Kaufman as cited in Malchiodi 1990).

Megan drew a picture of her family having a barbecue at her brother-in-law's parents' house (Figure 7.3). She included her relatives that resided in the United States but did not include her mother or stepfather. Megan placed herself next to her twenty-year-old sister and spoke of their relationship as one in which they talked and shared feelings. She focused on her relationship with her eldest sister, explaining the extent of the severity of their fighting. On three occasions, she stated, her eldest sister tried to physically strangulate her. She continued to speak about why her eldest sister resented her. She disclosed family dynamics, some of which were cultural and some dysfunctional.

Megan spoke about being fearful of being sent back to Panama. She appeared to be in the midst of splitting family dynamics (i.e. her eldest sister wanted to send her back to Panama and her brother-in-law wanted to keep her). She identified feeling bad and guilty about sharing family secrets but was adamant that she would not disclose and proceeded with whatever she needed to do in order to guarantee her future safety.

Figure 7.3. 'Family Portrait'

Session Four

During the end of the fifteenth century, crusaders across Europe designed their surcoats to illustrate their identity. This design, known as the coat of arms, was also displayed on the harness of their horses and their shields. The symbols used on the coat of arms varied widely and often included animals, plants and stars. The royal families were proud of their coat of arms and allowed no other to wear their emblem. The coat of arms did not only depict the individuals identity and family pride, it also illustrated where the knights came from (Horn 1983).

Megan engaged actively with the researcher, consistently making eye contact when not working on the art task (Figure 7.4). She identified pride in her family when speaking of her great, great grandmother who was an Indian princess. She explained that this ancestor had a lot of money and jewelry. She identified several self-pride items, including a first-place award for excellent Spanish skills, her ability to speak English and her eyes. She also stated her goal was to get a college diploma.

Figure 7.4. 'Coat of Arms'

Megan was able to identify many strengths, yet she appeared to have a hopeless attitude. At one point she stated: 'Honestly, I don't know if I'll make it to twenty-one'. She referred to her life being bad and teased that the women in her family were cursed. She disclosed that her family had a long history of women being raped and molested, in addition to property having been gambled away by men. She was unable to suggest ways to avoid future abusive relationships. She demonstrated pride in her artwork, as evidenced by her hanging the coat of arms in her room.

Session Five

According to Jung, a mandala is a representation of the self, the center point of our personality (Jung 1959; Fincher 1991). 'This center is not felt or thought of as the ego but, if one may express it, as the self' (Jung 1959, p.73). It represents the wholeness of the psyche, which includes both conscious and unconscious (Jung and von Franz 1964). In many cultures the mandala is often seen as a visual aid used to attain a desirable mental status (Jung and von Franz 1964). This circular symbol represented enlightenment and symbolized human perfection in the Zen sect. In Christian art it appeared as the halo of Christ and in non-Christian art as sun wheels. Europe, Africa, India and the South Pacific incorporated this circular form into creation myths. It was believed to have a healing effect when it occupies sacred space. 'The mandala invokes the influence of the Self, the underlying pattern of order and wholeness, the web of life that supports and sustains us. By making a mandala we create our own space, a place of protection, a focus for the concentration of our energies' (Fincher 1991, p.24). Spontaneous creation of color and form within a circle can elicit healing, self-discovery and personal growth (Fincher 1991).

Figure 7.5. 'Mandala'

Megan was quiet as she worked on her mandala and appeared to be in deep thought. She identified knowledge, people who love her, dreams, her future, faith and chastity as her strengths (Figure 7.5). Megan focused on chastity and explained that virginity was sacred in her culture.

The subject's change in behavior appeared to be the result of conflicting feelings she had regarding a male peer on the psychiatric unit. She spoke of a disagreement she had had with this peer the previous day and feared that he may be soon discharged. Megan appeared to have become quickly attached with this peer and seemed to be having feelings of loss regarding his impending discharge. Similar to being abandoned by her ex-boyfriend, Megan had to deal with yet another loss.

She did not disclose the reason for her feelings but did say she would have got drunk had she been home. She explained being unable to think when she was angry and described her behavior as being uncontrollable. She acknowledged having unsuccessful coping skills and avoided discussing healthy ways to cope without self-mutilation. Megan appeared feeling hopeless as she discounted her many strengths as being useful in helping her deal with her frustrations.

Figure 7.6. 'Termination Folder'

Session Six

According to Kwiatkowska (1978), the last picture of a series is not only useful in diagnostic value but also denotes a personal message. The termination folder provides a means of closure, it enables the subject to explore his or her fantasies. Naumburg (1973) wrote that spontaneous drawing can allow a client to create imaginative products which satisfy wishes in a hypothetical manner. During the last session, termination does not only review what has gone before but also sets the stage for a beginning (Wadeson *et al.* 1989).

Megan initially presented as being distracted and rescheduled the session for a later time that day. Upon meeting the second time, Megan made many incongruent excuses regarding her inability to meet for the final session (Figure 7.6). She attended the session after much coercion.

While making her folder, she spoke in a pressured flamboyant manner, tapping her feet, and shared being anxious about an impending family session. She also spoke about her fear and excitement regarding the next day's school pass. She made the folder quickly, without putting much effort into it, as she discussed her medical release. She used yarn to weave together two pieces of paper and painted large bright flowers on the folder. Upon completion, she acknowledged her initial unwillingness to meet because she would talk about her impending school pass and family meeting. She thanked the researcher for insisting that she proceed with the session.

Summary

Throughout the treatment Megan repeatedly touched on issues regarding identity and her cultural heritage. During the first session she focused on a photo of a mother and child, titled *Tradition*, and stated: 'It is the way we are brought up'. She identified the basketball player and child behind bars as Hispanic and spoke of feeling isolated as a result of being an immigrant and having a accent. During the second session she dealt with issues regarding being stereotyped as Puerto Rican. She spoke of not wanting to be sent back to Panama during the third session and spoke of her cultural heritage and pride during the fourth. Finally, she spoke of chastity and identified its virtue in relation to her culture.

Megan appeared to deal with issues of sexuality throughout the treatment. Prior to the hospitalization, she considered cutting off her breasts. During the early stages of treatment she repeatedly stated that her peers

viewed her as a 'Puerto Rican slut'. This may have emphasized and/or evoked memories of childhood abuse. She also seemed to focus on male peers wanting her only for her physical attributes, yet she appeared ambivalent – evidenced by her wanting her ex-boyfriend back. Towards the end of the treatment she identified chastity as a strength and no longer focused on the stereotype of being 'easy'.

Megan seemed to benefit greatly from the treatment. She was able to abstract and integrate culture into her daily life and her perception of life. Megan dealt with the concept of culture on many levels from being stereotyped to having pride of her heritage. According to the Minority Identity Development Model, Megan appeared to move from stage 2, 'Dissonance', to stage 3, 'Resistance and Immersion' (Atkinson *et al.*1993). She initially resented being an outsider. She disliked the manner in which her ancestors raised their children and despised the dominant white group for stereotyping her. Towards the end of treatment she incorporated cultural aspects of pride into her identity and chose to abandon shame issues. For example, she identified with chastity and opposed corporal punishment. Her artwork displayed several cultural images – such as Hispanic persons in the collage, her olive complexion and blue-black hair in the self-portrait and her Indian princess role model. In addition, her self-portrait displayed similarities between her and her ancestor, the Indian princess, drawn on the coat of arms. This alone demonstrated an identification with her heritage and ancestry.

Conclusion

The case demonstrates the use of art therapy and the exploration of culture in psychiatric treatment. As evidenced, art therapy can play a role in formulating cultural identity and development in individuals. It proved to be a useful tool as it provided a means to probe cultural issues. At the same time, it did not limit the exploration to only culture and identity.

Just as the significance of·a painting cannot be fully grasped without knowledge of its origins and resulting influences on later art, so identity formation during adolescence cannot be fully appreciated without knowledge of its childhood antecedents and consequent adult states (Kroger 1989). Working in a cross-cultural setting may require the researcher to educate him or herself in the belief systems, behavioral patterns and values of that particular minority group. A researcher should give special attention to how cultural differences influence the therapeutic relationship (Westrich

1994). 'When the researcher fails to comprehend differences in cultural patterns, the result is a recurrent incongruity between the researcher and client' (Kagawa-Singer and Chung 1994, p.200). Questions regarding predominant beliefs, values and norms should be asked, such as: 'What is the ideal self?', 'What is the means for gaining integrity or wholeness?' and 'What are the rules of interaction?' (Kagawa-Singer and Chung 1994).

'It is esteem and love for one's own cultural background and identity which form an important base for valuing the diversity in other peoples experience' (Cattaneo 1994, p.186). In order to not place inappropriate expectations upon patients, therapists must be aware of their own personal values. It is necessary for therapists to respect and acknowledge cultural differences and similarities. Misdiagnosis and therapeutic termination can occur when cultural barriers exist. By acknowledging differences, we respect and provide the individual with pride and esteem.

References

Atkinson, D., Morten, G. and Sue, D. (1993) *Counseling American Minorities: A Cross-cultural Perspective.* (4th ed). Dubuque, IA: Wm. C. Brown Communications.

Burns, R. and Kaufman, H. (1972) *Actions, Styles and Symbols in Kinetic Family Drawings (KFD).* New York: Brunner/Mazel.

Burt, H. (1993) 'Issues in art therapy with the culturally displaced American Indian youth.' *The Arts in Psychotherapy 20,* 143–151.

Campanelli, M. (1991) 'Art therapy and ethno-cultural issues.' *The American Journal of Art Therapy 30,* 34–35.

Cattaneo, M. (1994) 'Addressing culture and values in the training of art researchers.' *Art Therapy: Journal of the American Art Therapy Association 11,* 3, 184–186.

Chapman, H. (1990) *Rembrandt's Self-portraits.* Princeton, NJ: Princeton University Press.

Chiu, T. (1994) 'The unique challenges faced by psychiatrists and other mental health professionals working in a multicultural setting.' *The International Journal of Social Psychology 40,* 1, 61–74.

Davis, L. and Proctor, E. (1989) *Race, Gender and Class.* Englewood Cliffs, NJ: Prentice Hall.

Erikson, E. (1968) *Identity Youth and Crisis.* New York: W. W. Norton Company Inc.

Fincher, S. (1991) *Creating Mandalas.* Boston, MA: Shambhala Publications.

Furnham, A. and Malik, R. (1994) 'Cross-cultural beliefs about depression.' *The International Journal of Social Psychiatry 40,* 2, 106–123.

Goldscheider, L. (ed) (1937) *Five Hundred Self-portraits.* London: George Allen and Unwin Ltd.

Haghighat, R. (1994) 'Cultural sensitivity: ICD-10 versus DSM-III-R.' *The International Journal of Social Psychiatry 40,* 3, 189–193.

Horn, D. (1983) *The Crusades Arms and Armor: Story Hour.* Unpublished manuscript, Philadelphia Museum of Art, Philadelphia, PA.

Jung, C. (1959) *Mandala Symbolism* (R. F. C. Hull, Trans.). Princeton, NJ: Princeton University Press.

Jung, C. and von Franz, M. (1964) *Man and his Symbols.* New York: J. G. Ferguson.

Kagawa-Singer, M. and Chung, R. (1994) 'A paradigm for culturally based care in ethnic minority populations.' *Journal of Community Psychology 22,* 192–208.

Kerwin, C., Pontesotto, J., Jackson, B., and Harris, A. (1993) 'Racial identity in biracial children: a qualitative investigation. *Journal of Counseling Psychology 40,* 2, 221–231.

Kroger, J. (1989) *Identity in Adolescence: The Balance Between Self and Other.* New York: Routledge.

Kwiatkowska, H. (1978) *Family Therapy and Evaluation Through Art.* Springfield, IL: Charles C Thomas Publisher.

Landgarten, H. (1994) 'Magazine photo collage as a multicultural treatment and assessment technique.' *Art Therapy: Journal of the American Art Therapy Association 11,* 3, 218–219.

Lee, C.C. (1991) 'Cultural dynamics: their importance in multicultural counseling.' In C.C. Lee and B.E. Richardson (eds) *Multicultural Issues in Counseling: New Approaches to Diversity.* Alexandria, VA: American Association for Counseling and Development.

Malchiodi, C. (1990) *Breaking the Silence: Art Therapy with Children from Violent Homes.* New York: Brunner/Mazel.

Markstrom-Adams, C. and Adams, G. (1995) 'Gender, ethnic group, and grade differences in psychosocial functioning during middle adolescence.' *Journal of Youth and Adolescence 24,* 4, 397–417.

Martinez, R. and Dukes, R. (1991) 'Ethnic and gender differences in self-esteem.' *Youth and Society 22,* 3, 318–338.

Moreno, G. and Wadeson, H. (1986) 'Art therapy for acculturation problems of Hispanic clients.' *Art Therapy: Journal of the American Art Therapy Association 3,* 122–130.

Naumburg, M. (1973) *An Introduction to Art Therapy.* New York: Teachers College Press.

Oaklander, V. (1988) *Windows of our Children.* Highland, NY: The Gestalt Journal Press.

Pedersen, P. (1991) 'Multiculturalism as a generic approach to counseling.' *Journal of Counseling and Development 70,* 6–12.

Pinderhughes, E. (1989) *Understanding Race, Ethnicity, and Power: The Key to Efficacy in Clinical Practice.* New York: The Free Press.

Riley, S. (1994) *Integrative Approaches to Family Art Therapy.* Chicago, IL: Magnolia Street Publishers.

Sue, D., Ivey, A. and Pedersen, P. (1996) *A Theory of Multicultural Counseling and Therapy.* Pacific Grove, CA: Brooks/Cole Publishing Company.

Tibbetts, T. and Stone, B. (1990) 'Short-term art therapy with seriously emotionally disturbed adolescents.' *The Arts in Psychotherapy 17,* 139–146.

Wadeson, H., Durkin, J. and Perach, D. (1989) *Advances in Art Therapy.* New York: John Wiley and Sons, Inc.

Weiser, J. (1994) 'Being different: A theoretical perspective.' *Art Therapy: Journal of the American Art Therapy Association 11,* 3, 224–228.

Westrich, C. (1994) 'Art therapy with culturally different clients.' *Art Therapy: Journal of the American Art Therapy Association 11*, 3, 187–190.

Winn, N. and Priest, R. (1993) 'Counseling biracial children: A forgotten component of multicultural counseling.' *Family Therapy 20*, 1, 29–36.

Art Therapist's Countertransference
Working with Refugees who had Survived Organized Violence

Nicole Heusch

Abstract

This chapter explores various aspects of countertransference which did occur between an immigrant art therapist and refugees who survived traumatic events in their native country. The aftermath of trauma, culture shock and identity changes brought by patients to therapy may be overwhelming for therapists. In this context, the author examines the limitations of the concept of vicarious traumatization. Through case examples, she also describes the feelings of loss, helplessness and guilt she experienced and the nature of the art therapist's gratification drawn from this work. She will show how her post-session art helped improve her understanding of transference and her monitoring of countertransference reactions.

Countertransference is a topic often neglected in the literature, with the exception of a few authors such as Racker (1972), Slatker (1987) or Wilson and Lindy (1994). Wilson and Lindy (1994) described transference and countertransference as the mutual emotional impact between the patient and the therapist. During the course of therapy the patient exhibits affective states, behavioral tendencies or symbolic role relationships which may elicit memories, fantasies, creativity or acting out behaviors on the part of the therapist.

For years, it was assumed that therapists' emotional reactions to their patients' affective responses were detrimental to the progress of therapy and, therefore, should be repressed or controlled (Laplanche and Pontalis 1967; Reber 1985). However, during the past 10 years there has been an increasing number of articles written about this issue. This renewal of interest may originate from difficult experiences encountered by professionals in their work. Racker (1972) reconceptualized countertransference by acknow-

ledging the importance of addressing the therapists' affects throughout treatment in order to help the therapist understand the mental process of the patient and to facilitate the timing and the content of interpretation.

Clinicians involved in the treatment of patients with personality disorders described how these individuals caused them to frequently confront their own emotional limits and how developing awareness regarding countertransference reactions was crucial for maintaining a therapeutic relationship (Maltsberger and Buie 1974; Adler 1985; Putnam 1989). Later, therapists with expertise in dealing with traumatized individuals also identified some of their own responses to the expression of trauma as a major interference in successful treatment (van der Kolk 1994). Some of these emotional responses were numbing, dissociation, fascination, revulsion, blaming or a rescuing impulse.

In examining the feelings of hatred among psychiatric professionals, elicited by suicidal patients, Maltsberger and Buie (1974) have suggested that therapists protecting themselves from full awareness of their countertransference reactions can have a damaging effect on their patients. In order to prevent therapists' detrimental acting out against their clients, these authors recommended that professionals acknowledge, accept and put into perspective the entire range of their emotional reactions towards the patients.

In art therapy several unconscious exchanges between therapist and patient are non-verbal in nature. Transference can be expressed in the choice of material, the art process and the artwork content or style, thereby provoking the therapist's defences. The texture of clay or paint can bring about various intense emotions or behavioral responses in the patient and eventually raise the therapist's affective reactions, which may hamper or facilitate the unfolding therapeutic process. The product itself may have a variety of meanings which can bring about countertransference reactions. Some art therapists (Fish 1989; Kielo 1991) have demonstrated how therapists' own image making after sessions can help them clarify the dynamics of their countertransference responses and facilitate effective work.

Health professionals who provide services to refugees who have survived organized violence deal with two kinds of countertransference responses. Some of these responses concern the therapists' reactions raised by the story of trauma and their ability to contain patient's or their own aggressive feelings during sessions. Other reactions relate to cultural differences between the therapist and the immigrant patient, eliciting the issue of identity and its impact on communication throughout the therapy.

Countertransference and Trauma

In my work as a psychiatric nurse I had noted that health professionals often physically abused or manipulated patients without recognizing the sadistic component of their behavior. Nurses are particularly at risk for aggressive acting out with severely ill patients. Patients who resist or sabotage treatment are inevitably rejected by staff, who may retaliate by punishing or frustrating them throughout their stay. When a patient had a crisis and could not be calmed down without physical interventions, I was able to notice my own potential for violence. These observations have taught me about the caregiver's low tolerance threshold for therapeutic failure, especially when issues regarding the saviors role have not been resolved. Herman (1992) described how disempowering it can be for the patient when therapists defend themselves against their own helplessness by assuming the role of rescuer.

Caregivers who work with refugees soon become familiar with the notion of organized violence. Saralee Kane (1995) has elaborated on this concept:

> Organized violence is the purposeful and systematic use of terror and brutality to control individuals, groups, and communities. Through the use of overwhelming force, it causes fear and helplessness among its victims. Its methods include causing severe pain and suffering, killing, intimidating, threatening and in some cases destroying a community, ethnic group or political opposition. Governments usually direct military, police and political organizations to perform violence; or these groups may act independently in the persecution of specific individuals, groups and communities. Opposition groups may also terrorize and brutalize civilian populations in order to gain power by creating fear and social disorder. (p.5)

By disclosing their experienced background of organized violence, survivors often bring about intense affective reactions among those who listen to their stories. When I began to work with refugees I was concerned about my ability to cope with the horror stories, possible behavior problems or troubled attitudes these patients could bring into therapy. Wilson and Lindy (1994) explain how the client involves the therapist by focusing on particular dynamics of the trauma experience and by casting him or her into trauma-specific roles through the transference process. These role enactments may range from playing the helpful rescuer or supporter to endorsing the part of the hostile judge or the perpetrator. Likewise, these

negative responses may stem from a rupture of empathy when patients recount extremely stressful events, such as torture stories. Herman (1992) noted that 'trauma is contagious' (p.140). She defined traumatic countertransference as 'the entire range of the therapist's emotional reactions to the survivor and to the traumatic event' (p.141). After viewing and discussing the products made by their patients, art therapists also may be inclined to relive traumatic experiences belonging to their own past (Golub 1989).

Several authors who have written on therapists' responses to this population (Comas-Diaz and Padilla 1990; de Andrade 1994; Meier 1994; Watson 1994) have emphasized the risk of being victimized by patients and the possibility of vicarious traumatization. This concept refers to the detrimental effects traumatized clients may have on their caregivers by exposing them to an accumulation of shocking images of horror and suffering. Watson (1994) noted that therapists 'may notice disruptions in their psychological needs for safety, trust, control, intimacy and esteem' (p.116). Service providers who have been vicariously traumatized may feel burned out, helpless and doubtful about their competencies.

However, a few authors (Viñar and Viñar 1989; Herman 1992; Wilson and Lindy 1994) have mentioned that not only trauma survivors themselves but also therapists working with them may have aggressive responses within the therapeutic relationship. These clinicians indicated that continuous exposure to horror can trigger the therapist's sadistic feelings and elicit detrimental behavior towards the patient. Herman (1992) described different forms which identification with the perpetrator can take. Skepticism of the patient's story, minimization of the abuse, disgust, contempt, hate, voyeuristic excitement, fascination or sexual arousal can be experienced, confronting therapists with their own capacity for evil. This eliciting of therapist's sadistic drives can be terrifying for the clinician, who may feel his or her identity as a caring person is threatened.

Coming to Terms with Culture Differences

Although many clinicians initially feel attracted by the exotic nature of working with a multicultural population, it is not infrequent that they express preferences regarding one or more specific cultures. They may feel less empathic or even rejecting towards patients from backgrounds different from their own. Sometimes these reactions could relate to misunderstandings regarding the patient's culture or the therapist's lack of awareness concerning

his or her assumptions, values and biases. I remembered initially having maintained a sceptical attitude towards the therapeutic commitment of a young African woman because she avoided eye contact with me when I talked to her. I interpreted her attitude as a sign of distrust and refusal to disclose of herself until I questioned her and was informed that in her country it is disrespectful to look another person in the eye, especially if such a person has a socially valued position such as 'healer', teacher or lawyer.

When working with traumatized people seeking refugee status, the caregiver needs to be cognizant of the many problems confronting this population. Currently, Canada is becoming very selective regarding new immigrants, therefore tending to be more restrictive in granting refugee status. Thus many individuals who have survived organized violence in their country of origin arrive in Quebec not only having to find a means of financial support but also the skills to cope psychologically with traumatic events of the past and the uncertainty of the future. Moreover, pressure is exerted on the refugee, by the host society, to demonstrate linguistic capabilities in a very short period of time. Refugees pending immigration status are in the most critical position. They have to prepare for their hearing at the Immigration Commission, during which immigration agents examine their reasons for leaving their native country. According to their perception of the danger confronting the claimant, agents assess the relevance of their request for refugee status, relying on the Geneva Convention definition of refugee status. For the pending 'refugee', the preparation for the hearing is a very stressful time, requiring the recall of painful traumatic events while increasing the fear of being deported. The frequent postponing of the hearing and the potential or actual rejection of their refugee status claim can be devastating and result in retraumatization. Often, concerns about the uncertainty of the refugee's future outweigh other concerns in therapy sessions and may be expressed in the transference by distrust of the therapist and sometimes even leading to the abandonment of the treatment.

Therapeutic treatment modalities of the Western culture are not necessarily known, understood or accepted by newcomers. They may perceive therapy as another way to control them. It is not infrequent that refugee clients question their therapists about their possible connection with the immigration services, fearing that the disclosure of personal information within the sessions could be used against them at their hearings. Furthermore, a group therapy format may prevent some participants from expressing emotional concerns when they have previously experienced

repeated negation of their individuality in dictatorships or rigid communist societies. These political systems undermine individual expression and encourage denouncement among citizens, leading them to hide their feelings or constantly role play in daily life. Consequently, patients from these countries may lack social skills and may not easily achieve trusting relationships, a crucial element in the therapeutic process.

Refugees may experience the shock of relocation at a deeper level than other immigrants. For refugees, the decision to leave the country of origin is based on external constraints and they usually have no future in their native country. Most of them have a sense of failure regarding their past life and often lack confidence in their cultural values and customs, which no longer serve them in the context of the adopted society. The loss of perceptual reinforcements from their native background exposes them to culture shock, a kind of crisis consisting of a set of emotional reactions towards new cultural stimuli. In this state, process of anomie, an individual finds little or no meaning in his or her new environment and has difficulty understanding new and diverse experiences. Comas-Diaz and Jacobsen (1987) have described how this experience may threaten the individual's core identity and how it may bring about a heightened awareness of identity. Newcomers have to cope with two conflicting demands: first, they need a time of respite which allows them to work through their grievances and, second, they have to gather their strength and face the demands of daily life in order to maintain their survival.

Viñar and Viñar (1989) note that in the experience of exile, an individual may enhance his or her positive qualities and amplify personal faults. Adjusting to a new culture requires a reshaping of identity through simultaneously demolishing important aspects of the persona and constructing a new meaning of life which permits the person to overcome the disruption of narcissistic anchoring (self-grounding). Viñar and Viñar (1989) describe how the harmony existing between the person and her or his personage (i.e. the social image reflected by others) in the native country is suddenly broken in exile: 'He (the exiled person) loses the multiple mirror through which he created and nurtured his own image, his personage. In exile nobody knows him, nobody acknowledges him. The one I was does not exist anymore.' (p.79). Here the personage is more than a figure in display. It is embedded in a person's centre and is essential to self-esteem. Having experienced the painful feeling of inadequacy resulting from exile, I was easily able to sympathize with pending refugees who had the impression

of being in limbo. My empathic response was amplified by the fact that I was desperately looking for more hours of work in my profession. I had a sense of being discarded, causing me to question my stay in Quebec.

Art Therapy Session

The Clinical Setting

At the request of a community advocacy group for pending refugees, I provided art therapy sessions to 13 people. Most of their traumas dealt with persecution related to politics, religion or sexual orientation. The advocacy group considered art therapy an appropriate treatment because it allowed patients to express feelings they were unable to communicate verbally due to language limitations or their refusal to discuss events they sensed as re-traumatizing. The clients originated from a number of different continents, including Africa (Algeria, Ghana, Cameroon, Nigeria, Zaire, Morocco), Asia (Lebanon, Iran, India, Bangladesh, Tadjikistan) and South America (Colombia). The majority of participants had been in Quebec for less than a year.

Session Format

I worked with these persons as either a primary or an adjunctive therapist in collaboration with a medical doctor, a psychiatrist, a psychologist and a social worker, or both of them. Initially, the format consisted of weekly ninety-minute group sessions. Sessions took place in either English or French, depending on the cultural background of my clients. At times I had to work in both languages and act as a translator when the group had no single language in common.

Treatment Orientation

In response to the clients' condition, I fostered a supportive therapeutic environment as described by Yalom (1985). Therapeutic factors of this approach included instilling of hope, imparting information, interpersonal learning, developing socialization and universality. This latter factor allowed participants to gain validation of their own feelings through the sharing of similar concerns by other group members. This validation appeared to be crucial for torture survivors, who came to sessions with a deep sense of guilt and shame. Emphasis on their support system was another issue regularly

addressed. In order to reinforce group cohesiveness, I also favoured structured groups by assigning a specific theme or by using certain materials. Because of the group's heterogeneity of gender, age and culture, I usually waited until I felt a strong sense of belonging among participants before suggesting paired or group exercises. In keeping with the characteristics of my clients and their issues, I chose a semi-open group format, emphasizing the commitment to attend but also allowing gradual membership changes as people left and newcomers arrived. As Liebman (1986) noted: 'in this way the ethos is maintained, while allowing for a natural or an organized turnover' (p.22).

The strained living conditions of refugees in the receiving country often challenge the therapist's empathic support. However, I rarely experienced a sense of being overwhelmed, although certain sessions were quite intense. My relative serenity could be partially due to the small group size (a maximum of five persons per group), the limited number of hours (3 per week) I worked with refugees and the brief duration of the therapeutic relationships with individuals. This pace provided enough time for me to seek balance and nurturance elsewhere, which heightened my threshold tolerance of my patients' traumas. The way in which many clients addressed their personal histories (i.e. by suggesting the trauma through symbolic images and events occurring in their lives, instead of expressing it directly) could have been psychologically protective for both the patients and the therapist. Linguistic limitations combined with restricted body language or poor graphic expression may have jeopardized the sharing of information. My personal style of communication (i.e. intermittent use of humor) may have also interfered in the development of the transference/counter-transference relationship. humor can help alleviate tensions within a group. However, it can also distance and prevent patients from expressing emotions.

Review of the art therapy sessions provided substantial material regarding my countertransference reactions. In addition to charting the session, I also collected post-session material by jotting down notes, generally a few hours after the session. I commented on my emotional responses towards the clients' verbal communications, behavior and/or artwork, and completed my personal session record with one or more drawings. Factors indicative of countertransference consisted of physiological and/or physical responses, emotional and psychological reactions and behavioral signs. My reactions were often manifested in recurrent situations and provided insight about my

personal issues, which, in turn, enlightened me regarding my patients' concerns.

Loss and Attachment

Regardless of the impetus to immigrate, as soon as they decide to stay in a new country and start the process of acculturation immigrants undergo an unending succession of losses. In order to lessen the painful impact of these losses, immigrants sometimes try to resist acculturation by isolating themselves from the host society or by staying within a group of members of their native community and attempting to maintain similar cultural traits. However, they never totally succeed in reproducing their original lifestyle because of the change of surroundings. But, as the grounding process gradually progresses for those who accept the new culture, the cultural gains offered by the new society – such as peace, freedom, wealth, education and relationships – often compensate for their inevitable losses. If an immigrant has access to these gains and can integrate them into the values of his or her culture of origin, they can help enhance his or her self-confidence and world view.

Being an immigrant myself put me in a peculiar position. Throughout the therapeutic process, refugees often not only ascribed to me special competencies regarding their problems but also considered me an expert on the new country, for I projected for them an image of the cultural adjustment for which they were longing. This assumption may have stemmed from the patient's need for identification with the therapist (Comas-Diaz and Jacobsen 1987) in order to develop a better sense of self. Although this attribution of competence may be empowering for a therapist, it is an unfounded projection. Compared to a pending refugee, I had capitalized on privileged settlement conditions upon my arrival in Quebec. As a European with Western cultural references and fluent command of the language in Quebec, I had not experienced a dramatic cultural shift when I was first exposed to North American customs. Through a rapid integration into the work market, I easily developed social skills which helped me feel more comfortable in this culture. Moreover, I did not feel threatened by assimilation as some of my abilities related to my culture of origin were seen as assets in the host society. This acknowledgment encouraged me to maintain original cultural traits and gave me a certain pride in my native identity, which is often missing among the refugee population. Notwithstanding, like any newcomer I would not have been able to

accomplish acculturation without going through the mourning process of losing certain illusions regarding my new social environment, forgetting or abandoning some of my habits, altering my native tongue and modifying some of my beliefs.

Most of my patients made limited cultural gains because of the uncertainty about their staying in the country and the restrictions of their rights. They often grieved their culture and their country in their artwork (Figure 8.1), although they expressed a desire to forget them or reject them totally. While examining what kind of relationship refugees had with their roots, I realized that I tended to identify clients through their country of origin, talking about them as 'the Iranian lady', 'the Ghanaian man', etc. Although I used this identification in order to protect confidentiality, eventually I noticed that my labeling could also be seen as defensive in limiting my perception of this person to his or her cultural background (or, rather, my own construction about his or her native culture). I was inclined to consider the person's name or country as a reference to his or her past and, as such, as valuable, because I myself derived several benefits from being a French European in Quebec. As treatment unfolded, I had to acknowledge the vast distance between the person and my folklorish representation of patients and how my attitude served me in defending myself from facing their complex uniqueness. Distancing myself from the specificity of my clients demanded less energy than constantly reassessing their needs.

Issues of attachment and loss are often raised during the termination process. When a patient is deeply invested in art making, producing expressive artworks, and then decides to destroy his or her whole production, the art therapist may experience many countertransference reactions. Aram (pseudonym) was 32 years old when he came to art therapy. He was a gay man from Lebanon with an Armenian background and had arrived in Quebec as a pending refugee. During the Lebanese war he had joined the military of General Aoun on the side of the Christians. Just before the end of the conflict he had been kidnapped by the Syrian military, tortured and raped for two weeks and then released after his parents had paid a ransom. When I met him he suffered from chronic post-traumatic stress symptoms and was experiencing significant identity crisis regarding his native background. He felt betrayed by Lebanese Christians and he rejected the Armenian community. He felt the latter were indirectly responsible for his victimization because they had not been able to prevent his torture or that of his grandparents, who had fled the slaughter of Armenians in Turkey in 1915.

Figure 8.1. Aram: 'Thanking God'

He engaged very easily in art therapy, directly addressing the trauma and the pain which were powerfully depicted in his artworks (Figure 8.2).

His last piece was about his current support system (Figure 8.3), although this work included many elements of suffering. The patient portrayed himself as the cross in the center and, instead of writing 'pray' (for praying), wrote 'prey' (as a hunted animal) above the cross. On the right he drew a green cross which symbolized the various persons who had helped him in this country. I was pleased by this work and considered it an optimistic conclusion to therapy, but, at the last session, Aram insisted on destroying his whole production because, he said, his artworks would bring back bad and painful memories and he wanted to get rid of them. Although I felt uncomfortable with this decision and tried to offer other options, I complied and let him tear up what he had made, with the exception of the last piece. I asked him if he could wait until I had taken a picture of it. He agreed to my request, provided I promised to destroy the drawing after. However, once I took the photograph, I 'forgot' my promise, finding a number of pretexts to avoid destroying the piece. Six months later, Aram phoned to tell me he had been granted refugee status in Canada. After congratulating him, I asked him

Figure 8.2. Aram: 'What is Happening in My Brain'

Figure 8.3. Aram: 'My Support System'

again what I should do with his piece, hoping he would have changed his mind since he felt better and seemed to see his life more positively. But Aram confirmed his initial decision, explaining to me that this work was too fraught with pain and that he never wanted to see it again. With reluctance, I finally complied with his decision and destroyed the piece.

The numerous situations which facilitated acting out by the therapist in this story taught me about one type of countertransference resistance encountered in art therapy. In order to protect myself against the risk of contamination, I had denied, or at least minimized, the painful content of Aram's artwork. Moreover, my difficulty in destroying the last piece reflected my fear of narcissistic injury: I had felt very gratified by Aram's investment of art therapy. In destroying this picture I eliminated evidence of his investment and a positive transference, which had been reassuring for me as the therapist. I was not self-confident enough to carry out his decision, unconsciously viewing his wish to end treatment and to destroy his art therapy products as an invalidation of my competence. I also thought that perhaps he identified me with the perpetrator, since our work together had

raised painful feelings. Nevertheless, this time, in contrast with his torture experience, he had tried to free himself from the dependent and painful position of victim. Aram's phone call allowed me to release my feeling of guilt and helped me fulfill my promise.

Throughout therapy the constant interplay between transference and countertransference causes the therapist to take on different roles, in which he or she may feel more or less comfortable. The traumatized refugees I encountered expressed many projections of idealizations or fears regarding the therapist in their artwork. I was often seen as a nurturing mother (Figure 8.4) and, in other sessions, I felt as if I were perceived as the perpetrator. When this alternating image of myself occurred unpredictably, I had a sense of betraying my therapist's mandate of caring for my patients and I

Figure 8.4. Cantaloupe

experienced guilt. At this time I found drawing to be a precious resource to express and understand my emotional reactions to my patients' projections.

During a session with a group of three African patients who had all experienced torture or rape and who repeatedly expressed physical complaints such as headaches, eye pain and stomach aches, I suggested that they make a clay sculpture about their bodies. I was very troubled when all three participants delivered a piece related to maimed bodies or their personal experience of torture and detention. Annie (pseudonym) had made a little statue of a naked female on which she had made numerous poking marks. She explained that it represented her when she came out of the jail. She had been raped and had contracted scabies. She had wanted to add red spots on the marks but had not done so. She mentioned still having scars on her body related to this disease, which reminded her of the profound humiliation and shame she had experienced. I was baffled by the straight-forward style of this patient, who had expressed herself in a withdrawn or elusive manner in previous sessions.

Robert (pseudonym) modeled a little male-looking figure with a cut-off leg. He said this 'human being' reminded him of a cherished aunt who lived in Cameroon and who used to give him presents. He recalled that in Africa aunts are often considered as second mothers for children. This person was a dynamic business lady who had developed cancer and needed to have an amputation. After her operation Robert mentioned that her personality and abilities had changed and it was painful to recall this memory. Because the statue looked like a male, I thought that it seemed to represent a displacement from his torture experience to his aunt's suffering. But I also wondered if the contradiction between his words and his artwork reflected his transference – I had, perhaps, been aggressive with my proposal and he may have needed now to retaliate by representing me without a leg.

Tom (pseudonym) decided to make a miniature model of the house where he had been tortured, saying: 'it is because of that place I had to come to Canada'. Tom's statement and his work gave me the impression that he was unable to represent body or body parts at this time.

After the participants had explained the meaning of their pieces, Robert asked permission to destroy his piece and, eventually, Annie and Tom made the same request. I thought I could not refuse, even though it meant the loss of very significant artworks. However, before destroying his figure, Robert gave me a sketch of his work (Figure 8.5). I interpreted these responses as an indication that I had forced the participants to express something they would

Figure 8.5. Robert: 'My Aunt'

rather have kept to themselves or, at least, have disclosed at a time of their choosing. At the end of this session I felt fearful about my ability to deal with my clients' reactions. When I proposed they make sculptures about their bodies, I had not anticipated their producing works that related to their torture experiences. In retrospect, I realized that their responses should have been predictable to me, based on my knowledge of their backgrounds. I felt as if I had been the rapist. I could not tolerate the emotions that were aroused in me. I wanted the patients to be relieved from painful feelings but I had the impression my proposal had produced the opposite effect. I felt helpless and very guilty and tried to reassure them by telling them that they could call me during the week if they had any difficulty in relation to this session. Nevertheless, at this time, it was no longer clear who needed more comforting, the patients or the therapist.

After the session I sensed pervasive autonomous nervous system reactions: I felt cold chills down my spine and my hair stood up. I needed to make a post-session drawing about this experience. Wilson, Lindy and Raphael (1994) have described this type of therapist response as counterphobic countertransference:

In response to the client's distress about having been victimized, the therapist may experience empathic distress, which in turn, leads to a sense of anxiety about professional efficacy in the therapeutic process. The experience of anxiety may then lead to a need to establish control over distressing affect and to attempts at reducing an inner sense of uncertainty and vulnerability. (p.43)

Making art about this session was also part of what these authors called 'security operations' – that is the therapist's efforts to retrieve some control and predictability in the therapeutic process. The image which came first to my mind was the punishment of Algerian partisans by the French military during the Algerian war of 1954–1962. During this period officers tortured their prisoners with electrical discharges on sensitive parts of the body. This punishment was called 'la gégène'. I felt as if my art making proposal had been such torment for participants that they had put me in the stance of the torturer, like the French officers in relation to the Algerian opponents. I thought I was caught in a complementary countertransference (Hunt and Issachoroff 1977) where I reacted to the patients' behavior and comments, identifying myself with their internal objects. Relying on the cathartic potential of art making, I decided to draw about this association. In so doing,

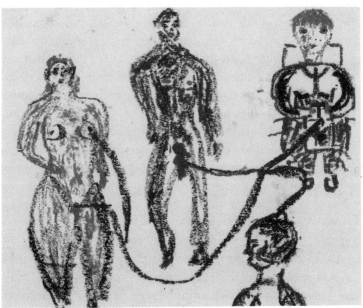

Figure 8.6. 'La Gégène'

I hoped I could free my mind from recurrent thoughts of guilt and anxiety, and from physical arousal. I also hoped to gain some insight about the next step in the therapeutic process with these clients.

The assignment was difficult to perform and the result was even more difficult to accept (Figure 8.6). Now I better understood the patients' wish to get rid of their pictures when they were fraught with extreme violence. However, I experienced a certain relief after completing my image. Whereas I was accustomed to drawing more abstract images, this time I used a representational style. What came out was a stiff and contrived image of the persisting fantasy which had troubled me. I had represented myself holding an electric battery between my knees, with my hands ready to push on the button. The three naked patients were bound to it by wires fixed on parts of their bodies: Annie's nipple and genitals, Tom's genitals and Robert's head (this patient had often complained of headaches, which seemed related to the after-effects of being beaten up during his stay in prison).

When the image was finished I noticed certain details I had not planned. The wires made a cross design and seemed to connect the males together, on one hand, and the females on the other. The end of the wire connecting to the electric battery was located at the height of the therapist's genitals. I understood this link between Annie and me as reflecting a special countertransference dynamic: her unexpected and straightforward work of art was particularly threatening for me, who, as a woman, easily identified with her injured body. The battery connected to our genitals illustrated the sadism of the relationship with its two aspects of erotic excitement and aggression. Also, the persons portrayed were sketchy and without expressiveness. The image seemed to reflect the ambivalence of the therapist struggling between depicting her fantasy in order to get rid of it and thwarting it by the frozen appearance of the figures which seemed to annihilate the emotional content of the picture.

Despite the numerous pitfalls and snares, it is difficult to ignore the important rewards therapists can gain from working with refugees. Some of these satisfactions are not easy to recognize and accept because he or she may feel they conflict with his or her image as an altruistic person. Nevertheless, I am prompted to address these gratifications to objectify them so that they are not eventually projected onto patients. Thus fantasies of omnipotence may often secretly sustain the therapist's motivation and can easily be roused by immigrants or refugees who have survived organized violence. Whereas in their country of origin they generally relied on family or community support

to overcome tremendous stresses, when they arrive in Canada, culture shock and the aftermath of their traumas often lead these individuals into isolation. Pain, depressed feelings and a sense of loss of control bring them to therapy in a state of great need to be heard and accepted. Without doing anything else, except being there and listening to their story, the therapist can feel important to these clients because, in a sense, the therapist is replacing very significant persons who supported them in their native country. This feeling is further reinforced when they disclose personal secrets to the therapist or when the therapist witnesses their general improvement.

Yet, listening to the report of traumatic events may involve a risk of vicarious traumatization. I sometimes found myself fulfilling voyeuristic needs in collecting visual evidence of the trauma in the patient's artwork in order to gain a sense of validation of my own work. Later, I learned that I could effectively help traumatized people without having to obtain avowals of their torture or rape in their pictures, especially if they had addressed it spontaneously in our talks. Attuning myself as closely as I could to their needs and following their pace during the unfolding of the therapy provided much more effective results.

The therapist's gratifications, fortunately, are not limited to ego-dystonic cravings. As Golub (1989) mentioned in relation to Cambodian adolescents, I noted strong ego integrity among most of the participants of my groups. I agree with her interpretation that 'this may be connected with an earlier life of stability and nurturance by family, community, and tradition' (pp.22–23). Patients have demonstrated inner strength reflected as much in the quality of the patient–therapist relationship as in the richness or expressiveness of their artwork. In order to overcome the tragic events of their lives, many survivors of organized violence exhibited courage, determination, compassion and responsibility – attributes which command the therapist's profound admiration and respect. I felt extremely privileged and grateful to meet individuals whose virtues had been preserved, and probably enhanced, through the traumatic experience. Such individuals have given me hope for the human race and our ability to transcend evil and fatality.

Conclusion

Therapists choose their profession out of a deep inner need, which often relates to an unconscious wish to heal or control their own psychic wounds. Taking care of mentally hurt persons may be part of this process of reparation. Nevertheless, the encounter with pending refugees can be confrontive

and, sometimes, overwhelming for professionals, especially when the client mirrors characteristics which, for the therapist, are emotionally charged, such as the experience of trauma, or states which foster the therapist's identification with the client, such as immigrant status. Although the time I spent with this population and the number of participants were limited, this experience with refugees or pending refugees having survived organized violence has allowed me to apprehend my defences against loss, helplessness or guilt,which have been described as common affective reactions among therapists treating traumatized or culturally different populations (Comas-Diaz and Padilla 1990; Fischman 1991). Power and trust were critical issues for both therapist and patient and coloured the therapeutic relationships. A need for controlling the course of therapy was probably reinforced by the therapist's uncertainty regarding the dynamics of the treatment, but the monitoring of these reactions in supervision and post-session work helped readjustment to the patients' needs.

The content of the artwork and the patients' interpretation of it, compared with my own perception of the work, provided new information about what was unfolding in the therapy. Nevertheless, Aram's case showed that the therapist's understanding could often be delayed because of countertransferential reactions when the meaning ascribed to the artwork by the patient conflicts with the therapist's interpretation. Thus, when the client uses his piece as dumping ground whereas the professional acts as if the picture was a personal gift, it becomes difficult for the therapist to accept its destruction.

Although the use of post-session artwork was not practiced extensively, it helped restore a supportive environment, despite the anxiety the clients' artworks and disclosures had raised in me. In putting myself in the patients' shoes I could experience the difficulty inherent in projecting painful feelings and frightening fantasy into art making and the resistance which may occur. I could also sense the relief it brought and was able to discover the hermeneutic value of my artwork.

References

Adler, G. (1985) *Borderline Psychopathology and its Treatment.* New York: Aronson.

Comas-Diaz, L. and Jacobsen, F.M. (1987) 'Ethnocultural identification in psychotherapy.' *Psychiatry 50,* 232–241.

Comas-Diaz, L. and Padilla, A.M. (1990) 'Countertransference in working with victims of political repression.' *American Journal of Orthopsychiatry 60,* 1, 125–185.

de Andrade, Y. (1994) 'Breaking the silence and circles of support: Assisting survivors of psychosocial trauma.' In K. Price (ed) *Community Support of Survivors of Torture: A Manual.* Toronto: CCVT.

Fischman, Y. (1991) 'Interacting with trauma: Clinical responses to treating psychological aftereffects of political repression.' *American Journal of Orthopsychiatry 61,* 179–185.

Fish, B. (1989) 'Addressing countertransference through image-making.' In H. Wadeson, J. Durkin and D. Perach (eds) *Advances in Art Therapy.* New York: Wiley.

Golub, D. (1989) 'Cross-cultural dimensions of art psychotherapy.' In H. Wadeson, J. Durkin and D, Perach (eds) *Advances in Art Therapy.* New York: Wiley.

Herman, J. (1992) *Trauma and Recovery.* New York: Harper Collins.

Hunt, W. and Issachoroff, A. (1977) 'Heinrich Racker and countertransference theory.' *Journal of the American Academy of Psychoanalysis 5,* 95–105.

Kane, S. (1995) *Working with Victims of Organized Violence from Different Cultures. A Red Cross and Red Crescent Guide.* International Federation of Red Cross and Red Crescent Societies.

Kielo, J.B. (1991) 'Art therapists' countertransference and post-session therapy imagery.' *American Journal of Art Therapy 14,* 14–19.

Laplanche, J. and Pontalis J.B. (1967) *Vocabulaire de la psychanalyse* [Psychoanalysis vocabulary]. Paris: Presses universitaires de France.

Liebman, M. (1986) *Art Therapy for Groups.* Cambridge, MA: Brookline.

Maltsberger, J.T. and Buie, D.H. (1974) 'Countertransference hate in the treatment of suicidal patients.' *Archives of General Psychiatry 30,* 625–633.

Meier, R. (1994) 'Doing the right thing: suggestions for non-medical caregivers.' In K. Price (ed) *Community Support of Survivors of Torture: A Manual.* Toronto: CCVT.

Putnam, F.W. (1989) *Diagnosis and Treatment of Multipersonality Disorder.* New York: Guilford.

Racker, H. (1972) 'The meanings and uses of countertransference.' In R. Lang (ed) *Classics in Psychoanalytic Technique.* New York: Aronson.

Reber, A. (1985) *Dictionary of Psychology.* London: Penguin.

Slatker, E. (1987) *Countertransference.* Northwale, NJ: Aronson.

van der Kolk, B.A. (1994) 'Preface.' In J.P. Wilson and J.D. Lindy (eds) *Countertransference in the Treatment of PTSD.* New York: Guilford.

Viñar, M. and Viñar, M. (1989) *Exil et torture. [Exile and torture].* Paris: Denoë.

Watson, S. (1994) 'Preparing caregivers to work with survivors of torture: The importance of self-awareness and self-care.' In K. Price (ed) *Community Support of Survivors of Torture: A Manual.* Toronto: CCVT.

Wilson J.P. and Lindy, J.D. (1994) 'Empathic strain and countertransference.' In J.P. Wilson and J.D. Lindy (eds) *Countertransference in the Treatment of PTSD.* New York: Guilford.

Wilson, J.P., Lindy, J. and Raphael, B. (1994) 'Empathic strain and therapist defense: Type I and II CTRs.' In J.P. Wilson and J.D. Lindy (eds) *Countertransference in the Treatment of PTSD.* New York: Guilford.

Yalom, I. (1985) *The Theory and Practice of Group Psychotherapy 3rd edition*. New York: Basic Books.

Further Reading

Cross-Cultural Topics

Apollon, W. (1993) 'Fascination et fuite dans la rencontre de l'Autre.' [Fascination and flight when meeting the Other]. In *Santé mentale au Québec 13*, 9–22.

Bibeau, G., Chan-Yip, A.M., Locks M., Rousseau, C., Sterlin, C. and Fleury, H. (1992) *La sant, mentale et ses visages.* [Mental health and its faces]. Montréal: Gaëtan Morin.

Corin, E. (1994) 'The social and cultural matrix of health and disease.' In R.G. Evans (ed) *Why are Some People Healthy and Others not?* Chicago: Aldine de Gruyter.

Dyche, L. and Luis H. Zayas. (1995) 'The value of curiosity and naiveté, for the cross-cultural psychotherapist.' *Family Process 34*, 389–399.

Locke, D.C. (1992) *Increasing Multicultural Understanding*. Newbury Park, CA: Sage.

Sayegh, L. and Lasry, J.C. 'Acculturation, stress et santé, mentale chez les immigrants libanais à Montréal.' [Acculturation, stress and mental health of Lebanese immigrants in Montréal]. *Santé mentale au Québec 13*, 23–51.

Sue, W.D. and Sue, D. *Counseling the Culturally Different.* (2nd ed.) New York: Wiley.

Torture and Trauma

Ager, I. and Jensen, S.B. (1994) 'Determinant factors for Countertransference reactions under state terrorism.' In J.P. Wilson and J.D. Lindy (eds) *Countertransference in the Treatment of PTSD*. New York: Guilford.

Kellog, A. and Volker, C.A. (1993) 'Family art therapy with political refugees.' In D. Linesch (ed) *Art Therapy with Families in Crisis*. New York: Brunner Mazel.

Kinzie, J.D. (1994) 'Countertransference in the treatment of Southeast Asian refugees.' In J.P. Wilson and J.D. Lindy (eds) *Coutertransference in the Treatment of PTSD*. New York: Guilford.

Rousseau, C. (1994) 'The "significance" of torture experience: towards an awareness of individual, family and cultural factors.' In K. Price (ed) *Community Support of Survivors of Torture: A Manual*. Toronto: CCVT.

Rousseau, C. (1995) *Donner un sens à la torture. [Giving a meaning to torture]*. Unpublished manuscript.

Self-Body-Image and PTSD in Australian Spanish Speaking Trauma and Torture Survivors
Empowerment Through Imagery-Art-Dialogue

Beth A. Stone

Abstract

This is a report of the processes and successful outcomes of an Imagery-Art-Dialogue Group (Art Therapy) for Spanish-speaking, South American women who are survivors of psychological and physical torture and trauma as political prisoners in their homelands. These women were part of an ongoing group at STARTTS.[1] This cross-cultural group art therapy half-day session was assessed to be successful by clients and staff. The powerful outcome was greater than expected for this brief experience. Its success has at least three aspects of interest: (1) Self-Body-Image (SBI) Process: the use of Imagery-Art-Dialogue processes with SBI to empower people with Post Traumatic Stress Disorder (PTSD); (2) Cross-cultural communication: the primary therapist's language is English. Communication through art easily crossed language barriers. Most of the verbal part of the group process was translated and augmented by a Spanish bi-cultural co-therapist; and (3) Lasting Effects: six months later, the participants reported positive long-lasting effects in terms of new internalized positive Self-Body-Images created through the art-imagery therapy and the discovery of color cues for self-management of mood and feeling.

Introduction

This is a report on a privileged experience and an apparently successful therapeutic interaction with a small group of South American women who

1 Please see Acknowledgements on page 198.

were torture and trauma survivors, and clients at Services for the Treatment and Rehabilitation of Torture and Trauma Survivors (STARTTS), in Sydney, Australia.

Aims and Art Imagery Processes Goals

A safe, caring environment was a basic requirement. For this Art Therapy experience, the overall aims for these torture and trauma survivors were empowerment and a new inner safety through the development of their own personal imagery. The work was done in a group which met for half a day.

The group session had at least four specific aims:

1. The primary aim was to give the women an opportunity to use Imagery-Art-Dialogue – non-verbal and verbal expression in a safe, respectful Gestalt-oriented art therapy – to experience, create, draw and make a concrete, empowered Self-Body-Image (SBI).

2. The second goal was to give the women an opportunity to express non-verbally (draw) and verbally their feelings of disempowered, traumatized or victimized sense of SBI.

3. In the third process, the goal was for the clients to move into a change-resolution dialogue process between the two drawings.

4. A fourth aim was to compare their SBIs with over a hundred SBIs collected for an independent study in progress (not discussed here in detail).

Client Evaluation

In order to look at the effects on the participants of the overall program, including the Imagery-Art intervention, the Spanish worker, Lucy Marin, interviewed the group participants a few weeks after the art-imagery group and then six months after the group.

What and Why: Imagery-Art-Dialogue

In General

Eclectic Imagery-Art-Dialogue is the author's integration of imagery therapy, art therapy, Gestalt, communication processes, parts work and dialogue. Basically, it is the use of particular non-verbal art imagery processes in the here-and-now, 're-owning' dialogue or the Gestalt Therapy process of

becoming the parts (of the artwork) in dialogue or other actions so that the client finds meaning without any interpretation by the therapist. What Jung noted in 1959 is still true: as yet, there is very little empirical evidence for art therapy interpretations except by the client.

On the other hand, it is known that non-verbal imagery is a direct and powerful expression of affect. It is estimated that 70 to 90 per cent of attitude and affect are communicated non-verbally (Birdwhistle 1970; Mehrabian 1970). Imagery and the arts were a significant aspect, if not the basis, of early healing methods in native cultures and in the medicine of the 'Golden Age' of Greece (Achterberg 1985; Samuels and Samuels 1987).

The use of art imagery aims to facilitate expression and communication of feelings. Art imagery, like dream work, often taps feelings, attitudes and memories that may not be in conscious awareness or are not easily accessible. It easily bypasses the barriers of language, cultural, educational, intellectual and age differences. Of course, we need to clinically handle the needs of some people for whom art therapy may be threatening because they may see the non-verbal enactment as a potential for losing control; they may fear regression; or they may fear revealing. However, art therapy usually facilitates a feeling of mastery and control since the images and affect are contained in concrete art form.

In addition to the advantages of non-verbal communication, art therapy adds other particular contributions which are not commonly present in general therapy or counseling. These include important elements of pleasure and tactile, visual and kinesthetic integration and involvement.

Imagery-Art-Dialogue offers unique therapeutic opportunities for the integration of sensory experience; of physical materials and movement with emotional communication; for communication between right-left brain hemispheres; conscious and unconscious content and processes; inner and outer realities; the personal and transpersonal; present and past time.

Transcultural, Cross-Cultural and Multicultural Work

Above are the overall reasons to use Art Imagery as a basis for transcultural, cross-cultural and multicultural work. In addition, in relation to body image drawings, there appears to be a shared human transcultural neuromuscular vocabulary for many emotions and feelings which is expressed in body posture and facial expression (Ekman 1992; Izard 1994; Ekman and Friesen 1975). Like the arts, facial and body language can communicate without verbal language.

Trauma and Post Traumatic Stress Disorder

For Post Traumatic Stress Disorder (PTSD), art therapy may well be a primary method of choice. (1) Recent research finds that traumatic experiences are encoded primarily in encapsulated non-verbal imagery, probably following different pathways in the brain from non-traumatic memories and probably not connecting with the cognitive association areas of the frontal lobes (Ledoux 1994; van der Kolk 1994; Herman 1992). (2) The basic necessary conditions of successful therapy with trauma are reported to be client empowerment and safety (Herman 1992). Gestalt-oriented non-interpretive art therapy can be readily used to develop self-empowerment because in the process of doing art therapy the client is directly instrumental in accessing her/his own resources and concrete symbols of empowerment and safety.

For people suffering with PTSD or other effects of trauma, this art therapist-psychologist consistently finds that – given that the basic clinical approach is sound and compassionate – art therapy processes give the client a sense of distance from the feelings by objectifying and containing them in art form. The person can use this mild, healthy dissociation and look at the feelings on paper or in clay, talk about the image and feelings 'out there', re-frame or re-work the feelings and re-own them verbally and emotionally. Both the verbal and non-verbal integrate and the learning is greater (Stone 1996).

'Self-Body-Image' (SBI)

In some physical respects body image has been shown to be long lasting, as for example in a phantom limb. However, what this author calls 'self-body-image' is based on feelings, intuitive energies and kinesthetic and visual imagery of body and self. It seems there can be as many SBIs as there are aspects or parts of the self, whether we talk in terms of Jung's archetypes or Freud's 'ego, superego and id'; Transactional Analysis' child-adult-parent; Psychosynthesis or Voice Dialogue's construct of parts work; or personal life experiences of parts and roles (i.e. mother, survivor, creative child, etc).

In addition, there is evidence that body image can be located in the non-dominant (usually right) temporal lobe near centers of emotions. Therefore, body image may easily reflect, or be a reflection of, the feeling-defined experiences of self frequently found to be moderated by the non-dominant hemisphere (Achterberg 1985). That would seem to be

supported by the women's drawings and the other hundreds of drawings I have collected.

Brief Background to STARTTS and Multicultural Group Work

STARTTS is an Australian federally- and state-funded organization. Its mandate is to work with the refugee trauma and torture survivors who have emigrated to Australia. As a signatory to the International Convention for Human Rights, Australia has provided refuge for over half a million people since World War II.

The STARTTS director found that there was a lack of literature on group work with torture survivors (Cunningham 1994, verbal report). On the other hand, those who have worked in other areas of trauma, such as adult survivors of child abuse, domestic violence and rape, report very positive outcomes from group work carried out for a variety of aims and at various stages of therapy (Herman 1992).

The Imagery-Art-Dialogue Group for the Spanish Women Torture-Trauma Survivors

Group Facilitators

Having previously given a training for STARTTS staff, I was asked by the director to do a half-day Imagery-Art-Dialogue group session with these Spanish-speaking women. This was one of a series of nine sessions of enactive therapy processes. An English-speaking psychologist and art therapist, I was the primary therapist and designer of this particular group process. Lucy Marin, a bi-cultural Spanish-speaking counselor, translated as needed. The director, Margaret, also participated as part of her on-going therapeutic role in the nine sessions. I remembered some Spanish and could get a felt sense of what was being said, but we all certainly needed and depended on Lucy's translation. Lucy, of course, is trained in interpreter work and I am trained to work with interpreters.

The Group and Their Acceptance of the Newcomer ... Art Therapist

The three women in the group were from different countries in South America. All had been tortured and one, possibly, had been a victim of childhood trauma. Their pseudonyms for this chapter are Juana, Molly and

Lorrie. They had been coming to STARTTS for at least two years and were involved in both individual counseling and social support groups. These women had already been together in a 'writing group' (enactive therapies group) for three sessions out of a planned nine. This was the fourth session.

Personal details about these women are not necessary to the work reported here and were not specifically addressed in the group. *It is important to note that by focusing on process, one can do effective therapy without getting into the story details.*

Each of these women had been subjected to betrayal and torture by their governments' agents, had had to leave their homelands and were suffering some degree of PTSD. I wondered how difficult it would be for them to accept and be open with me. The women were very accepting of me and showed remarkable trust in me, an English-speaking newcomer. I immediately felt included in their energetic camaraderie. I believe that is probably a reflection of their trust for the STARTTS staff and the group cohesion that had grown over time.

Process and the Art Imagery

The Materials and Setting

We met in the director's office and I was introduced to the women. It was a warm and easy atmosphere. After a bit of shuffling around, we all sat on the floor. The office is very casual and busy. We had large sheets of butcher paper, about 18"x24", and boxes of oil-based pastels. I showed them some basic ways of using the oil pastels and we played with them for some time. I had also brought some Plasticine (an oil-based plastic modeling material) in case there was time for clay.

Therapeutic Philosophy

I believe that as professionals we bring our skills to the therapeutic meeting. But we are the catalysts and the clients are the authorities on themselves. I come from a place of respect for our common human condition. Working first towards empowerment and safety, I choose processes which mirror and enact respect and empowerment.

Group Preparation

The week before, in their last writing group, the women were told I would be coming. They were told that we would be doing art therapy work similar to what the staff did with me in their training day. So, the clients were prepared.

Language Communication in the Group

Lucy Marin translated what I said and we talked about language. I told them I used to speak Spanish in high school: 'pero no recuerdo muchas palabras; solomente poco'. I asked Lucy to tell them I would listen and try and understand. If you have ever travelled in a non-English speaking country, this was one of those conversations with lots of laughs on both sides as we struggled to communicate at first.

When Lucy was not translating, she and Margaret drew (I do not draw with clients). I watch the process and sequence of each person's drawing and stay in the facilitator-therapist position so I am available and can intervene when needed.

The Imagery-Art-Dialogue Process

'Safe Place', Relaxation, Empowerment and SBI

I took the group through a brief relaxation of breathing into a place in their bodies that the Chinese call the 'tantien' or 'caldren' – a source of the life-force or 'chi'. Then I suggested they each create an individual safe place and imagine themselves there: some place in nature that is beautiful and safe to that individual. It doesn't have to be a 'real' place. The person can create the safe place out of the elements that person likes. For example, ocean and mountains can be in the same safe place.

Once in their safe place I asked them to stay in touch with their individual sense of that very alive, energetic place in their body; to remember a time when they felt fully empowered, fully alive, being just the way they wanted to be. To help each person see and feel and realize her individual empowered self-body-image, I guided them through a series of imagery experiences tracking their life-force energy through their bodies. I guided them to take a mental picture of that body energy, represented as light and color, moving throughout their empowered self-body-images. (I prefer to do this individually so the process can be interactive, but the group work is also quite effective.)

Then, asking them not to speak so that they did not interfere with their own imagery process, I asked them to draw themselves as their empowered self. There was a good deal of energy and feeling in the way they worked (see Figures 9.1, 9.4, 9.7).

After about 10 to 15 minutes of drawing their empowered SBI, I told them we were now going to do the image of the victim or the disempowered SBI. Lucy translated. I took them in imagery to their individual images of their disempowered selves. I told them they would draw those in a minute, but first, we went back to the empowered image, the feeling good, positive SBI, so they could hold that also in their minds' eye. I then suggested that

Figure 9.1. Juana's empowered SBI

from that point of view, they may feel compassion for the victim in them and pride in her survival. I asked them to draw the disempowered or victim self in the next 10 to 15 minutes (see Figures 9.2, 9.5, 9.8).

Next I asked them to have a dialogue between the empowered and the disempowered victim self and see what each part gained from the other. With people of the same language, a good deal of this stage of process is verbal but, in this case, the women drew the interaction and wrote some of the interaction dialogue.

Figure 9.2. Juana's disempowered or victim SBI

The Art Images and the Dialogue

The women took turns showing and telling what they did and felt. They gave full supportive attention to one another. Through Lucy, I asked questions, made comments and had discussions and dialogues with the women.

As stated above, my approach is eclectic with a strong Gestalt orientation. I provide the clients with techniques they can use to explore and find meaning in their work. I ask the person to talk about what they draw. If it's comfortable for the person, I ask them to own it, become it. The dialogues below are very brief examples of this process.

Drawings and Dialogue by the Women

Juana's Imagery-Art-Dialogue

To give the reader a fuller example, more detail will be given about Juana's drawings than the other women.

When looking at the drawings we begin with the strengths. In Juana's empowered self (Figure 9.1), we see the golden yellow glow or aura around the empowered one and the amount of detail, color and energy that is given to her. Her feet are planted firmly, emphasized. She surrounds herself with music.

We can also see how this part is highly defended. The face is overly made up – almost mask-like. The neck is often seen as the place of communication or separation between our head thoughts and body feelings. The neck is extremely long, which is sometimes said to suggest a strong attempt to separate the feelings (body) from the thoughts (head). It seems that, in this case, the long neck isn't enough, for in addition, the necklace goes right through the center. We may speculate, but what are finally meaningful are Juana's comments and the elation she got from doing the drawing.

Juana's disempowered or victim SBI (Figure 9.2) is a black stick-figure whose legs are folding up under her. There is the suggestion of one foot. Her hair looks as though an electric current is running through it and she is smiling with tears.

If you glance at the disempowered, victim self, you will notice that the stick-figure center line continues down so that it could look like a protrusion from, or an emphasis on, the genital area. The line also continues down between her legs coming out of the skirt. It's possible that there was some sexual aspect to her trauma and pain. *Only the client knows what her drawings mean to her,* and in this short group, I did not explore any of these details with

Figure 9.3a. Detail of reintegrated SBI

Figure 9.3. Juana's dialogue drawing or integration SBI

the clients. It would not have been appropriate in terms of the agreed group goals of empowerment and safety. Even if the contract had included these issues, many more sessions would have been needed to get closure on the material that may have come up.

As part of her dialogue, Juana wrote on the disempowered one (Figure 9.2): 'I am alive but without energy. I appreciate the way I feel because, whether I like it or not, I am living. It is part of me. Now I realize that my problems were small compared to other people who have lived worse experiences. This (hearing other people's stories) gave me courage to keep ahead and help other people by listening to them. Sometimes what I do when I feel like this (drawing) is to talk to God as if I was talking to a person next to me. He is the one who gives me strength'.

Juana's third drawing (Figures 9.3, 9.3a) is the interaction or dialogue between the empowered (Figure 9.1) and the disempowered or victim (Figure 9.2). Juana shows the SBI as relaxed in an embrace of music and color.

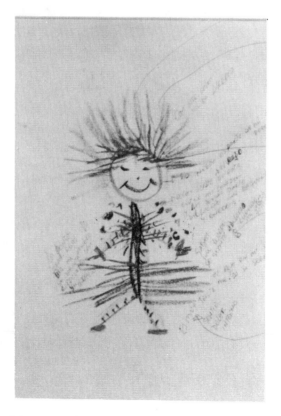

Figure 9.4. Molly's empowered SBI

Figure 9.6. Molly's dialogue drawing or integrated SBI

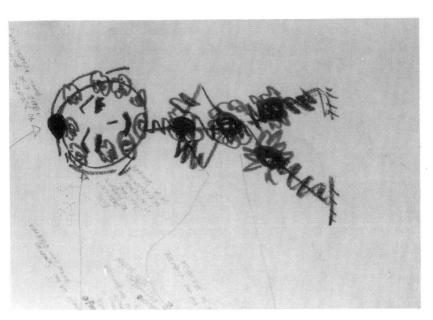

Figure 9.5. Molly's disempowered or victim SBI

The hard exterior armor and mask-like face are gone. There is a bird in the upper left-hand corner. Juana points to the sky and tells us about the spiritual power she has gained from her ordeal. The bird represents the spiritual, as it does in many cultures.

Color

The musical notes are a variety of colors. Her body is outlined in lavender and her hair continues in lavender. The top of the dress is red, the bottom lavender. The shoes are purple, the necklace is gold and the face is brightly made up (also see her comments in the 'Outcome', below).

Molly's Imagery-Art-Dialogue

Molly says that her empowered self (Figure 9.4) is full of bright energy. The power centers are represented by red that is coming out of her head, heart area and lower body. When we did the empowerment imagery, she felt it start in her heart, which is deep red. However, her smile is emphasized and her eyes are closed, as they are in the disempowered drawing. She is smaller than her disempowered figure, but vibrant.

As you can see, Molly's disempowered drawing (Figure 9.5) has harsh large black spots with electrical looking red zig-zags around them. There are lots of zig-zag and spiral lines, suggesting an anxious energy or anger. I did not ask STARTTS professionals, Margaret or Lucy, about Molly's torture experience but they volunteered that Molly only wore pants and never showed her legs. For me, the drawing felt painful to look at.

In Molly's integration dialogue drawing (Figure 9.6), her eyes are open. She is larger and has a defiant stance. Her power centers are now red circles in her body and a red shape of ideas coming out of her head. These replace some of the black circles in the disempowered one. She is on the ground.

Molly wrote what she says to herself, the instructions she gives to herself in her healing dialogue: 'To Go out; to Talk; to Breathe Deeply; To Talk to the Sea; To Walk'. One message is a drawing next to the red shape of ideas coming from her head. It is an image of her peaceful 'safe place'.

Lorrie's Imagery-Art-Dialogue

Like Juana's and Molly's drawings, Lorrie's empowered SBI (Figure 9.7) is easily contrasted with her disempowered SBI (Figure 9.8). In terms of color, the former is full of color with her empowering energy clearly represented in

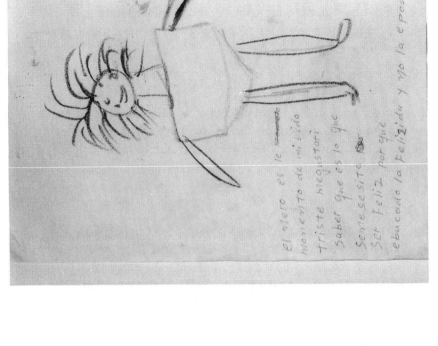

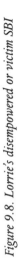

Figure 9.8. Lorrie's disempowered or victim SBI

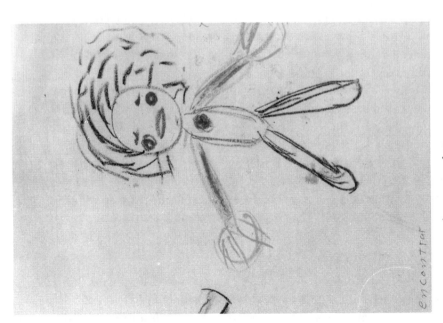

Figure 9.7. Lorrie's empowered SBI

her red heart area, her purple arms and bright yellow hands, the blue energy flowing out of her head and around her and the blue energy in her legs. The disempowered one is only black. Lack of color is often said to represent flattened affect. Her empowered face is full of color too. Although the eyes are represented, it's not clear whether or not they are open.

The empowered self is about the same size, or a bit smaller, than her disempowered SBI. The body shape is asexual in both cases with more squared-off shapes in the disempowered one. In both cases, the right and left feet are drawn differently. The disempowered figure, as you can see, has no hands, which is often seen as indicative of not feeling able to manage or take control of, or make effective contact with, the environment.

To discover what some of these graphic elements might mean or indicate for this particular individual, we would need to explore with the client. With my orientation, I would ask the client to speak for these parts and/or explore through further drawings. As discussed above, details were not explored. I stayed with our contract and goals.

Lorrie wrote part of her dialogue between her disempowered and empowered SBIs. From the disempowered SBI she said: 'Black is the sad moments of my life. I would like to know what I need to be happy because I look for happiness but have not found it'. The empowered SBI responded: 'Red makes me feel strong. Blue gives me energy. Yellow gives me ability. Purple gives me happiness. This is how I see myself (in the empowered self) and I feel happy'. Lorrie's dialogue, or integration, picture is, unfortunately, not available. For interest and comparison, I'm including two drawings from the hundreds of empowered and disempowered SBIs done by people in professional trainings in Australia and the United States (Figures 9.9 and 9.10). Although the sets of drawings are each unique, there are significant differences between the empowered and disempowered SBIs in terms of graphic elements. The drawings shown here (Figures 9.9 and 9.10) seem representative and do point to some differences and similarities to the STARTTS women's group. The reader may want to explore these comparisons.

Figure 9.10. Disempowered SBI by the same trainee

Figure 9.9. Empowered SBI by a trainee

Outcomes

Reported Outcomes, General and Individual

A few weeks and then six months later, Lucy asked the three women individually if they were aware of any effect of the art therapy experience. The women report these shared outcomes:

1. Each woman said she has tangible lasting images of the empowered SBI and the disempowered SBI which she 'sees' daily.

2. All three said they continue to be able to separate the images of themselves as empowered self and disempowered (victim) self.

3. Each reported being able to use these images constructively to make decisions in daily living. For example, Juana said that when she gets up in the morning, feels low and wants to dress in black, she remembers her body image drawings and chooses to dress like the empowered self rather than the disempowered one. She reports that this affects her mood and sense of self.

4. Color became a means of self-healing and self-management. They all reported gaining an insight into their own sense of 'colorlessness' as the traumatized victim and had gained awareness of how to use color to shift their feeling states and achieve a sense of self-empowerment. For example, six months after the group, Lorrie said about her empowered drawing (Figure 9.7): 'When I search for that spiritual communication, my energies reach 100 per cent and I listen to music as I look for happiness. The colors red and yellow are like a light that I feel inside of me and enlighten me to help other people'. The staff at STARTTS have noted the change in her clothes from 'solemn' to 'bright and cheerful'.

5. All reported sharing their other enactive group therapy experiences and the SBI experience with close friends and family.

6. As a side benefit, each reports that their creativity has been enhanced. For example, Juana is painting on wood and doing woodwork. She reports having an understanding of what the feelings are in the images she makes. This awareness and understanding of feelings in art is something she says she did not have before the art therapy session. Lorrie said she always thought she couldn't paint and is now drawing designs on materials.

Through their various therapeutic experiences at STARTTS, including the art therapy self-body-image session, all report an awareness that their trauma is still there and being worked on. However, they now see themselves as survivors rather than victims.

Discussion

General Comments: SBI Drawings, Trauma and Empowerment

In looking at the drawings reprinted here, my immediate response is not a cognitive response. I feel the drawings are trusting, honest and very gutsy. I feel awed and privileged. Which drawing is the first drawn, empowered SBI, and which the second, or disempowered SBI, is self-evident. I'd like to offer some other observation.

Size

When I compare these drawings to the hundreds I have collected from people in training workshops, the most outstanding difference is size. In the training populations the drawings of the empowered SBI are consistently larger than the disempowered self, with three exceptions. In those three cases, the figures are the same size. That is not consistently true in this group. This leads me to hypothesize that their traumatized self is active and large in the women's consciousness. Molly's disempowered or victim self is clearly larger than her empowered self. Lorrie's are almost the same size but the victim is a bit larger. Juana's empowered self is also larger.

PTSD and the Art Imagery

The clients' torture and trauma was intense and occurred repetitively; and it was relatively recent – in the past three to eight years. The women are actively working on the memories and PTSD symptoms. We know that when people are in the early middle stages of effective therapy for PTSD, the symptoms and imagery may be more pronounced for at least two reasons: (1) the very act of focusing on them and (2) before effective therapy, one major means of coping with PTSD is through avoidance of reminders of the trauma(s). This avoidance would be progressively on the decrease for these women because therapy would mean awareness and expression of their affect and trauma rather than avoidance of the traumatic incidents.

Color and Darker/Lighter

In both the STARTTS women's drawings, and in the collection of SBI drawings I have, the victim or disempowered self is usually lacking color and is darker than the empowered self. In art therapy, as in everyday language, color is taken to mean an expression of feelings. Lack of color can mean absence of emotion or flattened affect, or as emptiness and sadness, depressive feelings or avoidance of feelings. Darkness is often thought of in terms of heavy mood – secretive, shadow side of self in art and in everyday expressions – like 'being in the dark' or 'looking on the dark side'. Light and bright is associated with happiness, uplifting, the sun and/or stars. Expressions come to mind like 'sunny side of the street' or 'look on the bright side'.

Body Posture

In a majority of the pairs of SBI drawings I have collected, and in the drawings of both STARTTS staff members, the disempowered self is bent, curled up or in a closed stance. This is noticeably not true for these South American Spanish-speaking women who are survivors of torture and trauma. These women are active participants in their recovery. This may be one reason for the difference between their drawings and others. On the other hand, I have not found this body posture difference to be as prevalent as the nearly universal size or color (brightness/darkness) differences.

The Process and Group Leaders

Contributions to a Successful Outcome

To learn from this experience and be able to repeat the processes that lead to a positive outcome, it's important to speculate on the reasons for the apparent success and lasting effectiveness of this short experience. Here are some of the major elements which appear to have contributed:

1. There was thoughtful preparation of the group for the experience.

2. This was one out of a series of nine group sessions. Before this session, the group had established trust with one another, with the bi-cultural counsellor and STARTTS.

3. At a previous meeting the art therapist/psychologist described and discussed the group design with the STARTTS team. Therefore,

the facilitators' approach was consistent and the facilitators were prepared.

4. The design was structured in terms of the contracted experiences and goals and the approach was flexible and responsive to the clients' processes. We would have moved in and out of the experiences if the clients' needs called for it. It is a case of both leading and following.

5. Initially, after introductions, the overall plan of the session was shared and discussed with the group in the interest of the clients feeling respect and a sense of safety and control. These issues are always important. However, they are particularly important with people who have experienced trauma and the betrayal that is such a key element in PTSD.

6. The artwork: the materials were simple and before doing the SBI experiences we all played with the colors. I showed them various ways to get textures and deeper and lighter color, etc. It was emphasized that no one was interested in how talented or able they were with the artwork.

7. The focus was on process, not on content.

8. The focus was on empowerment and safety, not finding blemishes and problems that are obvious in all of us. The group began with empowerment and safe place imagery.

9. A sense of humour and genuine warmth was maintained.

10. The therapist took an active and positively supportive position.

11. After the group, permission was obtained from each participant to take photos of the drawings and to use them for professional publication or education with the assurance that no client's identity would be revealed. The original drawings were returned to the participants.

Summary

The concept and manifestation in art form of SBI has clearly been useful, particularly as a process to explore and even to create change. Necessary parts of this process are the use of open-ended imagery, dialogue and encouragement of actual changes to the art-imagery drawing or other art

work. The therapist's positive support of the client in the process seems to be another necessary ingredient. To be effective in using this process, the therapist needs to be comfortable with being active and interactive.

With our Spanish-speaking women at STARTTS, communication between the therapists and clients, and between therapists, was easy and open, irrespective of the language and cultural diversity of the group. This may be due in part to the reasons cited above and in part to the use of non-verbal universals: body image and art expression.

Given the short time spent in the art therapy experience, the long-lasting impact of this experience was not anticipated. In part, this may be attributed to the women's use and re-imaging of the experience by having their pictures available or actually hung up at home. In part, it appears that the experience affected core issues for these women: Self-Body-Image, safety and empowerment.

References

Achterberg, J. (1985) *Imagery in Healing*. Boston and London: New Science.

Birdwhistle, R. (1970) *Kinesics and Context*. New York: Ballantine Books.

Cunningham, M. (1994) Director of STARTTS, Australia. Verbal communication.

Ekman, P. (1992) 'An argument for basic emotions.' *Cognition and Emotion*, Vol.6 (3–4), 169–200.

Ekman, P. and Friesen, W.V. (1975) *Unmasking the Face*. New Jersey: Prentice-Hall.

Herman, J.L. (1992) *Trauma and Recovery*. New York: Basic Books.

Izard, C. (1994) 'Innate and universal facial expressions: Evidence from developmental and cross-cultural research.' *Psychological Bulletin 115*, 2, 289–299.

Jung, C. (1959; 1977, fifth printing) *The Archetypes and the Collective Unconscious*. New Jersey: Bollingen Series, PrincetonUniversity Press.

Ledoux, J.E. (1994) 'Cognitive-emotional interactions in the brain.' In P. Ekman and R. Davidson (eds) *The Nature of Emotion, Fundamental Questions*. New York: Oxford University Press.

Mehrabian, A. (1970) *Tactics of Social Influence*. New Jersey: Prentice-Hall.

Samuels, M. and Samuels, N. (1987) *Seeing with the Mind's Eye*. New York: Random House.

Stone, B.A. (1979) 'Art and psychotherapy: Advantages and cautions.' *NSW Counsellors Newsletter*. Australia.

Stone, B.A. (1996) *No more Flashbacks: The Successful use of Imagery and Art Therapy for PTSD*. Paper presented at the International Congress on Stress and Health, Sydney, Australia.

van der Kolk, B.A. (1994) *Trauma, Memory and the Self*. Lecture, Australia and New Zealand Association of Psychotherapy, Westmead Hospital, NSW, Australia.

Acknowledgments

Acknowledgments and appreciation go to Lucy Marin, Bi-Cultural Spanish Worker, STARRTS, and Margaret Cunningham, MSW, Director of STARTTS during the time of this group, now Lecturer, Community Medicine, University of New South Wales. Without their initiative, skill and caring, the work could not have been carried out. The details of their contributions are in the body of this report. This report is about the specific art therapy processes in one group session. Part of the larger therapeutic program run by L. Marin and M. Cunningham, this art therapy group session was one out of a series of nine enactive group therapy sessions for these Spanish-speaking women. Of course, unbounded appreciation and respect go to Juana, Molly and Lorrie.

PART 2

Educational Issues
in Art Therapy

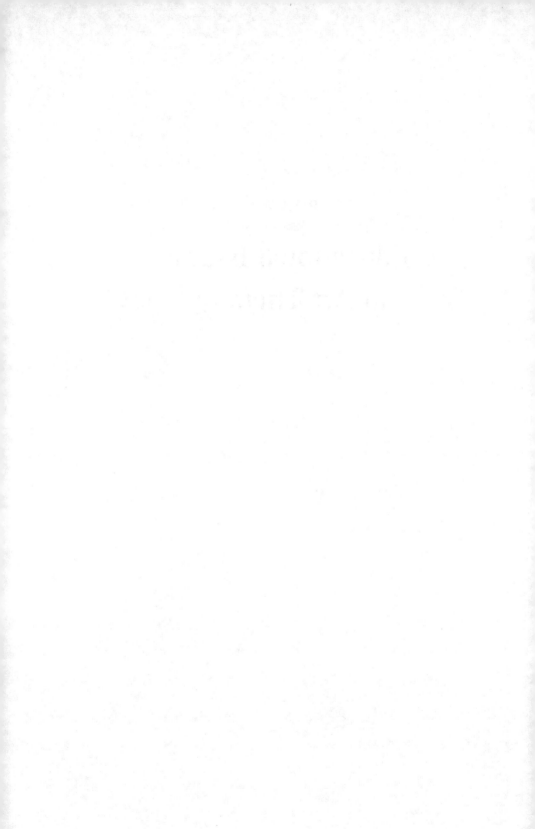

Multicultural Perspectives in Art Therapy Supervision

Abby C. Calisch

Abstract

This text examines an essential element of psycho/art therapy training: cross-cultural supervision. Cross-cultural dynamics impact upon the supervisor, supervisee and the client, necessitating both examination and unbiased application of techniques for therapeutic competence. The text discusses the cross-cultural relevance of current supervision theories and approaches while proposing the use of art as a useful intervention technique within cross-cultural supervision. Important research variables are discussed and other areas needing investigation are suggested.

Clinical supervision is an essential element of the art therapist's training, but research in the area lacks maturity (Agell *et al.* 1981; Russell, Crimmings and Lent 1984). It would seem a timely evolution to develop theoretical and empirical information with respect to cross-cultural issues. If supervision is the act of overseeing the development of therapeutic competence and preparation for inclusion in the larger world of health professionals, then the articulation, examination and management of factors affecting supervisory relationships and the eventual therapeutic relationship are of critical importance (Holloway 1992; Calisch 1989, 1994a; Dulcai, Hays and Nolan 1989; Malchiodi and Riley 1996). Cross-cultural dynamics have been clearly implicated as features of a wide range of other relationships, including therapeutic and educational ones (Atkinson, Morten and Sue 1993; Lofgren 1981; Cattaneo 1994). Furthermore, competence in treating culturally diverse other is currently viewed as an essential component of therapeutic competence (Calisch 1994; Cattaneo 1994a; Pedersen 1990; Sue and Sue 1990).

Clinical supervision is not exempt from cross-cultural dynamics. In fact, it will amplify issues within the supervisor/supervisee relationship and eventually further affect the supervisee/client relationship as well. A supervisor's cultural frame of reference, or world view, is likely to influence, for example, the therapeutic choices made by supervisees and their supervisors. Furthermore, world view conflicts between supervisees and supervisors may be reflected in the evaluation of the trainee, in the quality of the supervisory relationship and in each person's therapeutic approach.

There appears to be a tremendous void in the literature on the subject of multicultural dynamics in clinical supervision, despite the increasing publications on cross-cultural therapy and, to a lesser degree, cross-cultural education (e.g. *Journal of the American Art Therapy Association* special section on Art Therapy and Multicultural Issues in 1994; Pederson 1990; Bradley 1987; Calisch 1994a). Since scant attention has been paid to intercultural dynamics in supervision, there is very little known about the practice of cross-cultural supervision.

Before identifying the possible cross-cultural factors that might affect clinical supervision, it is helpful to first identify the different relationships germane to this supervisory process. It is obvious that the supervisory process consists of at least three parties – the client, the art therapist-supervisee and the supervisor – each with direct influences on the other, affecting the content, process and outcomes (Calisch 1989; Calisch 1994a; Holloway 1992).

The supervisor directly influences the attitudes, aesthetics, knowledge and skills of a supervisee through his or her own personal characteristics, modes of relating and nature of concerns in supervision. These elements affect how a supervisor is perceived by the supervisee and, as a consequence, influence supervisor/supervisee interactions. Indirectly, the supervisor influences the client through his/her influence upon the supervisee's performance.

The supervisee, as clinician, directly influences the attitudes, aesthetics, knowledge and skills of the client. The supervisee also indirectly influences the client and the supervisor through his or her personal characteristics, modes of relating and nature of concerns brought to supervision.

The client indirectly influences the attitudes, knowledge and skills of both the art therapist/supervisee and the supervisor through his or her personal characteristics, modes of relating and nature of concerns brought into therapy. These influence the perceptions of the client that are held by the art therapist/supervisee and the supervisor. I contend that the attitudes,

aesthetics, knowledge and skills of all supervisory parties, as well as their personal characteristics, modes of relating and concerns, reflect or express cultural influences. Therefore, all parties in the supervisory process bring to it a number of cross-culturally relevant features that influence the process. It is impossible to accurately monitor the supervisory process without alluding both to the client/therapist/supervisee/supervisor triad and to the influence of their world view perspectives. I contend that the parties involved must acknowledge and explore, as part of that supervisory process, how the world is viewed and how its cultural expression derives from the cultural context which shapes our values and aesthetics. Although cultural expression may be common to all people, how and what is expressed is specific to class, race, ethnicity, gender, beliefs and value systems. Likewise, expression through the arts and its subsequent meaning are interwoven with cultural attitudes and are not universal in the sense of being value free (Cattaneo 1994).

Dimensions of Difference

Cross-culturally relevant characteristics of the client, art therapist/supervisee and supervisor can be classified along three major dimensions of difference: (1) differences from the general population, (2) differences from one's cultural group and (3) differences from either or both of the other parties in the supervision. Those differences may pose significant barriers to effective supervision that are identical to factors that inhibit effective psychotherapy, such as client anger and resistance, therapist defensiveness, therapist over-identification, supervisee resistance, poor therapist development, supervisor countertransference and supervisor patronization (Atkinson *et al.* 1993). The barriers can affect the quality of interpersonal relations, the nature of the art therapy and supervisory process and the effectiveness of the treatment and supervisory enterprise.

Differences From the General Population

Differences between each member of the supervisory triad and members of the general population (European Americans) are probably the most discussed as characteristics that might influence psychological processes and perspectives. These differences include language or dialectical differences, social and/or economic status differences and associated value systems, educational differences and differences due to cultural isolation. To the extent that any supervisory triad member differs on any salient feature from

the general population, the content, process and outcome of supervision can be negatively affected. In addition, to the extent that supervision and counselling theory are predicated upon an understanding of 'the general population', the use of those theories may be inappropriate for understanding and managing cross-cultural dynamics in clinical supervision.

Some differences in values and interaction styles between parties in the supervisory process and those from the general population are due to social status or economic status differences. Social status has been separated because of the observation that persons who may not differ economically from the general population, at least in terms of net family income, may differ quite significantly in terms of social status. Such persons may harbor significant levels of resentment or sensitivities that surface when these persons encounter the social status imbalances characteristic of treatment and supervisory encounters. Value differences associated with economic status differences may also be reflected in people's appointment making and keeping behavior, attitudes toward sexual and substance taking and attitudes towards counseling and supervision (Sue 1981).

Relatedly significant educational differences between the client, the therapist/supervisee and/or the supervisor from the general population of European Americans can affect their perspectives and approaches with regard to the whole range of human concerns and conditions (Sue 1981). Such differences can affect the contents and processes associated with supervision and counseling, resulting in radically different outcomes than have been typical or characteristic.

A supervisor, supervisee/therapist and client may come from cultural groups that may experience different degrees of separation and oppression than are experienced in the general population. Those experiences shape one's general view and rules about life and how to approach living in it. In other words, the experiences impact one's level of acculturation. Culture-based perspectives may be so fundamentally different that effective supervision involving the supervisory parties is obstructed.

Cultural differences may be reflected in assessed levels of acculturation, perceptions of oppression and unfair discrimination, confidence in societal institutions and world views.

One or all of the supervisory parties may also differ from the general population in terms of ethnicity and/or race. Although such differences may not be token psychological content or process differences, they can affect the perception of such differences, reflecting biases, stereotypes and 'isms'

(racism and ethnocentrism) that are sure to affect the supervisory process adversely. People hold values associated with racial/ethnic physiognomy such as skin color, hair texture and size of physical body parts. The biases of supervisory constituents regarding perceived racial classification and perceived values associated with racial physiognomy are expected to influence both the counselling and supervision relationships, just as they do broader social relationships.

Other possible areas of difference between supervisory parties and persons from the general population include ethnic or racial identity, nationality, urbanicity, geographic origin and occupational and economic background. Few of these issues have been investigated with respect to psychotherapy or art therapy processes and outcomes and virtually none of them have been studied with respect to supervisory processes and outcomes.

The main point of this section is that, given the perspectives of contemporary psychology and art therapy, supervision science is currently constructed to address characteristics most represented in the general population. I reiterate that the extent to which any member of the supervisory triad differs from the general population of European Americans can affect the content, process and outcome of clinical supervision. There is a need for research designed to test this assertion.

The fields of psychology, counseling and art therapy are recognizing more and more that members of various ethnic or racial groups differ from one another in psychologically meaningful ways. To the extent that any part of the supervisory relationship differs from others of his or her ethnic or racial group, knowledge, experience and attitudes with respect to relevant ethnic or racial groups may not generalize to that party. The three relationships in the supervisory process can be seriously affected by misperceptions and wrongly applied culturally specific knowledge and experience.

Ethnic and racial group members may be found to differ from one another on the following dimensions: ethnic or racial identity, facility with English and the language of one's ascribed ethnic or racial group, traditionality of interests and concerns, cultural values orientation, mental ability, nationality, migration history, migration status, reservation residential status, tribal identification, occupational and economic background both here and in country of origin and urbanicity. Each of these dimensions will affect how members within a group perceive problems and how they engage in relationships with others who are either within or outside of their ethnic or racial group.

To the extent that members of the supervisory process differ from one another on salient, between-group and within-group dimensions identified already, they may encounter difficulty in identifying problems and goals for counseling and supervision. They may also confront challenges to developing effective working alliances. These dimensions can challenge the understanding of supervisory triad members about one another, the manner in which they may interact with one another, the subject matter of focus in supervision and counseling and the outcomes associated with both supervision and counseling.

World View Congruence Model

Another useful means of construing the impact of dimensions of difference is through use of the World View Congruence Model. World view is defined as the way an individual perceives his or her relationship to the world (nature, animals, institutions, objects, the universe, God) (Sue 1981). The concept of world view is used to illustrate how different individuals and cultural groups tend to experience the world in different ways. World views are learned ways of perceiving one's environment and, as a result, can become salient factors in shaping the way that individuals perceive and respond to individuals and events in their environment.

The concept of world view has been used by researchers to discuss how interpersonal conflicts are often a result of conflicts on eight world view dimensions: psychobehavioral modality, axiology, ontology, ethos, epistemology, logic, concept of time and concept of self (Myers 1991; Nichols 1976; Nobles 1972; Calisch 1996). This conflict is termed world view incongruence (see Figure 10.1).

The world view incongruence model illustrates how world view conflicts come into play in relationships. World view incongruence is not a static variable. It is dynamic in that it can vary according to relationship pairs, situations, world view dimensions and time constraints.

World view dimensions	Example of world view positions
Psychobehavioral modality	Doing vs. Being vs. Becoming
Axiology (values)	Competition vs. co-operation Emotional restraint vs. expressiveness Direct verbal expression vs. indirect Seeking help vs. 'saving face'
Ethos (guiding beliefs)	Independence vs. interdependence Individual rights vs. honour and protect family Egalitarianism vs. Authoritarianism Control and dominance vs. harmony and deference
Epistemology	Cognitive vs. Processes Affective vs. vibes/Intuition Cognitive and Affective
Logic (reasoning)	Either/or thinking vs. both/and thinking vs. circular thinking
Ontology (nature of reality)	Objective vs. material Subjective vs. spiritual Spiritual and material
Concept of Time	Clock based vs. event based vs. cyclical
Concept of Self	Individual self vs. extended self

Figure 10.1. World view incongruence
 Source: Myers (1991)

World view conflicts within the triadic relationship may result in distrust, hostility and resistance. Although it is not always necessary for all parties in the relationship to have congruent world views, it is critical that the supervisor and the supervisee be aware of potential world view incongruencies that may disrupt the therapeutic and supervisory process. As with most issues, awareness and knowledge are the initial steps, with assessment of the world views of the other parties within the triadic relationship as a secondary step.

Given the possibilities of cross-cultural world view conflicts, supervisors and supervisees may need to gain an understanding of their world view and how world view conflicts play a role in the therapeutic and supervisory

relationship. This is where the use of art materials and artistic non-verbal intervention can be a powerful tool for stimulating awareness and illustrating similarities and differences between parties that can lead to conflicts and misunderstandings. The significant contribution of the use of art and non-verbal exploration regarding the supervisory relationship has already been noted (Calisch 1994a, 1994b) and the need for examination of culture and values within one's training (Cattaneo 1994).

Cross-Cultural Relevance of Current Supervision Theories and Approaches

Quite a few models of supervision exist, although none address cross-cultural issues directly. Since the relevant cross-cultural dimensions that may affect supervision have been noted, a review of the major classes of supervision models with a critique regarding cross-cultural issues is in order.

As Holloway (1992) pointed out, models of supervision first paralleled the major schools of psychotherapy. The psychoanalytic school presented the first model of supervision requiring psychoanalysis, intensive self work and awareness, and modeling by the supervisor. The goal of the supervision process is to use the dynamics of the supervisor/supervisee relationship to work through non-therapeutic patterns of relating with others (Russell *et al.* 1984). The psychoanalytic supervisory approach, like the psychotherapy approach, provides a rigid frame for interpreting client and supervisee behaviors and attitudes. The culture-bound nature of interpretation limits the introduction of culture-specific information pertinent to either the client or the supervisee. Psychoanalytic approaches, among others, emphasize that most problems, in both content and process, are a function of intrapsychic rather than societal forces within the client and/or the supervisee (Atkinson *et al.* 1993; Sue 1981; Sue and Sue 1990; Sue and Zane 1987).

Observational Supervisory Models

The ability to directly observe the behaviors of therapist/supervisee and the client appears to have generated more contemporary approaches to supervision (Holloway 1992). The major focus of these approaches is the operationalization of Rogers' (1957) and Truax and Carkhuff's (1967) facilitative conditions. Those conditions are predicated upon a view of human beings as positive, growth-directed beings who would develop appropriately if the conditions were present. The objective of phenomen-

ological approaches such as the approach of Rogers is to train the supervisee to create and effectively communicate the therapeutic conditions. The use of direct observational methods led to the description of discrete psychotherapy behaviours or skills that are used to train supervisees/ therapists.

However, Ivey (1987) indicated that the appropriateness of various psychotherapy skills or behaviors is likely to be dependent upon the cultural perspective of the client. The appropriateness of counseling and supervision behaviors is dependent upon the cultural perspectives of all parties to the supervisory process. It is possible, therefore, that cultural conflict between the supervisor and supervisee can surface with respect to skills usage such as self-disclosure or direct confrontation (Sue 1981). Furthermore, to the extent that observational approaches to supervision are based on phenomenological approaches such as person-centered psychotherapy, they are flawed by the same cultural biases that plague other talk-oriented, intrapsychic-oriented approaches.

Also, there is a lack of empirical evidence supporting the relationship between exhibiting high levels of facilitative behavior and positive therapeutic outcome (Russell *et al.* 1984). It may be that unexplored cultural dimensions mediate the relationship.

Group Supervision

As Holloway (1992) pointed out, group supervision approaches represent another evolution in the development of supervisory models. Group supervisory approaches rely on the multiple feedback of additional parties to the supervisory process, though the focus has chiefly been on increasing the self-awareness of the therapist/supervisee's interpersonal style and behavior. To the extent that group supervision can be utilized to elicit alternate cultural perspectives concerning psychotherapy and supervisory relationships, it would be a very effective supervisory approach (Gibbs 1985). The usefulness of group supervision as a means of increasing the cultural relevance of supervision is probably positively correlated to the degree of cultural homogeneity present in the group.

Behavioural Models

Behavioral theories have been the source for several more approaches to supervision (Jakubowski-Spector, Dustin and George 1971). Common to these approaches, according to Russell *et al.* (1984), is the identification of

specific skills and behaviors that make up each stage of the psychotherapy process and the application of learning principles to the reinforcement of those skills and behaviors and to the extinguishing of inappropriate behaviors. The major criticism of behavioral approaches to supervision is that they appear to oversimplify the psychotherapy process and ignore some of the interaction dynamics that characteristically surface in cross-cultural encounters – such as client cultural restraints on self-disclosure or therapist denial of culturally dissonant components of client problems (Atkinson *et al.* 1993; Russell *et al.* 1984).

Cross-Theoretical Models

There exist other models of supervision based upon theories of psychotherapy such as rational-emotive therapy (Wessler and Ellis 1983), client-centered therapy (Patterson 1983) and social learning theory (Hosford and Barmann 1983). However, these have been criticized for providing few directions for research and practice and for being inconsistent with the observation that supervisors do not practice supervision in the same way that they practice psychotherapy (Holloway 1992). Holloway (1992) pointed out that, over time, recognition that the practice of psychotherapy is different from that of teaching psychotherapy has given rise to cross-theoretical models of supervision. These models, according to Calisch (1989) and Russell *et al.* (1984), incorporate knowledge of individual differences, social role theory and instructional psychology. These are two major cross- theoretical approaches: social role models and developmental models (Holloway 1992).

Social Role Models

Holloway (1992) observed that a number of supervisory approaches (Bernard 1979; Littrell, Lee-Borden and Lorenz 1979) emphasize a set of roles for the supervisor that establish certain expectations and attitudes about what functions a supervisor will perform. Supervisor involvement that is consistent with role expectations will promote Behavioral consistency and certainty for the supervisee/therapist. These approaches have already been criticized for their lack of specificity (Russell *et al.* 1984) and for the lack of research testing the models (Holloway 1992; Russell *et al.* 1984). What has yet to be established, on either a conceptual or an empirical level, is the possible role of between-group and within-group cultural variables in shaping or mediating the formation of efficacious expectation and attitudes.

Expectations and attitudes are products of a person's cultural perspective. If a supervisor engages in a role that interacts unfavorably with that expected by a supervisee, there can be conflict. Given that supervisors and therapist trainees rely upon their social power to influence the attitudes and behaviors of supervisees and clients respectively, how the influencers' roles are perceived by those they hope to influence can affect their perceived credibility and attractiveness. These perceptions will ultimately affect their ability to exert their influence (Strong 1968).

Developmental Models

Several models present clinical supervision as a process possessing sequential and qualitatively distinct stages through which the supervisor and the supervisee pass (Littrell *et al.* 1979; Russell *et al.* 1984). These models represent the latest development in the evolution of supervisory models and theories. They generally assume that formal training is necessary for a supervisee's skills to improve – that is culturally biased in itself. Supervisees, for example, may believe that they need an academic credential in order to practice psychotherapy but they may not believe that traditional approaches to psychotherapy training will enhance their repertoire of therapeutic skills. Quite to the contrary, they may actually believe that current training approaches will rob them of the ability they have developed prior to entry into the training program.

Developmental models of supervision have been influenced by theorists such as Chickering (1969) and Erikson (1963), who proposed models of universal psychosocial development chiefly predicated on studies of people in Western societies. The first of these supervisory models proposes clearly defined stages of supervisee development, often predicated upon a trainee's position in the training hierarchy (namely pre-practicum, practicum and internship) in which specific issues or developmental tasks must be resolved before progressing.

Supervisory models that fit into this category include Hogan's (1964), Littrell *et al.'s* (1979) and Stoltenberg's (1981) models. Common to these notions is the assumption that novice therapists need more structure and instruction than experienced therapists. It seems that cultural conflict and misunderstanding are most likely to surface in the earliest stages of the supervisory process. This is due to the power differential in the supervisor/supervisee roles, as described by the models. If not handled properly, the early stages of supervision along the lines of those models will result in

cultural oppression for both the client and the supervisee/therapist. Such oppression is unlikely to be experienced by a trainee in the last stages of those models because if the supervisee/therapist has survived up to that point, the trainee is likely to be well-indoctrinated or culturally assimilated and because the models allow a more collegial relationship between supervisee and supervisor to engage in a mutually growthful experience.

A second category of developmental supervisory model exists that incorporates a step-by-step, cyclical process of conflict resolution and skill mastery of various issues encountered in professional training. The models of Ekstein and Wallerstein (1972), Delaney (1972) and Loganbill, Hardy and Delworth (1982) are examples of this second group of models. These models allow for much more mutuality in the relationship between the supervisor and the supervisee for joint problem-solving than occurs in the early stages of the first category of developmental supervision models.

Indeed, one model – Loganbill *et al.* 1982 – explicitly identifies the issue of respect for individual differences for skill mastery and conflict resolution, though it is the only such model that does so. Nonetheless, the Loganbill *et al.* model ignores the influence of supervisor and supervisee cultural backgrounds on the process of clinical supervision. Instead, the model focuses solely upon the importance of the trainees acquiring skills and facilitative attitudes with respect to the client's cultural frame of reference.

Neither category of supervision model explicitly articulates the potential interaction between clients, therapist/supervisees and supervisors of different racial, ethnic and cultural characteristics. Nor does either address the salient cross-cultural dimensions and dynamics to which focus should be given in supervision. It would seem that a new development in supervisory model building is needed that explicitly addresses the cultural characteristics of all supervisory parties, the dynamics of their interactions and the process of working through cross-cultural dilemmas in supervision and counseling.

Needed Conceptual and Empirical Directions: Current Studies

Only two studies could be located in the published psychological literature in which the role of cultural and racial characteristics in supervision was investigated. In the first study, van der Kolk (1974) found that black supervisees anticipated less supervisor empathy, respect and congruence than white supervisees. In the second study, Cook and Helms (1988) studied the responses of four racial/ethnic groups – Asian, black, Hispanic and Native American – concerning factors affecting the quality of cross-cultural clinical

supervision. They found that supervisor liking and conditional liking were related positively to satisfaction with supervision. Especially noteworthy were findings that supervisees' perceptions of their supervision relationships with largely white supervisors varied according to their race/ethnicity. Furthermore, only two of five relationship dimensions (supervisor's liking and emotional discomfort) were related positively.

A third study (Ladany, Pannu and Brittan 1994) is currently unpublished but presents findings worthy of note. Offered as a test of Helms' (1990) model of racial identity interaction in the context of counselor supervision, the author investigated the influence of racial identity interaction and racial matching on supervisory working alliance and the supervisee's perception of his or her cross-cultural competence. Notwithstanding numerous method-ological shortcomings, findings appeared to indicate that racial identity was related to supervisory alliance and the supervisee's perception of the influence of the supervisor on his or her cross-cultural competence. The three sets of findings suggest that additional empirical study and concept-ualization concerning cross-cultural supervision is warranted, but the call has yet to be heeded.

Current Conceptualizations in Cross-Cultural Psychotherapy

Much has been written about the culture-bound nature of psychotherapy (Atkinson *et al.* 1993; Casas 1984; Sue 1981; Sue and Sue 1990; Sue and Zane 1987) but little has been written addressing the culture-bound nature of the supervision process. Of those who have addressed cross-cultural issues in training and education (D'Andrea and Daniels 1991; Hunt 1987; Leong 1993; Leong and Kim 1991; McRae and Johnson 1991; Parker, Valley and Geary 1986; Ponterotto and Casas 1987; Swanson 1993), most writers have delineated the structures of psychotherapy training as well as the needed training experiences necessary for producing multicultural competence. Regarding training structures, writers argued for the presence of racially and ethnically diverse faculty members and students, an articulated commitment to addressing training issues with respect to multicultural populations, modification of the core curriculum to ensure appropriate conceptual and experiential preparation to conduct effective therapy with diverse others and contact with diverse client groups. With respect to needed training experiences, writers have addressed the need to develop trainee knowledge, skill and attitudes relevant to psychotherapy across cultures. In order to accomplish this, most writers have argued for trainee assessment of cultural

attitudes and knowledge base through reading ethnic literature and taking classes in ethnic studies, developing culturally sensitive attitudes through various self-awareness programmes and expanding social and counselling contact with ethnically and racially diverse others.

Very few writers have presented a discussion of possible cross-cultural issues in clinical supervision. Peterkin (1983) and Morgan (1984) wrote about their experiences supervising pastoral care and psychiatric trainees respectively. Both of the authors spoke about the language barriers that surfaced, even in supervising individuals using 'English'. They also addressed the success that they experienced with their supervisees when they forthrightly addressed the role of cultural differences in their supervisory sessions in shaping their views of the client, supervisee and the psycho-therapy and supervisory processes.

Morgan (1984) suggested that cultural and racial differences in supervision pose problems that exceed those encountered in psychotherapy because the supervisee may not be free to escape the hierarchical and, possibly, oppressive environment of the supervisory relationship, whereas clients can quit therapy altogether. Holiman and Lauver (1987) discussed the use of co-counseling, direct observation and video recording to examine culture-based difference in perceptions of clients. The authors emphasized that their approach would be useful in exploring supervisee and supervisor perceptual filters.

Brinson and Kottler (1993) did not address supervision *per se* but they did address a number of issues surfacing in cross-cultural mentoring that can generalize to the supervisory relationship. The following issues were highlighted as sociocultural factors impeding cross-cultural mentoring and could impede the supervisory process: issues of trust, managing power relations, the unwillingness of the mentee to express a need for help, the readiness to believe that the trainee is judged and treated differently, feelings of isolation and cross-cultural misunderstandings. None of these issues have been addressed in existing supervisory models.

Because of the nature of ethnic and race relations in the United States, it is reasonable for racially and ethnically different others to approach one another cautiously. That caution is likely to be at high levels in supervisory relationships, in which European Americans are more likely to be the supervisors and racial and ethnic others are more likely to be supervisees. Hence, specific power dynamics will need to be carefully managed: paternalism and oppression on the part of the supervisor and internalized

racial oppression (Landrum and Batts 1985; Landrum and Brown 1990) on the part of the supervisee. Internalized racial oppression is the conscious and unconscious psychological response exhibited by individuals to racism. It is characterized by psychological reactions to internalized stereotypes and other negative messages regarding one's racial distinctness and is exhibited in the following ways: system beating, blaming the system, denial of racial heritage, avoidance and rejection of whites and Eurocentric systems and lack of understanding of the political and psychosocial significance of race and racism.

Effective supervision of these circumstances would be to explore the behavior and appropriately identify it as acting out or manipulative and to facilitate the therapist's understanding of how the behavior is played out in the therapeutic process, possibly as resistance. An excellent tool for this is the use of drawing and art to capture the perception and effect of the situation as experienced by the supervisee/therapist. Then supervisor and supervisee can discuss the rendering and make suggestions while uncovering insights into the situation.

Supervisees of a different race or ethnicity may be particularly sensitive and resistant to corrective feedback. When this sensitivity is added to the sense of isolation and 'fishbowlism' that many non-European Americans may experience in their graduate training programs, it is easy to see how cultural misunderstandings can become significantly problematic to the supervisory relationship and lead to the unconscious, but systematic, filtering out of such persons from the profession. Unfortunately, more racial and ethnically diverse persons are needed in the profession.

Supervisees may wish to maintain their cultural consciousness as well as what they may believe to be the cultural relevance of their therapeutic approaches. They may resist supervisory interventions in order to protect those approaches. Research and theory have yet to show how the cultural relevance of therapeutic and supervisory approaches is to be evaluated and developed.

What is urgently needed is an expansion of current supervisory models to incorporate the intercultural dynamics of world view, values, guiding beliefs, how one knows, reasoning process, nature of reality, concept of time and concept of self. A logical starting place might be an integration of my supervisory process model including the utilization of art with Loganbill *et al.*'s (1982) developmental model of supervision. For example, Loganbill *et al.*'s (1982) discussion of the assessment of the supervisee could be greatly

expanded to address the cultural interplay between the supervisee, supervisor and client. They did not formerly address this area within the framework of a cross-cultural encounter. In addition, the discussion of the supervisee developmental issue of respect for individual differences focused only on the need to appreciate client differences in backgrounds, values and physical appearance. They failed to include the fact that supervisors have these same issues with respect to clients and supervisees.

Important Research Variables

Recently, Holloway (1992) reviewed the research literature on supervision and determined that it could be organized around the following themes: individual and cultural characteristics of the participants, domain-specific expectations and goals, supervisory relationship, teaching objectives and strategies, evaluation and institutional factors. I will discuss some needed research directions in each of these areas with respect to cross-cultural issues.

Individual and Cultural Characteristics

No studies were found that examined the impact of the supervisor's ethnicity, race or cultural characteristics on important supervision variables. As already posited, it is expected that dimensions of difference interact with those of the supervisee/therapist and client to affect the supervisory process. Investigators have sought to determine ideal supervisor characteristics, the impact of supervisor experience and theoretical orientation and the influence of supervisor gender. It is still unclear, however, whether supervisor race, ethnicity and cultural characteristics affect how a supervisor is perceived by supervisees. Further, the impact of supervisor race, ethnicity and cultural characteristics is unexplored for a number of important dependent variables: supervisor satisfaction, supervisee satisfaction with supervision, preferences for interpersonal power bases, interpersonal influence and attraction, supervisee evaluations, supervisor effectiveness and role expectations.

With the exception of two studies (Cook and Helms 1988; van der Kolk 1974), investigations of the role of ethnicity/race and cultural characteristics of the supervisee have not appeared in the published literature with respect to the supervisory process. A number of important questions have yet to be asked and answered: Are there preferences for certain types of supervisees? How are culturally different supervisees perceived and evaluated by their supervisors? Do those perceptions interact with supervisor characteristics?

These are a few of the many questions currently unexplored by supervisory investigators.

In addition, there is a need to study whether supervisee ethnicity, race and cultural variables, either alone or in interaction with cognitive characteristics and experience level, influence the typical supervisee variables: supervisory needs, acquisition of psychotherapy skills, in-session cognitions, reactions to supervisory style, supervisory problems or issues, supervisee ratings, evaluations of supervisee, preference for supervisory activities, satisfaction with supervision and role expectations.

The possible influence of matching supervisor and supervisee characteristics on trainee satisfaction and performance has been studied, but not with respect to ethnicity, race and cultural characteristics. Possible additional dependent variables in such studies could be interpersonal influence and attraction, supervisory satisfaction, acquisition of skills, evaluation of supervisee and evaluation of supervisor.

It is evident that client characteristics affect the therapy relationship with the supervisee/therapist and may also influence the supervisory relationship. However, the possible influence of client characteristics on supervision has generally escaped empirical scrutiny. This is a surprise, given the current general assertion that the psychotherapy relationship needs to be more culturally relevant to multicultural others. Because of the role of supervision in shaping the structures of psychotherapy and art therapy, it makes sense that client cultural and racial characteristics might influence the content and process of psychotherapy and, as a consequence, be found to influence the content and process of clinical supervision. An important line of future research would be to investigate the possible effect of client characteristics, particularly cultural ones, on clinical supervision. I posit that these characteristics might be found to interact with those of the supervisee and supervisor as well.

Because of the likely influences among the world view perspectives of the client, supervisee/therapist and supervisor, it is suggested that an examination of this impact be made. Several authors agree that the supervisor is responsible for initiating the investigation and discussion of cultural and possible world view differences (Malchiodi and Riley 1996; Calisch 1989). A particular intervention and modality are suggested as well – the use of art materials and imagery in conjunction with the dialogue (Dufrene 1991; Malchiodi and Riley 1996; Calisch 1989).

References

Agell, G., Levick, M., Rhyne, J., Robbins, A., Rubin, J., Ulman, E., Wang, C. and Wilson, L. (1981) 'Transference and countertransference in art therapy.' *American Journal of Art Therapy 21*, 3–24.

Atkinson, D.R., Morten, G. and Sue, D.W. (1993) *Counseling American Minorities: A Cross-cultural Perspective.* Madison, Wi: Brown and Benchmark.

Bernard, J.M. (1979) 'Supervisor training: A discrimination model.' *Counselor Education and Supervision 19*, 60–68.

Bradley, R.W. (ed) (1987) 'Special section: Discussion on multicultural counseling.' *Counselor Education and Supervision 26*, 3, 162–191.

Brinson, J. and Kottler, J. (1993) 'Cross-cultural mentoring in counselor education: A strategy for retaining minority faculty.' *Counselor Education and Supervision 32*, 241–253.

Calisch, A. (1996) 'Multiculturalism and Art Therapy: Looking back and seeing beyond.' *Canadian Art Therapy Journal 10*, 2, 63–68.

Calisch, A. (1989) 'Eclectic blending of theory in the supervision of art psychotherapists.' *The Arts in Psychotherapy 16*, 37–43.

Calisch, A. (1994a) 'The Metatherapy of supervision using art with transference/countertransference phenomena.' *The Clinical Supervisor 12*, 119–127.

Calisch, A. (1994b) 'The use of imagery in teaching, learning, and supervision.' *The Canadian Journal of Art Therapy 8*, 30–35.

Casas, J.M. (1984) 'Policy, training, and research in counseling psychology: The racial/ethnic minority perspective.' In S.D. Brown and R.W. Lent (eds) *Handbook of Counseling Psychology.* New York: John Wiley.

Cattaneo, M. (1994) 'Addressing Culture and Values in the Training of Art Therapists.' *Journal of the American Art Therapy Association 11*, 184–187.

Chickering, A.W. (1969) *Education and Identity.* San Francisco; Jossey-Bass.

Cook, D.A. and Helms, J.E. (1988) 'Visible racial/ethnic group supervisee's satisfaction with cross-cultural supervision as predicted by relationship characteristics.' *Journal of Counseling Psychology 35*, 3, 268–274.

D'Andrea, M. and Daniels, D. (1991) 'Exploring different levels of multicultural counseling training in counselor education.' *Journal of Counseling and Development 70*, 1, 78–85.

Delaney, D.J. (1972) 'A behavioral model for practicum supervision of counselor candidates.' *Counselor Education and Supervision 12*, 46–50.

Dufrene, P. (1991) 'Comparison of treatment of traditional education of native American healers with education of American Art Therapists.' *Art Therapy; Journal of the American Art Therapy Association 8*, 1, 17–22.

Dulcai, D., Hays, R. and Nolan, P. (1989) 'Training the creative arts therapist: Identity with integration.' *The Arts in Psychotherapy 16*, 1, 11–14.

Ekstein, R. and Wallerstein, R.S. (1972) *The Teaching and Learning of Psychotherapy* (2nd edition). New York: International Universities Press.

Erikson, E.H. (1963) *Childhood and Society* (2nd edition). New York: Norton.

Gibbs, J.T. (1985) 'Can we continue to be color-blind and class-bound.' *The Counseling Psychologist 13*, 3, 426–435.

Helms, J.E. (ed) (1990) *Black and White Racial Identity: Theory, Research and Practice.* Westport, CT: Greenwood Press.

Hogan, R.A. (1964) 'Issues and approaches in supervision.' *Psychotherapy: Theory, Research, and Practice 1*, 1739–41.

Holiman, M. and Lauver, P.J. (1987) 'The counselor culture and client-centered practice.' *Counselor Education and Supervision 26*, 3, 184–191.

Holloway, E.L. (1992) 'Supervision: A way of teaching and learning.' In S.D. Brown and R.W. Lent (eds) *Handbook of Counseling psychology* (2nd ed.). New York: John Wiley.

Hosford, R.E. and Barmann, B. (1983) 'A social learning approach to counselor supervision.' *The Counseling Psychologist 11*, 1, 51–58.

Hunt, P. (1987) 'Black client's implication for supervision trainees.' *Psychotherapy: Theory, Research, and Practice 24*, 1, 114–119.

Ivey, A.E. (1987) 'Cultural intentionality: The core of effective helping.' *Counselor Education and Supervision 26*, 3, 168–172.

Jakubowski-Spector, P., Dustin, R. and George, R.L. (1971) 'Toward developing a behavioral counselor education model.' *Counselor Education and Supervision 10*, 242–250.

Ladany, N., Pannu, R. and Brittan, C.S. (1994, August) *Supervisory Racial Interaction, the Supervisory Alliance, and Cultural Competence.* Paper presented at the annual convention of the American Psychological Association, Los Angeles.

Landrum, J. and Batts, V. (1985, August) *Helping Blacks Cope with and Overcome the Effects of Racism.* Paper presented at the annual meeting of the American Psychological Association, Los Angeles.

Landrum, J. and Brown, J. (1990) 'Black mental health and racial oppression.' In D.S. Ruiz (ed) *Handbook of Mental Health and Mental Disorder Among Black Americans.* New York: Greenwood Press.

Leong, F.T.L. (1993) 'The career counseling process with racial-ethnic minorities: The case of Asian Americans.' *Career Development Quarterly 42*, 1, 26–40.

Leong, F.T.L. and Kim, H.H.W. (1991) 'Going beyond cultural sensitivity on the road to multiculturalism: Using the Interactive Sensitizer as a counselor training tool.' *Journal of Counseling and Development 70*, 1, 112–118.

Littrell, J. M., Lee-Borden, N. and Lorenz, J. (1979) 'A developmental framework for counseling supervision.' *Counselor Education and Supervision 19*, 129–136.

Lofgren, D. (1981) 'Art therapy and cultural difference.' *American Journal of Art Therapy 21*, 25–32.

Loganbill, C., Hardy, E. and Delworth, U.A. (1982) 'A conceptual model for supervision.' *The Counseling Psychologist 10*, 3–43.

Malchiodi, C. and Riley, S. (1996) *Supervision and Related Issues: A Handbook for Professionals.* Chicago: Magnolia Street Publishers.

McRae, M.B. and Johnson, S.D., Jr. (1991) 'Toward training for competence in multicultural counselor education.' *Journal of Counseling and Development 70*, 1, 112–118.

Morgan, D.W. (1984) 'Cross-cultural factors in the supervision of psychotherapy.' *Psychiatric Forum 12,* 2, 61–64.

Myers, L.J. (1991) 'Expanding the psychology of knowledge optimally: The importance of cultural differences.' In R.L. Jones (ed) *Black Psychology* (Third Edition). Berkeley, CA: Cobb and Henry.

Nichols, E. (1976) 'The philosophical aspects of cultural differences.' Paper presented at the conference of the World Psychiatric Association, Ibadan, Nigeria, November.

Nobles, W. (1972) 'African philosphy: Foundations for black psychology.' In R.L. Jones (ed) *Black Psychology* (First Edition). New York: Harper and Row.

Parker, W.M., Valley, M.M. and Geary, C.A. (1986) 'Acquiring cultural knowledge for counselors in training: A multifaceted approach.' *Counselor Education and Supervision 26,* 1, 61–71.

Patterson, C.H. (1983) 'A client-centered approach to supervision.' *The Counseling Psychologist 11,* 1, 21–26.

Pedersen, P. (1990) 'The multicultural perspective as a fourth force in counseling.' *Journal of Mental Health Counseling 12,* 93–98.

Peterkin, J. (1983) 'A White Australian woman's reflections on supervising Black students in America.' *Journal of Pastoral Care 37,* 2, 98–102.

Ponterotto, J.G. and Casas, J.M. (1987) 'In search of multicultural competence within counselor education.' *Journal of Counseling and Development 65,* 430–434.

Rogers, C. (1957) 'Training individuals to engage in the therapeutic process.' In C.R. Strither (ed) *Psychology and Mental Health.* Washington,DC: American Psychological Association.

Russell, R.K., Crimmings, A.M. and Lent, R.W. (1984) 'Counselor training and supervision: theory and research.' In S.D. Brown and RW. Lent (eds) *Handbook of Counseling Psychology.* New York: John Wiley.

Stoltenberg, C. (1981) 'Approaching supervision from a developmental perspective:The counselor complexity model.' *Journal of Counseling Psychology 28,* 59–65.

Strong, S.R. (1968) 'Counseling: An interpersonal influence process.' *Journal of Counseling Psychology 15,* 215–224.

Sue, D. and Sue, D. (1990) *Counseling the Culturally Different* (Second Edition). New York: John Wiley.

Sue, D.W. (1981) *Counseling the Culturally Different.* New York: John Wiley.

Sue, S. and Zane, N.W.S. (1987) 'The role of culture and cultural techniques in psychotherapy: A critique and reformulation.' *American Psychologist 42,* 37–45.

Swanson, J.L. (1993) 'Integrating a multicultural perspective into training for career counseling: Programatic and individual interventions.' *Career Development Quarterly 42,* 1, 41–49.

Truax, C.B. and Carkhuff, R. (1967) *Toward Effective Counseling and Psychotherapy: Training and Practice.* Chicago: Aldine.

Van der Kolk, C.J. (1974) 'The relationship of personality, values, and race to anticipation of the supervisory relationship.' *Rehabilitation Counseling Bulletin 18,* 41–46.

Wessler, R.L. and Ellis, A. (1983) 'Supervision in counseling: Rational-emotive therapy.' *The Counseling Psychologist 11,* 1, 43–50.

We Wear the Masks
A Study of Black Art Therapy Students

Chantel Laran Lumpkin

Abstract

Although in a field of study that places emphasis on the visual, black art therapy students often feel invisible. The lack of ethnic and cultural diversity among students, staff and research within the field of art therapy often translates into feelings of isolation for the student and lack of empathy and effectiveness for professionals when working with clients of color. This chapter looks at other common factors among art therapy students of color. Through survey and questionnaire, students addressed their academic backgrounds and professional experience; age, sex and marital status; family involvement and support systems; future goals in the art therapy field; program satisfaction; practicum placements and ethnicities of clients; interaction with fellow students, faculty and art therapy alumni; and education funding sources. By drawing awareness of, and attention to, the experience of being a visible minority, understanding will be fostered for peers and, subsequently, clients of color; a recruitment plan, specific to blacks, as art therapists and faculty members will be developed; the need for art therapy research, exploration and program development specific to ethnic minorities will be promoted; and national networking for ideas and support among black art therapy students will be encouraged.

There is a lack of ethnic and cultural diversity among students, faculty and research within the field of art therapy. Most art therapy students of non-European ancestry are noticeable minorities in their program of study. According to La Brie and Rosa (1994), only 1.9 per cent of those in the art therapy field are African American. Of the 3777 members responding to the survey, 591 were students. If we apply the ratio of 1.9 per cent, only 11 of the students were black. Although there has been increased interest in ethnic and cultural issues that affect art therapy, most studies focused on the therapeutic relationship of a European American therapist and a client who is a member

of an ethnic minority group (McGoldrick, Pearce and Giordano 1982; Campanelli 1991). Few studies, if any, focus on African Americans as clients or as art therapists.

My graduate research project, *A Study of Black Art Therapy Students and Implications for Recruitment* (Lumpkin 1995), responded to a need for work that addressed the experiences and irony of black students as visible minorities in a field of study that emphasizes the importance of the visual. The term 'African American' is specific only to blacks born in the United States; the term 'black' was used in this study to include all students of African ancestry. By exploring the cultural issues affecting students of African descent, I hoped to increase empathy among art therapists for fellow students, peers and clients.

Issues fostering this study included: the scarcity of diversity among therapists; the failure of art therapy programs to reflect the cultural diversity of host cities, despite large minority populations; the prevalence of non-black students who work cross-culturally with minority clients in practicum; the difficulties created by cultural differences and client preference for therapists who shared their culture (Hunt 1987; Jones 1991; Wilson and Stith 1993); my own feelings of isolation and need to connect with others who shared my culture and experience; and the scant attention paid to blacks as clients or therapists in art therapy literature. The study looked at the statistics and experiences that connoted common bonds for the students. This chapter will address the highlights of the data compiled and pay specific attention to the black experience.

Literature Review

Since materials about blacks and art therapy were basically non-existent, *A Study of Black Art Therapy Students* examined literature pertaining to blacks as graduate students, art and art therapy, the characteristics of the accredited art therapy programs and the self-reported experiences of the graduate art therapy students of African ancestry enrolled at the time of the study. Based on the findings, the black art therapy student places extreme importance on the support and influence of family and friends (Bucher, Stelling and Dammeruth 1969); believes that experience is necessary for learning and providing framework for the individual's personality, expectations and aspirations (Goebels 1984); believes in the interrelatedness of the arts, community and mental health (Naitove 1980), which is founded on the African world view that being with someone or part of something is more

important than being in the process of becoming (Sodowsky *et al.* 1994), is impacted by alienation (Sayal-Bennett 1991) and struggles to achieve parity with peers and faculty (Smith and Davidson 1992); and attempts to survive, or fit in, or integrate the both (Goebels 1984; McGee 1981). The literature also suggests that the struggles faced by the black art therapy student are not solely based on the internal struggles of becoming art therapists but result from the external socio factors experienced in the becoming (Floyd 1982; Nettles 1990). This collage of literature lays the foundation for the experiences of the black art therapy student.

Method

To solicit participants for this study, I sent each of the 27 American Art Therapy Association (AATA) accredited programs a letter describing the study and requesting its participation in the survey. I also enclosed the Minority Art Therapy Student Enrollment and Consent for Release of Information forms to enroll students of African ancestry in the study. Once enrolled, I sent each consenting participant the questionnaire that formed the basis of this study. I designed the *Black Art Therapy Student Questionnaire* to gather specific demographics and experiential information about black art therapy students. That information provides an overall picture of the black art therapy student and his/her experiences in the art therapy program environment.

All eight respondents were female. Only one program reported having a black male enrolled. Sadly, we were unable to reach him for consent for inclusion in this study. It would have been interesting to compare his responses with black female students since he was a double minority, black and male. The use of the term 'blacks' as an ethnic group permitted inclusion of any student of African ancestry. This was beneficial since responses came in from six African American, one African (Somalian) and one Haitian-Canadian (born in the Caribbean) students. The median age of the respondents was 35; ages ranged from 24 to 45 years. Only three of the students were younger than 30 years old.

Results

Of the reported 27 AATA approved programs that I contacted, four were inactive. Twelve of the 18 programs that responded returned information about minority enrollment. Twelve black students were enrolled in nine

programs. Three more students were reportedly enrolled at a school that did not return materials for inclusion in this study. Personally, I knew three additional students of African ancestry who attended schools that did not participate in the study. In total, 18 black students were enrolled in 23 active AATA-approved art therapy programmes, at the time of this study.

Black Art Therapy Student Responses

I sent nine questionnaires to art therapy students of African ancestry – six after receiving their signed consent forms and three whose addresses I acquired at the 1994 AATA national conference. An additional student completed the questionnaire via a phone conversation. I myself filled out a questionnaire. Eight of eleven questionnaires were completed and returned.

For most students, the family was the main support and their school was close to home. Except in one instance, all listed family as the primary source of emotional support. Other sources included friends and the church. The church's traditional role as the central force in black communities is reflected in most of the subjects report of some religious affiliation or spiritual faith. The majority are Christian. Other common denominators among students were educational financing and status as the only black student in their respective art therapy program. All students reported financing their education through either financial aid (loans, scholarships, grants, work-study) and/or employment. Expense did not play a significant role in choosing a program but did figure in whether a student finished the program on time. Most students noted the program's curriculum and art therapy theory was the deciding factor. The added stresses of having to work while attending school resulted in some students taking an additional year to complete the thesis and practicum requirements. Interestingly, five of the respondents planned to pursue doctoral degrees; all reported plans to continue in the field of art therapy after graduation and to become Registered Art Therapist's (A.T.R.). Most respondents also planned to get additional licensing, either as a Board Certified Art Therapist (B.C.A.T.), Marriage Family Child Counselor (M.F.C.C.) or Licensed Professional Counselor (L.P.C.).

The students worked with a diverse population of ages and diagnoses in their practicum and job sites. Settings varied and included schools, hospitals, out-patient clinics and a shelter. The majority of students worked with children, teens and families on mental health issues. Prominent issues included child abuse, emotional disturbances and chemical dependency.

Most placements permitted students to use art therapy with black clients and those belonging to other ethnic groups. For most, however, blacks comprised a minority of clients served. Only one student worked exclusively with black clients and two others worked only with clients of European ancestry. Not surprisingly, the latter two students expressed feelings of isolation and a lack of awareness or understanding on the part of their peers. As one respondent wrote: 'I feel that I am the only one that has to address ethno-cultural issues. Despite the support of the faculty and other students, no one else seems to be personally affected'.

Students were also asked to rate, on a scale from 1 to 5 (failing to excellent), their respective art therapy programs regarding curriculum and policies for ethno-cultural awareness, sensitivity, knowledge, diversity and willingness to address cultural issues. (Ethno-cultural awareness is the conscious perception of racial and cultural issues and differences. Ethno-cultural sensitivity is the act of being easily disturbed by, and the ability to register, the nuances of racial issues subtly evidenced, although one might not be able to pinpoint the cause of the disturbance.) The highest programme ratings averaged 3.75 in the area of willingness to address ethno-cultural issues. Below-par ratings occurred in the areas of diversity, knowledge and awareness. Students repeatedly expressed concern in these areas: 'Although my program is anti-racist and tolerant, the [feeling of having] a cultural curriculum for one, marginalizes and ignores issues of blackness'; 'More ethnically diverse faculty is needed for rapport, academics, mentor[ing] and advice'; 'I feel that I am the only one who has to address ethnocultural issues. I do not see either faculty or [other students] addressing these issues'.

Three students responded outright that they had experienced racism in their art therapy programs, two students answered 'yes' regarding experienced racism on campus and three others reported experienced racism in their practicum setting. One student was unsure about experiencing racism at her practicum. Wherever it occurred, in most cases the perceived racism was 'subtle and untraceable ... difficult to prove'. One student stated that the experiences in her class had not been so subtle and included telling racial jokes and off-color comments. Another student reported witnessing racist incidents directed at the only other blacks on her campus, the janitorial staff. Students also reported incidents of racism that they related to program location and the host city's historical racial tensions. A couple of students reported overlooking racial slurs as 'simple ignorance'.

Students were asked with whom they could discuss cultural issues and problems. All reported family and friends. Although they could speak with other art therapy students or their supervisors about these issues, students were ambivalent about talking with them. Some others were torn between the need to make others more culturally aware and resentment of expectations that they were spokespersons for all blacks and ethnic minorities. Some students, however, expressed a willingness to use every opportunity to educate others on cultural issues.

Only one student reported that she seldom felt isolated in her program as an ethnic minority. However, she had frequent contact and interaction with black art therapists. All other students responded that they always or often felt isolated: 'Even as an undergraduate, I was one of two blacks in my art education program. In that program I felt less sensitivity and [as a result] more isolated. Concerns of African Americans were not addressed. Because of the sensitivity of the primary head of [this] art therapy program, … I feel more support; however, the isolation still exists'; 'I am aware of being visibly alone, and that no one else truly understands'.

There were essay questions asking students to comment and suggest ways to improve the cultural conditions in the field of art therapy. Students were also asked for ideas about minority recruitment. Similar suggestions were grouped together and all are listed and discussed in the study's Implications and Recruitment section.

Finally, subjects were given the option to create a piece of art that represented their experience as a black art therapy student, and to title it. They were sent a consent form for use of the art in this study and subsequent presentations. Despite students' stated intentions to send slides and art, none were submitted. The reasons given for not completing or sending art were time constraints and busy schedules. Although valid excuses, based on questionnaire responses and phone conversations with the respondents, there seemed to be more personal reasons for their reticence to submit art. Art gives a visual voice to the feelings, it says what might otherwise be impossible to verbalize or articulate. That students did not submit artwork hints at varied possible reasons for their reluctance: an inability to reconcile ideals or to articulate the message; or their inability to balance the concept of high visibility due to skin color, as opposed to invisibility to society; or a desire to remain anonymous in this study. The lack of art created a very loud silence.

Epilogue

We Wear the Mask

We wear the mask that grins and lies,
It hides our cheeks and shades our eyes,
This debt we pay to human guile;
With torn and bleeding hearts we smile,
And mouth with myriad subtleties.
Why should the world be overwise,
In counting all our tears and sighs? Nay, let them only see us,
While we wear the mask ...

(Paul Laurence Dunbar, quoted in Mullane 1993, p.349)

I originally thought that I was not ready to take off my mask because I did not want to reveal all. Although it would be far easier and less painful to just get through the program with a mask on, it's not always possible. I have finally realized that in attempting to reach out to my peers, and in trying to maintain my own balance as the *only Black*, I had removed the mask and found validation for my own experiences, feelings and choices concerning art therapy.

References

Bucher, R., Stelling, J. and Dammeruth, P. (1969) 'Differential prior socialization: a comparison of 4 professional training programs.' *Social Forces 48*, 2, 213–223.

Campanelli, M. (1991) 'Art therapy and ethno-cultural issues.' *American Journal of Art Therapy 30*, 2, 34–35.

Dunbar, P.L. (1993) 'We wear the mask.' In D. Mullane (ed) *Crossing the Danger Water: Three-Hundred Years of African-American Writing*. New York, NY: Anchor Books.

Floyd, N. (1982) *The Minority Student in Higher Education: An Annotated Bibliography*. Microfiche.

Goebels, V. (1984) 'Some views about the new art therapist.' *Art Therapy, 84,* May.

Hunt, P. (1987) 'Black clients: Implications for supervision of trainees.' *Psychotherapy 24*, 12, 114–119.

Jones, F. (1991) 'The African American psychologist as consultant and therapist.' In R. Jones (ed) *Black Psychology, Third Edition*. Berkeley, CA: Cobb and Henry Publishers.

La Brie, G. and Rosa, C. (1994) 'AATA, Inc. 1992–1993 Membership Survey Report.' *Art Therapy 11*, 3, 206–213.

Lumpkin, C. (1995) *A Study of Black Art Therapy Students and Implications for Recruitment*. Loyola Marymount University: Unpublished Master's Thesis.

McGee Jr., S. (1981) *The Black Family: Culture Specific Therapeutic Needs.* Unpublished paper presented at the proceedings of the 12th Annual American Art Therapy Association Conference.

McGoldrick, M., Pearce, J.K. and Giordano, J. (1982) *Ethnicity and Family Therapy.* New York: The Guilford Press.

Naitove, C. (1980) 'Creative arts therapist: Jack of all trades or master of one?' *The Arts in Psychotherapy 7,* 4, 253–259.

Nettles, M. (1990) 'Success in doctoral programs: Experiences of minority and white students.' *American Journal of Education,* 494–522.

Sayal-Bennett, A. (1991) 'Equal opportunities – empty rhetoric?' *Feminism and Psychology 1,* 1, 74–77.

Smith, E. and Davidson, W. (1992) 'Mentoring and development of African American graduate students.' *Journal of College Student Development 33,* 6, 531–539.

Sodowsky, G., Maguire, K., Johnson, P., Ngumba, W. and Kohles, R. (1994) 'Worldviews of white American, Mainland Chinese, Taiwanese and African students: an investigation into between-group differences.' *Journal of Cross-Cultural Psychology 25,* 3, 309–324.

Wilson, L. and Stith, S. (1993) 'The voices of African-American MFT Students: suggestions for improving recruitment and retention.' *Journal of Marital and Family Therapy 19,* 1, 17–30.

Cross Cultural Inquiry in Art and Therapy

Mona Chebaro

Abstract

Mental health professionals as well as art therapists tend to generalize the mental, environmental, and emotional meaning of their client's artwork, especially those with foreign backgrounds. Information such as cultural background, and its particular attributes, is frequently discarded. This chapter will document how clients are misdiagnosed when therapists erroneously diagnose clients irrespective of their art and culture. Clients are constantly being separated from their roots, ethnicity, cultural values, beliefs and language. Art therapists are misdiagnosing clients by limiting their treatment evaluation to their academic training. This forces clients to adapt and adjust to the 'requirements' of different art directives and testing. Art therapists need to be their client's advocates, by recognizing their ethnic beliefs. The emphasis of this chapter is on helping therapists to understand and increase sensitivity to diverse groups.

Introduction

As an immigrant to the United States who was born and raised in Beirut, Lebanon, I believe that an individual is part of his or her ethnicity regardless of the cultural differences existing between the new foreign country and his or her country of origin. McFee (1986) states: 'He/she has no culture is almost as bad as he/she has no personality' (p.9). This chapter will address the impact of culture and ethnicity on art and therapy by exploring the risks involved in misdiagnosing individuals by disregarding the existing relationship between their art and culture.

Before addressing the above issue, I would like to share the reasons I became interested in multicultural issues and the use of art as a therapeutic tool. While I was completing my master's in art therapy at the University of Arizona, I conducted most of my art therapy tests – such as Kinetic-House-

Tree-Person (Burns 1987), Kinetic Family Drawings (Burns and Kaufman 1970) – and other diagnostic tests with Lebanese students who were 18 years and older. I also conducted family art psychotherapy tasks with family members who came from a mixed marital background – Japanese and Lebanese – whose children were born and raised in the United States. The outcome of these art therapy tasks were examined in the classroom with fellow students and my professor. I was alarmed when I realized that the focus was centred around the participants' family histories, ages and genders and disregarded all ethnic, religious, social and cultural contexts that may have influenced the symbols employed in the artwork of these individuals. According to Chalmers (1973), 'the way art functions is to identify cultural values, belief systems, status and roles, ways of making order.' (p.8).

During one of my internships in a psychiatric hospital I had the opportunity to work with juvenile delinquent adolescents. During that time the cultural and ethnic bias and disregard of my rearing became a struggle between my supervisor and I. Many of my experiences, such as living in a war zone, were similar to events in my clients' lives. However, my supervisor did not take these similarities into consideration. My training evaluation was completed in light of my supervisor's experience and schooling rather than my own experiences and relationships with my clients. The anger, aggressiveness and despair that my clients exhibited was perceived by mental health professionals as 'resistant, borderline personality and/or depression'. This evaluation overlooked the daily living conditions these clients had to endure in order to stay alive. As a person who had witnessed similar violent events and lived under war conditions, I didn't consider these clients' violent behavior 'normal' but I did understand the source of their misconduct and their perception of survival. My role as an adjunctive and art therapist was not to judge their actions but to guide them through art directives to identify the sources of their anger and depression and to substitute inappropriate behaviors with other means of defence.

The need for multicultural education and cross-cultural awareness among mental health professionals became evident. McFee (1986) states: 'these art functions operate individually, in combinations, and in varying degrees throughout cultures, affecting the experience of the people subjectively' (p.9). Arnheim (1969) describes artistic activity as 'a form of reasoning, in which perceiving and thinking are indivisibly intertwined' (p.5). Naumberg (1973) notes: 'most drawings of the emotionally disordered express problems involving certain polarities. Graphic art affords the opportunity to

project all of these trends excessively, and after the student of the productions discovers the key to interpreting them, an opportunity is available to ascertain what occurs under an organized therapeutic procedure' (p.5).

Risks, Misdiagnosing and Disregarding Existing Relationships

Let us take, for example, the artwork of ancient Egypt to show the vital role art could occupy in revealing and understanding essential aspects of a culture and its people's identity. Ancient Egypt, as a living tradition, was dead by 400 AD. Egyptologists had to reconstruct the life of ancient Egyptians in order to understand their cultural beliefs and traditions. The success in bringing this ancient culture back to life was possible due to the important role art occupied during that millennium. It is through the significant number of artworks portraying their religion (death and the life beyond) and culture that ancient Egypt is a living tradition. The walls of the temples, tombs and palaces became a diary of that millennium to Egyptologists, historians and the rest of the world. Walls of paintings were discovered containing religious components depicting their lifestyle, political rulers and social and cultural beliefs. Sculptures also had the same importance, they represented political and religious aspects as well as the role of the king. They were a constant reminder of the divine power of the king, God and ruler. Another indication of the important role of the king can be seen in the composition of both art forms, paintings and sculptures. The king's image is always the dominant figure in a painting or sculpture. This hierarchy also influenced the composition and content of the artwork and language (hieroglyphics). Art in those millennia was interwoven with language. Wilkinson (1992) states: 'through symbols the Egyptians sought to represent many of their religious beliefs and ideas and pictures were used in this way to make the transcendental and the unseen both immediate and understand- able' (p.9).

This ancient culture, with its significant art, is an excellent example of the risks and the danger art therapists and mental health professionals inflict on their clients' personal growth by forcing them to dissociate from their roots and their ethnic and cultural ties. Art in ancient Egypt was the center of that civilization's world and understanding the Egyptians' 'world view' meant understanding the art world that represented these views symbolically. Today, art therapists and mental health professionals are faced with an equal challenge because the role of art differs from one country to another, as well as having different cultural connotations. Mental health professionals and art

therapists need to understand their clients' cultures and belief systems by raising the level of their cross-cultural awareness. Cross-cultural education through the arts is essential because it serves to enhance creativity and develop an unbiased view of foreign countries and foreigners. Art may be considered a common tool. People are aware of the craft. However, visual art, such as painting, requires more of the viewer because it provides the viewer with the opportunity to develop a sense of respect and understanding for different people with individual differences. No one alive today could tell what the ancient Egyptian was thinking when he or she created the artwork. However, with living cultures, people have the benefit of having a living representative and the resources to understand these countries by investigating their literature, poetry, history, geography, language, arts and customs. Regardless, even with living representatives, art therapists and mental health professionals need not resort to assumptions.

Being an immigrant, an art therapist and a painter, I know that art is a language that gave me the freedom and the ability to connect to my roots. It also helped me to open the door between the life I left behind and the new one I was about to adopt. This travel in time (past life and present) was a part of the healing process which I needed to face in order to grieve the loss of my country of origin and accept my new foreign life. As an immigrant, I firmly believe that a person can be a member of a new society but can never become a part of its culture. As an artist, I was able to transfer these personal issues into a visual reality. Once these unconscious disturbing thoughts surfaced into my conscious mind, I was able, through my drawings, to identify the beauty of the ugliness of starting a new life within a foreign culture. I believe that a foreigner who is given the opportunity by his or her art therapist to travel to his or her 'private native mind' will be capable of succeeding in relieving his or her anxieties and concerns through the use of art. Art, to artists and clients, is the language of the self and the world that exists around that self. Therefore, it is to the client's benefit not to jeopardize the projected symbolic imagery by stereotyping its role and meaning. The clients' right to express their feelings freely without the fear of being misdiagnosed or labeled is the key to a productive therapeutic session.

Over-generalization of the Symbolic Meaning of Art

Ethnic traditions and dominant cultures can be traced through the artist's projected symbols and images. Murphy (1984) asserts: 'human figure drawings can act as indicators... The approach to the patient and the style of

the therapy is of paramount importance' (pp.102–3). Therefore, it is important to help foreign clients, regardless of their ages, gender and ethnic backgrounds, restore the balance of their native cultural traditions by avoiding assumptions.

Art therapists need to keep in mind that their clients' artwork involves the client/artist's internal and external experiences. The approach to picture interpretation may differ with foreign clients due to the influence of their ethnic background. Art therapists need to see what the picture is saying and not resort to an unfounded psychological analysis. Furth (1988) states: 'hearing with the eyes is a formidable task, but it is, in fact, the person who approaches picture analysis with apprehension who will most probably succeed in it' (p.34). Art therapists impede the growth of their foreign clients by stereotyping the meanings of their art symbols. The generalization of these symbols changes the outcome of the diagnosis and destroys the healing process. In a therapeutic setting the art therapist who is the analyst first needs to be conscious of the client's own impression of his or her personal artwork. Second, he/she does not needs to limit the interpretations of the artwork to a specific academic training. The drawing should be addressed gradually to allow the repressed cultural, ethnic, religious and personal connotations to emerge.

Let us take, for example, Vernis, Lichtenberg and Henreich (1974). The Draw-a-Person-in-the-Rain test was adapted to measure the amount of stress a person was undergoing and how well this stress was able to be dealt with without psychotic regression. The client was asked to draw a person in the rain with the assumption that the rain would indicate the amount of stress felt by the subject. The client's defences against stress were then symbolized by the defences drawn against the rain (i.e. an umbrella, coat, clouds or tree). Although untested, it is probably safe to suggest that the Draw-a-Person-in-the-Rain test would be of limited value to clients who grew up in the Middle East or North Africa (with the exception of those from the Levantine coast, Palestine, Lebanon and coastal Syria). Since rain is very rare in this part of the world, particularly on the Arabian Peninsula and North Africa, rain is considered a blessing, an event to be celebrated and a source of wealth. Therefore, rain is neither viewed as a source of stress, nor as something from which to be protected. In Egypt and Saudi Arabia when it rains, people dance in the rain. It is more than likely that a drawing of such an event would be misinterpreted by a Euro American therapist unfamiliar with the Arabic cultural connotations of rain. Art therapists need to consider the risks

involved in misdiagnosing the existing relationship between their clients' art and culture. Furth (1988) also states: 'not all ... suggested considerations apply universally to all drawings, so the researcher must break the drawing down into its components, and only then decide the appropriate elements on which to focus' (p.35).

Another tragic example of our (art therapists and mental health professionals) failure in providing an accurate reading of these clients' artwork is evident in our tendency to generalize components that appear similar among different countries but may carry specific values in preserving the traditions existing within these clients' countries of origin. Overlooking the ethnic identity of these clients is due to the following aspects:

1. Lack of Education in Regional Geography

Westerners, including mental health professionals and art therapists, do not understand that Lebanon, for example, is located on the Mediterranean coast, not in the middle of the desert of Saudi Arabia. In fact, as a native Lebanese, I feel confident in confirming that no desert exists in Lebanon, yet the stereotypical view is that the country is a desert surrounded by sand and is filled with nomads roaming the Baququa valley. My concern is that, frequently, art therapists who do not understand Middle Eastern cultures end up treating these foreign clients. The same disregard to cultural sensitivity is being applied in the schools. All Arabs are not the same, nor are all Arabic countries. It is very dangerous to assume that all Arabic countries use camels for transportation, live under tents and use a pile of sand as a mattress. These misconceptions of the cultural heritage lead to the misdiagnosis of these clients' symbols by generalizing the meaning of their visual vocabulary.

2. Over-generalization of Cultural Traditions

Culture is a series of beliefs, habits and ideas shared and adapted by a group of people; each group of individuals together create a nation. These beliefs, habits and ideas together create a tradition. All countries share to some extent the same traditions but, nonetheless, have produced different means of functioning within the same set of traditions. The same concept applies in art. Social, political and religious traditions dictated and influenced artists' creativity for centuries. Everyday life scenes, portraits, figurative images and religious themes occupied their canvases, although the similarity of the

subject matter of these artist's canvases, sculptures, poetry, and literature did not limit their creativity and artistic expression.

The challenge that faces foreign clients in therapeutic settings is unethical assumptions and bias. Cultural diversity is being discussed more often in the United States and major educational issues, such as immigration, accelerate the need to face these differences rather than ignore them. Mental health professionals, especially, need to confront these issues.

Art therapists have to realize that foreign clients or immigrants are individuals with roots associated with independent traditions. The survival of these interconnected ties is what keeps these immigrants' integrity alive as well as their moral sense and self-esteem intact. These bonds and boundaries, that may seem unnecessary to a Westerner, are essential to these individuals' integrity. Through the use of art as an expressive medium, these individuals connect to their parents, communities, religious beliefs and educational systems. The misconception that the Western world has about immigration is pushing these foreign individuals to dissociate and reject the new country they immigrated to as well as its people. Immigration doesn't mean leaving one's roots, immigration means to occupy a new country physically, not mentally, emotionally and spiritually. Cross-cultural inquiry in art education has been excluded from the general literature and the lack of understanding of art itself is due to the professionals' need to develop an interest in understanding the 'hidden reality' existing behind the images rather than being consumed by always searching for the similarities in the artistic product.

A. INADEQUATE THERAPEUTIC GUIDANCE

Many symbols used by foreign clients are adapted from their culture of origin and are, as well, a projection of the individuals' rearing. It is relevant to say that the work of art is a channel of symbolic release of all the suppressed beliefs and maladjustments of the child hidden within all individuals. These representational images are a guide to the clients' state of mind and conflicts such as life/death situations, male/female sexual identity, father/mother relationships, love/hate feelings and, maybe, immigration. When clients draw, the meanings of these symbols are projected onto images that are intertwined with the relationship that exists between the client and his or her external and internal being, which frequently revolves around the client's past, present and his or her perception of his or her own future. The goal of the art therapist is to break down these internal ties rather than disconnect

them. Any attempt to disconnect these symbolic ties through the guidance of a non-cross-culturally oriented art directive will create alienation in the client/artist. They may become distant from their artwork and gradually move emotionally and mentally away from their pictures. The inability to release the speech of the unconscious mind will affect the growth of their egos and leave them unprotected from their personal issues and inherited beliefs and customs. The lack of adequate cross-cultural therapeutic guidance will affect their creativity and threaten their therapeutic environment by making it unsympathetic to their needs. Within the mental health profession the arts take a formal therapeutic role in being able to keep the trust of clients of different cultures and ethnicities. Art therapists and mental health professionals should acknowledge the need for a culturally pluralist approach in the field of therapy.

B. INADEQUATE DIAGNOSIS

Chalmers (1973) states: 'Art should be studied that is meaningful to the targeted population.' It is vital for art therapists interested in treating foreign clients to be democratic in their approach and multi-culturally oriented in their education. Art therapists need to modify their art directives and tailor them to assist their clients' therapeutic treatment, including their social concerns, moral beliefs and lifestyles. Art therapists and mental health professionals will succeed in overcoming the cultural barriers with foreign clients if they will allow themselves to accept alternative perspectives. This open-minded approach will provide foreign clients with a sense of appreciation and acceptance by their art therapists and mental health professionals. It is only then that a foreign client will feel safe in his or her environment and able to create and project personal symbols that can be analyzed accurately within the cultural context rather than judged for the unfamiliar individuality of that culture. Lynch (1992) asserts: 'it is only when we join the observed on the other side that it is possible to see ourselves and others clearly…but getting to the other side of the glass presents many challenges' (p.34). Over-generalizing foreign clients' artwork limits the art therapist's capabilities in achieving a cross-cultural competence and forces clients to compromise their ethnic individuality and identity.

C. LACK OF PROGRESSIVE REFORMS IN SCHOOLS CURRICULUMS

Many school curriculums in the United States exclude multi-cultural programs that serve to increase awareness and respect by majority groups

toward minority cultures – even the study of foreign languages which could play the role of a cultural mediator between these groups is not encouraged and nor are many museums' approaches. Most school curricula present foreign cultures by teaching predominately about the culture's history, religious traditions and customs, disregarding the social aspects that may have influenced these cultures. These limitations in the curricula have been practiced since the end of the Civil War (1880–1917). The 'tracking' system of differentiated curricula was adapted in public schools to isolate socially, economically, intellectually and spiritually the working-class masses from the élite in society. Due to the crucial alteration in the educational system between 1880 and 1917, Jane Addams and Ellen Gates Starr founded the first Hull-House, a social settlement in Chicago (1859–1940). These social settlements', or what we call today 'museums', main purpose was to provide equal educational opportunities by exposing and equipping working-class students with the proper art education. Addams states that the social settlement 'represented not so much a sense of duty of the privileged toward the unprivileged ... as a desire to equalize through social effort those results which superior opportunity may have given the possessor' (cited in Amburg 1990, p.105).

The injustice practiced, at the beginning of the 20th century, against industrial labor is similar to the injustice applied toward students in public and private schools today. The schools' curricula do not extend and enrich the students' knowledge of other countries or languages. The tracking system today has again succeeded in isolating individuals from their own ethnic, cultural, religious, artistic and spiritual roots. Educators, students and mental health professionals have suffered 'educational quarantine'. The lack of multicultural education and cross-cultural training in the United States has deprived all students of receiving the proper education. Similar cross-cultural bias is present today in museums where the ethnic identity of the artist is overlooked. The museums' agendas are to exhibit socially and politically 'acceptable' artwork, disregarding all 'unfamiliar' customs and religious beliefs projected onto the artwork. Only the artists' styles are evaluated and compared with other Western and European styles. The artists are then deprived of having their personal beliefs and cultural identity revealed to their viewers. The viewers are presented with superficial and limited information about the 'familiarity' of the artists' styles and choice of palette. The visual vocabulary in the artwork becomes another decorative element rather than a spiritual aspiration and, above all, a cross-cultural mediator.

Nadaner (1985) states: 'multi-cultural art education is first of all education, and all educational programs should serve the contemporary needs of contemporary students. It has become clear that the 'museums' approach to multi-cultural art education is not adequate' (p.53). The isolation of the artist from his or her ethnic background prevents the viewers from freely developing an independent intellectual opinion of the artists' country of origin and its ethnic beliefs. This biased 'aesthetic' approach in the study of visual arts has had a great impact on teaching, especially in the mental health profession.

3. The Influence of the Media

Journalism is another expressive form of art illustrated by words and presented through sentences. With the guidance of 'the written word', people have had the opportunity to travel to other countries and gain knowledge of new and unfamiliar foreign cultures, political systems and customs. Sojourns to other countries also influence ethnic beliefs as well as heritage and the role of religion on the traditions adapted in these countries. Words that represent these new cultures and ethnicities universally affect students, professors and the public all over the world. The eagerness to learn and understand other cultures played a major role in inviting journalism into peoples homes. The written words of journalists became wildly accepted as an eye-opener to the knowledge of the unknown.

Stereotyping Foreign Cultures

Many other forms of media have dominated peoples perceptions of other cultures, such as: television, theatre, movie industry, radio and even children's cartoon stories. However, journalism is the most powerful media influence on peoples' knowledge of foreign cultures. Through the power of their 'written words', journalists have succeeded in framing a global stereotyped image of foreigners and foreign beliefs.

The voice of journalism remains the representative of all foreign countries who cannot represent themselves. Let us take, for example, the American journalistic view of the Orient and then examine its significant impact on American readers. It is only recently, because of political and economic reasons, that Americans have become aware of the Japanese and Korean influential investments in the United States. Regardless, the American impression of other countries in the Orient, such as India, Arabia and Egypt,

remains veiled by the biased opinions of the media. American journalists continually portray Oriental countries as powerless, uncivilized and defeated Third-World countries. Today, journalists mislead their readers by portraying Islam as an Arabian religion followed mostly by Middle-Easterners and has overlooked the fact that Arabs are a minority within Islam (among Turks, Iranians, Indonesians, Chinese, Americans, Indians, Japanese and Pakistanis).

Journalists have replaced the religious and cultural identity of Islam with the symbol of terrorism and crime. Islam and Muslims are depicted as individuals who are restricted from all pleasures and bound by limited rules that rob them of their self-esteem and self-identity. The journalists' main concern was to attract a high number of readers by providing them with a 'European representation' of the Arabic-Muslim world rather than revealing the true identity of the Orient. These misconceptions transformed the cross-cultural learning experience between Americans and foreign countries, especially Arabic countries, and, instead, created a dispute between them about moral values and ethics. Said (1978) noted the following when speaking of Orientalism: 'After all, any system of ideas that can remain unchanged as teachable wisdom (in academies, books, congress, universities, foreign-service institutes) from the period of Earnest Renan in the late 1840s until the present in the United States must be something more formidable than a mere collection of lies' (p.6).

The goal of this chapter is to honor all clients of foreign origin and to encourage my colleagues (readers) to see, hear, and walk the way of their clients by acknowledging their ethnic backgrounds when planning their goals, objectives and interventions. Cultural beliefs and customs are the foundation of an individual's identity and personality. I believe that when a person cannot speak for him or herself, his or her culture can speak on his or her behalf. Even though this chapter discloses several risk factors involved in the diagnosis and treatment of foreign clients, mental health professionals are capable of helping their foreign clients if they are cross-culturally trained and respect the cultures which their clients represent.

References

Amburg, P.M. (1990) *Framing the Past: Essay on Art Education*. Reston, VA: the National Art Education Association.

Arnheim, R. (1969) *Visual Thinking*. California: University of California Press.

Burns, R.C. (1987) *Kinetic-House-Tree-Person Drawing: An Interpretive Manual*. New York: Brunner/Mazel.

Burns, R. C. and Kaufman, S.H. (1970) *Kinetic Family Drawings.* New York: Brunner/Mazel.

Chalmers, G. (1973) 'The study of art in a cultural context.' *Journal of Aesthetics and Art Criticism 32*, 249–256.

Furth, G.M. (1988) *The Secret World of Drawings.* Boston: Sigo Press.

Lynch, E.W. (1992) *Developing Cross-cultural Competence: A Guide for Working with Young Children and their Families.* Baltimore, MD: Paul H. Brookes Publishing Company.

McFee, J.K. (1986) 'Cross-cultural inquiry into the social meaning of art: Implications for art education.' *Jounal of Multi-cultural and Cross-cultural: Research in Art Education 4,* 1, 9.

Murphy, J. (1984) *Art as Therapy.* London: Tavistock/Routledge.

Nadaner, D. (1985) 'The art teacher as cultural mediator.' *Journal of Multi-cultural and Cross-cultural: Research in Art Education 3,* 1, 53.

Naumberg, M. (1973) *An Introduction to Art Therapy.* New York: Teacher College Press.

Said, E.W. (1978) *Orientalism.* New York: Pantheon Books.

Vernis, J.S., Lichtenberg, E.F. and Henreich, L. (1974) 'The draw-a-person-in-the-rain technique: Its relationship to diagnostic category and other personality indicators.' *Journal of Clinical Psychology 30*, 107–414.

Wilkinson, R.H. (1992) *Reading Egyptian Art.* London: Thames/Hudson.

Art Therapy and Native Americans
Blending Culture, Creativity and Healing

Phoebe Farris-Dufrene and Michael Garrett

Abstract

This chapter discusses elements of Native American healing processes and the significance of the arts in both indigenous and contemporary therapy. Suggestions are given for art therapists and other mental health professionals that work with Native American clients. Acknowledging that Native Americans are a product of both the dominant culture and their indigenous culture, the authors highlight historical and contemporary issues that affect Native American health, healing and creativity.

Native American Identities

Geographical and Racial Issues

Today, it is estimated that there are more than 2.3 million Native Americans in the United States – a population that is steadily growing (US Bureau of the Census 1991). Although Native Americans account for only about 1 per cent of the total U.S. population, they have been described as comprising 'fifty per cent of the diversity' that exists in this country (Hodgkinson 1990). Diversity among Native Americans is illustrated by 252 languages and 505 federally recognized tribes, and many nations (Herring 1990; Thomason 1991). The diversity is also seen in varying levels of cultural commitment among the members of a given tribe or nation (LaFromboise, Trimble and Mohatt 1990).

Art therapists and other mental health professionals need to be aware of the geographical and regional differences that exist among Native Americans. These differences reflect ceremonial beliefs and practices, Indian language use or non-use, the degree of acceptance or rejection of mixed-blood Indians, urban versus rural environments and reservation versus

non-reservation status. The above differences all affect Native Americans' mental health and well-being (Sage 1991).

With the migration from reservations to urban communities, there has been an increase in inter-tribal and inter-racial marriage. Today, more than 60 per cent of all Native Americans are of mixed heritage, the result of inter-racial marriages with African-Americans, Asians, Hispanics and Caucasians (Peregoy 1993). Depending on tribal matrilineal/patrilineal descent, mixed Native Americans can be denied tribal enrollment and are often ineligible for Indian Health Service (IHS) benefits. Since approximately 50 per cent of the Native American population now resides in urban areas, the degree of traditionalism versus the degree of acculturation to mainstream American values and cultural standards for behavior is an important consideration in research and practice with Native Americans (Garrett and Garrett 1994; Heinrich, Corbine and Thomas 1990; Thomason 1991). Cherokees and Navajos are both Native Americans but their regional cultures, climatic adaptations and language differ greatly (Garcia and Ahler 1992). However, a prevailing sense of 'Indianness' based on a common world view seems to bind Native Americans together as a people of many peoples.

Family and Tribal Identities

Native Americans experience a unique relationship between the tribe and themselves. The extended family and tribal group take precedence over all else. The tribe is an inter-dependent system of people who perceive themselves as parts of the greater whole rather than as a whole consisting of individual parts.

Tribal relationships with the federal government affect tribes tremendously. Art therapists must be cognizant of the impact of the government on tribes and its relationship to mental health care. In the early years of westward expansion, the US government signed treaties with tribes recognizing them as sovereign nations. By the end of the 18th century, however, most of these treaties were ignored and many tribes were either exterminated or forced onto reservations. Policies of extermination and land seizure were so common that the population of native peoples had been reduced to 10 per cent of its original size by the end of the 19th century. Native Americans were made dependent on the federal government through agencies such as the Bureau of Indian Affairs (BIA) and the Indian Health Service (IHS). Most Native American experience with Western health care

originated with the IHS. Today, Native Americans seeking therapy are forced into the position of trusting health care providers employed by the same federal agencies responsible for much of their mental stress.

Despite adverse conditions such as racism, colonialism, poverty and genocide, the concept of family endures. Individual survival is synonymous with that of the community; family structure extends beyond the nuclear unit to encompass grandparents, cousins, clan members, adoptive kin, all living creatures (including four-legged brothers and sisters, rocks and minerals (rock people)), the land (Mother Earth, Father Sky), etc. The universe is considered the family with each member performing a useful and needed function. In essence, all things have life, spirituality and importance. All things are connected and deserve respect and reverence.

Native Arts and Healing
A Synthesis of Ancient and Contemporary Practices

Native Americans regard art as an element of life, not as a separate aesthetic ideal. In native societies the arts are aspects of public life which bring together dance, poetry, plastic and graphic arts into a single function: ritual that is the all-embracing expression. Art is indispensable to ritual and ritual is the Native American concept of the whole life process. Native people see painting as indistinct from dancing, dancing as indistinct from worship and worship as indistinct from living (Farris-Dufrene 1996).

Traditional Native healers (medicine men/women, shamans, priests, etc) draw upon the vast love of symbolism that has been passed down through the centuries. These images are stored in the memories of traditional healers and passed from one generation to the next. Myths, prayers, songs, chants, sand paintings and music are used to symbolically return the patient to the source of tribal energy.

Indigenous philosophies do not separate healing from art or religion. Almost all of the healing disciplines originate in religious beliefs and the spiritual leader's practices. Throughout North America there are native societies in which medicine people or holy people share the power of vision with a group of initiates, sometimes their former patients. These organizations include the Iroquois Society of the Mystic Animals, the Midewin of the Ojibwa and numerous other societies, including those of the Pueblos and Navajos. All of these societies incorporate some aspect of the arts into their healing/religious ceremonies. In traditional life, where religion,

medicine and art are intertwined in a unity of purpose, the central principles in healing are: return to the origins, confrontation and manipulation of evil, death and rebirth and restoration of the universe (Tedlock and Tedlock 1975).

Traditional healing using shamanic knowledge is remarkably consistent across the planet. In spite of cultural diversity and the migration and diffusion of peoples across the earth, the basic themes related to the art and practice of shamanism form a coherent complex. The trance, dance, painted drums and shields central to early shamanism still are to the continuing practice of this art today. Awareness of the universe is codified in song, chants, poetry, storytelling, carvings and paintings.

In Eskimo/Inuit stone carvings and Native American paintings the eagle symbolizes transportation to other realms. Eagles and other bird symbols are considered bearers of celestial messages to the Creator. Among several woodland peoples, masks are used in healing rituals, especially among the Iroquois and Cherokee. Materials used in mask construction include wood, hornet's nests, gourds, animal skins and natural dyes. Among the Navajo, cultural symbols are expressed by the medicine men during sandpainting ceremonies.

Indigenous healing constructs a symbolic world in which the individual can feel familiar, safe and comfortable. Among the Navajo, Lakota and other Indian nations this is done with mandalas. Mandalas are drawn in Navajo sandpaintings and projected out into space and time in the form of medicine wheels. The medicine wheel, a ceremonial circle of stones and other materials, has been used by various Native American groups for thousands of years. According to tribal custom, it is oriented to the four directions with varying symbolic colors (often, black, red, yellow, white and/or green). The medicine wheel brings into relationship the powers ruling those directions (Farris-Dufrene 1996).

The use of the arts in healing goes beyond sickness *per se* and encompasses a multilevel concern with the well-being of the individual and the community. Healing deals with psychological, social and spiritual crises. With its emphasis on prevention, traditional healing effectively addresses a wide range of physical and social ills.

A major distinction between Native arts and healing and Western/ Eurocentric art therapy or psychotherapy is the location for working with clients. Healers are responsible for designing and constructing the place of treatment, usually situated outdoors, subject to nature's whims. One of the

most popular healing structures throughout North America is the sweat lodge, used for purification before and after treatment or as the site of treatment itself. Small and hemispheric in shape and made from willow branches, the lodge is covered with skins or tarpaulins to ensure total darkness. Participants sit in a circle on the dirt floor, either nude or wrapped in towels. A shallow pit is dug in the centre to contain hot rocks that have been heated for several hours. The first rocks are placed in the four directions to symbolize the four generations prayed for in the sweatbath: grand-children, children, parents and grandparents. The number four also symbolizes the four races/colors of humanity: black, red, yellow and white. Water is poured onto the hot rocks, causing steam to fill the lodge and thereby allowing the participants to sweat profusely and rid the body of impurities. Sage is used to wipe off the body sweat and leave a sweet body odor. The lodge is decorated with green, blue, black, white, red and yellow cloth pouches filled with tobacco. The pipe is placed in a central place and the healer leads the group in prayers, songs and a pipe ceremony (Stolzman 1996). As in most native healing rituals, music is the dominant art form.

Ethical Issues Involving Native Arts and Healing

Art therapists must respect the spiritual, symbolic and artistic dimensions of Native American culture. Although spirituality in Native culture is prominent, specific practices are determined by individual tribal values, beliefs and customs. Some Native American clients may prefer that art therapy sessions begin and end with a prayer. Most Native Americans believe that healers can only be successful if they seek the aid of spiritual forces.

Non-native art therapists should acquire background knowledge of the particular tribal affiliation of their Indian clients. Art therapists should be familiar with the values, beliefs, customs and traditions of Native Americans and have an overall appreciation and understanding of the idiosyncrasies and nuances peculiar to Native Americans. In the pursuit of understanding Native cultures, people outside the culture must not be deluded by profit-making enterprises in shamanism, vision quest or sweat lodge bathing. These commercial attempts to train instant medicine healers are damaging to participants and to Native American integrity. There is no expeditious way to acquire information about Native Americans. Involvement in 'quick fix' activities will have only a deleterious effect on the therapist and client. Mental health educators, especially those teaching in areas with large Indian

populations, should consider expansion of curricula to include courses that incorporate detailed discussion of Native American culture.

Art therapy clinicians and educators must critically examine the philosophy of Western therapy and education techniques to assess whether there is congruence with the values and beliefs of Native American culture. Instead of relying only on the visual arts for communication, art therapists working with Native American populations may consider also utilizing other creative arts therapies such as dance therapy, music therapy, poetry therapy and drama therapy. These modalities have already been incorporated into traditional cultures as a mechanism for healing. Non-native art therapists should inquire about the appropriateness of integrating traditional Native American arts healing practices into Western art therapy before proceeding to do so. It is preferable that a Native American therapist familiar with the varied values and beliefs related to art and healing provide services for Native American populations. If such therapists are unavailable, however, non-native therapists must acquire knowledge, sensitivity and respect for Native American cultures in order to provide appropriate services. Consultation with tribal leaders, community workers and tribal educators is always beneficial.

Conclusions

Art therapists have a responsibility to their clients to determine, through the most appropriate and efficient observation techniques, the extent to which clients' creative productions are influenced by ethnic, tribal, religious and other cultural factors. True, much is universal and much is common to all humankind, but when difference does exist, different solutions for treatment must be considered (Farris-Dufrene 1996).

Central to Native American tribal cultures is the emphasis on unity through a search for harmony and balance inwardly and outwardly. For many Native Americans the importance of unity resounds in a world where all things are connected in one way or another. Many elders speak of the Circle of Life, or the Web of Life, as a means of illustrating the interrelationship of all living beings. All things are believed to possess a life-force and purpose, and all things are interconnected in a balanced way. When the balance is disturbed, the Circle has a natural way of returning to a state of balance. People are constantly in motion, seeking balance in one way or another.

People are also connected with all things, having a purpose beyond that which we may perceive. In the traditional way there is a sacred design to the world that one inhabits – to the process of life itself. Often, it is not a matter

of whether 'things' fall into place but whether or not one's capacity for awareness of things falls into place (Garrett 1991).

With these issues in mind, we welcome the opportunity to address art therapists and other mental health professionals about some of the urgent issues facing Native American clients. We are always open to questions about cultural identity and spirituality and their relationship to mental and physical health, to political issues affecting mental health and education and to suggestions for ways to improve services to Native American clients. Our research, teaching and clinical practices acknowledge both the strengths and weaknesses of Native American life and tries to avoid perpetuating stereotypical messages.

As clinicians and as persons of Native American ancestry, we encourage our colleagues to recognize the unique perspectives of the various Native American populations and to incorporate Native world views as much as possible into their work with Native American clients. We anticipate feedback from readers and encourage dialogue for future research on this vital topic.

Finally, recognizing that we are only vehicles for therapy and education, we give honor and thanks to the Creator, our ancestors and our elders, who guide us and make our work possible.

References

Farris-Dufrene, P. (1996) 'Art, Visual (to 1960).' In F. Hoxie (ed) *Encyclopedia of North American Indians*. New York: Houghton Mifflin Company.

Garcia, R.L. and Ahler, J.G. (1992) 'Indian education: Assumptions, ideologies, strategies.' In J. Reyhner (ed) *Teaching American Indian Students* (pp.13–32). Norman, OK: University of Oklahoma Press.

Garrett, J.T. (1991) 'Where the medicine wheel meets science.' In S. McFadden (ed) *Profiles in Wisdom: Native Elders Speak About the Earth*. Santa Fe, NM: Bear and Company.

Garrett, J.T. and Garrett, M.T. (1994) 'The path of good medicine: Understanding and counseling Native Americans.' *Journal of Multicultural Counseling and Development 22*, 3, 134–144.

Heinrich, R.D., Corbine, J.L. and Thomas, K.R. (1990) 'Counseling Native Americans.' *Journal of Counseling and Development 69*, 128–133.

Herring, R.D. (1990) 'Understanding Native American values: Process and content concerns for counselors.' *Counseling and Values 34*, 134–137.

Hodgkinson, H.L. (1990) *The Demographics of American Indians: One per cent of the People; Fifty per cent of the Diversity*. Washington, D.C.: Institute for Educational Leadership.

LaFromboise, T.D., Trimble, J.E. and Mohatt, G.V. (1990) 'Counseling intervention and American Indian tradition: An integrative approach.' *The Counseling Psychologist 18*, 4, 628–654.

Peregoy, J.J. (1993) 'Transcultural counseling with American Indians and Alaskan Natives: Contemporary issues for consideration.' In J. McFadden (ed) *Transcultural Counseling.* Alexandria, VA: American Counseling Association.

Sage, G. (1991) 'Counseling American Indian adults.' In C.C. Lee and B.O. Richardson (eds) *Multicultural Issues in Counseling: New Approaches to Diversity.* Alexandria, VA: American Association for Counseling and Development.

Stolzman, W. (1996) *The Pipe and Christ.* South Dakota: St. Joseph's Indian School.

Tedlock, D. and Tedlock, B. (1975) *Teachings from the American Earth: Indian Religion and Philosophy.* New York: Liveright.

Thomason, T.C. (1991) 'Counseling Native Americans: An introduction for non-Native American counselors.' *Journal of Counseling and Development 69*, 4, 321–327.

US Bureau of the Census (1991). *1990 Census Counts of American Indians, Eskimos or Aleuts, and American Indian and Alaska Native Areas.* Washington DC: US Bureau of the Census.

Conflict and Culture in Art Therapy
An Australian Perspective

Andrea Gilroy and Margarete Hanna

Abstract

This chapter addresses the formation of art therapy as a profession in various European countries, in North America and in Australia. We describe how our interest in the development of the profession worldwide grew out of our knowledge and experience of art therapy's development in our home countries of Britain and Canada and our work as art therapy educators on the new Master of Arts, Art Therapy course at the University of Western Sydney, Nepean, New South Wales, Australia in 1994 and 1995.

While we were in Australia, we became aware of the considerable conflict and friction existing within the tiny, fledgling art therapy community that we encountered. We undertook a study of the early art therapy movements in countries where the profession is more established and/or differently constructed, in order to examine and compare their beginnings to those we experienced in Australia. We found that the socio-cultural conditions of differing countries had a major impact on art therapy's development, and that conflict seemed to inevitably accompany the establishment of the profession. However, it became clear that not only was the cultural context influential, but also that the manner in which conflict, divergent opinions and struggles for ownership were addressed within the developing profession either became empowering of a strong, dynamic and collaborative professional identity, or resulted in considerable fragmentation which impeded the profession's development.

This led us to explore the particular geographical, cultural, social and political context in which the profession exists in Australia, especially that of Australian psychiatry. The knowledge we gained enabled us to better understand and contain the situation in which we found ourselves, and equipped us to work with the conflict and culture that are central to the process of establishing art therapy in Australia.

Introduction

Australia is a vast continent with the majority of its peoples concentrated around the ocean rim in a handful of cities such as Sydney, Perth, Darwin and Brisbane. Moving away from the coastline, the land becomes more arid until eventually sand and rocks dominate the endless interior landscape. A sparse population resides in the center of the continent, both aboriginal people and new settlers to Australia. In February 1993 the University of Western Sydney (UWS) Nepean opened one of two new MA Art Therapy courses in this vast land where great distances separate the population. The other MA program was being established at the same time on the other side of the continent, at Edith Cowan University in Perth, Western Australia. These were the first art therapy training courses in Australia.

We were involved in the development of the UWS' program between 1994 and 1995, trying to integrate new and fresh ideas unique to the culture with the understanding we brought with us from our experiences of developing art therapy in our own countries. Naturally our previous work colored our vision and expectations of the issues we encountered in Australia. Many of the challenges were familiar but others were new to us, attributable to the socio-cultural and political differences, and thus the unique aspects, of establishing art therapy in Australia.

In retrospect, reviewing the immediacy of our experiences alongside the awareness we gained of the particularities of the Australian environment and comparing these with our first-hand knowledge of shaping the profession in our own countries, we gained an appreciation of the complexity and delicateness of the task we had committed ourselves to do. In the light of these insights we came to understand the conflicts inherent in the process of building the profession in Australia as inevitable by-products of the introduction of something new and unknown into an environment which may not be immediately sympathetic. In this chapter we hope to illuminate our experiences in Australia in the light of the particular milieu of Australian psychiatry, comparing it with the history of the development of the profession of art therapy in Europe and in North America. As well, we hope to identify the ways in which art therapists in Australia might work with the conflicts which arise in the establishment of a new profession. As we will show, conflict is an inevitable part of the process and can be important in the development of clarity, collaboration and cohesiveness of a new profession. However, conflict can also lead to destructive splits which, if they continue to

exist, seriously affect the strength of the discipline and its ability to become an established professional group.

Art Therapy in the United States

Early practitioners of art therapy in the United States were artists, psychologists or related para-medical professionals working with psychiatric or mentally handicapped patients in hospitals or art educators working in schools and in institutions. For example, the art therapy pioneer Margaret Naumburg was a psychologist, Edith Kramer was an art educator and Myra Levick (who became the first President of the American Art Therapy Association (AATA), and the director of the first graduate-level training program) was a trained professional artist. Some of these early art therapy pioneers, isolated as they were in different parts of the country, found in the International Society for the Psychopathology of Expression a place where they could meet each other and other individuals from disciplines related to the psychopathology and psychology of the arts. Although the Society was dominated by psychiatrists (Junge 1994), art therapists were active participants. However, Don Jones (another pioneer of American art therapy), described the Society as having something of a caste system in which the art therapists were invited guests. By 1966 there appeared to be a strong interest amongst these early pioneers in the development of an organization of art therapists that would be responsive to their needs and would address questions about art as treatment as well as pathology and diagnosis (Junge 1994). Furthermore, these art therapists recognized that the American mental health community was based on the medical model and formed a hierarchical structure and that separation was necessary in order to achieve a discrete mental health profession of art therapy. Junge suggests that the era of intense civil rights activity in America in the early 1960s stimulated art therapists to identify themselves as a separate group and to establish a professional identity of their own, which occurred when AATA was founded in 1969. She says: 'This kind of separatism of a minority group is sometimes an unwanted result of prejudice, but is also a much practiced strategy and a recognizable first step of minority groups of all kinds in their efforts to achieve equality' (1994, p.175).

The literature on the establishment of AATA is replete with references to the intensity of different views and conflicts of all kinds in its early days. Junge (1994) writes that there was considerable and, sometimes, acrimonious controversy over whether to form an organization at all, with some art

therapists feeling that this was a premature step and others that it was an urgent need. Stormy sessions surrounding the formation of AATA were followed by heated debates once the Association was operating, with the first battle concerning the question of certification of art therapists. Judith Rubin, a past president of the Association, wrote: 'the early meetings were so full of passion and discord that I wondered whether I really wanted to be a part of this noisy group.' (Rubin 1985, p.30). Nonetheless, it seems that regardless of the wars and battles fought within the American art therapy profession during its establishment and growth, the overriding commitment of the pioneers to the development of art therapy as a therapeutic discipline is what held the organization together and helped it to grow and develop in strength.

> Like a vital, opinionated, competitive family, the members argued. But like a family, they pulled their covered wagons into a protective circle to fight the important battles necessary to carry the profession forward. Whatever else might be said about the American Art Therapy Association, it could never be called dull! (Junge 1994, p.179)

It appears that in America, its pioneers and those art therapists who followed were able to recognize the inevitability, indeed necessity, of conflict in developing a new discipline and profession. In the process they were able to maintain a vision of the larger picture in the midst of the storm generated by different personalities, emerging with new resolutions to conflict which facilitated the solidarity, collaborative spirit and cohesiveness of the art therapy profession in America. This allowed the profession to develop registration procedures for its members, cohesive standards of training supporting the creation of numerous graduate training programs in art therapy at various universities and institutes across the country and, most recently, certification of art therapists in an effort to support art therapists' ability to compete effectively with other mental health professionals. Although art therapists and psychiatrists were, and still are, sharing an interest in the efficacy of expression in the treatment and diagnosis of clients, a competitive element appears not to have arisen when art therapists became involved in separating themselves out as a distinct profession.

Art Therapy in Canada

To our knowledge the development of art therapy in Canada has not been described elsewhere in the literature, perhaps because of the difficulties

inherent in addressing continuing conflict openly with a view to strengthen art therapy as a profession in the country. Thus the history of Canadian art therapy that is outlined in this chapter comes from the direct knowledge of one of the authors gained while involved in the development of the profession and the professional associations of art therapy in Canada, and from discussions with other Canadian art therapists. Although Canada is a close neighbour of the US, the art therapy community in this country continues to attempt to resolve a long-standing split among art therapists which began with the profession's development. Historical events shed some light on how this split developed and why it continues to linger and affect the strength and competitive edge of the profession.

Early art therapy pioneers in Canada were, as in the UK and the US, artists and art educators working with patients and students in special schools, institutions and hospitals. These artist/educator therapists considered art making to have intrinsic therapeutic value for the patient/student. In clinical psychiatric settings, Canadian art therapy pioneers were often required to formulate diagnoses based on patients' artwork, supported by beliefs in the medical field that the art of patients provided valuable clues to their ailment or mental condition. These early artist therapists worked as adjunct staff under a psychiatrist and, in this setting, the therapeutic value of the art making process frequently took a back seat to the priority of the diagnostic value of the art product.

Efforts on the part of the Canadian artist or educator therapists to collaborate and to form a national group to define themselves and the art therapy profession grew strong when it became apparent that a founding psychiatrist was exerting a strong influence over the direction of the fledgling profession. This occurred as a result of the following events. At least ten years prior to this groundswell, a Toronto psychiatrist, Dr Martin Fischer, recognizing the significant improvements and progress made by patients who used art in their therapeutic healing work, organized the first effort in Canada to establish training of art therapists. He founded the Toronto Art Therapy Institute in 1969. His program provided a strong psychodynamic basis of studies with a primary emphasis on Freudian theory. A background in artistic training and experience was not emphasized, nor were courses in art highlighted as a vital requisite to becoming an art therapist. This line of thought diverged significantly from models of art therapy training in the US and, particularly, Britain – where art training was seen as a vital component in

defining art therapy practice, and where this uniqueness helped to forge the strength of the profession and to distinguish it from other therapies.

Student trainees at the Toronto Art Therapy Institute, with no art training, often worked side by side with highly skilled and gifted artists. This created an imbalance in the sensibility toward the art making process, and ambiguity regarding the identity of art therapists. Indeed, with students graduating from the program with little formal art training, reinforcement was given to the position that anyone with training in psychology or psychiatry could also do art therapy. This significantly weakened the position of art therapists as unique professionals with a set of skills which set them apart from psychologists and other practicing psychotherapists and psychiatrists. In many ways this established a norm suggesting that art therapists were 'adjunct' therapists supporting the more firmly established and defined clinical skills of psychologists and psychiatrists.

The Toronto Art Therapy Institute maintained a monopoly on training of art therapists in Canada until 1979. This impacted the creative development of art therapy training significantly, since art therapists had little opportunity to compare their training with other training programs. Also, an absence of competition in training created an atmosphere of conformity and adherence to the standards set, with little impetus to change the status quo, since students had no alternative training options. This often created tension among students when their requests for course improvements remained unmet. Often, student trainees, upon graduation, were re-hired by the Institute as lecturers, thus strengthening an adherence to the same training philosophy and loyalty to its founder. Many graduates gradually came to see the importance of 'independent thought' in the formation of a profession not dominated by psychiatry but constructed as a result of their own needs for professional definition.

By 1979, as it became apparent that art therapy as a profession was gaining momentum in Great Britain and the US, Concordia University in Montreal launched an MA in Art Therapy with a British art therapist, Michael Edwards, at its head. This program became established in the Art Education faculty of the university, thus refreshingly highlighting an emphasis on the significance of art skills in the training of art therapists. This event was followed shortly thereafter by the establishment, under the leadership of West Coast pioneer Kathleen Collis, of the BC School of Art Therapy in Victoria, British Columbia. She also brought a fresh, independent perspective to the profession and training of art therapy with a strong

commitment to the skills development in art as a requisite to becoming an art therapist. She spoke strongly in support of art therapists' self-government and later became one of the founder members of the National Art Therapy Council of Canada, a body advocating for art therapists, led by art therapists. Just prior to the opening of the BC School of Art Therapy, a recent graduate of the Toronto Art Therapy Institute opened the Vancouver Art Therapy Institute. This Institute mirrored training philosophies of the Toronto Art Therapy Institute and Dr Fischer became a key figure in its development. His influence over professional development of art therapy expanded to the West Coast of Canada, just as an independent art therapist brought a different view of art therapy training to this side of the country.

On the eve of these events Dr Martin Fischer also established the Canadian Art Therapy Association (CATA) in 1977. This association remained as established under his guidance, consultancy and leadership until his death in 1992, and it remains headquartered at the Toronto and Vancouver Art Therapy Institutes. This association, guided by a psychiatrist, greatly impacted on the direction of the profession in Canada as appointments to the Executive Committee of the Canadian Art Therapy Association were usually by invitation, and in this way input into the affairs of the Association remained within a small group of followers committed to the training norms developed by a psychiatrist.

A strong move by Canadian art therapists toward independence from psychiatric leadership began to emerge. The first major challenge by art therapists seeking to establish self-government took place at a meeting of members of the Canadian Art Therapy Association at the Ontario College of Art in 1982, when art therapists challenged the leadership of the Association with a request to open the Association to democratic process and the right of art therapists to self-government. Reports by individuals who attended this meeting indicate that tensions were considerable, and mediation was provided to maintain order. The result was that these negotiations were unsuccessful for art therapists, who wanted self-government, and the leadership of the Canadian Art Therapy Association remained in Martin Fischer's hands.

As a consequence, Concordia University graduates in Quebec decided to establish the Quebec Art Therapy Association (QATA) and distance themselves from the Canadian Art Therapy Association. QATA looked south to their US neighbors for direction and collaboration in setting training standards and practices. Similarly, Ontario Art Therapists decided to form the

Ontario Art Therapy Association (OATA) in an effort to establish a self-governing body representative of, and represented by, art therapists. More significantly, art therapists wanting to regulate themselves, and be instrumental in the direction which the profession took nationally, established a second national body, the National Art Therapy Council of Canada (NATCC). Although in principle this Council had a sound organizational foundation, rivalry and competitiveness, divided loyalties and suspicions between members loyal to CATA and its founder, and those loyal to the NATCC, eventually caused the NATCC to disband. The later introduction of art therapy training at the University of Western Ontario was a step in strengthening the independent direction of art therapy training, forged by art therapists, but did little to alleviate the loyalty conflicts among art therapists which were now firmly entrenched and have eluded a healthy resolution.

Most recently, the Canadian Art Therapy Association undertook a plan, in 1990, to become the accreditation body for Canadian training programs. In a timely manner, the other Canadian programs (i.e. Concordia University, University of Western Ontario and the BC School of Art Therapy) declined to lend their support to this move, first because they had not been invited to provide input and, second, because the step seemed premature.

Art therapy training in Canada has largely remained the domain of small private institutions, with only two universities offering programs in this large country, and only one of which offers training at the MA level. This may be a result of conservative financial planning of the Canadian university culture or of the historical precedent set by an influential psychiatrist in locating art therapy training in private institutes. It may also be the result of the diminished lobbying power of art therapists who have continuously fought for independent governing power in the face of ownership struggles of the profession between those who have loyally supported leadership of and by a pioneering psychiatrist with an interest in art therapy, and those who saw the greatest strength lying within their own identity and definition as art therapists. In this context it is indeed doubtful whether a founding psychiatrist can truly represent and champion the ongoing development of art therapy, particularly in the light of such considerable resistance by one-time followers and other founders who are seeking to assume independent direction and leadership of the profession.

Art Therapy in Europe

Examination of the profession of art therapy in Europe reveals an extraordinary diversity of therapeutic practice and education which has developed according to the specific contexts of art and psychiatry in each country. There are a few places in Europe, other than Britain, where art therapy is organized, if not under the aegis of a professional association then regulated by the government (Germany, Holland and Italy). We will illustrate, through a few examples, how such difference within a country has prevented the formation of strong professional associations of art therapy which has led to fragmentation, the absence of coherent art therapy identities and a lack of recognition of art therapy in the differing countries that comprise Europe.

In some countries the profession is split, sometimes in two, but sometimes into rather more fragments. In Switzerland, for example, art therapy began with an interest from psychiatrists in the art of their patients. Robinson (1992) cites the publication by Morgenthaler of the *The Mental Patient as Artist* (1921) about the work of Adolf Wolfi and Prinzhorn's *Artistry of the Mentally Ill* (1922); soon after this Bader described the work of his psychiatric patients in Lausanne, which later led to the Art Brut Collection. Thus the first interest was from psychiatrists. Robinson describes how an American-trained Swiss art therapist was the first to be employed in 1978 but how the Swiss Art Therapy Association, founded in 1985 as part of the International Society for the Study of the Psychopathology of Expression, is made up almost entirely of psychiatrists and psychoanalysts who have an interest in the art of their patients and who use art therapy as part of their practice as psychiatrists.

Robinson also describes another, quite different, kind of art therapy that takes place in Switzerland. In this instance practitioners focus on the art process and view themselves as an 'accompanier' to art marking and do not use interpretation. Carrigan (1993) describes this kind of work with Swiss mentally handicapped clients and the 'painting therapist's' explicit exclusion of verbal exchange in favor of a therapy based totally in creative development and a belief in art as inherently healing. Robinson discusses the evident split in the uses of art as therapy in the context of the complex political processes necessary to professional recognition in Switzerland, but also says that there is 'a good deal of disharmony and even perhaps an unwillingness on the part of each branch of the profession to overlook or accept their differences to better take up this cause' (p.7).

Similar situations prevail in Germany and Holland where, although art therapy is regulated by the governments, there are widely differing ideas about what art therapy actually is. Schweizer (1990) and another Dutch author, Nijenhuis (1992), describe 'creative therapists' who have a professional association, a national register and training (Nijenhuis 1992, p.94). Nijenhuis describes creative therapy as a 'perimedical profession on an academic level' (p.95) requiring a three- or four-year undergraduate diploma. However, other courses in Holland offer postgraduate education in both creative therapy and art therapy, thus creating a very confused situation.

In Germany art therapists are educated at undergraduate and post-graduate levels and in private practice and state education; there are no less than thirty training courses and eleven professional associations (Mertens 1996). Thomas (1996) identifies seven differing approaches used by personnel from professional backgrounds in art, teaching and psychiatry, resulting in what Herrmann (1997) has described as an 'archipelago of German art therapies' (p.23) and the profession remaining fragmented, unregulated and still, in some respects, in the early days of development.

In Bulgaria and Hungary non-art trained personnel are becoming art therapists (Szilard 1992; Vasarhelyi 1992). In Bulgaria, like Switzerland, there was an early interest in art from psychiatrists (Marinov 1972, 1975) out of which developed training in art therapy in the mid and late 1980s (Waller 1983; Waller and Bajadzhiev 1983; Waller and Georghieva 1990; Waller 1995). The situation in Bulgaria and in Hungary is one which has been heavily influenced by the prevailing political climate for many years and has only recently begun to change. In such countries there is no tradition of art education, artists in hospitals or non-medical therapists, hence the necessity to train those personnel who were already working in psychiatry and had an interest in art therapy, who were seconded to the art therapy training by their institution and/or who were interested in initiating a change in the existing medical system and the development of a psychosocial model of treatment (Waller 1995; Waller and Georghieva 1990). Their art therapy education included considerable input on the acquisition of art skills and the practice is heavily influenced by psychiatrists. Likewise, Vasarhelyi (1992) says that in Hungary only psychiatrists and psychologists can train as psychotherapists and art graduates could only be employed as occupational therapists with menial pay and diversional-style work.

An interesting situation is developing in Italy where, like Hungary, 'art' includes all the arts (visual art, music, drama and dance) and so the training

that has been established addresses art therapy and dance movement therapy (Cagnoletta 1992; Waller 1992). However, there is an Italian Art Therapy Association (founded in 1982 by three art therapists who had trained in the USA). Waller (1992) describes how Italian art therapists have not only to differentiate art therapy from the 'extensive use of art in occupational settings' (p.25) but also address the widespread influence of Psichiatria Democratia and its emphasis on generalist, non-specialist mental health workers, plus the fact that psychotherapy remains firmly the province of the medical profession. Thus the prevailing climate of health care in Italy, coupled with attitudes towards art, creates a particularly difficult situation for the establishment of art therapy as a discrete profession.

Art Therapy in the UK

Whether or not art therapy was a new profession or a collection of techniques that could be taught to any mental health worker who had an interest in art was a matter of debate and political struggle in Britain for many years. The history of art therapy in Britain is substantial and we will not document it here, but, instead, refer the reader to Waller's seminal work on the subject (1991). Our intention in this section of the chapter is to describe some particular points of the profession's history in Britain in order to highlight the importance of 'the containing body' of a professional association.

Waller (1991) describes how art therapy in Britain grew out of a variety of interests and disciplines during and immediately after World War II. The first art therapists were artists and art teachers who worked in hospital settings and were influenced by the child-centered approach to art education; broadly speaking, they espoused the notion of 'art as healing' (e.g. Adamson 1984; Hill 1951). As important was the contribution of psychiatrists who were interested in the so-called 'art of the insane', who collected their art and encouraged artists to work with their patients (Guttman and Maclay at the Maudsley Hospital, Cunningham Dax at the Netherne Hospital). At the same time, an experimental center for psychotherapy through the arts was established by a Jungian psychotherapist, which provided treatment and informal training in art therapy (Waller 1991).

During these early years of art therapy in Britain there was what Waller describes as 'a struggle for ownership' of the profession (p.101) between those who viewed art therapy as part of occupational therapy and those who considered it to be a part of Jungian psychotherapy. During the 1940s and 1950s art therapy continued to develop under the aegis of other professions

– occupational therapy, art education and psychotherapy – who were represented by individuals but who came into conflict about the nature of their emerging practice as art therapists. But, significantly for the establishment of art therapy as a discrete profession in Britain, '… in the interests of achieving autonomy from other groups, and to promote their work, and themselves, … they [came] together under the common umbrella of a "professional association".' (Waller 1991, p.107). This association, the British Association of Art Therapists (BAAT), was formed in 1964.

Waller describes how BAAT's early meetings were devoted to drawing up a constitution with aims, objectives and membership criteria – the early application form including a section for a personal statement about the applicant's approach to art therapy which would enable the new Council of BAAT to discern whether or not the individual 'fitted' the mission of the association. Conflict continued within this first small group, not only about the nature of art therapy but also because the new association was seen as promoting exclusiveness. Nonetheless, the first AGM in 1966 saw a full membership list of 36 with the differing threads of BAAT's various activities being 'held' by the leadership through the formation of committees to take on different functions.

Waller (1991) shows how, during the early days of art therapy in Britain, there was little concern about the conditions of employment of art therapists, the people concerned believing passionately and altruistically in 'the cause'. During the 1960s and early 1970s, art therapists in Britain were either employed on an *ad hoc* basis by the Department of Health, with appalling pay and no recognition of the graduate qualifications of many art therapists, or were employed as (graduate) art teachers by local adult education authorities, with rather better pay. A reflection of the alliance with art education was a close association with the teachers' union (the National Union of Teachers) and that membership of BAAT required a degree in art plus a Postgraduate Certificate of Education (PGCE). A further reflection was the initiation of two art therapy courses within PGCEs but, at much the same time, a third course began, whose entry criteria and general philosophy were seen as closely allied to the medical model of psychiatry. Nonetheless, graduates from all three colleges gradually joined BAAT and a relatively sizable and powerful group was formed.

At this time there had been a real danger of the profession fragmenting. Waller describes how this was enacted through a proposal that a Registration Board for art therapists be established which would not necessarily comprise

BAAT members. The proposal came from people who supported substantial entry into art therapy by non-artists (often members of non-graduate, paramedical professions) and who, by implication, envisaged art therapy very much as part of the traditional medical model of psychiatry. This was resisted by BAAT members who espoused a political and philosophical alignment with art education, believed that the making of art was about the development of the personality and was coupled with an allegiance to the anti-psychiatry movement (and sometimes left-wing politics), plus an extreme resistance to being allied with occupational therapists, the medical model and the poorly paid paramedical professions. The proposal was rejected, the professional association was able to contain the potential for fragmentation and a BAAT Registration Board was formed. Waller (1991) describes this time as:

> ...euphoric. Decisions had been made and with the agreement of the majority, not only of members but of the one-time 'enemy'. The mission seemed to be shared, and the means of achieving it clearer. Anxieties about becoming enmeshed in health service bureaucracy and hierarchy, which had preoccupied many art therapists, had got submerged, temporarily, in this phase of art therapy's perestroika. (p.272)

Again, as in the early 1960s, art therapists in the UK were able to submerge their differences in order to preserve the whole.

Since then (1976), art therapy in the UK has progressed significantly: in 1981 the profession was recognized by the Department of Health and an autonomous career and salary structure in the state health service was established; in 1985 BAAT published its Principles of Professional Practice and a National Register was first published in 1986; in 1992 the postgraduate qualification was recognized by the social services section of the government; and, most recently, changes in the education system in Britain have enabled art therapists to be employed in mainstream education (see Woddis 1992).

In March 1997 art therapy become a State Registered profession. What this will mean for British art therapists is that the actual title 'Art Therapist' will be legally protected so that only those registered with the Council of the Professions Supplementary to Medicine (usually via registration with BAAT) will be allowed to use the title. This has entailed an Act of Parliament which recognizes that art therapy is an established profession with a demonstrable body of knowledge, code of ethics, professional education and so on. This comes after 50 years of political campaigning and recognized work in the

state health, social and education services and some 15 years after the British government first recognized art therapists through the establishment of the discrete career and salary structure in the British National Health Service.

This is not to say that art therapy in Britain is without its' contentious issues. Within the profession there is a debate around its name – art therapy or art psychotherapy – and considerable diversity in clinical practice. But, despite the potential for fragmentation, the continuing debates and conflicts have been contained within the professional association, which continues to represent the profession at government level.

Arriving in Sydney in early 1994 from Britain and Canada respectively, we discovered that the profession of art therapy in Australia was exceptionally tiny, with just sixteen professional members in the Australian National Art Therapy Association (ANATA) in a continent the same size as the USA or all of Europe from Dublin to Istanbul. Although this was known to us before we left our home countries, it was not until we arrived in Australia that we experienced the dimensions of the land and were able to appreciate the influence of history and geography upon it and the infant state of art therapy within it. There was a sense of the profession being personified by a few individuals rather than held by a community of art therapists. In addition, initial conversations with art therapists and other colleagues were characterized by considerable caution, with a distinct impression of unspoken undercurrents and conflict within the profession.

Within this environment the MA in Art Therapy at the University of Western Sydney had opened its doors in 1993, one year before we were recruited. The educational and social, cultural and political context in which it was operating was, although full of potential, also very complex and difficult, as we were to find out. We were faced with a difficult situation on our arrival as the course had encountered a number of teething problems which had led to it becoming unstable and conflicted. However, much that we encountered was reassuringly familiar to the situations we knew back home in Britain and Canada. There were the same struggles to differentiate art therapy from occupational therapy and from artists working in hospitals; psychiatrists needed convincing of the benefits of art therapy and the same issues around the closure of large institutions and the move of patients into community care were also apparent. However, from art therapists, colleagues and our contacts with clinical placements we quickly gained the impression that mental health care in Australia was dominated by the medical model of

psychiatry, by behaviorism and by cognitive-behavioral therapy. Psychodynamic approaches were hardly acknowledged. A review of the history of psychiatry in Australia was very helpful in beginning to understand why this was.

Psychiatry in Australia

Lewis (1988) describes how publicly-funded custodial care of the insane existed right from the start in Australia as it was accepted that the public had to be protected from 'the possible violence and unseemly behavior of the lunatic' (p.191). Between 1788–1880 (the first century after 'invasion' by the British), the care of the mentally ill was closely linked with criminality – the management and 'treatment' of lunatics being in the hands of the military autocracy that governed the colony. Lay superintendents of jails, where almost all the insane were housed, were responsible to the government rather than to the Colonial Medical Services. The mid and late 1880s saw a change with the passing of the Lunacy Law of Australia (1843) and the introduction of the more benevolent regimes of lay superintendents. Care of the lunatic became a medical concern; insanity came to be seen as inextricably linked to physical causation and, hence, treated by physical means (e.g. purging, emetics and blood-letting) but, until the 1860s, this was coupled with reasonably humane treatment, conditions and minimal restraint of the patient. Some of the physical causes of mental illness cited at this time were particular to Australia: '...nostalgia, sunstroke, being lost in the bush and flogging' (Division of Health Services Report 1979, p.30). 'The isolation of bush life and the separation of immigrants from family and friends in the home country' (Lewis 1988, p.12). 'Goldmania' was also blamed as it was considered '...to operate in the psyches of the descendants of the miners, their "excited natures" being inherited by later generations' (ibid).

However, in the late 1800s there was a shift away from benevolent custodial care of the insane in Australia, which mirrored developments in psychiatry in Britain and in other parts of the Western world. Lewis (1988) describes how the jail-like, overcrowded environments, with an emphasis on discipline and too few trained, sympathetic staff, again '...made for a custodial rather than a curative environment' (p.13), the government being more concerned with the economic growth and physical exploitation of the resources of the continent than the care of the insane. The mentally ill were usually long-term dependents of a society where self-help was all – this reinforced a view of insanity as distasteful and dangerous and exacerbated a

tendency to associate mental illness and handicap with criminality. Nonetheless, the period from the 1860s until the 1950s saw the introduction of ECT and the use of penicillin, insulin, opium and quinine in the treatment of the mentally ill alongside '...profitable employment, organized amusements and pleasant surroundings' (ibid). The Division of Health Services Report (1979) states, however, that leucotomy was introduced in 1943 – 'And of course if all else failed, there was psychotherapy and occupational therapy.' (Lewis 1988, p.38). This was the prevailing climate of care of the mentally ill in Australia until post-World War II (Lewis 1988).

Lewis goes on to describe how the changes in post-World War II psychiatry in Europe and America travelled to Australia from 1945 onwards. There was a more liberal view of mental illness alongside the introduction of anti-psychotic, anti-depressive and anti-anxiety drugs, a decrease in the use of ECT and psychosurgery and an interest in the physical and social environment of the patient. However, the Stoller Report stated in 1955:

> The Mental Hygiene Department in NSW has lagged behind world developments in psychiatry. It has been so starved of essential moneys, even for adequate maintenance, over so many years, that its outlook has become somewhat restricted. Attempts have been periodically made to raise standards, but these have invariably failed, because of the lack of introduction of appropriate personnel training programs. (Stoller and Arscott 1955, p.52)

But was it simply a matter of appropriate training and inadequate funding which kept Australia behind developments in approaches to mental illness in Europe and America?

Lewis (1988) points out that Australian psychiatry has been considerably influenced by psychiatric practice in Britain. He highlights the impact of British graduates in positions of leadership in the Australian psychiatric services and universities, giving the example of Dr E. Cunningham Dax who was appointed to re-organize the state psychiatric services of Victoria in 1953. Many of these British psychiatrists, as well as Australian psychiatrists who trained in the UK, went either to the Maudsley Hospital, Newcastle-upon-Tyne University or Aberdeen University. Both the Maudsley and Newcastle-upon-Tyne University promote a 'strict adherence to the methodology of science' (Lewis 1988, p.49) although Aberdeen is more dynamically-oriented. Clare (1976) describes British psychiatry as basically medical but nonetheless modified by an eclecticism which recognizes the efficacy of behaviorism and of dynamic and social perspectives. Thus British

psychiatry has been, and is influenced by, psychodynamic approaches whilst Australian psychiatry, according to Lewis, has been influenced only in a relatively minor way.

During the 1920s some Australian psychiatrists were urging the integration of psychodynamic ideas but others maintained a 'fierce opposition' – this developed into a considerable controversy which continued into the 1930s and beyond. Looking at a few dates and figures comparatively illustrates the fact that psychoanalysis came late to Australia and 'remained a minor tradition in psychiatry' (Lewis 1988, p.54). Institutes of Psychoanalysis were established in 1941 and 1951 in Melbourne and Sydney respectively, as compared to 1920 in London and 1931 in New York. Lewis reports that in the 1960s there were just eight psychoanalysts practicing in Australia: four in Melbourne, three in Sydney and one in Adelaide (p.54). One of our colleagues at the UWS told us that in 1994/5 there were just 20 or so analysts practicing in Sydney. Lewis assigns the smallness of the private market and the growth of new physically-based treatments (which maintained the medical model) as possible reasons why 'psychoanalytically inspired therapy' did not grow significantly in Australia. But perhaps simple geographical location also played a part, given the inescapable fact that Australia is so far from North America and Britain where many middle-European psychoanalysts fled before the outbreak of World War II.

Lewis describes how the tensions between the psychodynamic and organic approaches to mental health in Australia heightened in the 1960s and 1970s. In 1966 the Medical Journal of Australia proclaimed that there were two cultures in psychiatry: '...and when in conflict the analyst accused the somaticist of superficiality, while the latter replied that he relied on science not the theories of cult heroes' (1988, p.58).

As recently as 1973, Wallace Ironside, then President of the Australian College of Psychiatrists, referred to a 'conflict at the interface of psychiatry and medicine', although at the end of the 1970s some Australian psychiatrists were reportedly ready to espouse a fashion for eclecticism (Lewis 1988, p.58). Orthodox psychiatry in Australia has been challenged by the anti-psychiatry and self-help movements and by psychodynamic ideas, as well as by official public scrutiny, but the medical model and behaviorism seem to retain a fierce hold. We wondered whether this was indicative of a continuation of attitudes associated with the penal system as behaviourism

and the medical model are fundamentally about control – of the illness, the person and their behavior.

More recently, in the Tolkein Report (1991), Andrews outlined a model mental health service and proposed a breadth of approaches: medication, counselling, psycho-education, social skills, rehabilitation and psycho-therapy. Similarly, Palmer and Short (1994) refer to the 1992 Australian National Mental Health Policy and a five-year plan for mental health reform involving moves to community care and greater integration of mental health services within general health care, citing the work of Foucault, Goffman, Laing, Szasz and Basaglia and their influence on the changing face of modern-day Australian psychiatry. So, in theory at least, there would seem to be an openness in Australian psychiatry that art therapists could exploit. But is there something particular to the prevailing practice of psychiatry in Australia that could usefully be addressed in order to promote the establishment of art therapy? Parker (1991) points out the difficulties in discerning a distinctively Australian brand of psychiatry, indeed of finding a famous Australian psychiatrist (apart from John Cade who discovered lithium in 1949). Parker assigns this to the difficulties of establishing a research tradition in Australian psychiatry because of poor funding and the demands of large teaching, clinical and administrative loads, but he also suggests that this might be to do with the Australian character – the skepticism, the tendency to destructive iconoclasm, the 'Tall Poppy' syndrome (the 'cutting down to size' of the unduly arrogant or successful person) – and to the nature of the place itself. After all, he asks, would Freud have discovered psychoanalysis if he'd biked across the Simpson Desert?

Art Therapy in Australia

It is interesting to juxtapose the history of art therapy in Australia with that of the development of the profession elsewhere in the world. Two pivotal figures in the history of British art therapy have had an influence on the early developments of art therapy in Australia. Writing in the Australian National Art Therapy Association's Newsletter (ANATA), Allison (1989) describes how one of the first art therapists in Britain, Adrian Hill, worked with Guy Grey-Smith (an artist) and Elizabeth Adams (an occupational therapist) at Midhurst Hospital, Sussex, in England – both these people later worked in the physical and mental health services in Western Australia. The other influential figure was Dr E. Cunningham Dax, who went to Australia from Britain in 1953 in order to re-organize the psychiatric services in Victoria,

Australia. (Cunningham Dax was one of the first psychiatrists to employ an art therapist in the mid-1940s, that is Edward Adamson at the Netherne Hospital (see Adamson 1984)). As at the Netherne Hospital, Cunningham Dax initiated studios at Royal Park Hospital, Melbourne, and Ballarat and Larundel Hospitals (Cunningham Dax 1989). During the 1960s, art teachers were seconded to work in two psychiatric hospitals in Adelaide, employment which was later to become the first established art therapy post in Australia. But these pockets of individual activity seem to have remained very isolated until the 1980s when a few overseas-trained art therapists returned to Australia to practice, centring on Brisbane. According to Coulter-Smith (1989), their efforts focused initially on securing work and running short courses at various colleges in Brisbane. Similarly, efforts in Sydney centered around art therapy education (Berecry 1989). The ANATA was formed in 1987 with 11 professional members and the first newsletter and conference happened in 1989.

According to the ANATA Newsletter, 1990/91 saw the beginnings of regional groups and the potential for contact with the few art therapists in New Zealand. Alongside this was an increase in membership, but with professional membership remaining small (14 members). There were also reports about the initiation of courses (Harvey 1991) but alongside these optimistic pieces was an editorial comment which referred to ANATA's 'many difficulties in its period of infancy' and a wish that 'the future will prove less stormy and more productive' (Edwards 1991, p. 1). Also discussed were differences between American and British art therapy education in the light of developing art therapy education in Australia (Coulter 1991), a debate which continued in Calomaris' letter calling attention to the richness in diversity and the potential for hybridization that is particular to Australia (Calomaris 1992).

There is, however, as we discovered, a tradition in Australia of artists working in hospitals and prisons. There is also a very strong and lively contemporary art scene which, coupled with the centrality of image making within Aboriginal culture, gives art a strong foothold in the Australian socio-cultural context within which art therapy is developing. Our sense is that this could be extremely helpful to the development of art therapy in Australia (as Campanelli and Kaplan described in 1996), but currently there are rather rivalrous and competitive feelings between art therapists and artists, as well as amongst art therapists themselves, in what seems to be a struggle for ownership of the profession.

Discussion

The establishment of art therapy as a profession in various countries around the world requires attention to several different areas: to issues within the 'interest group' as it develops into a professional community; to the nature of mental health care and to relationships with allied professions; and to the broad social, political and cultural context of the country in question.

Reviewing the early days of the profession around the world demonstrates the universality of conflict which is likely to arise as art therapy has its genesis, much as Waller (1991) has described in a 'process' model of the development of the profession in Britain. The development of practice and the formation of an 'interest group' may happen within the milieu of psychiatry, psychotherapy, education or community arts, each of which will have its own systems, ideologies and practices which may, or may not, prove sympathetic to the development of a new profession called 'art therapy'. Within each newly-formed group of artists, occupational therapists, art teachers, psychologists, psychotherapists and psychiatrists there are likely to be divergent views which can contribute to a struggle to 'own' the emerging occupation. In some instances difference and conflict has been worked with, and art therapy has been able to become an independent, established occupation recognized by political, health care and educational systems; but in others the profession is stymied by disagreement and disharmony and/or heavily dominated by psychiatry. In such situations art therapy continues to be fragmented, unformed and unable, so far, to gain recognition as a distinct discipline in its own right.

Waller's commentary on the aims of professional education and her reference to the work of Ben-David and Collins (1966) is useful in discussing this issue. She asks about:

> ...the extent to which a training is intended to produce followers, or to put it another way, the culture-carriers of a new discipline and the forerunners of a new profession; or is it intended to sensitize workers to the potential of art therapy so that they can make use of it in specific programs? (Waller 1992, p.16–17)

Comparison of experience around the world indicates that the training of already established mental health workers might well serve only to 'sensitize' them to the use of art in mental health care. This, together with the continuation of a struggle for ownership of a new discipline beyond a formative period – by individuals, by factions within the group or by allied

professions – seems to result in art therapy remaining essentially an adjunctive treatment. This may be because the group which is created stays one which is merely 'interested' (because art therapy is not, and does not become, the primary profession of its practitioners) or one which is dependent (on allied professions), rather than one whose members have sufficient identification with their new role to enable them to form an entirely new profession with unique parameters of theory and practice. In this context it is worthy of note that the only countries where art therapy is regulated and established as a discrete postgraduate profession are the UK and US, where the sole 'interest group' that formed was able to both separate from other disciplines in mental health care *and* survive the tensions and disagreements of the early days. Indeed, it seems to be necessary to have an energetic debate about identity where difference, even divergence, is acknowledged but contained and through which separation from allied professions is achieved.

What also seems necessary to the successful establishment of art therapy is the formation of a critical mass of practitioners. The sheer weight of numbers who speak with the same voice creates an infinitely stronger force than a multiplicity of voices saying different things. An obvious point, but it seems to us that there are salutary lessons to be learned from the situations in Canada and Germany where continuing splits between relatively small groups has created an ambiguous professional identity with art therapists working in competition or opposition to one another. Waller says that models of group processes are useful in thinking about why this might continue when it seems obvious that the resolution of conflict is in everyone's best interests; she suggests that evasion of interaction through fragmentation, splitting and projection between the groups avoids the tensions within the subgroups which might be destructive (1991, p.140).

Both the US and the UK have been fortunate in their creation of professional organizations that have been able to weather the storms of the early days, and which continue to contain the differing forces which live within them. Perhaps it is worth noting that, in both instances, a significant amount of time passed between the formation of the small group of individuals interested in developing the use of art in mental health; and the establishment of an association with a significant membership, only later reaching a point at which the association was able to establish agreed norms of clinical practice and postgraduate education. All in all, this suggests that in order to thrive the profession of art therapy has to acknowledge and work

with conflict, as well as evolve through a significant passage of time; each country in its own way.

However, issues within and between groups are not the entire story for the context and its culture are also significant in the development of the profession. It is interesting that, in Britain and the US, art therapy made significant moves towards becoming established when the mores of time and place had an enabling influence (as Waller (1991) and Junge (1994) describe). It is also important to acknowledge that in both countries this occurred within relatively positive economic climates. The extent to which socio-political and socio-economic influences were consciously utilized at the time, or are only discernible with the benefit of hindsight, is debatable; but it is a point worthy of consideration in those countries where art therapy is currently endeavoring to establish itself when worldwide the prevailing economic climate is one of 'downsizing' and psychiatry is dominated by medical and behavioral interventions.

Conclusion

So where does this leave the development of art therapy in Australia? The nature of the situation in Australia is, in several ways, unlike that of the early days of art therapy elsewhere in the world, particularly Britain and the US. There are the realities of a different history of psychiatry, a much smaller population, the significant geographical distances within Australia, and between Australia and the rest of the Western world – all of which seem to us to have had an impact on the very nature of the profession's beginning.

The work of the profession's founders prior to the inauguration of ANATA is not yet fully documented but it is clear that artists, art teachers and occupational therapists were initiating their individual art therapy practice in much the same way as the profession began elsewhere in the world. However, the Australian founders were usually working in considerable geographical isolation from one another, which might have prevented them forming an initial 'interest group' as has been the case in other countries. By the late 1980s art therapists who were trained overseas had returned to Australia with varying models of art therapy theory, practice and professional organization learnt in the differing (from each other as well as from Australia) cultural contexts of the US and Britain. This diverse group of practitioners formed ANATA and worked towards the introduction of art therapy education but, by the time we arrived in Sydney in 1994, there was obviously conflict within the group and tension between art therapists and the 'Arts for

Health' movement of artists in hospitals. However, considered within the process model of the development of professions, and given the experience of other countries, such conflicts within the new professional group and between allied professions can clearly be seen to be both an expected and necessary part of Australian art therapy's identity formation.

Some of these developmental factors can be considered in the context of Waller's point (1991) about the distinction to be drawn in art therapy between 'forerunners', 'founders' and 'followers' in the development of a profession (Ben-David and Collins 1966). In several countries (the UK and US) art therapy clearly had its forerunners and founders (i.e. those who were not themselves students of art therapists, but who educated their followers), but other countries (Hungary, Bulgaria, and perhaps Italy) seem not to have had this experience but rather to have art therapy 'brought home' by followers educated in Britain or America, or 'brought in' by founders from either of those two countries. In Australia the situation is one where there were a few isolated Australian founders, but they appear not to have educated their followers. In addition, there appears to be what could be described as an intercultural exchange between Britain, North America and Australia! Australians have trained overseas, non-Australian, UK- or US-trained art therapists have migrated to Australia, and the new Australian art therapy courses have employed a mixture of Australian, American, British and Canadian clinicians and educators. This has created a complex situation where, alongside the Australian founders, there are both founders and followers from Britain and the US who have transmitted their work to Australia. Art therapy education and clinical practice which is, in effect, imported from another socio-political and socio-cultural context is in danger of being, as Horgan (1992) describes, insensitive to local practitioners and a form of 'academic imperialism'. This is particularly delicate in a situation where founders, overseas-trained followers and unqualified personnel are seeking to join forces to form a relatively homogenous, egalitarian, professional organization. The difficulty lies in recognizing the considerable diversity in education, theory and practice which makes up Australian art therapy whilst working towards the formation of an unambiguous identity. It is important that this neither disenfranchizes any practitioners nor restricts the freedom to develop the profession in a way that is uniquely Australian. As Horgan says: 'The problem for an emerging art therapy association is to be selective without being exclusive. In this way we can hopefully nurture the seeds of a culturally relevant art therapy' (p.5).

As has become clear in our description of the differing socio-cultural and socio-political contexts in which art therapy has developed around the world, art therapists in Australia also need to consider the wider situation in which they function. Australian art therapists are seeking to establish themselves within mental health care systems that are heavily dominated by the medical model of psychiatry, a system that is not inherently conducive to a dynamically-oriented treatment. Within Australian psychiatry there seems to be little danger of art therapy becoming dominated by other mental health care professionals, particularly psychiatrists, although there is considerable, sometimes acquisitive, interest in the diversional and diagnostic use of art from members of the multi-disciplinary team. As we have described, psychotherapy is gradually gaining ground and it could be that art therapy will be in the vanguard of the acceptance and inclusion of dynamically-based treatment approaches in Australian psychiatry. Alliances with interested colleagues in psychiatry, education and social services, with other arts therapies, psychotherapists and professional associations of allied disciplines seems to us to be an important focus of activity. But attention could also usefully be paid to those particular attitudes, movements and socio-cultural phenomena in mental health and in Australian society at large which might be capitalized upon, e.g. the tradition of artists working in hospitals and prisons and the centrality of art in the indigenous culture of Australia. Creating alliances which establish difference in orientation and clinical practice as well as areas of common concern, has the potential to create a situation where mutual understanding, support and effort could work in the best interests of all concerned.

Most of all, art therapists in Australia, together with their professional association ANATA, would do well to heed the history of art therapy associations around the world. It can clearly be seen that fragmentation into more than one professional association hinders the establishment of art therapists as an autonomous group, restricting overall development to the level of an adjunctive activity. Gathering together a critical mass of membership, and building one association that can contain philosophical and individual difference, is crucial to the growth of the discipline and its recognition as a primary treatment. This critical mass of working members is a prerequisite to the organization's 'teeth', to its negotiating authority. From this it seems an organization can be created which is able to maintain a focus on the bigger picture, one which represents the interests of the professional group *as a whole*.

However, whilst learning from the experiences of others overseas, too literal a transfer of ideas and procedures (from British and American art therapy in particular) could inhibit the evolution of theory, practice and organizational structures which are suitable for the Australian context. Creating something entirely new from the heterogeneous group of practitioners that currently comprise the profession in Australia will inevitably give rise to controversy, friction, tension and anxiety; but only through such a process will a uniquely Australian art therapy be formed.

We learned an enormous amount whilst we were teaching at the UWS Nepean, not only about art therapy in Australia but also, as we gained a new perspective about ourselves as educators and clinicians, about the profession in Canada and Britain. Despite our return to our respective homelands we remain committed to the development of art therapy in Australia and look forward to our continuing involvement with it. Doubtless it will continue to be a stimulating, creative and sometimes turbulent process.

Bibliography

Adamson, E. (1984) *Art as Healing*. London: Coventure Press.

Allison, J. (1989) 'How art therapy came to the West.' *Newsletter of the Australian National Art Therapy Association 1*, 1, pp.7–8.

Andrews, G. (1991) 'The Tolkein Report. A description of a model mental health service.'

Ben-David, J. and Collins, R. (1966) 'Social factors in the origins of a new science: the case of psychology.' *American Journal of Sociology Review 31*, 4, pp.451– 65.

Berecry, N. (1989) 'Art therapy in Sydney.' *Newsletter of the Australian National Art Therapy Association 1*, 2, p.2.

Cagnoletta, M.D. (1992) 'Art therapy in Italy.' *Inscape*, Summer, pp.23–25.

Calomaris, S. (1992) Letter. *Newsletter of the Australian National Art Therapy Association 4, 1*, pp.10–11.

Campanelli, M. and Kaplan, F. (1996) 'Art therapy in Oz: report from Australia.' *Arts in Psychotherapy 23*, 1, pp.61–67.

Carrigan, J. (1993) 'Painting therapy: a Swiss experience for people with mental retardation.' *American Journal of Art Therapy 32*, pp.53–57.

Clare, A. (1976) *Psychiatry in Dissent: Controversial Issues in Thought and Practice*. London: Tavistock.

Coulter, A. (1991) Letter. *Newsletter of the Australian National Art Therapy Association 3*, 2, pp.2–3.

Coulter-Smith, A. (1989) 'Art therapy in Queensland.' *Newsletter of the Australian National Art Therapy Association 1*, 1, p.6.

Cunningham Dax, E. (1989) 'The first 200 years of Australian psychiatry'. *Australian and New Zealand Journal of Psychiatry 23*, pp.103–110.

Division of Health Services Report (1979) 'Psychiatric statistics: 1. notes towards a history of public psychiatry of New South Wales.' Report no.79/1. Health Commission of New South Wales.

Edwards, C. (1991) Editorial. *Newsletter of the Australian National Art Therapy Association 3*, 1, p.1.

Harvey, D. (1991) 'Report from WA.' *Newsletter of the Australian National Art Therapy Association 3*, 2, 5–6.

Herrmann, U. (1997) 'German art therapy: a puzzle and its pieces.' Unpublished essay, Master of Arts in Art Therapy. London: Goldsmiths' College.

Hill, A. (1951) *Painting Out Illness*. London: Williams and Northgate.

Horgan, D. (1992) 'Bringing it all back home.' *Inscape*, Winter, pp.2–5.

Junge, M. (1994) 'The formation of the American Art Therapy Association.' *Journal of the American Art Therapy Association 11*, pp.175–179.

Lewis, M. (1988) *Managing Madness: Psychiatry and Society in Australia 1788–1980*. Canberra: Australian Government Publishing Service.

Marinov, A. (1972) 'Psychopathology of expression and pscyhelic art.' *Inscape, 5*, 24–9.

Marinov, A. (1975) 'Free art expression produced by a drug-addicted male.' In I. Jakob (ed) (1975) *Transcultural Aspects of Psychiatric Art: Psychiatric Art 4*. Basle: Karger.

Mertens, M. (1996) 'Kunsttherapie Entwicklung eines Berufsbildes. Argumente für die Anerkennung durch die Gesetzlichen.' *Krankenversicherungen*. Hamburg: Kova Verlag.

Morgenthaler, F. (1921) *The Artist as Patient (Ein Geistenkranker als Kunstler)*. Translated into French by Henri-Pol Bouche under 'Adolf Wolfli' (1964) in Publications de la Compaigne de l'Art Brut. Paris: Fascicules 2.

Nijenhuis, A. (1992) 'Fieldwork and training in the development of the profession of creative therapy: a fruitful dialogue.' *Arts in Psychotherapy 19*, pp.93–97.

Palmer, G.R. and Short, S.D. (1994) *Health Care and Public Policy. An Australian Analysis*. Melbourne: Macmillan Education Australia Ltd.

Parker, G. (1991) 'The Australian contribution to psychiatry.' In: D. Copolov (1991) (ed) *Australian Psychiatry and the Tradition of Aubrey Lewis*. Melbourne: The Mental Health Research Institute of Victoria and Monash University.

Prinzhorn, H. (1922) *Artistry of the Mentally Ill*. Berlin and New York: Springer Verlag.

Robinson, N. (1992) 'Art therapy in Switzerland.' *Inscape*, Winter, pp.5–8.

Rubin, J. (1985) 'Meet the ole timers. Perspectives on the American Association of Art Therapists.' 'Messages in Art', 16th Annual Conference of the American Association of Art Therapists, New Orleans.

Schweizer, C. (1990) 'Art therapy in Holland: defining a position in a hierarchical structure.' *American Journal of Art Therapy 28*, pp.66–67.

Stoller, A. and Arscott, K.W. (1955) Report on mental health facilities and needs of Australia. Canberra: Government Printing Office.

Szilard, J. (1992) 'A short history of Hungarian psychiatry and psychotherapy in the light of psychiatric and psychoanalytic developments in twentieth century Europe.' *Inscape*, Winter, pp.18–20.

Thomas, C. (1996) '"Ich kann aber nicht malen..." Geschichte, Verfahren, Moglichkeiten, und Grenzen der Kunsttherapie.' In: W. Kraus (1996) *Die Heilkraft des Malens, Einfuhrung in die Kunsttherapie Beck'sche Reihe.* Munich: C.H. Beck.

Vasarhelyi, V. (1992) 'Visual psychotherapy – the Hungarian challenge. The establishment of the profession and the first postgraduate art psychotherapy course in Hungary.' *Inscape,* Winter, pp.21–33.

Waller, D. (1983) 'Art therapy in Bulgaria: Parts 1 and 2.' *Inscape,* April, 12–15 and October, 15–17.

Waller, D. (1991) *Becoming a Profession.* London: Routledge.

Waller, D. (1992) 'The development of art therapy in Italy: some problems of definition and context in training and professional practice.' *Inscape,* Winter, pp.9–17.

Waller, D. (1995) 'The development of art therapy in Bulgaria. Infiltrating the system.' In: A. Gilroy and C. Lee (eds)(1995) *Art and Music. Therapy and Research.* London: Routledge.

Waller, D. and Boyadzhiev, V. (1983) ' Art therapy and its relationship to psychiatry in Bulgaria.' In K. James (ed) (1983) *The Institution.* Hertfordshire College of Art and Design.

Waller, D. and Georghieva, Z. (1990) 'Art therapy in Bulgaria – Part 3. *Inscape,* Summer, pp.26–35.

Woddis, J. (1992) 'Art therapy: new problems, new solutions?' In: D. Waller and A. Gilroy (1992) *Art Therapy. A Handbook.* Milton Keynes: Open University Press.

Cultural Diversity and Implications for Art Therapy Pedagogy

Anna R. Hiscox

Abstract

This chapter documents some of the educational biases that affect black American students in art therapy graduate schools and discusses an observation of the American Art Therapy Association (AATA) by a black woman who attended an AATA gathering. The personal editorial perception of the AATA by a non-member was so provocative that it propelled the author to document the black experience of some students in art therapy graduate programs. Racism, issues of communication, responsibility of educators and supervision are areas addressed. The AATA is progressively pursuing diversity within its Association. This chapter will help educators to broaden their scope of knowledge and interactions with students of color.

The field of art therapy has increased its membership twofold in the 1990s. Males have shown a greater interest in the discipline and people of different ethnicities and cultures have also trained as art therapists. The increase of people of color in this unique discipline has broadened the diversity and scope of art therapy. The expansion of art therapy, in regards to the growing numbers of non-white students and professionals, posits culture-specific issues that should be addressed in art therapy pedagogy. This chapter addresses problems which are frequently overlooked or discounted in the training of African American students. Issues about black students are not addressed as the word 'black' is misleading and may imply that I am writing cross-culturally (i.e. blacks in Brazil, Africa, Haiti, etc). African American will be used to identify blacks of African heritage born in the United States.

Boyd-Franklin (1989) notes: 'Black people in this country are not a monolithic group' (p.6). 'There are differences between Black families from the North and those from the South. There are also important urban versus

rural differences' (Ibid., p.7). This chapter will address issues in the education of African American students that may affect professional training, peer relations and clinical decisions. It is hoped that the topics addressed in this chapter will help educators in increasing awareness and sensitivity in the training of Euro American students.

Cultural Diversity: A Pedagogy

The recognition of cultural diversity cannot be understood without an appreciation of the similarities within the African American culture. Literature research documents four areas of study in which African Americans differ from other ethnic groups. The four main areas in which the experience of black people in this country has been unique from other ethnic groups are the African legacy, the history of slavery, racism and discrimination and the victim system (Boyd-Franklin 1989, p.7). It is imperative that educators understand the impact of these four cultural paradigms to effectively educate black students. Students and educators enter a collaborative relationship, with each bringing their own baggage into the classroom environment. I believe it is the instructor who must be prepared to work with students from different ethnic and cultural groups. Although many white professionals have great understanding and empathy for minorities, they can never fully appreciate the dilemmas faced by a minority member (Sue and Sue 1990). An instructor who is not aware of paradigms which affect African American students is ill-prepared to educate students who, similarly, may have a tremendous effect on their clients.

As an African American educator and student mentor, I have heard countless stories of racism and injustices in art therapy training programs veiled in the guise of color-blindness, being discounted and 'making a big deal out of nothing'. The mis-education of African American students has been documented by many writers. Lock (1995) contends: 'many school experiences of African American students are negative due to errors of both commission and omission on the part of educational profession. Tracking, low expectations, the absence of sufficient role models, and a disregard for cultural diversity are barriers to African American educational achievement' (p.21).

Art therapy is a human service discipline and, as such, it is perplexing that black students have difficulty relating to instructors and peers and in understanding diagnostic and strategic techniques and interventions specifically designed for use with diverse clients. As educators, we need to

provide a safe environment in which students can examine their personal and cultural identities, their values and beliefs and their biases and assumptions (Cattaneo 1994). It would be advantageous for students if instructors reviewed their life scripts. Students cannot begin to work with clients who are ethnically and culturally different than themselves in the absence of positive role modelling and a pedagogy that glosses over emotionally laden material. Sensitivity training for positive instructor/student relations must begin in the safe environment of the classroom. Many therapists have written about developing sensitivity and empathy with diverse clients (Cattaneo 1994; Westrich 1994; Sue and Sue 1990; Boyd-Franklin 1989). It is imperative that we begin to transcend cultural biases by acknowledging cultural differences. Honouring differences cannot be obtained by having ethnic dinners in lieu of research and exploration of ethnic and cultural differences and similarities.

The American Art Therapy Association (AATA) ethical standards for art therapists clearly defines the standards for client and therapist relationships. Ethical standard 1.0 posits: 'Art therapists shall advance the welfare of all patients, respect the rights of those persons seeking their assistance, and make reasonable efforts to ensure that their services are used appropriately.' Ethical standard 1.9 posits: 'Art therapists shall not engage in therapy practices or procedures that are beyond their scope of practice, experience, training and education. Art therapists shall assist persons in obtaining other therapeutic services if the therapist is unable or unwilling, for appropriate reasons, to provide professional help, or where the problem or treatment indicated is beyond the scope of practice of the art therapists' (AATA 1995). These ethical standards are focal points that connote what is in the client's best interest. It is pertinent for art therapists to provide services according to the standards of the discipline. It is imperative for therapists to be cognizant of their scope of practice, skill and knowledge when working with people of color.

The Chameleon: Social Cultural Issues

This provocative subheading is being used to address an experience with my sister when invited to participate in the 1993 National Art Therapy Conference in Atlanta, Georgia. I am held in high esteem by friends and relatives for pursuing and obtaining credentials in art therapy. Art therapy remains a mysterious profession for many of my relatives. Since my sister lives in the host city of the conference, I invited her to the closing ceremony.

She was cordial and actively engaged with my colleagues. Having engaged in the celebration for approximately 20 minutes, she asked: 'why do we always have to be a chameleon in order to get along?' This was an intriguing question. It elicited memories of my graduate studies and the topics that were never discussed in my training. Three African American female students attended my graduate school during my tenure – two new entries, of which I was one, and one senior student. I was fortunate to have another person of African heritage to converse with in this new field of study which remains alien to many African Americans. My art therapy experience culminated in a great deal of respect and admiration for my senior colleague, who must have felt isolated in her training. My sister's metaphor of comparing African Americans to chameleons prescribed a reality check for me. I was forced to dissect my graduate experience in relation to class, race and gender issues in the classroom. My turning inward to reflect on the chameleon theory and cogent discussions with peers regarding this notion has increased my respect and gratitude to African American pioneers who opened the doors for me. It also reinforced my belief that African Americans are a resilient people.

A noted scholar and feminist, hooks (1989), documented her experience of being asked to lecture to a group composed of scholars and working-class people. Her recall of the event eloquently describes my sister's chameleon theory. hooks made a conscious choice in how she would deliver her address. The following describes her preparation and response from peers:

> Combining personal with critical analysis and theoretical perspectives can engage listeners who might other wise feel estranged, alienated. To speak simply with language is accessible to as many folks as possible is also important. Speaking about one's personal experience or speaking with simple language is often considered by academics and/or intellectuals (irrespective of their political inclinations) to be a sign of intellectual weakness or even anti-intellectualism. Lately, when I speak, I do not stand in place – reading my paper, making little or no eye contact with the audience – but instead make eye contact, talk extemporaneously, digress, and address the audience directly. I have been told that people assume I am not prepared, that I am anti-intellectual, unprofessional (a concept that has everything to do with class as it determines actions and behavior), or that I am reinforcing the stereotype of black people as non-theoretical and gutsy. (p.77)

hook's resulting dilemma of being perceived by some as anti-intellectual is a paradox experienced by many African American students. Which persona do

I wear in the classroom? How would I like others to perceive me? How does my family perceive me? These are questions that are not directly addressed in the classroom, although students are encouraged to seek therapy regarding personal issues. Racism, class issues and gender issues are core problems and dilemmas for clients as well as therapists. If students are asked to work through these issues in isolation, stereotyping and discrimination remain powerful tools that manifest in poor self-concept for both white and black students. Academia must begin to address topics which may upset their idealized notion of group cohesiveness sanctioned by the use of art therapy as a non-verbal modality which can bypass language but does not eliminate internalized racism (conscious or unconscious).

The process of making art in the classroom is ideal for students and educators to begin to address differences and to begin to develop sensitivity to people of different cultures and ethnicities. Stereotyping is one issue that must be addressed – many art therapy students are asked by instructors to speak on behalf of, and to qualify, the behaviors of people in their culture. It cannot be emphasized enough that students and clients from diverse cultures must be viewed by white therapists as *individuals* first – who are also members of ethnic groups. Black people are perceived and classified as a group without the understanding or awareness that there are distinct differences within the culture (Hiscox 1995). This perspective of people and groups must be addressed by all in academia if we are to deliver effective, quality care to others. The chameleon in all of us must be acknowledged and worked through. Racism, class and gender differences must not be a closet topic. To be effective with clients, we must be honest with ourselves regarding our stance on issues which are embedded in American culture and politics.

Racism

According to the Oxford Dictionary and Thesaurus (1996, p.1233), racism is defined as a belief in the superiority of a particular race; prejudice based on this. Oh, how we hate the word 'racism'. For some of us, the whole idea that therapists can be racists is an atrocity. One prevalent myth in the mental health field is that all the differences seen in black families are essentially class issues rather than racial or cultural ones (Boyd-Franklin 1989). It is much easier for many to codify color-blindness in academia than to acknowledge racism. According to Boyd-Franklin (Ibid.), color-blindness refers to the tendency on the part of many members of the mental health field to deny the impact of color differences in therapy. Thomas and Sillen (1991)

assert: 'color-blindness is no virtue if it means denial of differences in the experience, culture, and psychology of black Americans and other Americans. These differences are not genetic, nor do they represent a hierarchy of "superior" and "inferior" qualities. But to ignore the formative influence of substantial differences in history and social existence is a monumental error' (p.58).

Racism is often cloaked and masked – demoted to practice by racists and the unintelligent. Color-blindness is then heightened by social liberals and educators. Ironically, racism is practiced in classrooms and proliferated by institutions and associations of higher learning. Fortunately, educators are becoming more aware of how this insidious disease is manifested in the training and education of art therapists and other mental health professionals.

King (1990) contends: 'in dealing with difference teachers have always found it easier to discuss "others" as strange and unusual people living in far-away lands. Alternatively, they sometimes just ignore difference altogether and act as if there were no diversity among children or among various peoples and nations' (p.46). Educators who are cognizant of racism in pedagogy can greatly enhance the respect of students and increase the numbers of ethnically diverse students in the field of art therapy by acknowledging racism's existence and work to eliminate it.

African American students endure the pain of racism, whether it is implicitly or explicitly conveyed. Racism abounds in areas of study that are traditionally male-oriented disciplines (i.e. Psychology and English). Blacks who venture into these disciplines are well aware of their struggles. However, they may not be aware of the intensity of the obstacles placed before them (i.e. racist instructors and racist institutions). In my graduate training I had the most difficult time in my psychopathology class. I hypothesized that it was because the course was psychoanalytically based. I was adamantly opposed to internalizing this information. I believe psychoanalytic theory may work for white men but may be inappropriate for African Americans and women. I could expound on this hypothesis but it is not the premise of this topic. I did not want to believe that the difficulty of passing the course was because the instructor was a white woman. Reflecting on the situation, I have come to believe that racism was indeed the issue. One of the difficulties of black scholars and students is the investment of time and energy in dealing with racist instructors, insensitive reading material, insensitive comments and statements and coping with insensitive peers. Note: The insensitivity of peers

is evidenced in the 'do nothing, say nothing' attitude that allows the perpetuation of racist ideology.

hooks (1989) meticulously documents her challenge of completing her degree in English. Her story is mentioned here because she carefully recounts the frequency of racism in higher education. Her story is also reiterated because it is worthy of repeating – many instructors are not in touch with their racist behaviors. In fact, many are appalled that someone would even think of them in that context. The following passage by hooks is a fragment of her clear conception and dissertation of her struggles in higher education:

> During my graduate school years, I dreaded talking face-to-face with white professors, especially white males. I had not developed this dread as an undergraduate because there it was simply assumed that black students, and particularly black female students, were not bright enough to make it in graduate school. While these racist and sexist opinions were rarely directly stated, the message was conveyed through various humiliations that were aimed at shaming students, at breaking our spirit. (p.56)

hooks continues by stating:

> Of course, there were rare occasions when taking a course meant so much to me that I tried to confront racism, to talk with the professor; and there were required courses. Whenever I tried to talk with professors about racism, they always denied any culpability. Often I was told, 'I don't even notice that you are black'. (p.57)

Vignettes such as those described above run rampant in academia. In fact, it is so prolific that the individual who suffers the abuse is no longer discounted but ignored. I believe there has to be a solution to every injustice such as this. The solution begins with accepting our own prejudice and seeking help to eliminate it. In addition, open communication between instructors and students can assist in the downfall of institutional racism.

One of the initial strategies educators can use to minimize racial divisions in the classroom is to help students understand the theory and history of racism and color-blindness. Psychotherapy is becoming a familiar way of coping in the black community. Open, honest discussions on race will assist and prepare students to work with culturally different people. Greene (1994) describes effective, sensitive ways of working with African American women in therapy. Her therapeutic interventions are also applicable to African American students in the classroom. She suggests that 'therapists who do not

feel that race is an important area of scrutiny should utilize peer and other forms of supervision to explore racial issues before raising them with the client' (p.25). She explicitly clarifies ambiguity in addressing racial issues. Educators will find her recommendations helpful. Ladson-Billings (1994) describes African American and white teachers who are effective with African American students. They taught in a variety of styles, but one common approach was to deal directly and explicitly with issues of injustice and oppression and the privileging of mainstream knowledge and perception as they came up in the curriculum and in the reported daily experiences of their students (cited in Banks and McGee Banks 1997). There are additional things educators can do to increase sensitivity toward non-white students: (1) respect differences (2) eliminate stereotyping and (3) integrate art making with theory in reducing resistance and denial of emotionally laden issues. I am in agreement with Banks and McGee Banks (1997), who contend: 'Trust of school's good intentions especially by students and parents of color, is not automatic. But relationships of mutual trust and respect can be established between teachers and students in the classroom. Sensitive multicultural pedagogy is one foundation for such trust.' (p.50).

Paradigms of Communication

In keeping with the Chameleon Theory discussed earlier, it is pertinent to comment on styles of communication in the training of African American art therapists. I will refer to female art therapy students because the contents of this section are based on my interactions and communication with female students and professional art therapists.

Every family develops its own special style, its own strategies for dealing with family living. In doing so, the family operates as if it were guided by a family paradigm, a model of what the family is, can and should be (Constantine 1986, p.14). A close kinship to families in therapy is the classroom environment. In the classroom setting, African American students frequently display their scholarly persona. All other character traits, including cultural affiliation, are diminished in the classroom acculturation process. The evolution of the chameleon may manifest in linguistic differences, dress and mannerisms to avoid being perceived as different.

The academic environment inherently produces a hierarchy in relation-ships between students and instructors. The academic environment and communication style between instructors and African American students

carry the historical legacy of Jim Crow. Absurd? Euro American therapists might be quick to react to this statement. Satir (1972) was a pioneer of communication styles in family therapy. Satir certainly understood non-verbal communication – black people have communicated in this fashion prior to forced subrogation.

I would argue that there are two styles of communication described by Satir which I believe are relevant to the success or failure of African American students. As a mentor, I have conversed with students regarding the necessity of being a placator or computer. The placator always talks in an ingratiating way, trying to please, apologizing, never disagreeing, no matter what (Satir 1972). The computer is very correct, very reasonable, with no semblance of any feeling visible (Satir 1972). I believe the communication styles of placating and computing leads to self-destruction and schizophrenic responses to everyday challenges. The hierarchy in academia is evidenced in professor/student relations as well as peer relations. An example of a placator response is when a professor invites a guest speaker who is African American to lecture. The individual may symbolically represent his or her entire culture. What if the art therapy student does not agree with the guest speaker's conception of life in the black community? What happens when the guest speaker omits pertinent cultural information? The student may place herself in a vulnerable position by disclosing the erroneous information provided by the speaker. The perception of faculty and peers may result in being perceived as having a computer style of communicating. The alternative behavior of being perceived as a computer is the placator mode of expression.

The above scenario demonstrates how racism may be perpetuated in the classroom. It also identifies how black students are frequently discounted or elevated to be an exception within their culture. Many African American students believe their options are limited with respect to open communication in the classroom. Opting to cope with stress by placating or computing may be perceived as being passive or aggressive. Both behaviors may perpetuate stereotypic images of black women. Satir's doctrine of communication may be perceived as healthy compared to *sisters* turning it out in public. Turning it out or acting colored means that we give up trying to respond to a situation as if both we and they (white people and/or men) are operating within the same codes of conduct. It means handing over to our adversary our version of the stereotype that motivates their disrespect to us,

just to prove to them that they could not better handle the stereotype than they can determine and control our character (Holloway 1995).

African American students are frequently forced to confront the subtle prejudice and ignorance of professors and peers by having to set personal and physical boundaries. Being perceived as different is frequently demonstrated by comments related to hairstyle and texture and clothing. Physical boundaries are also blurred when people feel entitled to touch physical body parts (i.e. dreads or cornrows). Holloway clearly documents how race, physical appearance and education are inextricably intertwined. It is pertinent to comment upon this subject because it is another form of color-blindness, cloaked in the guise of curiosity. Holloway (1995) states:

> Regardless of our stature within our communities, our incomes, or our schooling, there comes some essential moment when black women must acknowledge the powerful impact of our physical appearance. How we look is a factor in what happens to us. Whether our conduct controls for this factor, or if it ignores it, has a potential consequence on its outcome. I think the reality of racism and sexism means that we must configure our private realities to include an awareness of what our public image might mean to others. This is not paranoia. It is preparedness. (p.36)

The demonic behaviors of some white instructors are consistent regardless of the type of discipline. It is my hope that the information contained in this chapter will help to transform racist behaviors that are seen as innocent. Differences should and can be addressed in art therapy by using our asset – art!

Locus of Responsibility

Locke and Parker (1994) discuss how to improve the multicultural competence of educators. Their perspective is an engaging commentary. They focus on the Attribution Theory: how people come to believe what they do about other people and themselves. They postulate that, when considered as a dimension, locus of responsibility is a measure of degree of blame, or acceptance of responsibility, placed on the individual or environment. Additionally, 'Locus of responsibility can be viewed as a continuum where at one end we place blame on the individual and at the other end we place blame on the system.' (p.52). They continue to state:

> Rather than operationalize a simplistic view of locus or responsibility, Sue (1981) suggested that we refrain from perpetuating the myth about a

person's ability to control his or her own fate. Educators must come to understand that a young African-American male may be quite realistic when he reports that institutional racism prevented his employment. It has not been a part of the history of this country for all people to be able to make it on their own. (p.53)

Educators should be cognizant of the Attribution Theory as they interview and accept non-white students for graduate programs. This theory should also be emphasized in pedagogy. An art technique educators can use to discuss sensitive issues in class is asking students to 'draw your place of birth' (Hiscox 1993). This technique is non-threatening and will provide the instructor, student and client with a wealth of information. More importantly, the art will provide an arena to begin communication. Supervision of African American interns should be viewed in a multicultural context.

The United States is becoming increasingly pluralistic. The AATA has to encourage research on multicultural issues to survive the 21st Century. Graduate art therapy schools are required to have at least one course on multicultural issues. One course is insufficient for anyone to totally comprehend the extensive material on this topic. Conversely, schools cannot be expected to fulfill the gaps posited in social learning. However, art therapy institutions can increase their proficiency in teaching multicultural issues and theory. In addition, the AATA would serve its students and educators more proficiently if it supervised multicultural curriculums through graduate schools to ensure consistency in what is being taught as 'multicultural issues'. Overseeing curriculum agenda will also help the Association to ensure that all students are prepared to take the American Art Therapy Credentialing Board certification exam. AATA can also help to eliminate outdated racist texts and assist students to cope with cultural issues in supervisor and supervisee relationships.

Supervision

Malchiodi and Riley (1996) prodigiously discuss cultural issues in supervision. Both authors discuss their own identities as art therapists and their cultural identity without blurring boundaries between the two in supervision. Malchiodi and Riley (1996) present case vignettes related to cultural issues in supervision. They describe what can be done when the supervisor and supervisee are aware of their own culture but do not share the same culture. They assert:

This is a unique challenge that is not easy to solve completely. The positions between the two are not equal; the supervisor has more power. This imbalance may make the discussion about divergent ethnicity awkward. The supervisor must be the leader in this dialogue and bring up the differences in color, background, religious beliefs, or whatever seems appropriate to discuss about the differences in their life experiences. Denial of differences is the danger, not the dialogue. (p.42)

The above passage documents current literature which proposes that supervisors must take the lead in confronting racism and bigotry in the classroom and in assisting students to recognize their countertransference issues.

Summary

This chapter extensively outlined some of the abuses within the field of art therapy. Unfortunately, the offences of a few significantly affect all art therapists. Art therapy is still in its infancy and could benefit from the lessons of other disciplines as they worked through their growth issues on race, sex and gender. What the American Art Therapy Association (AATA) does not need is another committee to address these issues. It is adamantly clear to me that the topics discussed in this chapter should begin by first having each individual member look into their own mirror of responsibility.

The AATA has the power to eliminate abuses. Proactive supervision is addressed by Malchiodi and Riley (1996). These authors have documented the path to healing. It is up to all art therapists to facilitate the prescription. Respecting differences is incumbent to all. It is my hope that art therapy will continue to grow in diversity by addressing injustices.

I have had some wonderful instructors and have met life-long friends during my training and professional career. Many of the students who have told me their stories have also had unique experiences. AATA has taken progressive initiatives to increase diversity. Increasing diversity within the Association will help clients to receive the best quality of care and will also increase the scope of knowledge for all art therapists.

Reference

AATA (The American Art Therapy Association) (1995) *Ethical Standards for Art Therapists.* Mundelein, IL: American Art Therapy Association, Inc.

Banks, J.A. and McGee Banks, C.C. (1997) *Multicultural Education: Issues and Perspectives* (3rd ed.). Needham Heights, MA: Allyn and Bacon.

Boyd-Franklin, N. (1989) *Black Families in Therapy: A Multisystems Approach.* NY: The Guilford Press.

Cattaneo, M. (1994) 'Addressing culture and values in the training of art therapists.' *Art Therapy, Journal of the American Art Therapy Association 11*, 3, 184–186.

Constantine, L. (1986) *Family Paradigms: The Practice of Theory in Family Therapy.*

Greene, B. (1994) 'African American women.' In L. Comas-Díaz and B. Greene (eds) *Women of Color: Integrating Ethnic and Gender Identities in Psychotherapy.*

Hiscox, A. (1993) 'The art of West Indian clients: art therapy as a nonverbal modality.' *Art Therapy, Journal of the American Art Therapy Association 12*, 2, 129–131.

hooks, B. (1989) *Talking Back: Thinking Feminist, Thinking Black.* Boston: South End Press.

Holloway, K.F.C. (1995) *Codes of Conduct: Race, Ethics, and the Color of our Character.* New Brunswick, NJ: Rutgers University Press.

King, E.W. (1990) *Teaching Ethnic and Gender Awareness: Methods and Materials for the Elementary School.* Dubuque, IA: Kendall/Hunt Publishing Company.

Locke, D.C. (1995) 'Counseling interventions with African American youth.' In C.C. Lee (ed) *Counseling for Diversity: A Guide for School Counselors and Related Professionals.* Needham Heights, MA: Allyn and Bacon.

Locke, D.C. and Parker, L.D. (1994) 'Improving the multicultural competence of educators.' In P. Pedersen and J.C. Carey (eds) *Multicultural Counseling in Schools: A Practical Handbook.* Boston: Allyn and Bacon.

Malchiodi, C.A. and Riley, S. (1996) *Supervision and Related Issues: A Handbook for Professionals.* Chicago, IL: Magnolia Street Publishers.

Oxford Dictionary and Thesaurus, American Edition. (1996) New York: The Oxford Press, Inc.

Satir, V. (1972) *Peoplemaking.* Pal Alto, CA: Science And Behavior Books, Inc.

Sue, D.W. and Sue, D. (1990) *Counseling the Culturally Different: Theory and Practice.* New York: John Wiley and Sons.

Thomas. A. and Sillen, S. (1991) *Racism and Psychiatry.* NY: Carol Publishing Group.

Westrich, C.A. (1994) 'Art therapy with culturally different clients.' *Art Therapy, Journal of the American Art Therapy Association 11*, 3, 187–190.

The Black Madonna in New Mexico Prison Art

Linsay Locke

Abstract

This chapter will address the Penitentiary of New Mexico Hispanic inmates' depiction of 'Our Lady of Guadalupe', also called the 'Black Madonna.' Her archetypal image appeared as the ancient Earth Mother and continues to influence both the Old and New Worlds. Examples of her images, myths and symbols will be discussed and inmates interviewed concerning the meaning and significance she holds for them within their sterile prison environment. Juxtapositions of pagan/Catholic traditions – the virgin/whore paradox – and the bridging of cultures will be considered.

Introduction

This chapter will address the New Mexico State Penitentiary Hispanic inmate population's reapplication of the Black Madonna, as *Nuestra Señora de Guadalupe* (Our Lady of Guadalupe), from the viewpoint of archetypal art therapy. The role the New Mexican Black Madonna fulfills for the maximum security inmates who share 'patterns' of her image to draw on their *paños* (handkerchiefs) and paintings will be discussed. The Black Madonna, or Black Virgin, is an archetypal image appearing in religious artifacts within a historical tradition existing for thousands of years, and further receding into pre-history where she appears as the Earth Mother, promoting the fertility of the land and protecting it from malignant forces (Gimbutas 1989). Archetypes are collective archaic images or complexes. Carl Jung suggests that just as the body is based on a mammalian anatomical pattern with a long evolutionary history, so too the mind maintains primordial images or remnants of our ancestral experiences (DeLaszlo 1959). As such, the archetypal dark goddess continues to influence the unconscious depths of diverse contemporary cultures in both the Old and the New Worlds.

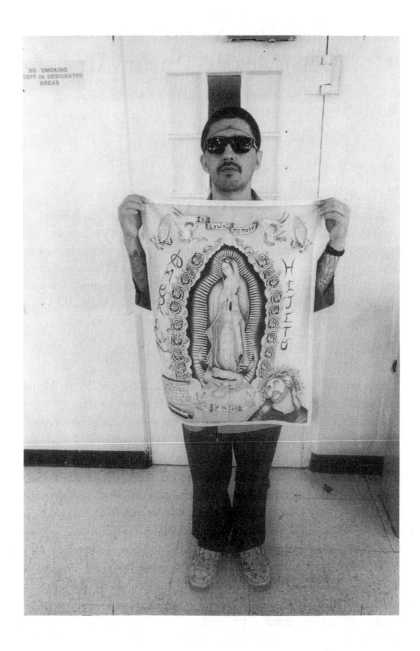

Figure 16.1. 'Amor Hijito.' Ink on torn bedsheet.
 Photo: Miguel Gandert

There will be a brief description of the penitentiary's population, the art classes and the students interviewed before commenting on the Black Madonna's transcultural implications and her migration to the New World. Her customary symbols and functions will be identified, as well as the inmates' associations to them. Questions considered or issues discussed with the inmates include: What is it about Guadalupe that speaks to you? Does she bring meaning and purpose within a sterile and regimented environment? Can a conventional image of veneration satisfy a personal need for expression and, if so, in what way? Does the myth offer truth on an individual basis and has this myth been reshaped to meet the needs of those delineating her image?

I worked as a full-time art teacher, and unofficial art therapist, at the New Mexico State Penitentiary in Santa Fe for 14 months. The penitentiary's population is all male, ranging in approximate ages from 17 to 70. Population ratios, as of mid-1996, were 56 per cent Hispanic, 26 per cent Anglo, 12 per cent Black, 5 per cent Native American and 1 per cent Oriental. Although the penitentiary's population is multicultural, the Hispanic majority tends to orient socially within its own culture. This reflects traditions of close-knit family and community support systems, contrary to the dominant Anglo culture that stresses individualism and independence. The inmates will specifically be referred to as men, or pseudonyms will be used, because personal names and human appellation are often avoided inside the system by those in charge. Rather, prison inmates are known by their assigned number – or worse, derogatory terms – and are the subject of insensitive procedures denoted by inhuman terminology such as, for example, a 'cell extraction'.

The Guadalupe images were collected from the men in the maximum security facility, which provided two small art classes for its 192 tenants. One class, that averaged 10 students, met for 1.5 hours three times a week in the open area outside the inmates' cells. Art materials were restricted to two-dimensional work using non-toxic materials that were brought in on a cart and taken out at the end of the class period. The classroom space contained five small cement tables, each with four bolted-down stools. Everything was painted white – tables, stools, cement walls and steel doors. Above the classroom, a wide expanse of clear glass windows allowed the guards, or Correction Officers (C.O.s), to view the proceedings from the control room. The sterility of the environment and the mix of men, who often did not wish to socialize with others in the class, resulted in limited

interaction. Most preferred to work on individual projects and to be spoken to individually rather than to follow suggestions for joint themes or media exploration.

For the second class, three to seven handcuffed men were escorted into a small cold room and made to sit on tiny steel stools inside individual locked cages of about 32 x 48 inches. Usually placed in the same row, they could not see one another's faces or artwork. Materials were passed to them through a small opening approximately 5 x 12 inches. In addition to these limitations, there was an air of secrecy or collusion and I soon learned that mutual gang members and their enemies were joint participants in the classes. I also encountered the consternation of never knowing when someone might be shipped out, placed on disciplinary, stabbed or die of an overdose. In addition to those two classes, 25 students were visited individually on a weekly basis at their solitary cells and any interchange took place through the steel doors' 'food ports', also 5 x 12 inches in size. One had to wait for the C.O. to open the port then work sitting on a folding stool, leaning over to look eyeball-to-eyeball with the individual inside. This method proved to be the most fruitful therapeutically. There was some degree of privacy (though curious neighbors often stood at the crack of their doors listening) and, after a period of gaining trust, self-disclosures could take place, sometimes via letters handed out through the port to be read later and responded to in kind. Authenticity about self and circumstances requires trust and nurturance. However, their experience has proved that no one can be trusted: fellow inmates, C.O.s, authority, families or loved ones who often desert them. Among the men it is known that staff or counselors are required to report and disclose information that may be detrimental to self or others. 'Ears' are everywhere and self-disclosure runs the risk of the information being passed to rival gangs or to the C.O.s, who may use the information for their own purposes. This knowledge added to their reluctance. It often took months for one of them to come forward with personal admissions or to begin to allow affect to come into the meetings.

A favorite ground, or surface, for their artwork is the paño – a handkerchief or other available fabric, such as torn sheets or pillow cases. Paños reputedly originated in south-western prisons and are primarily a Hispanic prison art form. They are inexpensive, easily stored and mailed out in an envelope. Because disposable tissues have replaced cloth handkerchiefs, the *pinta* (prison) canteen sells handkerchiefs for paño making. The fabric is usually drawn upon with ballpoint pens – black or colored ink – but colored

pencils, pastels, magic markers and, sometimes, acrylic paint are also used. The Smithsonian now has a paño collection recognizing the uniqueness of this cultural art form.

Often, there has been little or no exposure to art or art training prior to their incarceration. The men begin by copying stereotypical patterns which are shared with friends and, sometimes, neighboring inmates. In the New Mexican tradition of religious folk art, copying is a custom. The 17th century Spanish territory of what is now the State of New Mexico, U.S.A., was very isolated from Mexico, the center of Spain's control, and *santeros* (painters of saints) and *bultos* (sculptors) faithfully imitated existing portrayals of a given saint, its position and appurtenances, adding only stylistic elements (Steele 1982; Weigle 1983). Inside the prison, copying helps the men to develop technical skills such as media use, proportion, shading and compositions. Those more skilled are pleased and proud to help the beginners. Though patterns are often traced the end product demonstrates their individuality, which is as clearly identifiable as their handwriting. A very few of them, with experience and increased confidence, risk venturing into the unknown of finding their own style, content and means of expression. When rendering the Virgin though, it is important to hold to the familiar symbols and stylistic details rather than to alter or be individualist.

The Black Madonna has many names, variations and countries – 'The religious history of mankind shows a recurring tendency to worship a mother-goddess' (Walker 1983, p.611). She shows herself to us as the 21,000-year-old Venus of Laussel holding high the lunar crescent horn. Rituals in the sacred cave invoked her magic powers, for the earth was conceived as the body of the Mother. During the agricultural period her powers were invoked for both land and human fertility (Sjöö and Mor 1987). She is Lilith, Isis, Cybele, Diana, Queen of Sheba, Virgin Mary, Mary Magdalene, plus a multitude of other names (Begg 1985). She healed, performed miracles, revived babies and helped the crops grow. Sjöö and Mor (1987) conjecture that she originated in Africa or Egypt and the religion of the Black Goddess spread to other parts of the world. Her legends and icons are found throughout Europe – Spain, France, Italy and, especially, Eastern Europe (Ibid). During the Christian era her dark images were painted over or removed and, though she was forced underground, she could not be eliminated from the collective psyche. Today, for example, one shrine, the Polish Lourdes, draws thousands of visitors each day (Gimbutas 1989).

According to Begg (1985), of the 450 known images of the dark virgin throughout the world (excluding Africa) most are from white or light-skinned cultures and have been called black, dark, brown or grey. A painting dated 1676 in Holland, records an already ancient Spanish Black Virgin, Our Lady of Regula (Ibid). Many of the old Spanish patron saints that were used against the Moors travelled with New World settlers to become Americanized as patrons against Indian problems (Steele 1982). If their native beliefs could be changed, the Indians would become more compliant. To that end, Guadalupe eclipsed Tonantzin, her Central American predecessor, and appears in Mexican murals as early as the 16th century (Edwards 1966). In New Mexico she was painted on *retablos* (wood panels) with natural plant and mineral dyes. Of the religious themes copied or adopted by the men at the penitentiary, there were many more images of the Virgin than of her son, the *Christo*. Nuestra Señora de Guadalupe was the most popular *santo* (saint) in New Mexico prior to 1850 (Steele 1982) and she has made her comeback not only at the prison but as the theme of contemporary pilgrimages, articles, murals and art shows. Such enduring ability to evoke a response over centuries demonstrates her archetypal structure.

The sumptuously robed Guadalupe *bulto* (sculpture) brought from Spain included the Christ child on her arm, but the Mexican and New World Virgin appears alone, hands clasped in prayer, with her own version of an origin, legend and miracles. According to Pál Kelemen (Weigle 1983), a copy of the original statue was brought from Spain in the 16th century to a Peruvian village shrine and there miraculous cures were attributed to her. In another, often retold, New World legend, Our Lady of Guadalupe first appeared to a Christianized Aztec peasant, Juan Diego, near Mexico City in the year 1531. She appeared atop Tepeyac Hill, a hill that had been sacred to the Aztec earth and fertility goddess Tonantzin prior to the Catholic conversion of the natives. Guadalupe's apparition appeared miraculously to the bishop when Juan Diego opened his *tilma* (poncho) to drop an offering of roses that he had picked in December from a magical bush on the goddess' hill. She is sometimes shown in four vignettes illustrating her four apparitions to Diego (Steele 1982). Our Lady of Guadalupe was one who became 'syncretized in Mexico with the Aztec deity' (Ibid, pp. 97–98) and is shown 'often with perceptibly Indian features, standing in a full body halo, supported upon a dark upturned crescent and a winged angel' (Ibid, p.175). She appears to be a grounding connection to the Hispanic inmates' historical roots and many of

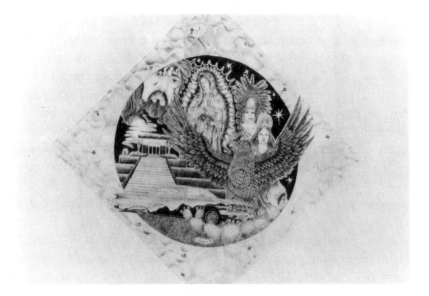

Figure 16.2. Guadalupe with Aztec figures and temple, Christo, low rider car, self-portrait and cactus. Black ink on handkerchief.

them know of this legend as well as other Aztec mythological heroes. In their paños the students often combined Aztec figures with Guadalupe. As Jesse explained: 'They belong together; they make me proud.'

Black Madonna sites throughout the world have long inspired pilgrimages (Gimbutas 1989), whether in 12th-century Europe, or 20th-century New Mexico. Often, the pilgrimage was sacrificial, somber and penitential, requiring the pilgrim to climb hundreds of stairs on knees or walk for miles barefoot and hungry. Today, each year in the southern New Mexico town of Tortugas, pilgrims gather on December 10 to carry her framed image 4.5 miles up a hill to a devotional area. That hill may be reminiscent of the hill where Juan Diego first saw her apparition. The men behind their steel doors have relatives and loved ones who participate in these rituals and are emotionally and psychologically connected to those outside events.

The Chicano movement of the past four decades has given hope and pride to the incarcerated Hispanics and they generally use motifs common to their culture, such as the *pachucos* in Zoot Suit, low rider cars, Aztec, Mayan and religious themes. These subjects are frequently combined into one collage along with prison images, as if nothing can be omitted. Often, Our Lady of

Guadalupe is central or made larger than other subjects in a composition. What is this centrality, why is she so important? When asked that question, José, responded: 'Because she takes care of us. She knows I'm here'. Others answered simply: 'She protects us' or 'She is the Virgin', with intonation implying, of course, SHE is special, has special powers, is goddess. Twenty-odd of the men had Our Lady of Guadalupe tattooed on their brown chests, backs or arms. Ramon pulled up his shirt and turned with pride to show his shoulder-to-waistline coloured tattoo. 'She protects my back!' – a valued ally in an unsafe environment, whether on the streets or inside the prison walls. According to Steele (1982), santo art does not exist for art's sake but is part of 'the magico-religious, through which the adept can exert a powerful, persuasive force on the sacred powers' (pp.36–37). Believing in the wonder-working miracles of Guadalupe affords confidence, hope and self-empowerment. When archetypes appear, they have a distinctly numinous character 'which can only be described as "spiritual," if "magical" is too strong a word ... and (they have) a corresponding effect upon the emotions' (DeLaszlo 1959, pp.75–76). Neither in the classes nor with individuals were there overt admissions to an emotional response, but the prevalence of her image in their work admits to her impact on their interior lives.

A related quality of the dark virgin is the mystery and wonder which surrounds her mythology. Many could not readily verbalize why they felt a connection to her but acknowledged that there was something special about her. Instead of speculating about that mystery, often there was a concrete answer, such as: 'My mother asked me to make one for her'. Or there was a sense, a feeling, such as: 'It gets my mind off this place' or 'Don't know. Maybe I meditate when I draw'. Mystery imparts a power to the icon as well as to the self. The men at the secured facility did not easily discuss their feelings, or their personal history or crime. It was generally an unknown, an unspoken sort of agreement between author and student that allowed each man to be viewed as a person and not as his crime. This missing link, or mystery, seemed to afford them a degree of control over their circumstances and to elevate the relationship to a more equal working status and one of mutual respect. Mystery and the unknown are part of the dark goddess archetype and, because of aspects parallel to themselves, there may be an identification with the Virgin.

Guadalupe seems to speak or call to the artist as a protectress and, more importantly, as someone who looks out for and who knows that he's there.

Knowing that 'I'm here', and being seen are powerful issues for these incarcerated men of Hispanic origin. They feel unseen and undervalued within the dominant Anglo culture. Rodriguez (1993) says of his growing up in Los Angeles: 'We were invisible people in a city which thrived on glitter, big screens and big names, but this glamour contained none of our names, none of our faces' (p.20). Inside the prison the not being seen or, conversely, forced to be always visible to the C.O.s even while inside the cell – seen without the authority to return a gaze – is demeaning and disempowering. The ensuing internalization of disempowerment, and the infantilization of always being watched and having every aspect of the day controlled, forces an equal and opposite reaction – misconduct and violence – self-harming acts that result in a report, disciplinary action and detention. The disempowerment backfires into exaggerated force or threat of force on the parts of both the men toward fellow inmates and the C.O.s toward the incarcerated men. But, momentarily they ARE visible, heard and acknowledged, even if painfully so. Having power and being 'on top' within the system was of consequence to the men and stories of withstanding excessive abuse were spoken with pride and understood as a means of gaining respect and leadership positions.

We respond unconsciously to symbols, even though we may consciously choose to ignore them, and 'there is also a re-creative meaning in these symbols' (Jung *et al.* 1964, p. 109). Distinctive symbols constellated around a particular archetype help one to intuitively or unconsciously understand various aspects of the archetype. Henderson writes:

> For the analogies between ancient myths … and … modern patients are neither trivial nor accidental. They exist because the unconscious mind of modern man preserves the symbol-making capacity that once found expression in the beliefs and rituals of the primitive. And that capacity still plays a role of vital psychic importance (Jung *et al.* 1964, p.107).

Our Lady of Guadalupe's distinguishing symbols are a black crescent moon, an angel supporting the moon, a luminous spiked full-bodied halo, roses and, sometimes, a snake, crown or stars on her robe.

When asked about the meaning of the crescent moon, the men's answers included a sign of power, she has power over the sun and the moon (refer to the verse from Revelation 12:1 below), it's a horn or it just shows she's up in the clouds. A number of them saw the crescent moon as a horn, a response that ties in archetypally with the ancient image of The Venus of Laussel who holds the horn above her head. This horn seems likely to be a related linkage

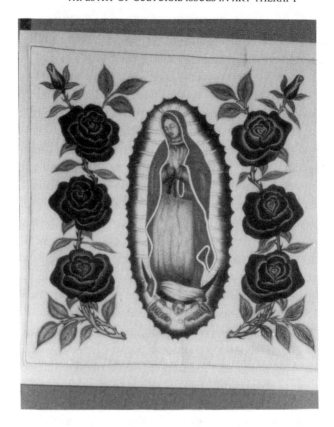

*Figure 16.3. Guadalupe wearing a red robe. Eight black roses. Black and red inks on
 handkerchief.*

to female fecundity and the phases of the moon. Another image, the bull, has
been associated with reproduction since ancient times and Gimbutus (1989)
illustrates the bull's head with horns, placed on ancient pottery, below the
figure's abdomen to echo the silhouette of a uterus and fallopian tubes.
Another illustration shows Upper Paleolithic cave paintings of bovines with
crescents as horns and Gimbutas says that 'the bull is connected with the
moon from earliest times' (p.280). The moon/horn, bull/uterus parallel
images apparently are archaically encoded symbols in the collective
unconscious of humankind.

The crescent moon was the pre-eminent symbol of the Moors and the
Guadalupe in Spain was invoked in their struggle to oust the Moors. Carried
with the emigrants to Spanish colonial America, Nuestra Señora de

Guadalupe was also called upon in their struggles against the Mexican Indians. The Aztec goddess Tonantzin, upon whose image and hill Guadalupe was overlaid, was often connected to a black crescent moon (Steele 1982). In an early encaustic Mexican mural, a dark Guadalupe with Indian features stands on a broad crescent supported by a full-bodied native man. He stands only slightly above the crowd that surrounds him. She appears to be parting the clouds, but none of the other familiar symbols are present. It was painted by a 21-year-old Indian man. Is she Tonantzin, not the Spanish Madonna? The text describes the mural as showing the first use of native costume (Edwards 1966). Edwards writes that the Spanish Conquest obliterated native life and art: 'As early as 1525, in San José, the first convent built in Mexico City, ... native artists were taught European form ... Some *chance similarities* [italics added] in the practices of Indian religions and the Catholic faith made the transition from old ceremonies to new easier for the natives' (pp.64–65). One explanation of the overlaying and correlation of the two can be explained because both goddesses were associated with a crescent moon, but there are other associations of the goddess to the moon. Archetypally, the moon is feminine and the sun is masculine. The Bible, in Revelation 12:1, refers to 'woman (with) the moon under her feet' (Ferguson 1981, p.45). Murals on temple walls at Çatal Hüyük, circa 6500–5650 BC, show the bull horns and the goddess in her triple aspects of maiden, mother, crone – aspects that correlate to the waxing, full and waning phases of the moon (Sjöö and Mor 1987). Gimbutus (1989) also relates that the moon in Crete and Çatal Hüyük is associated with bull horns and rites of seasonal regeneration with fertility. Steele (1982) associates monsters, bulls and female deities with the moon, as well as snakes:

> The serpent, born from itself when sloughing its skin, is symbolic of the lunar principle of eternal return. This relationship suggest Quetzlcoatl, the winged serpent deity of Aztec religion, as does the most plausible explanation of the name Guadalupe: *coatl llope*, 'snake' 'to tread on,' rationalized by the Spanish into the name of a Spanish Statue of the Virgin (p.100).

The Mexican flag and a snake occasionally appeared along with the image of the Virgin in the prison artists' work. It was usually a rattlesnake and, on several paños, Quetzlcoatl, the Aztec winged serpent, made his appearance. There was not a conscious recognition or spoken connection to Eve and the serpent in the garden or other associations to a snake, but the mythological projections and unconscious symbols surely attracted these artists' attention

and asked to be drawn, to be made visible and recognized or known again. The rattlesnake's poisonous venom kills, it instills fear – just as some prisoners' actions have. A harmless snake is the symbol of rebirth, of wisdom (its watchful lidless eye), is coiled on Aesculapius' staff of healing (Henderson and Oakes 1990) and, for Pueblo Indians here in the south-west, a snake is a messenger that carries prayers down to the Earth Mother.

The crescent moon is black, a 'color' that has a dark, shadow aspect to it, is associated with death, or has no color. In Old Europe black was related to fertility and rich soils, damp caves and the womb of life (Gimbutus 1989). The word 'Egypt' means black (Begg 1985). A large proportion of the ancient miraculous Madonnas of the world are black but, because of their non-scriptural, even heretical, origins, the blackness in statues of the Virgin tended to be ignored or whitewashed (Ibid). More is known about her wonder-working qualities than why she is black, dark brown or gray (Steele 1982). The renderings of the Virgin done in the penitentiary, however, do not always have a darker skin tone. This may be because shading and making skin tones are difficult for beginning art students and it is simpler and more successful to leave the cloth untouched inside the face and hands. However, when using colored pencils or acrylics, a pinkish 'flesh' color was most often used – perhaps because the Church's icons in the US are Anglo, perhaps because of a desire to conform to the dominant Anglo culture, perhaps it is an unconscious reversal to lighten their shadow sides, their dark existences, or perhaps it isn't considered: their brown-skin *chicana* girlfriends do not have shaded-in flesh tones on the paños. It is a curious reversal that most dark virgins come from light-skinned cultures, and these men of darker skin often seem to convert their Guadalupes into a 'white' madonna.

The halo, or nimbus, is a zone of light usually placed behind sacred personages to identify their great dignity (Ferguson 1981). It is the aura, a visible emanation of the breath, mana or prana, and is seen by mystics of many cultures. It is the light that allows the vision or apparition, it illuminates the way. When asked about the halo, the students only commented that she is holy or from heaven. One man thought it was fire – its heat and energy. When looking at the image, the radiant surrounding light adds a sense of wonder or the miraculous. The spiky pattern inside the halo may indicate vibration or layers of the aura. The spikes may even have developed from living in an arid desert with thorny plants (See Figure 16.2). Thorns, of course, remind one of the Christo and his crown of thorns.

'Angel' means messenger. Of this angel, who appears to support both the moon and the Virgin, Steele (1982) writes: 'Angels seem originally to have been connected, as serpents were, with lightening and rain, and ... to the snakelike phallus, particularly in ... Eros (Amor, Cupid), a personification and deification of masculine erotic drives' (p.101). He also suggests comparison with Hermes (a phallic trickster and psycho pomp of the underworld) and his Roman counterpart, Mercury, a winged messenger. The angel in the centuries-old retablo in the *Sanctuario* at Chimayó, New Mexico, appears very childlike and looks earthward. The angels in prison art generally appear very childlike but may look up at the Virgin or down toward the earth. Regarding their angel, some thought 'He is just there'. Rudy said of his: 'I think he's the devil'. Whether this was a projection, whether he wasn't pleased with his rendering or whether it is a reflection of the yin/yang qualities that appear to be present within the archetype are all conjectured possibilities.

Using the analogy of the libidinal cupid/holy angel opposites 'supports' the virgin/whore paradox. One of Guadalupe's archetypal functions is the Great Mother, 'the personification of grace and purity' (Ferguson 1981, p.94). Miguel wrote a paragraph entitled *What Our Lady means to me!* In it he said: 'She represents Love, Peace and Happiness, but more than that she represents a miracle ... (she) seems to talk to me and she listens, just like a mother'. Yet, while the Madonna is a vehicle for the great mother, she also contains the erotic archetype. She is agape and eros, the paradox of the virgin/whore. Walker (1983) concludes that Mary Magdalene, or 'Mary the Whore, was only another form of Mary the Virgin' (p.614). In a Gnostic poem the two are merged: 'I am the whore and the holy one' (Ibid). Contemporary inmates are influenced by Madison Avenue's erotic ideals seen in TV commercials and magazine ads, just as are their chicana girlfriends, who pose with teased hair, exposed cleavage, short skirts and high heels alongside the low riders, prison barbed wire, guns and Guadalupe on the paño collages. They are the 'anima', a culture-bound archetypal projection of the opposite sex. (The unconscious gender opposite for a woman is called the 'animus'.) The anima exists *a priori* (DeLaszlo 1959) and is *prima materia* (Moore 1989). She is the 'creative eros connecting with the awakening psyche' (p.270). She is a 'bridge across which roll fantasies, projections, emotions that make a person's consciousness unconscious and collective ... the deeper we descend into her ontology, the more opaque consciousness becomes (p.88). So, for these artists of the penitentiary, explaining the

conscious meaning of her symbols was understandably difficult. According to Singer (1994), these anima, or gender opposite, archetypes take many external forms – Aphrodite, Mary Magdalene, Marilyn Monroe, Sophia. They are larger than life and evoke powerful responses. Early childhood experiences, especially with the opposite sex, largely determine the image we carry of that gender. The social structure of our country is changing and, with it, the familiar cultural support systems within the Hispanic communities are also changing. Contained within the contemporary Hispanic family system are culturally based differences and shifting circumstances, and the effects of such changes are difficult to sort out. 'The anima and animus, for Jung, were the image-making functions in the psyche par excellence … and are usually related to something prevalent in the culture at a given time' (Ibid, p.180). It is fascinating that Our Lady of Guadalupe is so popular in New Mexico 'on the streets' as well as inside the penitentiary. She appears in contemporary art galleries as theme shows, street murals and 'folk art' executed by Anglo artists as well. Perhaps the paño exhibitions and current interest in prison art has generated some of this revival, but the question remains: Why the Black Madonna now at the close of the 20th century? As if to respond to such a question, Singer (1994) posits: 'Every culture introduces the appropriate images for its own time and condition (p.180).

The image of Guadalupe is often surrounded by an oval of red roses. The rose is a favorite theme in the prison. It appears on hand-embellished envelopes, stationery and hand-made greeting cards. Beginning students wanted to first learn to draw and shade the rose. The red colors and the form are indicative of erotica, passion, sensuality and seduction. The rose is a complex symbol meaning also grace, voluptuousness, beauty, the mystery of life, perfection, fertility and virginity and the life/death complement (Cooper 1978). Its red color is the blood-red of the goddess and the ochre of her earth (Sjöö and Mor 1987). All of those associations, as well as personal symbology, are appropriate for those qualities related to Guadalupe. Sometimes, the roses were colored purple, yellow or black (See Figure 16.3). Their answers to questions concerning the meaning of the roses were generalized to 'love' or a reference was made to the December miracle when Diego found the roses in winter. Growth in a season of the cold and dark time is a fitting metaphor for the work being done in the cold, dark solitary cells.

Conclusion

Some of the men knew the mythology associated with Guadalupe, but as many as half of them did not. Most of the artists who included Our Lady in their collages or single images had a sense of her import but her ancient archetypal presence and significance were more intuitively derived than acquired by a conscious knowing. When asked the questions, their logic or intellect usually responded in brief concrete answers. They searched for answers that weren't easily accessed through logic or use of words. Like a dream, the Virgin holds archaic memories and mythic symbols. She is the transpersonal self discovered by turning inward. Drawing and painting is a

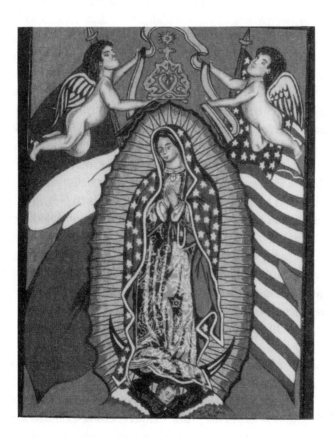

Figure 16.4. Guadalupe stands between the Mexican and American flags, uniting the two, and assisted by two angels who hold her crown. Acrylic and coloured pencil on mat board.

meditative process and invites receptivity and contemplation. It also is an active process over which they have some choice and control and just the proliferation of her image inside the prison indicates her importance to them. Historically, her image has been copied repeatedly and so it seems the inmates further that tradition, content to repeat her symbols and icons. Through the truth of her mythology, the men may discover the truth of their heritage, unconscious projections and shadow aspects, self-acceptance and increased ego strength.

Drawing and painting this image connects them to the collective heritage of their people and strengthens their sense of support in spite of their deprivations and solitary existence. For the men in Santa Fe, knowing her historical perspective placed the Guadalupe within a context to which they could then personally relate and recreate a familial connection with their culture's iconography. Guadalupe is a cultural bridge between the Old and New Worlds and here in New Mexico she appears to be a bridge between the cultures, carrying them across the border metaphorically, just as she has crossed global borders in the past. More importantly, she is a bridge to each man's own anima and to his cultural pride and beliefs. She is a bridge-prayer, a rosary, that carries them across cultural boundaries and beyond prison barriers. In building an alliance with Guadalupe they can be, in Bernie's words, 'close to creation, benediction and protection'. Outside the prison she is being depicted by groups other than her traditional New World cultures and the inmates of prisons in the south-west are responsible for expanding her popularity outside the limitations of their environment. Her longevity and her rediscovery in recent years confirms that she still exerts a profound and meaningful influence. She is a living archetype. Her growing popularity among the general population attests to the fact that the time is ripe for her reception. There have been many accounts of apparitions of Our Lady in this 'sophisticated' 20th century and those are not limited to any particular country. Begg (1985) suggests that her 'return' coincides with the emancipation of women and with the deep psychological need to reconcile sexuality and religion. He provides a fitting final metaphor for the men in the Santa Fe Penitentiary: 'As a spirit of light in darkness she comes to break the chains of those who live in the prison of unconsciousness and restore them to their true home ... She is, traditionally, the compassionate one' (p.134).

References

Begg, E. (1985) *The Cult of the Black Virgin*. NY: Penguin.

Cooper, J.C. (1978) *An Illustrated Encyclopaedia of Traditional Symbols*. London: Thames and Hudson.

DeLaszlo, V. (ed) (1959) *The Basic Writings of C.G. Jung*. NY: Random House.

Edwards, E. (1966) *Painted Walls of Mexico: From Prehistoric Times Until Today*. Austin: University of Texas Press.

Ferguson, G. (1981) *Signs and Symbols in Christian Art*. NY: Oxford University Press.

Henderson, J. and Oakes, M. (1990) *The Wisdom of the Serpent: The Myths of Death, Rebirth, and Resurrection*. Princeton, NJ: Princeton University Press.

Gimbutas, M. (1989) *The Language of the Goddess*. San Francisco: Harper-Collins.

Jung, C.G., von Franz, M.-L., Henderson, J.L., Jacobi, J. and Jaffé, A. (1964) *Man and his Symbols*. NY: Doubleday.

Moore, T. (ed) (1989) *A Blue Fire: Selected Writings by James Hillman*. NY: Harper Perennial.

Rodriguez, L.J. (1993) *Always Running: La vida loca gang days in L.A.* NY: Touchstone.

Singer, J. (1994) *Boundaries of the Soul: The Practice of Jung's Psychology*. NY: Anchor Books.

Sjöö, M. and Mor, B. (1987) *The Great Cosmic Mother: Rediscovering the Religion of the Earth*. San Francisco: Harper and Row.

Steele, T.J. (1982) *Santos and Saints: The Religious Folk Art of Hispanic New Mexico*. Santa Fe: Ancient City Press.

Walker, B. (1983) *The Women's Encyclopedia of Myths and Secrets*. San Francisco: Harper and Row.

Weigle, M. (ed) (1983) *Hispanic Arts and Ethnohistory in the Southwest*. Santa Fe: Ancient City Press.

PART 3

Personal Constructs
in Art Therapy

Hidden Borders, Open Borders
A Therapist's Journey in a Foreign Land

Julia G. Byers

Abstract

This narrative journey describes an expressive therapist's experience in the West Bank and Gaza. As Part of the Near East Cultural and Education Foundation of Canada's mental health team, the therapist describes the context within which she gave workshops and consultation to mental health workers from clinics, rehabilitation hospitals, prisons, schools and community centres. Therapeutic interventions were aimed at addressing the emotional traumas of people caused by the sustained violence and uprising in the Palestinian–Israeli conflicts. Emphasis is put on examining the commonalities between all cultures to raise the sense of collective humanity. Through describing several case vignettes, the author illustrates how hope, resiliency and renewal can be gained through communication of the arts.

Surrounded by the rubble of bombed-out buildings, a young boy with deep brown eyes sits in a cardboard box sucking his thumb and playing with his hair. On a nearby street, amidst more garbage and defaced buildings, two children take a long tube they have found and are playing 'telephone' through the wires. Behind them are the remains of an ornate dwelling, once carefully patterned and designed by a local artisan. This house stands behind a six-foot-high cement wall with a rusted, broken door. Other neglected shelters are woven in between new construction and the patterns of freshly laid sidewalks. These metaphors – the box, the wire, the doors and the hope of renewal – became the icons of my learning experience.

This chapter focuses on my second experience of working for the Near East Cultural and Educational Foundation of Canada. Funded by the Canadian Ministry of Health, the Partnership for Children Project focused on delivering multi-faceted professional and paraprofessional counseling, training and public education to community mental health professionals and

educators in the West Bank and Gaza. Interventions were aimed at addressing the emotional traumas of Palestinian children and their families caused by the sustained violence and uprising of the Intifada. The Gaza Community Mental Health Programme, the Palestinian Counselling Center, Bir Zeit University, Bethlehem Child and Guidance Clinic and Médicins San Frontière, (doctors without borders in Jenin and Hebron) were part of the local partners. The project also included an art exchange programme linking Tufah Education and Development Centre, Khan Ynis Free Thought and Culture Association, Nusserirat Girl's Elementary School, Abu Tour Elementary School, El-Bireh School (West Bank), eight Canadian schools (including the Coldwater Native Band School in British Columbia), several representative primary and secondary schools in Ontario and Dene school in Fort Norman (North-West Territories). The art exchange programme used kids-to-kids format to encourage both self-expression and empathetic communication through art as a means of bridging cultural and language barriers to an understanding of common humanity, broad human needs, aspirations, fears and sorrows which children and adults in all cultures and contexts share. An interactive CD-ROM entitled *Hidden Borders, Opened Borders: Linking Children through their Art* was created to exchange over 1000 drawings and paintings. This chapter focuses on the second trip that I made to the West Bank and Gaza with my team-mates Dr Sameh Hassan, child and family psychiatrist; Dr Fredericko Allodi, transcultural psychiatrist and world-renowned expert on victims of torture; Dr Mounir Samy, child psychiatrist and psychoanalyst; and Dr Jim Graff, philosopher, human rights advocate and President of the Near East Cultural and Educational Foundation of Canada.

This chapter aims towards sharing the inter-cultural implications of my role as a therapist and woman in the context of staying in the occupied territory. It is also written as a narrative of the experience because it felt inauthentic to distance the impact of my involvement through promoting a more scholarly approach of more formalized research. Yet I am acutely aware of my need to integrate what other therapists have found in their work. It is a struggle to present the personal with the professional integrity. This chapter reflects the struggle that mirrors all the participants' tension with how much or how little to deeply share in the angst and anguish of trauma associated with war. As Losel and Bliesener (1990) remind us: 'the first concern of a young child is to maintain the primary relations of life' (p.18). Wartime exasperates the fears of loss of home, separation from family members and

the probable violent death of a parent or family member. These issues touch us all in our sense of humanity. They may be hidden at times but our differences between cultures may indeed be our commonalities.

My Canadian passport often gave me the freedom to pass in and out of the demarcation zones between Israel and Palestine. My pale white skin and Western attire also identified me as a foreigner and increased my freedom to travel through different territories. My gender and ethnicity were of frequent comfort to the local people since I represented little or no bias of political affiliation. My identity as a mother crossed over many cultural and political barriers. The fact that I was a mother who temporarily left her children in the safety of others while helping other children and families bonded our sense of humanity. It was not my credentials of educational status or my university affiliation that carried the most weight in the interpersonal relationships, it was our mutual sense of empathy that transcended our cultural differences. We all loved and cared for children.

Beginning The Journey In Rumallah

In Rumallah square stood a new tall monument with a digital clock on top of the phallic shape and cement lion heads spurting water at the base of its water fountain. This was previously the spot where stonings, bombs and riots were recorded on the global news networks. An entrepreneurial marketer stood in the streets, dressed in traditional costume, offering Arabic coffee. From a huge brass vessel on his back he offered the coffee to customers in their cars. Even a European-style bakery was open for lunch. Lush fresh figs and assortments of nuts and produce were abundant in street vendor's carts.

I began my trip by giving a two-day workshop for the Bir Zeit University Continuing Education Department in Rumallah. *En route*, I noticed many physical changes that had occurred since my first trip in the summer of 1995. On the roads from Tel Aviv to Jerusalem many border crossings and check-points were not operating, although the evidence of sandbags and metal surveillance boxes were left behind. In Jerusalem and Rumallah there was evidence of renewed life in the streets. Buildings that had been boarded and decorated with political graffiti, showed signs of fresh paint.

My first assigned task was to provide mental health training to local therapists and educators, specifically in the modality of expressive therapy. After two days of attending my 'training' at the university, each participant received a certificate in the introduction of art therapy. Many of the therapists came from rehabilitation hospitals and centers. Their clients ranged from

children with severe and profound physical ailments, such as paralysis due to spinal cord injuries caused by gun shots, and Post Traumatic Stress Disorders (PTSD) due to being victims of, or witnessing, violence.

Art Therapy Workshop

Methodology

To set the context and frame for the art therapy experience, I started with dialogue drawings entitled *Lines of Communication*. Major paradoxical issues of conflict and frustrations were evident in the drawings. One participant explained that her scribble drawing illustrated fire and broken trees which represented broken dreams. She felt powerless in the face of the devastation that so many children had experienced. Often, the children themselves were the target of violence for the current political aggression. Another therapist, who was blind, worked animatedly in plasticine instead of the scribble drawing which was less tactile. She portrayed children who often identify with the aggressor. She stated that the two horses she moulded were playing, although to the observers in the class the projected animals appeared to be boxing each other. She acknowledged her denial and defensive reaction, wishing for national peace.

To focus on the residue of emotional responses I then asked participants to group together and make a three-dimensional setting integrating objects found outside with clay creatures. This allowed each group to projectively illustrate a dynamic scene where the groups re-enacted their sense of distance and closeness in coping with their environment. One scene was depicted through a sculpture made from barbed wire which was left over from a temporary check-point border crossing or prison when the area was in the height of occupation. The wire was shaped into a tree. On a branch of Styrofoam lay twigs from a nest and several wild berries as eggs. The message of hope was as precarious as the heavy wire which had difficulty standing in 'this environment'. Onlookers concurred that 'something precious was hidden'. The metaphoric animals were looking away, each trying to find ways of nurturing themselves. As several researchers remind us, dimensions of traumatic experiences vary with the degree of several factors. These include Post Traumatic Stress Disorder (PTSD), life threats, bereavement or loss of significant others, the rate of onset and effect of the stressors and displacement (dislodging of persons from their community). The person's role in the trauma and the degree of moral conflict inherent in being the

agent or the victim in any given situation creates disturbing ongoing or chronic PTSD. The complexities of the stressors and impact of the trauma on this community were indeed evident. At any moment the symbolic eggs could fall from the tree. The underlying attachment issues and fear of not being able to protect and nurture ones young were very powerful to the group. I remembered Dr Vivica Hassboun of the Bethlehem Child and Guidance Clinic, who told me explicitly that every child and adult had experienced some trauma related to the war.

High levels of stress were evident in the next day's activities. In applying a supervisory technique of role playing, each participant used collage materials to re-enact a situation with a client that they had significant difficulty with. Countertransference problems and the challenge of providing alternative therapeutic intervention strategies were discussed. One occupational therapist attempted to portray the struggle of balancing issues that surrounded his client. On a painted backdrop of red, black, green and blue squares portraying the impression of a flag, he displayed his sense of the contradictions that faced his young client. On the first red square he overlaid collage pictures of two men in suits discussing issues on a clipboard. He tried to depict the hospital goals of helping patients to lead happy and active lives for the future. On the other side of the picture, surrounded by black, he collaged together images of people in a hospital clearly wounded with massive injuries. As if to explain the image, Akie (a pseudonym) wrote: 'the crisis'. He stated that 'children in Palestine do not live in a safe environment'. The therapist's client was playing in the streets when military men opened fire randomly, causing his permanent disability from the gun wounds.

Juxtaposed on the paper, the therapist illustrated attempts by his client to learn how to manage new life in a wheelchair. Flooded by a background of blue paint, the participant picked a cartoon figure placed in a huge wheel to depict his dream of driving a fancy red car and getting married. Perhaps this illustrated flag earmarked the precarious complexity of life situations. For myself and the therapists in the workshop, we all struggled to make sense of this human tragedy.

The post-traumatic effects of this particular child were increased when he was taken to a hospital miles away from his family to rehabilitate for a year. Because of the restrictions of the border crossings, his family members were not allowed to visit him. As a 12-year-old child, he not only had the traumatic event to resolve but the ongoing issues of separation and loss and any sense of security. My participant felt overwhelmed by the sense of having

to be everything for the child, not knowing the future potentialities for the young man. Through discussion, the class realized what was missing in the therapist's image. There was a lack of human connectedness and affection. The role of religion and culture were also omitted in the picture. The therapist used collage material that showed Western clothes with little representation of national ethnicity and culture. In the therapist's desire to 'normalize' life events for his client, he realized his need to look toward Western cultures as an escape and, perhaps, relief. He became aware of his need to please the international relief organizations as a chance to expand his opportunities. He reflected on how he may have unwittingly prevented his client from validating and building his own identity and purpose in life. I felt humbled by the experience, remaining focused on facilitating the awareness that the strength of reconstruction was within the participants. I offered no magic in taking the pain and hurt away. I was only able to give additional tools of communication to empower the therapists to continue their profound work.

Another woman participant depicted her work with an autistic child. It was difficult to ascertain whether the autism was due to environmental or organic problems. Unlike the previous case, this child had no physical injuries sustained from the uprising and, reportedly, was too young to have experienced direct confrontations in the Intifada. One might speculate that the traumas of the war were still extremely fresh in the eyes of her parents. The father had spent many years in prison as a result of his participation in the Intifada. Her mother, overwhelmed by raising seven children, had little emotional energy to share with her youngest, unplanned child. In the religious Arabic traditions women are expected to produce as many children as possible.

The therapist's fragmented image displayed a young child with a huge head placed on a small-proportioned body. The child's image was connected to the body of the therapist, whose head, hands and feet were cut off. The psychotherapist drew blue breasts like wings instead of arms for the child. According to an Object Relations Theory, the image could represent the dichotomy of good and bad breasts. On one side she wrote: 'I need you' and 'I want to fly'. On the other side of the image the participant wrote: 'leave me alone' and 'I want to smell your glue'. In the upper left of this image she glued five different cars on top of each other, representing the child's fixation of objects. On the right side of the paper she used an image of a person with closed eyes in profile crying 'help'. Through discussion the therapist realized

that her image portrayed a lack of cohesion. In attempting to understand the child she was mirroring back fragmented parts. She admitted that she felt she was running after the child with no clear sense of direction or goal. This participant felt it was appropriate to re-evaluate her work and develop new goals for her client. In reassessing this client one goal may be to provide the mother with some alternative skills in dealing with the attachment needs of her child. This therapist also discussed the stigmatization and difficulty of dealing with a new generation of young children who live in the shadow of the devastation. It was also difficult to be a progressive, non-veiled professional woman working in traditional patriarchal family systems.

To end the two-day workshop I facilitated a group sculpture created from multiple textures and different types of wire, metal, plastic, wool, thread, elastics and grass ropes. We connected them together with a single ball of string, metaphorically emphasizing the tensions and stresses that occur in family systems. The spontaneous sculpture gave the opportunity to look at any situation from multiple perspectives. Even the blind therapist was able to 'see' parts of the sculpture through touching the different textures and tensions. Perhaps the major breakthrough during the two-day workshop was the group's awareness to build and trust their intuitive skills to provide supportive peer supervision. It sounds simple and basic, but for many of the mental health workers who work in isolation it was a mirror of hope; and building resources for team work assisted in renewing self-esteem. The pervasive sense of low-esteem appeared to be a result of the trauma that they too constantly felt through day-to-day living in occupied territory.

Near East Cultural and Education Foundation Conference (NECEF)

A conference was arranged by local partners in the West Bank to bring together various agencies who were working in the same region. To begin the day, NECEF team members began to raise some of the issues facing mental health workers. Dr Allodi began by drawing his map of the experience of trauma in this part of the world (Figure 17.1).

The vice-president of the university, Dr Ahmad Baker, child psychologist, emphasized that the Palestinian Community was now in a new phase of development. He wanted the professionals to aim at reducing cognitive confusion, making sense out of what happened as encouragement to people and the need to talk about ways to reintegrate the Palestinian depressed personality. Dr S. Hassan continued the talk, focusing on the human rights

Figure 17.1. Health and trauma

issues for children, the rise of family violence and the need to address rehabilitation therapy for torture victims.

I chose to contribute by acknowledging everyone in the room and encouraging them to discuss their reason for attending the conference. I emphasized the role of alternative treatments as a way to open dialogue about their anxiety, angst and hope for the future. A debate began about the role of the arts in this society and the changing appreciation of new and old values. Person-centered therapy is a new concept for many who engage in traditional religious ideologies. Discussion focused on how to integrate religious stories in the treatment strategies of encouraging children to ventilate their concerns. Dr Hasbourn re-emphasized the universal connections of envy and struggle in a traumatized community that needs to find ways to enjoy themselves again.

Vivica Hasbourn, an American-trained psychiatrist and director of the Bethlehem Child Guidance Clinic, continued the discussion on childhood development and family intervention. She talked about the universality of war and the effect on child development using a psychoanalytic perspective.

Conversely, Dr Jumana Odeh, a medical doctor and director of the Palestinian Happy Child center, focused on the societal impact of counseling

students with disabilities. She discussed the issues of dignity, accountability, competence, self-reliance, decision making and choices, image and status, human rights and the quality of life. Her topic was followed by Dr Cairo Arafat, director of United Nations Institute for Children Education Foundation in the West Bank. She discussed the need for empowerment, prevention and the societal impact in child development. She stated that there is only one counsellor for 15,000 people in the West Bank. Public education is vastly needed to impact positive changes in future generations. Cairo reiterated pervasive family myths such as 'it's better to be married and miserable to being a spinster'. Since it is common for many poor families to get their daughters married by the time they are twelve years old, the need for mental health education is pertinent.

Ms Haifa Baramki and Ms Abla Nasser from the university's Continuing Education Department gave a presentation on the statistics of those students who graduated from the counseling model courses funded by NECEF and an evaluation of their experiences. From qualitative and quantitative data they showed how the communities' needs refocused from the need to learn 'normal' development to expanding on the concepts of psychosocial and cognitive areas. They currently felt therapeutic para-professional training needed to provide workers with family intervention skills. The increase of family violence, echoed by all the presenters, was a growing concern.

The conference day ended with a team of mental health workers from the Doctors without Borders Clinic in Hebron, who discussed their specific treatment approach with five mothers in a therapy group with their children. The use of play and art materials in therapy amongst all of the practitioners seemed to be one of the most effective forms of diagnosis and treatment.

The Mandela Institute

The twilight hour at the end of the day marked one of the most difficult personal experiences in my profession as a therapist/educator. The NECEF team invited me to join them in meeting with the directors of the Mandela Institute (named after the Nelson Mandela Institute in Africa). Members of the team were concerned it would be an awkward meeting because I would be the only woman present. One of the tasks of the psychiatrists was to visit prisoners of war to make sure that they were not being tortured. Incidences of military torture had increased beyond the statutes of United Nations human rights. This preliminary meeting was to update the team on the protection of core human rights in the Middle East. In addition, Dr Jim Graff,

the President of NECEF, wanted to introduce arts therapy as a possible treatment modality in the establishment of a transition home and service for discharged prisoners re-entering society.

I was warmly greeted by the director, who, to the team's relief, introduced me to an Arab human rights female worker. She had been an advocate for inmates and family members for several years. We sat quietly as the men discussed current practices of tortures. They provided us with drawn images of the horrific methods of the latest forms of military tortures. The institute's challenge is to maintain human rights and ethics during the political transition. Some of the main factors that impinged on the situation of human rights included (a) the Israeli-Palestinian agreements with consistency of the nature and pace of such a process; the possibility of failure in concluding satisfactory agreements or in implementing them and the possibility of widespread Israeli-Palestinian and/or intra-Palestinian conflict; and (b) tension that might develop within the Palestinian community, such as conflicts between resident Palestinians and Palestinians returning from abroad and those remaining abroad; conflict between groups advocating competing ideological/political models for organization and/or the possibility of the proliferation of arms and the development of militias within the Palestinian society. These thoughts were identified by Khaled Batrawi in a brief paper prepared for the third consultative meeting on the Protection of Core Human Rights in the Middle East which the Director provided for us.

A colleague at the meeting informed me that I would be the first international woman to enter a Palestinian prison, which had been under the authority of the Israeli government one year previously. My presence would show that outsiders are concerned about the welfare of the military prisoners. Many of the inmates were kept in detention because of alleged organized activities but had not received a trial to date.

The Prison Facility

As we walked along the cement and dirt rubble on the ground, I felt an eerie sense of trepidation. I had visited adolescent locked facilities in North America and worried about what I would experience. I was acutely aware of the misconceptions and stereotypes of Arab soldiers and knew that what I was about to experience would be a humbling process. My task was to connect to any prisoners who had used art as a form of rehabilitation while incarcerated. Wearing my North American blue suit, I was told not to look at the men directly, to sit when men were discussing issues and not to shake

anyone's hand. I never felt the oppression of women's traditional behaviour in this part of the world so acutely as when I entered the prison walls. All I could see was barbed wire, with razor blades every six inches along the tangled wire on top of the thick white cement walls. There appeared to be a courtyard of sorts, after the two guard gates that entered and locked the facility. Many guards in uniform stood around informally chatting with well-dressed men. These men, clean shaven and in clean clothes, were the prisoners. Everyone was allowed to walk freely once in the compound. The courtyard and many passageways had no roof. The wires obscured one's vision of the sky. The actual ward units consisted of bunk beds, approximately 12 people in a very small room. At night all the barred doors were locked. Inmates were allowed to eat and store food family members provided.

The team initially entered the warden's office. While the psychiatrists spoke with some of the prisoners, the warden sent for an 18-year-old adolescent boy who had made several mosques on paper and cardboard to rebuild his life while he was in prison. With the aid of an interpreter I discovered that this softly spoken boy had killed a civilian woman when he was 15 years old. He showed me his leg, where he had multiple gun wounds and fractures as a result of open gunfire in a market square when he was fourteen. With little medical aid, his leg became infected and the bone tissue was not medically operable. He alleged that the pain increased one day to such an extent that he 'burst in frustration' and assaulted a girlfriend that he was having an argument with. Without realizing the severity of his violent behavior, he inadvertently killed her. He had been tortured and held in prisons several times in his early teens for suspected war activities. The warden reported that his psychotic behavior at the time of the murder was confused by his retaliation for being victimized. Since the victim's family did not press charges, he was sentenced to nine years in prison.

Art and Rehabilitation

This boy caringly showed me steps he had carefully made that surrounded his golden dome, that represented the steps he had to go through to become whole. Through religious belief, he prayed for forgiveness and renewal. The rehabilitation program provided him with educational books to study so he could graduate from high school. By the age of 21 he would be eligible for parole. Every attempt was being made to encourage his successful rehabilitation. We spoke about how he would cope with his emotional

development over the next few years and about his dreams and aspirations. He told me that he had changed and was learning to channel his aggressive feelings. He spoke of biblical themes which were helpful to him as he found ways to make sense of his life. He felt grateful to the guards for helping him. Due to my intervention, he was given additional art supplies. He was a talented youth who needed encouragement.

Our 'session' took about 45 minutes but it felt like hours. With boxed-in cement walls and wires for a ceiling, the need to artistically express was more than a luxury. It seemed to be a necessity in the paucity of the visual environment. Most inmates didn't know when they would be released. He was one of the lucky ones. He had a family with 13 brothers and sisters waiting for him, all of whom lived in a two bedroom house. I felt the chill of the stone walls and the spirit of a child lost in the sea of men peers. For this client, cardboard structure was a magnificent dream beyond the confines of his prison or his meager space at home.

Art in the Schools: The Art Exchange

The next day I was escorted by Jeannie, the local co-ordinator, to a school that had participated in the art exchange. Surrounded again by white, thick, cement walls, the sound of children playing at recess felt more familiar than the stillness and soft voices at the prison. An inner courtyard was again boxed in by the protective wall. Upon my suggestion, the children had painted a mural on the walls. Birds, traffic lights and drawings of other animals were illustrated. The drawings appeared random and not organized. Inside the small school children packed into their classroom. Twenty-two double-seated desks were crammed into the same size room as the prison cells. The classroom walls were blank. In the corridors the principal, art teacher and students proudly showed me the cement tiles they had painted, created and affixed to the walls. In order to create a sense of permanence and color to the building, these works served as a reminder to the children that they could appropriately express themselves.

This was a very progressive school because it allowed the children to create artwork that were not religious artifacts. They were encouraged to draw their environment, family, hopes, fears and dreams. We looked at one image, carefully painted in bright orange, of three soccer players, only the person in the middle got his head kicked off instead of the soccer ball. Another image showed the perspective of looking through a cave wall to a magnificent building with dark clouds and sky. With few caves and magnificent buildings

in the everyday life of these children, the image seemed to portray both trauma and desire. Another painting showed battleships on the water attacking buildings and people on the land. Since the school was near Jerusalem and there is no immediate access to water, this image appeared to render the feeling of attack and being attacked – water in similar images may have referred to the flooding of emotions during the uprisings and/or the dispute over water claims not defined. I observed that the teachers and students attempted to draw and paint like they imagined North American children would do – with stereotyped flowers and details. Encouragement for the children to draw their own cultural identity was not evident. It seemed hard to imagine how children could advance given the poverty of their physical environment. The art served to be a window for dreams.

The next facility on my itinerary that day was the K. Abu Raya Rehabilitation center, which was part of the Patients' Friends Society. Araf, the occupational therapist, gave me a tour of the facility. The agency was funded by the Swedish government. It was one of the best and most comprehensive hospitals I had ever seen. The agency was initially built for children with spinal cord injuries, often from gunshot wounds. Every form of new technological rehabilitation equipment was available. The occupational facilities were extensive, offering multiple kinds of art activities for every kind of physical disability. One adolescent took a woodburning tool to decorate plates. In observing him work, he began by drawing images of guns that caused his disability. Paralleling his physical and emotional progression, I observed his ability let go of violent symbols and sublimate houses and environments indicative of his growing ego strength. He became so talented in using the burning tool, that he started selling and commissioning his work. The art had led him from battle into a new way of coping in his transition back into society. Araf felt proud of this client's rehabilitation but warned that not all children were so successful.

On another ward a 9-year-old boy with polio lay in his hospital bed waiting for his doctor. This was a child who was a casualty of the political conflicts, not because he was disabled as a result of his physical injury but the fact that he was stigmatized and neglected by his family, who were desperately trying to survive themselves. This boy had been hidden by the family from the community because he was born with polio. Only healthy children showed promise for the family in the eyes of the community. When a social worker found the boy she brought him to the hospital to learn how to become physically self-reliant. The family could not financially support his

need for equipment and education. Because of the changes in the military check-points, his family, who lived two hours away, were not permitted to visit. For five months he waited for family visits.

I will never forget the courage and hope in this child's eyes. We played together, unable to speak in the same language, and yet it was the same language – of human caring. The occupational therapist informed me that there are forty additional patients with war-related or general emergency problems who were waiting for the hospital services. Due to the closure of the Gaza border, they were not permitted to receive services.

Entering Gaza

As international special persons, the team was permitted into Gaza on our continued journey. The physical changes from the trip last year were noticeable. Although we still had to walk about one-quarter of a mile with our luggage from the Israeli border to the Palestinian border along a barbed wire and cement fence, two official customs guard houses were now in operation. The streets were paved and sidewalks were installed. Last year, open sewage and garbage covered the city streets into Gaza. The doors to Gaza appeared more open, as evidenced by more people in the streets. Still, the inequality of the way people lived was apparent. Overcrowding and buildings in disrepair were abundant. Gaza Community Mental Health Program (GCMHP) showed signs of renewal.

The GCMHP conference itself was a testimony to the professional development of the staff. Ahmed Abutawafena began the conference identifying the clinical 'Gaza Syndrome'. He focused on six major cultural factors that impinged on the mental health of the community.

Religion was clearly evident in the community, even for non-religious people. There seemed to be an enmeshment of individual and family identity. In clinical interventions it is important to build an ally with the authority figure, such as an uncle, to get help for the patient. The taboo and shame of counseling was apparent. Many felt that they should consult with their religious leader to avoid the stigmatization of 'needing' therapy. For many 'soldiers', whose sacrifice and personal loss made them heroes, it also made it difficult for them to be 'less than a man' to seek therapy. It is still more common to see diagnosis of physical symptoms such as headaches, burning in the head, etc, than to acknowledge psychological problems, which tends to lead to over-consumption of medication. Symptoms such as insomnia and phobias reveal memories of tortures for many 'soldiers' who continue to

resist 'therapy'. One 'soldier' could not shower because it reminded him of his torture. He preferred not to wash than to deal with the psychological problems. Specifically, in Gaza, it is not the trauma of violence or abuse that is the problem but more so the chain of traumas that constitute the Gaza Syndrome. Systematic tortures created difficulty in diagnosis. Psychosis, depression, paranoia, intrusive thoughts, delusions, physical abuse of family members, etc, make the clinical treatment plans often unclear.

The conference continued with Zahiya Elkara commenting on the rehabilitation of children. She stated that all social classes were affected by the conflicts. The main clinical issue seemed to stem from the lack of protection by the parents. At one school there was an incident of a teacher being stabbed in front of the students because he was thought to be collaborating with the enemy. Children who witnessed this event showed signs of enuresis, poor concentration, day-dreaming, night terrors and frequent bursts of inappropriate screaming. Zahiya Elkara reminded the audience that 50 per cent of the children between the ages of 0–18 constituted the majority population of Gaza and most have had multiple traumas. One such case was when an 8-year-old girl saw her brother get his legs blown off in a land-mine explosion. Even though she had seen the horror, she initially denied that her brother lost his legs. She fixated with revenge. Through art and play therapy she was able to work through aspects of the trauma.

Initially, this client drew images that had little overt signs of the trauma, that is the sea, flowers, etc., as a defence mechanism denying the overt trauma. Due to the trusting therapeutic relationship, she began to manifest the psychological conflict in dreams. She related being attacked by a monster or wolf. With the intervention of family therapy and drawings of the members, she was able to express her trauma. The child had harbored guilt feelings of not being able to rescue her brother. Eventually, her issues came to be more focused on her academic performance and social relationships.

My contribution to the conference was a workshop on the modality of expressive therapies in the overall treatment of patients. By engaging all the participants to draw four symbols that represented themselves, I illustrated issues in developing empathy, the need for interactive interpretation, the role of identity and community and the goal of integration and re-integration. About 40 professionals participated, drawing from their own and from their clients' perspectives. As identified by Ahmed Abutawafena, people reiterated how they experienced the cultural factors. What was most intriguing to me

was when I asked the participants to divide into small groups of four people to share their productions. Several groups felt ill at ease to discuss and talk with each other without the leader/facilitator leading. Was this cultural or was it an indication that there were many complex and difficult issues in which they felt the need for the therapist to be fully attentive? As noted by some of the therapists, culturally they wait for the authority figure to lead and show others, rather than having a spontaneous open discussion. When I brought the whole group together to look at all of the drawings, it was amazing to witness how much the participants had developed a sense of empowerment through the exercise. The event served to give closure to the day's activities. It gave individuals an opportunity to express what they valued most about the conference. The fact that they there were able to host a professional quality seminar was very empowering. Repeatedly, they voiced that 'more time' is desired – reflecting a high level of involvement.

Back in Jerusalem

In Jerusalem I met with Dr Jumana Odeh to discuss the mission of her center. Dr Odeh stated:

> At the Palestinian Health Community center (PHCC), we believe that every child has the right to protection, good education, health care and well-being. In Palestinian society, the unsettled political, social, emotional and environmental conditions have deprived many children, especially children with disabilities, of these basic rights. PHCC strives to provide help for children with special needs so that they can fulfill their potential as fully participating members of society. Further, PHCC seeks to promote understanding among families and communities regarding these children and to encourage the society at large to recognize their potential.

Jumana was a very progressive professional who wore her own-designed clothes made with some traditional embroidery. We discussed her latest project, where she received funding from UNESCO, to develop curriculum in the early school grades that is inclusive of women who don't wear the hyjab (the traditional veil). She spoke about her concern that in most of the school's reading skills books, girls are not portrayed as being allowed to play when there is work to be done, especially in the kitchen. Boys are expected to play at their convenience. Jumana shared her personal story about how she changed from her cultural expectations. One day she lost her grandfather in a

crowd of people who were at a huge prayer gathering. She stated that she had her wits about her to stay beside the central waterfall where she had last seen her grandfather. When she finally saw him again, she was afraid that he would hit her and punish her. Instead, he laughed and took her to the candy store to make her feel better. She brought candies home for her brothers and sisters, who were envious of the attention she was getting. She remembered feeling proud and special. She attributes the fact that she became a doctor to her grandfather's dignity and respect of her as a person.

Jumana spoke of the need for sex education in the schools or, at the very least, information on human reproduction. She found women in universities who had serious misconceptions, such as if you have sex pregnancy will always occur. The consequence is many married women have sex infrequently as a method of birth control. She was also concerned that in her society there should be a law that girls should not marry before they are 16 years old. Too many girls were being married at 11 or 12 years old to make more room at home. With the average of five people sleeping in one room, and sixteen people in the household, it is difficult for men to lure wives under such conditions.

Frequently, cousins marry because they are familiar with the family and willing to join the household. Jumana reported that few families ever live independent of extended family members. Due to the military conflicts, there are few opportunities for men to meet unfamiliar women. There are no bars or social gatherings. We discussed how the use of art could bring people together for recreation, education and therapy.

Ending With Hope

I ended my part of the journey in Jerusalem, celebrating with therapists I had worked with the previous year at a local clinic with the NECEF team. Hope for the future was evident in Rana, our hostess', attempts to run for office in a local election in Jerusalem. Hope was also evident in the freedom to walk the streets without soldiers on every corner. Hope was in the voices of psychologists Shafiq and Reema. Although the center they had been working at was temporarily closed, they were able to find jobs in mental health counseling at nearby agencies. The need for interventions was strong. Public attitudes were changing to incorporate future opportunities for children that were progressive. The balance would always be to maintain one's cultural values while producing growth in human rights and the dignity of each child.

I left the West Bank and Gaza with a profound awareness of the human struggles in living in a land fraught with conflicts. The richness and history of a land where three major religions conflict mirror the paradoxical turbulence of all humanity. In each child I met in the schools, rehabilitation centers, or clinics and each mental health worker I met in Jerusalem, Rumallah, Gaza and other territories I experienced a deep respect for universal under-standing. I never felt more strongly that the Arts represent life itself. As Wadeson (1980) reminds us, 'Life, meaning Creativity. Art. In the largest sense, they are all one' (p.3). I referred to Wadeson in my first journey to the West Bank (Byers, 1996) and I felt the need to repeat her profound words.

Art can open doors, communicate and provide a holding environment in which verbal language is not a barrier. Hidden borders become open to the universality of experience. It takes only one moment of turning, one moment of openness to transform strife and trauma into a learning experience. This is the challenge of all art therapists. The solid state creations of boxes, wires and doors become transformed into metaphors that are human agent instruments of change.

To close the doors to other ways of utilizing arts therapy techniques beyond the North American presence is the death of our profession. It is through the dual empathy of exploring and discovering the symbolic messages inherent in the creative process that serves to heal those who are so deeply unsettled in their environments beyond their control.

References

Byers, J. (1996) 'Children of the stones: Art therapy interventions in the West Bank an Gaza.' *Art Therapy 13*, 4, 238–243.

Garbarino, J. and Kostelny, K. (1993) 'Children's response to war: What do we know?' In L.A. Leavitt and N.A. Fox (eds) *The Psychological Effects of War and Violence on Children.* Hillsdale, NJ: Lawrence Erlbaum Associates.

Hobfoll, S. *et al.* (1991) 'War-related stress: Addressing the stress of war and other traumatic events.' *American Pscyhologist 46*, 848–855.

Losel, F. and Bliesener, T. (1990) 'Resilience in adolescence. A study of the generalizability of protective factors.' In K. Hurrelmann and F. Losel (eds) *Health Hazards in Adolescence.* New York: Walter de Gruyter.

Wadeson, H. (1980) *Art Psychotherapy.* New York: John Wiley and Sons.

Crossing the Border
Cultural Implications of Entering a New Art Therapy Workplace

Martha P. Haeseler

Abstract

This chapter addresses the importance of paying thoughtful attention to border crossings. An art therapist attends to subtle cultural differences in the context of her entry into a new job at a veterans hospital. She describes her own border crossing as she learns the new language and seeks to promote art therapy in the new setting and presents case material which affirms the potent role of art making as guide and interpreter for patients for whom border crossings are troublesome.

The Story of an Art Therapy Session

I was an experienced art therapist but new to the Veterans Administration Hospital. I had been working for a month or so in art therapy groups with the E Team, a constantly changing group of Vietnam veterans in a short-term inpatient Post Traumatic Stress Disorder (PTSD) program. Things seemed to have been going well, patients were attending, creating rich imagery and sometimes reaching out of their isolation to enter a supportive group process. I had great respect for their expressivity and felt lucky to be able to work with them. I felt that they were allowing me a glimpse into their experiences and that I was beginning to understand some of the horror and humiliation they had endured and strengths they had developed. The group members had patiently explained to me the meaning of unfamiliar words and images that arose from their experience in Vietnam.

Today the group is large – ten men watch me as I begin the group with the customary statement: 'This is a chance to use the art materials in whatever way you think is useful. Sometimes people find it useful to draw something

troubling them, or you might want to draw something pleasurable, enjoy the colors or just see what the materials do'.

As the veterans reach for the supplies, with the usual laughing self-criticisms about their art abilities, one man, Joe, states that he 'hates art' and attends only because he has to. After Joe finishes a hasty color design, he holds it up for me to see, then rips it in two. A peer asks for a piece, he gives it away, and soon others are clamoring for a piece. He rips his work and gives it all away. My comment that he has given away his colors is received as an intrusion and he glares at me. The table is covered with intense images but it seems to be unsafe to say much about the art today – until they get to Dennis. Dennis says the smiling pig on one side of the paper represents how he uses humor to cover up the monster on the other side. He says that the powerful beast with red eyes and bloody teeth is a predator who lives alone, experiences no pleasure, is asexual and is the only animal that eats its own kind.

I say to Dennis: 'Is this the beast that lives in the human soul, within all of us?' Dennis says: 'No, this is the beast who came to life after Nam'. I had wished to connect, to find a commonality with Dennis. He pointed out the uniqueness of his experience, leaving me out.

Soon there is much animated talk among the group members, using slang terms which I do not understand, a secret code which they do not explain to me when I ask. Jeffrey draws 'my TV which the police smashed when they came into my apartment and arrested me'. After group, I discover that Jeffrey should not have been in the group – he was a visitor, an ex-patient. Chris's picture is a cartoon about drug-taking in Vietnam. He looks at my picture and says he sees a marijuana plant in it and that I must have been doing drugs back home while they were fighting the war. Much joking ensues as I struggle to bring the group to closure. At one point I acknowledge that my experience of the Vietnam war had been very different from theirs and express my wish to find commonalities between us.

My first thoughts after group were about my failures – failure to recognize Joe's vulnerability to any comment about his work, failure to recognize Dennis's need to remain unique, failure to create a sense of safety in the group.

My next thoughts were memories from the Vietnam era, of my own fear that my husband would be drafted, my anti-war protests, my anger at the men fighting the war. During group I had had a strong wish to connect with these men, learn their language, be initiated into the mysteries of their culture, be

accepted. Looking around the table I had had a sudden thought: 'These men are my age, they could all be my brothers', perhaps a countertransferential wish for a kind of closeness that was threatening to the group members and, perhaps, a way to assuage my own feelings of alienation and loss of control.

I then wondered whether their deliberately leaving me out and speaking a language I didn't understand was a recreation of what they had experienced both in Vietnam and after the war when they returned to a changed country. Veterans had told me that when they returned to the US it was as if they no longer knew the language. They had changed and the country they had left had become unfamiliar; they were spat on in the street, yelled at, called 'killers'. I also felt as though during group I had been in the war zone and remembered that many male PTSD survivors have difficult, sometimes abusive, relationships with women. I wondered whether the group members were holding onto their pain and specialness to avoid overwhelming feelings of inadequacy and disorientation.

I came to learn how fragile boundaries are for many who experience PTSD. Joe's comment 'I hate art' was clearly defensive, putting up a wall through which I had hoped to reach with my comment. When the comment was received with anger, as an intrusion, I realized the importance of helping him shore up the defences, not break them down. I recognized that my own instinctive wish for connection, perhaps serving a need of my own, was at odds with his needs for separation. There were other boundary crossings in the group. Jeffrey told of the police breaking down his door and his TV and, indeed, he 'crashed' the group. The group members colluded with Jeffrey to create a boundary around themselves, which excluded me. Chris pushed for knowledge about my personal life. Dennis affirmed the boundary between himself and me.

A Border Crossing

I had approached the new job with a confidence based on many years of clinical experience. I did not realize to what extent my own border crossing to work in the Veterans Administration (VA) would be similar to entering another country, with a new language to be learned, new cultures to adapt to and cultural assumptions to be re-examined in the light of new experiences. This chapter is about the importance of recognizing subtle cultural differences and of paying attention to boundaries and border crossings in working as an art therapist. It is also about how an art therapist makes her way through the current instability in the health care world.

Borders imply both containment and exclusion. There are often guards at borders, passports are checked. It is helpful to know some of the language and cultural mores, have a guidebook, an interpreter, a road map, currency. My border crossing to the new job went relatively smoothly, my credentials were in order and I spoke the language well enough. Gradually, I learned that there was a new language to be learned, new rules, new unspoken mores and that many assumptions I brought with me did not fit or were rejected. I had to learn more about how to cross borders, how to mourn the loss of what was left behind, how to hold on to treasures and create a home for them in the new world and how to learn the new language and embrace the richness of what I encountered.

The journey is ongoing. In the two years since I crossed this border there have been major changes at the VA and in my job, as well as in the health care profession, and so my journey may resemble journeys made by art therapists everywhere as they try to carve out new roles for themselves in a land of diminishing resources for people in need of care, as they adapt to changes and as they mourn the loss of what was and what could be.

A Different Culture

What was new about the culture? What was lost? What assumptions did I bring that did not fit? There was new language. Serving my tour of duty. Being off-station when not on my unit. Patients who run away or staff who do not call in are AWOL (absent without leave). Vietnam slang, hooches, recon (reconnaissance). A government employee. The military.

The military? I recall attending an Agricultural Fair Parade in my home town and the chill I felt when a tank was driven around the town square, being shown off, swivelling so that its huge gun pointed at the upstairs windows. The military industrial complex, the war machine. I grew up in an anti-war household and, although my father was away serving in World War II until I was two years old, he never talked of his war experiences and I did not know until after he died that he had earned some important medals. What was I doing associated with the military, with its intimations of killing and, at the very least, surrender of autonomy within a hierarchy? I would be working with veterans and, occasionally, military personnel on active duty.

Working with men's groups was new; there were few women in treatment in the psychiatric service. New patients wore pyjamas, so they wouldn't go AWOL. An art therapy group with men in pajamas seemed rife with implications of intimacy and loss of dignity. In my previous inpatient unit

everyone had to wear street clothes and shoes and was told: 'this isn't a rest cure or a Holiday Inn...' What would be the issues and differences in conducting art therapy groups almost exclusively with men? Would the transference/countertransference issues differ, and the balance of power in the therapeutic alliance? Some art therapists say that working with men is challenging, that art making threatens men's sense of competence, that they feel infantilized by 'coloring'.

There were differences in the patient populations. I had been working in a general hospital on an inpatient psychiatry unit for adolescents and young adults, which served a spectrum ranging from Yale doctoral students to street kids. Many people had families who were part of the treatment, sent flowers, brought laundry soap. Many patients went back to school or jobs. In my new job, most patients were diagnosed with schizophrenia and PTSD, conditions that often need ongoing treatment – and were often subject to relapse. Many veterans had gone into military service straight out of high school. These inpatients seldom had family members involved, no one brought them toothpaste or flowers. Few of them had jobs. Many of them were disenfranchised, with great risk of homelessness, arrest and addiction. I've spoken of my culture shock with the Vietnam veterans. Imagine their culture shock when, in boot camp, they were conditioned to think of Vietnamese as less than human and they were trained to become killers. Lt Col David Grossman (1995) writes that in World War II only 15–20 per cent of the soldiers fired their guns, so psychologists conducted an aggressive campaign to incite men preparing to go to Vietnam to kill. It was a successful campaign – the firing rate in Vietnam was 95 per cent. Many of these men then returned to this country ill-equipped to function in peacetime. As one veteran told me: 'I was recon. It was my job to sneak ahead and slit throats. I was good at it but every one of those heads comes back at me at night now'. Another said: 'When I get mad, like when my in-laws side with my wife against me, I start figuring out how to burn the village'. And then, on the Schizophrenia Unit, in my initial mural group, when I asked a patient if he had any comments about the space ship he had drawn, he yelled at me: 'You can't have it, it's mine. I know you want it all right. Oh well, I guess you can have it, go ahead and take it'. What had it been like for this man, as a paranoid teenager, to be posted on guard duty over nuclear missiles? I realized I had entered a land of people for whom borders or boundaries were, at times, non-existent. The Vietnam veterans would be back in the jungle at the creak of a floorboard, without having crossed a frontier or without going through any of the rituals

of travel. And my psychotic patients could come in and out of the land of reality without noticing that they had changed terrain.

The New Job

Due to corporate downsizing, I had lost a job I had held for 18 years. Although bitter about losing the job, I deeply missed my colleagues on the unit, with whom I had formed a secure role and an identity that was grounded in mutual respect and affection formed by many years of productive collaboration. In the new job I was given autonomy and respect but found myself wishing that there was more teamwork among the staff, as I had experienced previously. I found myself making assumptions about what other staff would do, particularly nursing staff – that they would help get patients to group or would even care if they made it to groups. It took me a while to realize that nursing role definitions at the VA were different from those in my previous hospital and that staff schedules at the VA did not permit the extent of collaborative work I had hoped for. I learned that it often takes years for relationships of mutual support to build up across disciplines.

A Positive Change

In my previous job I had sat administratively within a rigid hierarchical system of physical and occupational therapists, in which my every move was scrutinized and circumscribed. Initiative and originality were discouraged. It was difficult and sometimes humiliating. I had adapted by becoming the perfect worker. When I moved to the VA and was given little orientation to the unit and no unit key on the first day, I was homesick for the structure of the previous job (a structure which included a clear and welcoming orientation policy which I myself had devised). In the new job I was given a lot of autonomy but found myself checking in with everyone in sight before making any move, such as a schedule change. When I was finally told: 'Just do it!', I realized that at the VA peers and supervisors would not be threatened if I acted independently, and breathed a sigh of relief. In the corporate world new ideas from non-managers were perceived as threatening; in the VA my ideas so far have been welcomed and implemented. Furthermore, I had crossed the border from being the only creative arts therapist in a restrictive administrative structure to joining a group of recreation and creative arts therapists in the Psychology Service, where I am supported by peers with mutual goals and training.

Moving from Private to Public Sector

The major change I encountered in moving from the corporate world to the VA was in the quality of service given to patients. Both institutions had the benefits of Yale University's residency training programme but the VA's mission was 'Putting Veterans First', whereas the not-for-profit private hospital was driven by the economic requirements of for-profit managed care companies whose mission is not patient care but profit for its directors and stockholders. During the time I had worked in the private hospital the length of patients' stay shrank from 90 days (or more) to a week (or less). There were no outpatient services except a small, four-week day hospital with a revolving door to the inpatient units. At the VA, after I had worked there a year and a half, inpatient psychiatric units were reduced by 75 per cent and the length of stay also shortened. For a while, everyone's job seemed in jeopardy. However, in contrast to my former job, where corporate downsizing resulted in the replacement of experienced professionals by high school graduates, at the VA the therapists and some nursing staff were reassigned to outpatient work. There are many outpatient services at the VA. Outpatient rehabilitation programmes, work programmes of varying levels, community support programmes, and supported housing programmes are all designed to enable mentally ill veterans to sustain a productive life in the community. I was happily reassigned to a long-term outpatient programme.

The tradition of health care in this country originated from the concept of the public good. Hospitals grew out of communities to fill a need. The concept of medicine as a business in which profit is made from healthcare delivery is new. It is not profitable to take care of mentally ill people. At the VA I feel myself in the presence of total commitment to the long-term care of severely ill people. The patients feel it too, often saying they are at home in the VA. One patient said that when he was feeling unable to cope he would drive around the VA buildings and then feel better. The government made a commitment to take care of its veterans and there is no comparable commitment in healthcare left in the United States.

There is a charm about the big sprawl of buildings on the hill. People say 'hello' to each other as they pass through the endless walkways; there is a feel of a village. There is also a community of veterans' organizations, whose many volunteers provide parties and activities for patients, visit them and bring gifts. While there may be an element of mutual dependence in this process, it is refreshing in the face of the general rejection of mentally ill people in our society.

Ethnic Differences

The population at the VA is as diverse as the community in which it is situated. I have lived in this New England area most of my life and, before working at the VA, never knew that there is a Native American tribe based in my city. Working with people long-term has permitted me to learn more about their varied cultural backgrounds and, thereby, about the history of different populations who have originally come to my area from other countries such as Africa, Poland, Italy, Ireland and the Caribbean. In the music group that I conduct one veteran taught us that the drumbeat speeds up, as the heartbeat does, in the war song but is quiet in the harvest song. Another member has sung in a gospel choir for 20 years. Others like a Latin beat, big bands, Gregorian chants and Joni Mitchell. Despite the diversity in race, ethnicity and education, there is a specific VA culture, grounded in the spirit of service (give your all for your country) and comradeship, a culture that transcends difference and provides a deep sense of identity and belonging.

When I was losing my former job and told my unit chief I was considering a job at the VA, he said I would be a flower in the desert. He meant that the VA was a wasteland compared to the private hospital. I said that lately I had been enjoying growing thorns and the tough, leathery skin I would need to survive in a desert and produce a flower. But I didn't find a desert, I found a garden.

Adapting to Differences

Besides learning the new language and learning to function more autonomously, in what other ways did I adapt to my new culture? I had entered my previous job as a new art therapist and art therapy was only part of my job description. I had very quietly and slowly brought forward the importance of art therapy in assessment and treatment. In this job I decided to come in as an expert, to promote what art therapy had to offer and what I could contribute. For example, I sought out the opportunity to recreate a sense of working together among the staff – an aspect of my old culture that I wanted to keep. I volunteered to lead a task force to redesign the inpatient treatment programme to promote shorter length of stay. The resulting process of close collaboration became the model for a new programme with an emphasis on multidisciplinary teamwork that everyone found workable.

Another example is that when the inpatient units were closing and a new outpatient programme was envisioned, I made it my business to be knowledgeable about the requirements of the Joint Commission for the Accreditation of Health Organizations. I wrote up proposals, worked on policies and did what I could to promote the inclusion of art therapy in the new programme. Perhaps my activism during a time of change made me and my work known to others more quickly and more accepted as part of the culture. I also was able to contribute to the changes in the culture.

With this new population there were new things to learn. I've discussed some of my realizations about psychological and interpersonal boundaries. What about other therapeutic boundaries? I came from a unit with strict group rules – if you're late, you can't come in; if you leave, you can't come back. With the new population I found that while structure was important to the groups and individuals, schizophrenic patients sometimes needed to reduce stimulation or could not tolerate the full group time. My groups thus became much more open and welcoming to all. Additionally, my former unit had been conservative about giving patients privileges. I found that in the new culture patients were given privileges and responsibilities early in the hospitalization and handled them well, which resulted in increased autonomy and self-esteem. With outpatients I worked to make the groups worth attending and understood that imperfect attendance was not a violation of the therapeutic contract but could be due to various reality factors or attempts to manage symptoms. And in our outpatient programme we entered into patients' lives in a different way, as needed – we telephoned them and occasionally transported them to group and visited them in their homes.

This new population and culture have inspired somewhat different art approaches. Although patients are always free to work on whatever they want in the art, at times I suggest projects that move beyond the art room to affect the environment of the VA – projects like painted screens for room dividers for the VA Community Care center, murals for a dark tunnel and the creation of a garden. Through these projects veterans can help themselves by giving to their community.

The Garden

The inpatient unit was itself a garden waiting for a gardener. The first year, the patients and staff broke ground for a small garden in a quiet spot on the VA grounds. The patients planted vegetables and flowers, tended them

throughout the drought that summer, and enjoyed the strawberries, corn, tomatoes, peppers and herbs in their cooking projects. For the Fall Fundraiser (to raise money for patient activities) they hung the big sunflower heads in the dayroom to dry and roasted the seeds to sell, together with fresh flowers, stationery made from garden photographs and plants in painted pots. The garden produced intangible harvest as well: feelings of good fellowship, pride, hope and an active engagement with the real world.

The garden was such a success that an expansion was planned to fill the 28 x 48 foot space between three buildings. In mid-winter the patients and I pored over books of garden design, measured the area and marked out plots. To serve the whole VA community, we planned for bluestone paths and a raised bed to make gardening accessible to wheelchair-bound and elderly veterans. We added fragrant flowers and herbs and running water for the pleasure of patients who were visually compromised, and benches and an arbor to create a place of respite. The design was approved; a donor emerged who financed the construction of the stone raised bed and walkways; and funds were found for the arbor, fountain and benches. The patients' altruism and hard work resulted in a permanent and living change in the hospital environment (Figures 18.1 and 18.2).

There was a time when we were digging in the garden, working intensely to get it ready for a big dedication ceremony, when units were closing and my job was in jeopardy. The garden became a metaphor for both difference and sameness, change and stability. Perhaps the garden became a transitional object for patients and staff as the treatment emphasis shifted from inpatient to outpatient care. I now have outpatient garden groups, as well as art therapy and music/creative writing groups. Most seeds grow better in a garden than in a hospital window. The garden also contains plants that originally flourished in my father's garden.

The Military

What about being associated with the military? Perhaps some people drawn to the military are seeking the comfort of a structured world with clear rules and expectations. Perhaps I, too, wish for such a structured world, which is why I prefer working within institutions to working exclusively alone in a studio or in private practice. I have always had a passion for World War II movies. Perhaps, in embracing the VA, I am finding a hidden part of my father, and also parts of myself: my own potential for war and violence, my own potential for insanity. Perhaps, in working with the disenfranchised, I

Figure 18.2

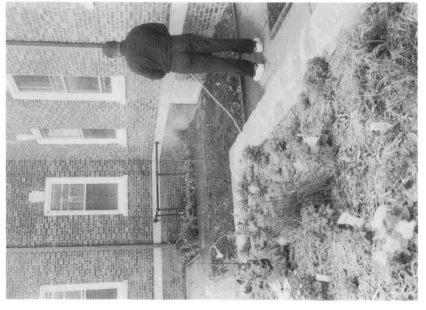

Figure 18.1

am coming to terms with my own sense of alienation, a sense I believe is shared, to some degree, by all those who become artists. I seem to be working along important borders between health and illness, war and peace and rejection and acceptance of what it is to be a human person in the United States.

Art Making and Borders

And what about men and art? I found, as I always have, that everyone makes art. Art lives on the border. Winnicott (1986) writes that art, or cultural experience, 'is located ... in the potential space between the individual and the environment (originally the object)' (p.100). It is born in the potential space between two people, mother and child. Ulman (1986) refers to art as 'the meeting ground of the inner and outer worlds' (p.128). It is, therefore, not surprising that art making is a potent tool in crossing and shoring up borders when needed. The edges of the paper can contain and border the infinite richness of human experience. Art making can help psychotic patients both get a foothold in reality and find the grain of psychological truth in the fantasy world. It can help PTSD survivors to turn reliving into remembering and create a needed boundary and bridge between the traumatic past and the present (Johnson 1987). It seems fitting that the Vietnam War Memorial in Washington, D.C., is a wall, a boundary, a work of art which reflects images of both the living and the dead.

All the veterans have made rich use of art therapy. Their art has helped me to enter into their culture; perhaps my art has helped bridge the gulf between our experiences. I realized how acculturated I had become to the imagery and views of Vietnam veterans when I first recoiled at seeing a green and brown papier mâché landscape that some art therapy students had constructed in a group class. I had a pang of fear and realized that it came from seeing so many pictures by veterans in which the colour green meant 'jungle', which meant a 'threat you cannot see'. Memorial Day now has a deeper meaning to me than 'the day the beaches open'.

Veterans

David was a big man who often came into the art room angry at someone or something; but he liked art. All but one of his pictures were drawn on black paper. He drew many images of isolation (like a lone cabin in the woods) and images of violence (such as nuclear explosions or fireballs). He was in and out

of the hospital for a year before he began to talk with me about himself and what he was trying to do in the art.

One day he drew a picture that was all green, with light in the center. He said it was about looking down at a helicopter crash and that he would feel guilt until his dying day. Later, he told me that it was his job to do triage in picking up wounded people. The helicopter could only land for a few seconds and he would select injured marines who he thought could be saved. If one died on the way, he wished he had chosen someone else. He had been in six helicopter crashes. In one, he was the only survivor. He played dead while the Viet Cong mutilated and killed everyone else. He stumbled back through the jungle to a camp, and was almost killed there because they did not recognize him. He felt guilty that he had not stopped to check whether there were any other survivors. Figure 18.3 is an invention, a joke, a helicopter turned into a boat, a well-armed Noah's ark rescue machine, perhaps a way through humor to come to terms with the guilt.

Figure 18.4 is 'a frog you would see when you're up to your eyebrows in the muck in Vietnam'. At this point David was active in discussions and contributed to a moving sense of camaraderie and support in the group. Fig-

Figure 18.3

Figure 18.4

Figure 18.5

Figure 18.6

ure 18.5 represents looking down and seeing blood spurting from his shoulder when he was shot.

In his next picture, Figure 18.6, he said he wanted to represent a frightening experience he had been having. It was a panic attack, but he said it came visually, as if he became part of a light that contained many colors, and that it was terrifying. When he drew the light, he did not see the intimation of a figure in its center – others pointed it out.

In talking about the artwork he told me that he had been drafted into the Marines at 17 and had served two tours of duty in Vietnam because he had security clearance to go into secret areas. After Vietnam he spent two years in

a hospital, during which time he kept saying he wanted to go home – home to Vietnam. He then became a diver for 11 years, working on oil rigs, hiding underwater. Diving was dangerous and frightening. He felt at home on the edge of danger. But when he was underwater, he needed to learn how to re-orient his body in space through sensation in the absence of visual/spatial parameters. Regarding his picture, I asked him whether there could be some hope in the experience of being one with the colours, that it was frightening but, perhaps, represented an effort to reconnect with his own sensations. In the picture of the helicopter crash viewed from above, there was a similar light, but he was above it, dissociated from it, perhaps numb to his own physical and emotional pain, as he was when looking down at the blood spurting from his shoulder. The diving may have been an effort to recapture sensation, perhaps it would be possible to go into the light and find something of value there. Figure 18.7 is my picture done in group in response to his. It is about trying to get a closer look at the figure in the light and about the existence of parallel interior and exterior worlds. David worked with the theme of light until he was discharged.

Gene was hospitalized from time to time, in a disorganized state, and seemed to take solace in drawing complicated grids and patterns of words

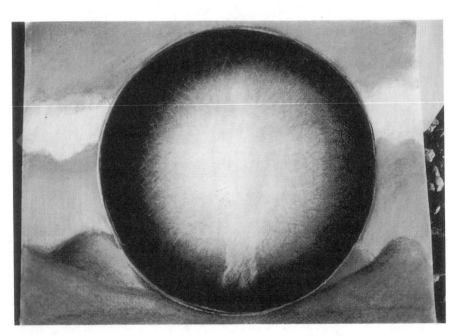

Figure 18.7

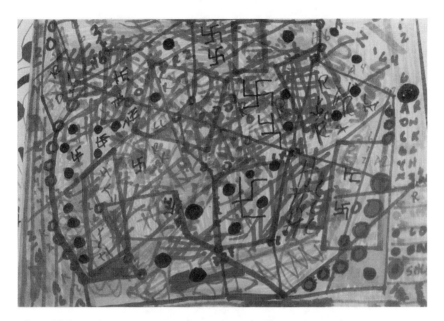

Figure 18.8

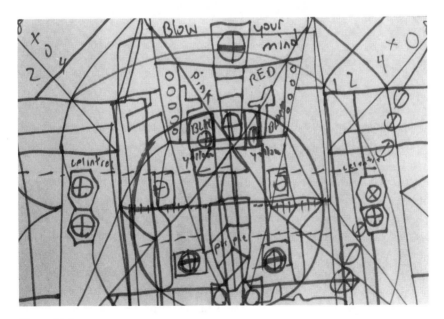

Figure 18.9

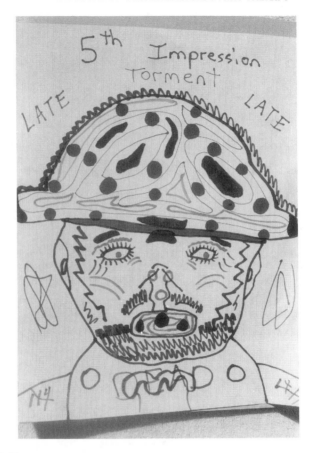

Figure 18.10

and numbers (Figures 18.8 and 18.9). His descriptions of them were almost unintelligible but contained references to wars and other catastrophic world events.

Over time, his word salad and his artwork became more clear and oriented to reality and he began to depict current concerns and emotions. Figure 18.10 is a self-portrait which seems to speak eloquently to the pain of being a schizophrenic. He said that '5th impression', 'torment' and 'late' mean he has suffered so much that he thought he would be reborn in a different consciousness, but this is the fifth time he has awakened to the pain.

In Figure 18.11, a portrait of me and himself as 'teacher's pet', I am depicted almost as if in a TV – perhaps he is putting me at a safer distance.

Figure 18.11

Figure 18.12

This drawing represents a major step out of his solipsistic world to connect with another person.

Figure 18.12 shows two people in the dining room of their home. Gene said 'I am searching for a home'.

Summary

There is no certainty that my job will last. VA facilities and programs are closing all over the country. There are rumors that there will be no VA in one, five or ten years. Meanwhile, there are new buildings rising on the hill and attendance in the art therapy, music/creative writing and garden groups is swelling. I am enjoying my job while I have it. My border crossing has affirmed for me the power that art has to transcend differences and adversity. And the process of entering new cultures – the cultures of the VA, PTSD, psychosis, ethnicities of my city – has enabled me to enter my own culture more deeply as well.

References

Grossman, D. (1995) *On Killing: Psychological Cost of Learning to Kill in War and Society.* Boston, MA: Little Brown and Co.

Johnson, D. (1987) 'The role of the creative arts therapies in the diagnosis and treatment of psychological trauma.' *The Arts in Psychotherapy 14*, 7–13.

Ulman, E. (1986) 'Variations on a Freudian theme.' *American Journal of Art Therapy 24*, 125–133.

Winnicott, D.W. (1986) *The Location of Cultural Experience. Playing and Reality.* New York: Tavistock.

Finding Myself in America
An Indian Art Therapist's Experience of Acculturation

Nina Mathews

Abstract

In order to understand the specific identity transformations that occur during ac-culturation, the author examined her own journals and artwork that were made during the past eleven years of her stay in America and then generated a body of artwork that corresponded to the journals and her prior work. The new art was then analyzed and supported by research conducted by using both art therapy literature and literature from other disciplines on acculturation. The data was then re-examined and compared to the new material. The implications for the use of art therapy in the acculturation process are discussed and will assist mental health professionals in understanding the significance of the creative process in working with new immigrants.

Acculturation

'Culture is created only in the confrontation between cultures as "self" is created only in the confrontation between selves' (Trawick 1992, p.67). This chapter examines the different selves I occupied during my years of acculturating to the United States. Acculturation is defined as a bi-directional process that involves independent movement in two directions: toward or away from one's original culture and toward or away from the new culture (Mehta 1994). There are, of course, many types of acculturation and all are unique. The United States is a country that experiences continued immig-ration and continued adjustments to new cultures. Immigrants, as part of their acculturation, face resistance from both their culture of origin and the culture to which they are acculturating. This chapter proposes that art therapy is an ideal medium through which the acculturation process can be understood and that by allowing everyone their creative freedom, a paradigm of wealth rather than poverty consciousness can be generated. My

acculturation process involved the disintegration and reintegration of identity and, for me, making art was the crucial way for me to make sense of the process. I employed the heuristic model of research inquiry whereby I reviewed twelve years of journals and artwork created during my years in the United States. I identified recurring themes which were used to create new artwork and writing. This data was examined against the data found in the literature on acculturation. Finally, conclusions about my own acculturation process and recommendations for art therapists who are working with acculturating clients are documented.

My acculturation began when I was three months old. I was relocated from India, where I was born, to Kuwait, where my father worked. Acculturation in Kuwait meant maintaining culture and class as well as mourning the loss of a geographical identity.

My childhood was culturally diverse. Although I lived in a fairly traditional Syrian Christian Malayalee household, I watched Tom and Jerry cartoons and public hangings on television. I went to an Indian school and studied Arabic. I grew up being comfortable with the fact that private and public culture seldom matched. When I was eight I was sent to a British-style military boarding school in India which presented its own challenges of acculturation, where being identified as a Christian, in a mostly Hindu environment, again made me a minority.

I have lived in the United States for the past thirteen years and wrestled with the issue of cultural identity, primarily because I didn't know what it meant to be Indian outside of its meaning in my family and in history books. When I returned to India, after an absence of five years, I was treated like a tourist, although I looked, spoke and dressed like a native. It made me wonder about the subtle changes that had occurred while I lived in the United States, changes that I attribute to the acculturation process. It was by examining that process that I discovered what it meant to be an Indian living in America.

I first came to the United States in August 1983, to study in Portland, Oregon. That first year I experienced what the research of Sue and Sue (1990) posits: that people who are raised in cultures inconsistent with their own, face denial, lack of pride and negative views of their own culture. The fact that I had left an academically-sound, though colonially-biased, bachelor's degree program in India to study in the United States reflected, on some level, I believe, a rejection of self as well as of India. I began to decipher the meaning of this double rejection only through doing this study.

1983: 'Twin Tongues'

I began the project by making a plaster mask from a mould of my face, which was then taken to the ocean and placed in a box with Indian and American newspapers. I took a series of photographs to introduce me to the project, just as I had been introduced to American shores that first year. The mask was then retrieved and rebuilt with fresh Indian and American newspaper.

The fact that the mask fell apart and had to be rebuilt is, perhaps, in essence the central metaphor for my acculturation process, namely a disintegration of what was originally present to create a new identity. The mask represents the identity with which I came to America, half Eurocentric and half 'Asiacentric', symbolized by one half covered with newspaper in English and the other half in Malayalam, my mother tongue. 'Twin Tongues' represents all the things I have left behind: my language, my culture, my parents, my country. It reminds me of the conflict I had felt all my life as a bilingual, bicultural person, not knowing where my allegiance should lie – with the people I was born among or with the people I had grown up trying to emulate, the British. It represents for me the lingual and cultural split between my parents – my father who only spoke to us in English and my mother who spoke to us in Malayalam.

1984: 'The Rootless Silence'

The main issues in my second year of acculturation were the feelings of being rootless, silenced and traumatized. There were two events that stood out during my first summer in the United States: I was raped, and my father disowned me for expressing an opinion contrary to his. This image represents feeling silenced and cut off from my identity as my parents' daughter, and from my own violated body. This piece is also about my identification with my mother's experience of feeling silenced in her culturally sanctioned arranged marriage.

This year I was forced to re-examine myself and my belief systems. The blue face represents how unconnected I felt in a school where I was the only Indian student. I experienced my cultural alienation particularly poignantly on the day after Indira Gandhi, the prime minister of India, was assassinated. On wearing a traditional white salwar kameez (tunic and pants) in mourning, an innocent student asked me if I was going to a fancy dress party. That year I was particularly silent because I had brought with me a cultural tradition

Figure 19.2. 'The Rootless Silence'

Figure 19.1. 'Twin Tongues'

where insults took the place of affectionate interchange and I had to slowly learn the new culture's rules of conversation.

1985: 'The Holding'

This image is about my inability to view being in a relationship as anything other than binding, given my mother's experience. My journal entries reveal a dilemma about my identity regarding place. During my sojourn in America I completely forgot about my life in Kuwait and India because who I was in each place was very different. The triangular frame around the figure represents these three places to which I felt bound.

The image also represents my growing awareness that summer, as I visited my parents in Kuwait, of my 'triangulated' role in the family. That year I was accepted into art school and began to claim an identity as an artist. The nudity and pose of the figure reflect a growing awareness of my sexual identity and the discrepancies between American and Indian cultures with regard to sex.

Figure 19.3. 'The Holding'

1986: 'Love's Cold Embrace'

The image represents an all-consuming relationship I had with an emotionally-unavailable man. The dynamics of this relationship duplicated those of my childhood and so it was tempting to try and solve, albeit unconsciously, the issues with my past in the present. To further my commitment to my identity as an artist, I travelled to Florence, the land of my artistic hero Michelangelo. Being in a school in Italy for Americans made us all foreigners, and this common bond helped me feel at home and gain some perspective on America.

Figure 19.4. 'Love's Cold Embrace'

1987: 'Dissolution'

The image of the daisy reflects a year in which I flailed around for an identity based on my associations with people. On meeting some old acquaintances from India, I discovered that the sense of community that I longed for could not be satisfied solely on the basis of ethnicity or on past bonds in other countries. I wanted to adopt the traditional views held by these newly-arrived Indians because I realized I had never accepted the world view of my culture to begin with. Geographical and cultural distance made those traditions seem different and yet familiar. I wanted to be able to relate to my fellow countrymen, whose frame of reference was still India, while I had 'crossed over' to being more American. The awe that I had felt for America had prevented me from appreciating all I had given up – in terms of India and 'Indianness' – to be in America.

Figure 19.5. 'Dissolution'

1988: 'The Split'

This image reflects my ongoing confusion about geographical and familial loyalties. That year I returned to India and spent four months living with my parents, for the first time since I was seven. It was a difficult time since I had spent the previous five years formulating an identity very different from what my parents knew. This image is about trying to resolve the split between how I saw myself and how they saw me, between being their Indian daughter and being an Americanized stranger.

When I returned to the United States this time I felt another culture shock. I recognized from my reactions that I had brought with me my parents' world view. My journal entries reveal a tiredness with being the foreigner, the exotic commodity. I realized that I belonged nowhere.

1989: 'Journey Through Hell and Back'

The title and the image refer to my feeling the pressure of having to make art on demand in graduate art school. That year I began to sense that making art could help me integrate my fractured self that was trying to reconcile being Indian while living an American lifestyle.

In graduate art school I was informed that what I was doing was not 'art'. Since my work was attempting visually to resolve the aesthetic traditions of East and West, I felt the dismissal included both a dismissal of the culture I was from as well as my attempts to understand the culture I was in. The experience plunged me into a new identity crisis. I felt estranged from both cultures – from India because of geographical distance and my Eurocentric education and from America because of what I perceived to be academic élitism.

1990: 'The Vessel'

The artwork from this year reflects my recognition that being busy with the craft of making art kept me sane. The vessel reflects feeling that I was simply an instrument for ideas, feelings and identities. The vessel is a metaphor for the emptiness I felt as a graduate art student as I tried to gather myself together and differentiate between my perceptions of self and my art and others' perceptions of the same.

That year my sister married and my parents came from India to attend her wedding. During their visit I was further reminded of the many roles I played: as a container for my family's conflicts, as a graduate student who was

Figure 19.6. 'The Split'

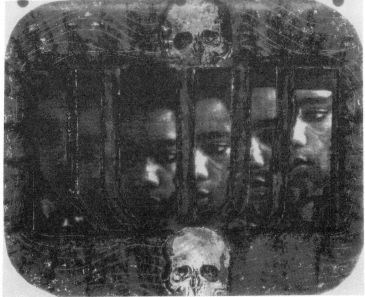

Figure 19.7. 'Journey Through Hell and Back'

Figure 19.8. 'The Vessel'

allowing her fear of not being perfect impede her creativity, as a girlfriend to a bi-racial man who identified both of us as 'black' by virtue of the darkness of our skin.

1991: 'The Family Crucible'

A line from a Bob Dylan song captures this year: 'If you're not busy being born, you're busy dying'. I felt I was mostly doing the latter this year when I undertook a heart-wrenching journey to explore my childhood past, through writing, art making, dreams and meditation. The image is of a burnt, roofless paper house, with pictures of my family and of myself as a young child in the center. It reflects a long-smothered rage at being the container for

varying kinds of familial actions. This was a year in which I considered changing my name in order to divorce myself from my family and my past and to take on a different identity.

I began training and working in an art and mural restoration studio and found, coincidentally, that the work I was doing both inside and out were synchronous: I was restoring old paintings and preserving damaged murals just as I was recovering and healing the wounded and ancient parts of myself.

Figure 19.9. 'The Family Crucible'

1992: 'The Blossoming'

The central image is a xeroxed photograph of myself as an infant emerging from a lotus flower. This refers symbolically to the availability of attaining God's grace, even if one emerges, as the lotus does, from the mud. The image refers to the journey I set out on to retrieve my spiritual identity and to be of service to others. After attending an art therapy workshop I decided to apply to the same programme at Loyola Marymount University the following year.

Over the years my spiritual path has undergone several transmutations of context which I find interesting in terms of acculturation. Upon entering boarding school as a child I discovered that my parents' Syrian Christian faith was different than the Hindu faith of the majority of Indians. Ever since then part of my desire to be 'Indian' has included a fascination with the

traditional religion of India. That year I came into contact with an Indo-American spiritual community in Los Angeles and, through working for one of the members of the community, I learned and added to my spiritual repertoire the basic tenets of Hinduism.

Bernal and Knight (1993) propose that as contact with the new culture continues, acculturation may also continue, or become less rapid, or even reverse to a stage of reaffirmation of traditional values. For me, considering shifting my spiritual allegiance from Christianity to Hinduism felt as if I was reclaiming my cultural identity.

1993: 'Death Mask'

This was a year in which death touched my family. My aunt and uncle both died and my father informed me that, according to an astrologer's prediction made at his birth, he was to die very soon. Unable to attend my relatives' funerals, I began to worry about my father's imminent death and tried to think about where my loyalties lay. I decided to stay in the United States rather than return to India, recognizing that culture and tradition are sometimes used to justify maladaptive behavior. This piece represents my saying goodbye to being a traditional Indian daughter and my childhood identity as the family's rescuer. It was also a departure from accepting culturally-sanctioned beliefs in astrologers' predictions. Interestingly enough, later that year my father underwent emergency double-by-pass surgery and today is in excellent health.

The mask is also about becoming aware of the many masks I wore – of being perfect and of having created a false self to protect myself from any future betrayals. Pulling the masks off has not been easy, but they have given me my freedom.

1994: 'The Resolution'

'Culture is a psychological construct that refers to the degree to which a group of people share attitudes, values, beliefs, and behaviors. Culture is not race, ... not nationality, ... not birthplace' (Matsumoto 1994, p.177). The image is a self-portrait with the map of India superimposed. It was started before I returned to India and completed on coming back. It is, I think, an unconscious comment about my sense of familial and cultural obligation to return to India, to rescue my parents and the masses there. I travelled with two American friends and switched easily between being Eastern and

Figure 19.10. 'The Blossoming'

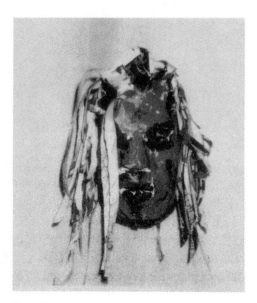

Figure 19.11. 'Death Mask'

Western, between speaking English, Hindi and Malayalam. It was an important discovery, realizing that I could embrace both the East and the West within myself and choose, depending on context, which way to be.

The trip was also important in that I made peace with my family by practicing the new skills I had learned from being in therapy and being a fledgling art therapist. On my return to Los Angeles I tracked down the local Syrian Christian community and found, for the first time, people who looked like me. It was a moment of affirmation of self and identity.

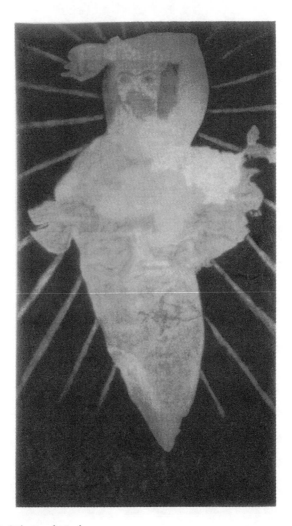

Figure 19.12. 'The Resolution'

The Summing Up

I concluded this journey by creating a final image to represent the four stages of my acculturation process: (1) flight or migration, represented by the red spiral in the black background; (2) creativity, represented by the multicolor swirl; (3) transformation, represented by the cloth heart; and (4) resolution, represented by a yin-yang composite made by images of myself at different ages: an infant, a toddler and an adult. The absence of an image of myself as a teenager is consistent with the absence of the concept of adolescence in India. In retrospect, I can see how my sojourn in America could be interpreted as an experience of delayed adolescence.

In this chapter I have focused on the need to be culturally educated and culturally sensitive as a clinician working with an acculturating population. Future research possibilities include looking at how indigenous, expressive traditions can educate and enhance current art therapy theory and practice to assist the transitioning client(s). Art therapy could also help bridge gaps between cultures in organizations like the United Nations and the Peace Corps, or any place where diverse peoples interact.

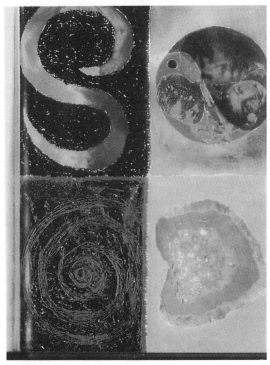

Figure 19.13. 'The Summing Up'

Implications and Applications

Clinical questions that art therapists who are working with a culturally-displaced client might keep in mind are: (1) whether or not the client's artwork can be misinterpreted due to the therapist's cultural bias or ignorance; (2) what aspects in the client's artwork are culturally reflective as opposed to reflecting pathology; (3) what art materials or art directives the client prefers that might reflect cultural preferences.

In taking inventory of having lived in the United States for the past thirteen years I realize that I have arrived at a sort of hybrid identity that is different from who I was when I first arrived. I know now that cultural identity is not a fixed, foregone conclusion but a constantly-evolving state of being.

Erikson (1950) felt that the final stage of human development is to come to terms with one's cultural identity. On the other hand, Rodriguez (1992) writes: 'As long as we reject the notion of culture, we are able to invent the future' (p.164). For me, the final stage of human development is about coming to terms with one's creative and spiritual identity. It is with this vision in mind that I practice art and art therapy.

References

Bernal, M.E. and Knight, G.P. (eds) (1993) *Ethnic Identity: Formation and Transmission among Hispanic and Other Minorities.* Albany: State University Press.

Erikson, E. (1950) In R. Banmeister (ed) (1986) *Identity: Cultural Change and the Struggle for Self.* New York: Oxford University Press.

Matsumoto, D. (1994) *People: Psychology from a Cultural Perspective.* Belmont, CA: Wadsworth, Inc.

Mehta, S. (1994) *Acculturation and Mental Health: Asian Indian Immigrants in America.* Unpublished doctoral thesis, Auburn University.

Rodriguez, R. (1992) *Days of Obligation: An Argument with my Mexican Father.* New York: Penguin Books.

Sue, D.W. and Sue, D. (1990) *Counseling the Culturally Different: Theory and Practice.* New York: Wiley.

Trawick, M. (1992) *Notes on Love in a Tamil Family.* Berkeley: University California Press.

The Contributors

Pascale C. Annoual is a Haitian-Canadian who currently lives in the Philippines. There she applies her inter-cultural experience through art therapy with street children. She is also involved in various multidisciplinary teams as an art therapy consultant. Her work focuses on ethnicity and racism in the mental health field.

Charlotte G. Boston is currently an art therapist who works with psychiatric adult inpatients at Walter Reed Army Medical Center in Washington, DC. She is an active member of the American Art Therapy Association. Charlotte was the 1996 Multicultural Committee Chair. She resides in Baltimore, MD.

Julia G. Byers is an Associate Professor. She is currently the Director of Expressive Therapies at Lesley College, Cambridge, Massachusetts. Julia worked at Concordia University, Montreal, Quebec, Canada, as a faculty member for 17 years. She served as Director of the Graduate Art Therapy Program at Concordia for 9 years. Julia has conducted workshops and presentations in Canada, the United States, the Middle East and Australia. Her research interests are in promoting arts therapies as alternative treatment approaches in organizations, mental health agencies and therapeutic schools. Clinically, Julia has worked with children and adolescents in crisis, people with AIDS, families and adults. Her approach emphasizes the integration of the creative arts studio approach with clinical psychodynamic theories.

Abby C. Calisch is Associate Professor and Director of the Graduate Expressive Therapy Programme at the University of Louisville. Formerly, she was the Director of the Graduate Art Therapy Program at Concordia University in Montreal, Quebec, Canada and an Assistant Professor at the School of the Art Institute in Chicago, Illinois. Prior to her academic positions she was directly involved in culturally diverse clinical work for over 15 years, culminating as the Director of the Expressive Therapy Department at University Hospital in Chicago, Illinois.

Abby earned her Master's in Art Therapy at Hahnemann Medical College in Philadelphia and her Psy.D. at the Illinois School of Professional Psychology in Chicago. Her dissertation was entitled *The Use of Imagery and Art Therapy in Conjunction with Verbal Therapy: Advantages and Implications*. She has presented panels, workshops and papers, as well as publishing nationally and internationally, in the professions of psychology and art therapy.

Mona Chebaro was born in Beirut, Lebanon, and graduated from the Kansas City Art Institute and the University of Arizona at Tucson. She has worked in a psychiatric hospital and has counseled victims and their families during the war in Lebanon. Mona has also worked with battered women. She is presently a drug and alcohol counselor in a residential and outpatient drug and alcohol treatment center. Mona is currently working on illustrations for a multicultural children's book. She resides in Kansas City, MO, with her son.

Kelly Ducheny received her PsyD in Clinical Psychology in 1993 from Wright State University, School of Professional Psychology. She is a licensed psychologist and is the Associate Director of Clinical Training/Core Faculty at the Chicago School of Professional Psychology. Her areas of interest include teaching and curriculum development; gay, lesbian and bisexual issues; professional development; multidisciplinary collaboration; white racial identity; and multicultural psychotherapy and assessment. She has published and presented nationally within these areas.

Phoebe Farris-Dufrene received a Bachelor's degree in Fine Arts from City College of the City University in New York, a Master's degree in Art Therapy from Pratt Institute, New York, and a Doctorate in Art Education from the University of Maryland, College Park, Maryland. Phoebe is an Associate Professor of Art and Design at Purdue University in West Lafayette, Indiana, and an art therapist in private practice. Phoebe has published extensively in national and international journals and presents workshops at national and international conferences. She is a recipient of several grants, including a Fulbright Grant to Mexico. Phoebe has consulted for the Eiteljorg Museum of American Indian and Western Art and the Jan Cicerro Gallery in Chicago. In 1996 her photographs were exhibited in a video production at the Beijing International Women's Conference.

Nadia Ferrara is a Registered Art Therapist who has been working with Native Americans for the past nine years as a consultant and art psychotherapist. She received her Master's degree in Art Therapy from Vermont College of Norwich University, and a Master's of Science degree in Transcultural Psychiatry from McGill University. Nadia has worked in residential treatment settings, educational settings and hospitals. In her attempts to develop the area of cross-cultural art therapy, Nadia has published several papers and presented workshops across North America and Europe. She is also a researcher at the Jewish General Hospital in Montreal, involved in the Native Mental Health Research Team. Nadia is presently working on her doctorate in medical anthropology.

Michael Tlanusta Garrett, Eastern band of Cherokee, is an Assistant Professor of Counselor Education at the University of North Carolina at Charlotte. He holds a

PhD in Counseling Education and a MEd in Counseling and Development from the University of North Carolina at Greensboro. Michael has written extensively on Native Americans and has published many articles on counselling. His experience with Native American people, both professionally and personally, lends a unique perspective and expertise with Native American issues and concerns. Michael grew up on the Cherokee Indian reservation in the mountains of western North Carolina.

Michael has worked with children and adolescents in schools. His practice also includes individual and group counselling as well as counseling in community agencies. During the past several years Michael has given many presentations, workshops and seminars on topics including wellness, cultural values and beliefs, spirituality, relationships, group techniques, conflict resolution, date rape and sexual violence, and play therapy. Michael also served as a project director of an urban Indian centre serving a local Indian community.

Andrea Gilroy, PhD, is an experienced art therapy educator and researcher. She teaches at the University of London, Goldsmiths College, and is involved in the development of art therapy as a profession through her work as an educator and Research Fellow at the University of Western Sydney, Nepean. She is co-editor of *Pictures at an Exhibition: Selected Essays on Art and Art Therapy* (1989, Routledge); *Art Therapy: A Handbook.* (1992, Open University Press); *Art and Music Therapy Research* (1995, Routledge) and *Theoretical Advances in Art Therapy* (1998, Free Associations).

Martha P. Haeseler has been an art therapist since 1972. Currently she works for the VA Connecticut Health Care System in a long-term outpatient psychiatric rehabilitation program, teaches and advises as Adjunct Assistant Professor of Art Therapy at New York University and maintains a private practice. She has served on the Ethics Committee of the American Art Therapy Association and is on the Editorial Board of *Art Therapy, Journal of the American Art Therapy Association.* She has published numerous articles and book reviews on topics which include art therapy with adolescents, ethics, eating disorders, groups and outsider art.

Margarete Hanna is an art therapist and clinical counselor in private practice in Vancouver, Canada. She was Course Co-ordinator (1994) and then Head of the MA Art Therapy programme at University of Western Sydney, Australia during 1995 and has taught at the Toronto Art Therapy Institute. She has published several book reviews for the *Arts in Psychotherapy Journal* (1996) and for the *Canadian Art Therapy Association Journal* (1987).

Nicole Heusch was born of mixed French and Swiss parentage in Strasbourg, France, where she spent most of her childhood and adolescence. She completed

degrees in sociology and psychiatric nursing. In 1981 she moved to Switzerland, where for four years she worked as a nurse in psychiatric and forensic units. In 1989 she moved to Montréal, Quebec, where she obtained a BA in Art Education. Nicole earned a MA in Art Therapy at Vermont College of Norwich University. Currently, she provides art therapy services to refugees who have survived organized violence and to the children of immigrants with attachment problems. She is also involved in developing special programmes to facilitate the integration of these children into the host society.

Anna R. Hiscox is an Assistant Professor of Art at Illinois State University. She earned a Masters degree in Marriage and Family Therapy from the College of Notre Dame, Belmont, California. She received National Board Certification from the Art Therapy Credentials Board in 1996. Her clinical speciality includes work with severely emotionally disturbed children in state hospitals and other mental health facilities. Her focus of interest is adolescent and child art psychotherapy. She has written extensively on art therapy and multicultural issues. Anna is an active member of the American Art Therapy Association, Inc. She has served on many Association Committees, including Chairperson of the Multicultural Committee. She is a member of the editorial staff of *Art Therapy, Journal of the American Art Therapy Association*. Anna is also a recipient of the Illinois State University 1995–1996 grant awarded for her work with children in domestic violent homes.

Linsay Locke is an artist who has taught art in colleges and has exhibited nationally and internationally. As an art therapist, she has worked with elementary to high school age children in schools and residential treatment centers. Linsay has also worked with geriatrics, hospice clients and patients, and in the state penitentiary in Santa Fe, New Mexico. She currently co-owns and manages a country bed and breakfast which is transitioning into a healing retreat that offers alternative healing modalities. Linsay is also in private practice and conducts workshops and rituals on spirituality.

Chantel Laran Lumpkin graduated from the Marital and Family Therapy/ Clinical Art Therapy at Loyola Marymount University with high honors. She also holds a MA in Christian counseling as well as a Bachelor of Fine Arts degree. Currently, Chantel is the Infant/Toddler Care Co-ordinator with the national service programme AmeriCorps Action for Children Today. She has been able to use her training as an art therapist to provide support to the program's participants and train on issues of cultural diversity, early childhood development, parent and child care provider relationships and special needs. In the fall of 1997 Chantel will begin her doctoral studies in Family and Child Ecology at Michigan State University. She also plans to work towards her ATR and BCAT.

Nina Mathews was born in south-western India and came to the United States several years ago to attend college. She has a MFA in painting from Pratt Institute and a MA in Clinical Art Therapy from Loyola Marymount University. She has her ATR and is studying for her MFCC licensing exams. She is a working artist who has had shows in both New York and Los Angeles and has worked as an art restorer, art teacher and as an art therapist. She has presented several clinical papers – at the 1996 National Art Therapy conference in Philadelphia, at mental health clinics and at her alma mater, Loyola Marymount University. She is currently self-employed working on writing children's books. Her passions include making art, practicing yoga and being in the great outdoors.

Marie K. Mauro is a bi-racial Asian American and has a special interest in the role of culture and how it affects our daily lives. She received her MA from Marywood College and is currently an art therapist at a partial hospitalization program for adolescents. Marie's undergraduate degree is in psychology from Millersville University of Pennsylvania. She has worked primarily with adults and adolescents in both partial and inpatient units.

Romy Montoya-Gregory received her MA degree from the University of Louisville in Art Therapy. She earned a BS degree from the University California in Fullerton, CA. Her work in art therapy includes children, adolescents and adults at a hospice facility. In addition, her social services experience includes working with adults with disabilities, children who have experienced domestic violence and incarcerated youths. She is a native of Nicaragua who resides in the United States.

Marcia L. Rosal, a registered art therapist since 1979, received National Board Certification from the Art Therapy Credentials Board in 1995. Her clinical work with children and adults spans two decades. Marcia is a graduate of, and a Professor at, the University of Louisville's Expressive Therapies Programme. She received her doctorate from the prestigious University of Queensland (Australia) in 1986. Her teaching specializations include art therapy research, group art therapy and art therapy with children. Marcia has published numerous articles and is an internationally recognized scholar who has lectured in Australia, Britain and Taiwan, as well as throughout the United States. A certified professional art therapist in the Commonwealth of Kentucky, Marcia serves as the Executive Secretary of the Kentucky Art Therapy Association. She is also President-Elect of the American Art Therapy Association. Marcia has served on the editorial board of *Art Therapy: Journal of the American Art Therapy Association* and is currently a member of the editorial board of the international journal *The Arts in Psychotherapy.*

Gwendolyn M. Short is currently Program Co-ordinator of the Mental Health Unit of North Forestville Elementary School, where she has been employed for the

past 16 years. The agency is part of the Prince George's County Maryland Health Department. She also works in Children's Intensive Treatment Services, an after-school programme at centers for Mental Health in Washington, DC. In addition, Gwendolyn works with psychiatric seniors at the Saturday socialization program at Greater South East Community Hospital in Washington, DC. She is an active member of the American Art Therapy Association and currently a Director on the Art Therapy Credentials Board. Gwendolyn resides in Washington, DC, with her husband, niece and nephew.

Nancy M. Sidun received her MS in Art Therapy from Emporia State University in 1978 and her PsyD in Clinical Psychology in 1986 from The Illinois School of Professional Psychology. She is a registered art therapist and licenced clinical psychologist. She is the Director of Clinical Training/Associate Professor of the Core Faculty at The Chicago School of Professional Psychology and Associate Adjunct Professor at The School of the Art Institute of Chicago. She maintains a small private practice and actively consults. Her areas of interest include adolescent and early adulthood development and psychopathology; sexual abuse; women's issues; transracial adoption; expressive therapies; and, most recently, white racial identity. She has published and presented nationally on these issues.

Beth A. Stone is a registered psychologist, MAPsS (Australia); registered art therapist, AATA; and a clinical relationship (Marriage, Family, Child) counselor (MFCC, AMFTA). She holds a Certificate in Gestalt Therapy from the Gestalt Institute of San Francisco; and a Postgraduate Certification in Interactive Guided Imagery (IGI), from the IGI Academy in California. A Macquarie University Psychology Hons graduate, Beth is currently a PhD candidate in the Department of Psychology at the University of Sydney. She is on the National Registry of Trauma Psychologists, and has over 25 years' experience in therapy, training and supervision. She has published articles in *Art Therapy* and *Imagery* and is on the editorial board of *Arts in Psychotherapy*. She has taught art therapy at the University of Hawaii and California State University, LA, and presently teaches at the University of Sydney.

Lisa Turner-Schikler, a native of south-eastern Kentucky, received her Bachelor of Art degree from Berea College in Berea, Kentucky. She attained her master's degree in art therapy from the University of Louisville's Expressive Therapies Programme in 1989. Upon graduation she joined the staff of Kosair Children's Hospital, Louisville, Kentucky, as a consulting art therapist. In 1995 she received National Board Certification from the Art Therapy Credentials Board. Her areas of expertise include medical and grief counseling and art therapy with children with chronic illness. She has lectured nationally and internationally on the applications of art therapy within the medical setting.

Donna Yurt is a registered dietitian and is employed at Kosair Children's Hospital in Louisville, Kentucky. She has specialized in pediatric dietetics for the past six years and has written extensively and lectured at numerous agencies and schools throughout Kentucky regarding nutrition and weight loss in children and adolescents. Her other areas of expertise include weight loss, diabetes, cystic fibrosis and nutrition with critical-care patients. An avid runner, Donna's other interests include wellness, biking and swimming.

Subject Index

Name Index